Dutch and Flemish
Painting in Norfolk

D0762762

Frontispiece:
William Kent (1684–1758)
Project for the decoration of the Saloon, Houghton Hall – Elevation of the North Wall
pen and black ink with grey and brown washes 25.7 × 25.7 cm
Private Collection

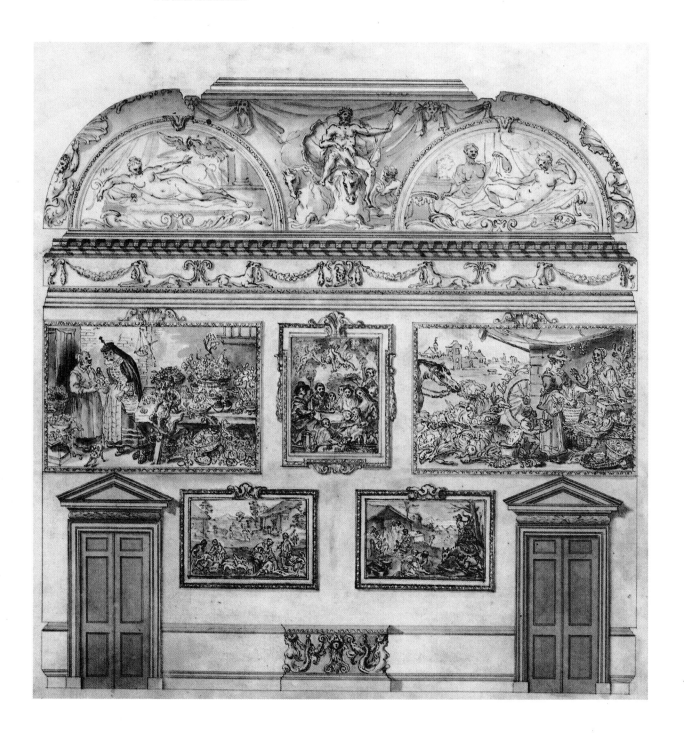

Norfolk Museums Service
Director: Francis Cheetham OBE, BA, FMA, FRSA

Dutch and Flemish Painting in Norfolk

A history of taste and influence,
fashion and collecting

Andrew W Moore

Published in conjunction with the commemorative
William and Mary Tercentenary exhibition
sponsored by Barclays Bank PLC

London Her Majesty's Stationery Office

©Crown copyright 1988
First published 1988

ISBN 0 11 701061 8

HMSO BOOKS

HMSO publications are available from:

HMSO Publications Centre
(Mail and telephone orders only)
PO Box 276, London, SW8 5DT
Telephone orders 01-622 3316
General enquiries 01-211 5656
(queuing system in operation for both numbers)

HMSO Bookshops
49 High Holborn, London, WC1V 6HB
01-211 5656 (Counter service only)
258 Broad Street, Birmingham, B1 2HE
021-643 3740
Southey House, 33 Wine Street, Bristol, BS1 2BQ
(0272) 264306
9-21 Princess Street, Manchester, M60 8AS
061-834 7201
80 Chichester Street, Belfast, BT1 4JY
(0232) 238451
71 Lothian Road, Edinburgh, EH3 9AZ
031-228 4181

HMSO's Accredited Agents
(see Yellow Pages)

and through good booksellers

Norfolk Museums Service acknowledges with gratitude the generous financial assistance given by Barclays Bank PLC towards all aspects of mounting the exhibition 'Dutch and Flemish Painting in Norfolk' at Norwich Castle Museum, 10 September - 20 November 1988, of which this publication is a permanent record.

Norfolk and Norwich
Triennial Festival
of Music and The Arts

Front cover
Peter Tillemans:
The Artist's Studio, c. 1716
cat. no. 78
Norfolk Museums Service

Back cover
Jacob van Ruisdael:
View of the lake at Haarlem, c. 1650
cat. no. 116
Private Collection

Contents

Foreword

From the earliest times the links between East Anglia and the Netherlands have been extremely close. They have been strengthened by mutual trade and commerce, while cultural interchange has also flourished. This publication provides a history of cultural exchange over the period 1500–1850 and gives a broad survey of taste and influence, fashion and collecting, specifically in the county of Norfolk. This regional emphasis is especially significant in the light of the emergence in the early nineteenth century of the Norwich School of painters, a regional group of artists with national status in the history of British art. The traditionally close links between East Anglia and the Low Countries were fully expressed in the collections of Dutch and Flemish paintings developed in Norfolk during the seventeenth, eighteenth and nineteenth centuries.

This book, devised and written by Andrew Moore, has been published to coincide with the Norfolk and Norwich Triennial Festival exhibition, *Dutch and Flemish Painting in Norfolk*, 10 September to 20 November 1988, and includes the exhibition catalogue. The theme of the exhibition was planned as a contribution towards the national celebrations in 1988 and 1989 marking the tercentenary of the formal Anglo–Dutch national links brought about by the accession of William of Orange and Mary to the English throne. The William and Mary Tercentenary has provided an occasion to examine and to celebrate the history of artistic links between Norfolk and the Netherlands, which stretch back at least as far as the early sixteenth century. The exhibition would not have been possible without the generous support of the owners, private and public alike, who have contributed by lending works of art from their collections. I also wish to express my gratitude to Her Majesty The Queen for generously agreeing to a loan from the Royal Collection. A full list of lenders may be found on p. 181. The items on loan for the exhibition have been indemnified by Her Majesty's Government under the National Heritage Act, 1980. I would like to thank the Museums and Galleries Commission for its help in arranging this indemnity.

I particularly wish to pay tribute to the generosity of our major sponsors, Barclays Bank PLC. Without their early promise of financial support, it would not have been possible to contemplate approaching potential lenders from abroad. Their backing has enabled the project to be far more wide-reaching than we could otherwise have hoped for. I acknowledge also the substantial help of the Chairman of the East Anglia Advisory Committee of the William and Mary Tercentenary Trust Ltd. and The Support Group for their negotiations on our behalf. I also wish to record my thanks to the Norfolk and Norwich Triennial Festival for helping to finance and promote the exhibition.

Finally, I would like to express my thanks to the Controller and Chief Executive of Her Majesty's Stationery Office for undertaking to publish this book on behalf of the Norfolk Museums Service, thus ensuring that much of the original research undertaken for the exhibition is published and widely available. I particularly wish to record my thanks for the way Barclays Bank PLC and HMSO have separately co-operated to support this project.

FRANCIS CHEETHAM

Director, Norfolk Museums Service

Acknowledgements

My first debt is to those lenders without whose generous support the exhibition *Dutch and Flemish Painting in Norfolk* would not have taken place. Listed separately on p. 181, they have all been consistently helpful in providing as much information as possible concerning the history of the various items loaned for the exhibition and in answering my numerous requests for help. I am particularly grateful to Mr G.W. Marshall of Bally Group (UK) Ltd for his intercession on my behalf in connection with the loan from the Bührle Collection, Switzerland.

I wish also to acknowledge with gratitude those who have so generously provided written contributions to this book. I am particularly grateful to John Mitchell for contributing two catalogue entries (cat. nos. 2, 3) which publish some of his findings concerning the early local use of continental print sources. I am also grateful to my colleagues Robin Emmerson and Dr Sue Margeson for their advice and contributions. Robin Emmerson kindly wrote two catalogue entries (cat. nos. 1, 6) and Sue Margeson contributed three entries (cat. nos. 9–11). I am indebted to my colleague Cathy Proudlove for her informed discussion and advice concerning conservation problems and for contributing Appendix I; to Robert Wenley for compiling Appendix II; and to Norma Watt for her work on Appendix III and the Index of names. The scope and interest of this book is greatly increased as a result of all these contributions.

I am also indebted to a number of people who have helped me in connection with previously unpublished material, notably Professor Andrew Martindale, Dr Miklos Rajnai, Paul Rutledge, Jenifer Frost and Ursula Priestley. I would like to record my thanks to Bridget Baldwin who spent many months compiling an index of Dutch and Flemish paintings formerly in Norfolk collections, drawn principally from catalogues held in Norwich Castle Museum. I am particularly indebted to Robert Wenley who continued this work and became a valued research assistant for the final year of the project. I acknowledge elsewhere in the text those numerous occasions on which his commitment and scholarship have informed my work.

Among those who freely gave advice and information I would like to thank G. Armitage, Professor Robert Ashton, Alan Barlow, Sara Barton-Wood, Chloe Bennett, Professor Ingvar Bergstrom, Robert Bruce-Gardiner, Liz Buckton, Charlotte Crawley, Betty Elzea, Marilyn Evans-Lombe, Richard Godfrey, Barbara Green, Evelyn Joll, Professor Michael Jaffé, Sarah Jennings, Frederick Jolly, Margret Klinge, Sarah Knights, Alastair Laing, Carolyn Lamb, Dr Walter Liedtke, Timothy Llewellyn, Hugh MacAndrew, Dr John Maddison, Fred Meijer, Sir Oliver Millar, Deirdre Mulley, Charles Noble, Stephen Reiss, Michael Robinson, Dr Malcolm Rogers, Giles Waterfield, Clive Wilkins-Jones and Dr Christopher Wright. I should also like to record my thanks to the late Sir Geoffrey Agnew.

I owe a personal debt of gratitude to the Friends of the Courtauld Institute of Art for their award of a bursary to fund two months research in London. I cannot now conceive how I could have completed this project without that support. I would like to record my thanks to Professor Michael Kauffmann and the staff of the Courtauld Institute and the Witt Library in particular who met my numerous requests for help with forbearance. My research time in London was the more fruitful for the additional support of Dr Christopher Brown: I gratefully acknowledge his help and that I received from Elspeth Hector and her colleagues at the National Gallery Library.

I would like to add my thanks to those of my Director to the principal sponsors of the exhibition, Barclays Bank PLC. Their support additionally helped to fund the inclusion of a colour section in this book. In addition I am grateful to those members of the Publications, Print Procurement and Graphic Design Divisions of Her Majesty's Stationery Office who have worked on this publication. I also wish to thank Heather Wilson and Ruth Atkin of the Museums and Galleries Commission for negotiating Government Indemnity for the exhibition. I should also record my thanks to all those who helped in the administration of loans and the provision of photographs, most notably Christopher Gatiss and colleagues at the Witt Library. Among my own colleagues in the Norfolk Museums Service I am grateful to the Administrative Office, and the Display and Conservation Departments in the preparation of the exhibition. I also wish to thank Francis Cheetham for his support from the inception of the project.

Finally, I would like to thank my wife, Dr Judith Moore for her rigorous but supportive criticism and polishing of my manuscript. I would also like to thank my other readers, Robin Emmerson, Norma Watt and Robert Wenley for their welcome advice at every stage. Needless to say, any mistakes or omissions are my own.

ANDREW MOORE

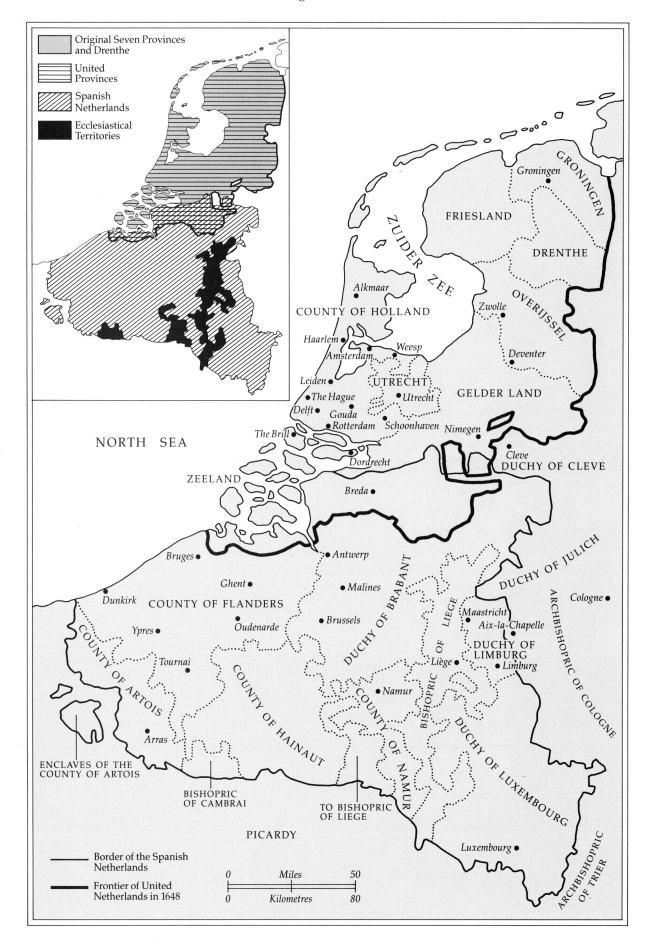

figure 1:
The Netherlands Divided

Introduction

This study of the cultural interchange between East Anglia and the Netherlands concentrates upon Norfolk in an attempt to achieve the sharpest focus. It is a history of cultural exchange over the period 1500–1850 and provides a broad survey of taste and influence, fashion and collecting which reflects the national pattern. The extent to which the regional pattern differs from the national one could not be established without undertaking similar regional studies elsewhere. Nevertheless it is possible to identify certain specific characteristics, particularly of geography and history, which establish a close relationship between Norfolk and the Netherlands. In addition, it is also possible to evaluate the importance of the example provided by London in terms of cultural interchange. Questions of fashion in taste and collecting cannot be answered without some statistical analysis which is the function of the majority of the catalogued items in the second part of this book.

The taste for Dutch painting – and landscape especially – is significant in the light of the emergence in the early nineteenth century of the Norwich School of Painters, a regional group of artists with national status in the history of British art. Individual artists of the Norwich School espoused the Dutch example, some more than others, at a time when the French or Italianate mode of landscape painting was still considered most desirable amongst Academic circles. One of the purposes of this study is to establish which Netherlandish paintings the Norwich artists could have known either locally or in London, and to determine whether any direct conclusions may be drawn.

The first four chapters set the context of what was available to be seen in Norfolk, while the fifth chapter, 'Norwich and London', identifies metropolitan influence and makes some art historical connections. The sixth chapter identifies some of those collectors whose tastes reflect the established fashions of the first half of the nineteenth century when the Norwich School itself was flourishing. To determine something of the origins of the artistic climate in which the Norwich artists were to flourish, it is the purpose of this introduction first to outline the historical background of Anglo–Dutch affairs; secondly to give some account of the geographical background; and finally to consider briefly the national taste for Dutch and Flemish painting.

Queen Elizabeth I, in her 'Declaration' of 1585, proclaimed the Dutch as England's 'most ancient and familiar neighbours', two nations 'by common language of long time resembled and termed man and wife'. Indeed, if the relationship was to become that much more intimate in the seventeenth century – culminating in the accession of William III in 1689 – ties had certainly been strong throughout the medieval period. In the fourteenth century, these were based upon the export of raw wool from England to Flanders, particularly the weaving cities of Ghent, Bruges and Ypres (where the wool would be transformed into finished cloths). English interests in Flanders were, however, severely impaired in 1369 by the marriage of the Count of Flanders' sole heiress to the Duke of Burgundy (brother of the French King), rather than to a son of the English King (Edward III). This rapidly led to the closure of Bruges to English ships and the eclipse of England's authority in the region – despite a futile attempt by the Bishop of Norwich, Henry Despenser, to lead a 'crusade' against the French in Flanders, in 1383.[1]

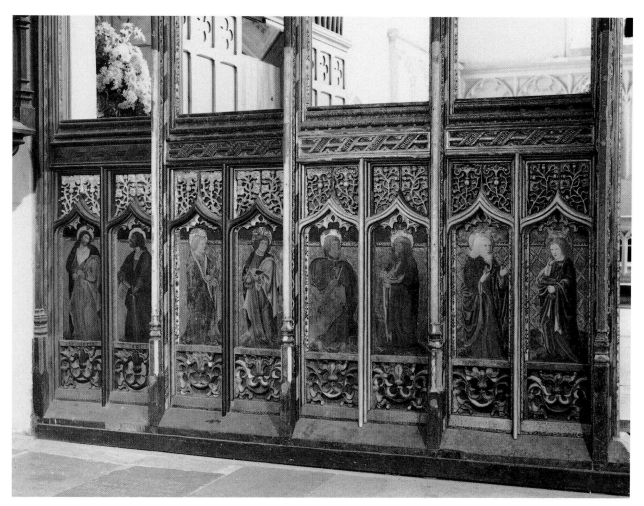

figure 2:
Chancel Screen (North Side)
Worstead Church, Norfolk

By the later fifteenth century, the Duke of Burgundy was effectively an independent ruler of a state, centred on the prosperous Netherlands, which, until 1477, stretched from Friesland in the north to Burgundy in the south. In that year, the Duke of Burgundy was killed in battle and his lands divided between Louis XI of France (who claimed Picardy and Burgundy), and Maximilian I of Austria – thence to his successor as Holy Roman Emperor, Charles V. The Netherlands once more became England's greatest trading partner, and Henry VII (1485–1507) promoted the export of undyed (white) cloth, which had slowly replaced wool as the prime English export. This would then be finished at Antwerp. In England, it involved the growth of East Anglia as a cloth centre (although the West Country remained more important) and the development of a specialist London–Antwerp trade, under the monopoly of the Merchant Adventurers. Trade flourished until the collapse of the Antwerp market in the 1550s. In this period, Antwerp was also a vital banking, credit and insurance centre for England and, indeed, the main source of government loans in the mid sixteenth century.

It is against this background of direct trade that the study of the East Anglian region's medieval art achieves a special focus. One of the earliest indications of close artistic links with the continent may be seen in the direct use of Netherlandish prints by local painters on some of Norfolk's church roodscreens such as that at Worstead (fig 2), where specific print sources can be identified (cat. no. 2).

One hiccough in relations was caused by Henry VIII in 1528. In a bid to win French support for his divorce case at Rome, he joined the French war against Emperor Charles V, having previously been an ally. The East Anglian cloth workers strongly protested at this threat to their export markets, and Henry was obliged to exclude the Netherlands from the war. Ironically, in 1533, Charles V took the English side on

Henry's divorce question principally to protect the Netherlands trade. The Protectorate established under Edward VI (1547–1553), continued the friendship with Charles V; but, a year before his abdication in 1555, Queen Mary of England (1553–1558) married his son, soon to be King Philip II of Spain. At this time Philip's territories in the Netherlands formed a sizeable and prosperous triangle of land, with corners at Dunkirk, Luxembourg, and Groningen, but the area was little more than a loose confederation of semi-autonomous provinces and cities.

However, with the accession of Philip, both the politics of the Netherlands, and England's attitude towards her, underwent dramatic change. Mary died in 1558, and under her successor Elizabeth I, who was quite hostile to the aggressive ambitions of the staunchly Catholic King Philip, relations sharply deteriorated: the governor-general of the Netherlands went so far as to suspend trade with England in the mid-1560s. Moreover Philip II embarked on a policy to impose more centralised rule upon the seventeen provinces of the Netherlands. This provoked a revolt led by the native nobility in 1566 – to which Philip reacted by sending an army (ultimately 50,000 strong) under the Duke of Alva, to crush it. The 'Council of Troubles' which dealt with the rebels heard over 12,000 cases and a thousand rebels were executed. In addition, very heavy – and permanent – export and sale taxes were imposed on the territories.

In the face of such persecution, it is estimated that 60,000 people – as much as two per cent of the population – left the Southern Netherlands, under Alva's rule (1567–73). Another 40,000 followed, as revolt broke out again in 1572, and warfare continued until 1609.[2] Although many of these refugees found shelter in Germany and the Northern provinces, a sizeable minority also escaped to London, the South and East Anglia. By the late sixteenth century as much as one-third of the population of Norwich was made up of 'strangers', principally from the Ypres area of western Flanders.

Queen Elizabeth, hampered by financial constraint, pursued a policy of minimum intervention – her fear of Spanish invasion from the Netherlands balanced by her natural disaffection for rebels in any form. She was, however, forced to retaliate when Alva arrested the entire English merchant community of Antwerp in 1568, which effectively closed trade with the Netherlands until 1573. By 1579, the Netherlands had already divided in all but name. The southern, Walloon provinces, with their Catholic nobility sympathetic to Spain, had united by the Union of Arras, broken with the seven northern provinces (led by William of Nassau, Prince of Orange), and succumbed to Spanish rule. The northern provinces, dominated by Holland and Zeeland, were themselves united by the Union of Utrecht, also in 1579. In 1581, the United Provinces (of the north) deposed Philip II as their sovereign – but the assassination of William of Orange, in 1584, left them leaderless.

This led the United Provinces to appeal directly to Elizabeth for military aid in 1585, in return offering her the sovereignty of their country. Although she rejected this latter responsibility, Elizabeth did provide English support on land against the Spanish army until 1595. The war dragged on until the 1607 armistice, followed by a truce (1609) in which the absolute sovereignty (or independence) of the United Provinces was effectively acknowledged and the modern Netherlands was born. The Catholic South, for its part, became a semi-autonomous state, loyal to Spain, and more or less covering the area of present-day Belgium.

The relationship with our 'most ancient and familiar neighbours' remained healthy. As J.R. Jones has written: '. . . Britain's links with the United Provinces continued to be closer than with any other country. Trade provided the chief connection. The Merchant Adventurers exported large quantities of cloth, which constituted over 80% of exports in the first decades of the [seventeenth] century, to their staple at Middleburg for finishing and distribution . . . During the season thousands of Dutch fishermen came ashore to east coast ports, particularly Yarmouth. Travel, on business rather than for pleasure, was on a large scale. Englishmen and Scots served in the garrisons of the cautionary towns or in the Dutch army. Sizeable English and Scottish communities existed in the big Dutch cities, and a large Dutch population lived in London. The ease with which emigrants crossed the North Sea in both directions, settled and were assimilated into the local population, is evidence of the similarity of the life, customs and composition of the English, lowland Scots and Dutch.'[3]

The association was particularly strong between South-east England and the Dutch provinces of Holland and Zeeland. London, like Amsterdam, was the great centre of trade, shipping, finance, food distribution and consumer goods: 'The surrounding countryside served the capital cities, while the larger towns – Haarlem and Leiden, Norwich and Colchester – contained the cloth industries, much of which had emigrated to both areas from Flanders.'[4]

In the seventeenth century, however, the majority of migrants came *from* England. Some, like the distinguished Norwich physician Thomas Browne, were only brief visitors, attracted by the intellectual reputation of the United Provinces. (In 1630, Browne presented his dissertation for the Degree of Doctor of Medicine at Leiden University.) Most were, in fact, either soldiers seeking experience or financial reward abroad, or those with unorthodox religious views seeking refuge in Holland from Archbishop Laud's authoritarian regime which was quite intolerant of Puritanism. Indeed the Pilgrim Fathers themselves first went to Holland in 1607 – before deciding their identity would be better preserved in New England.

A series of registers survive which record all those seeking travel permits from Great Yarmouth to Holland and New England in the period between March 1637 and September 1639. Of those going to Holland, '118 entries relate to those going to see kinsmen there and 185 more to those going to see friends and there are 109 entries of people who profess their intention of remaining indefinitely in the Netherlands'[5] – many of the last no doubt driven out by Matthew Wren, Bishop of Norwich (1635), who was keen to enforce Laud's policies. An interesting example is provided by an entry on 28 June 1637, 'The examinaction of FRANCIES HILLEN: of Yarmouth Limner ageed. 24 yeres and ELIZABETH: his wife ageed. 25 yeres and ANNE WRIGHT: his Mother ageed. 58 yeres. all of Yarmouth are desirous to passe into Holland. to inhabitt.'[6]

In fact, the majority of travellers were weavers, or those of related trades. But there was also a lone falconer, four tobacco-pipe makers and, on 21 August 1637, one '. . . CHRISTOPHER HATTON: of Norwich, a potseller of earthen vessells borne in Bradish in Norff. ageed about 36 yeares. is desirous to passe into Holland. to by commodities and to Retorne in a Mounth.'[7] This is clear evidence for the direct import of Dutch earthenware at this period (cat. nos. 10, 11).

Significant links of a rather different kind were made at a higher social level, through Anglo–Dutch aristocratic and royal marriages. In 1613 Elizabeth Stuart ('The Winter Queen'), daughter of James I, married Frederick, the Elector Palatine, and a member of the House of Orange. Her court at The Hague became a celebrated centre of cultural patronage and interchange. A (later) notable figure in the context of this study who married a lady from the Low Countries was Henry Bennet, Earl of Arlington, and Secretary of State for Foreign Affairs. He married Isabella, a grand-daughter of Prince Maurice of Nassau, and their only daughter was to be the wife of Henry, Duke of Grafton (cat. no. 17). Another example, who married a Flemish lady, was Sir Jacob Astley (see cat. no. 14).

The period of the Interregnum (1649–60) ironically did not mark an era of closer links with the United Provinces, although both countries were now republics. Indeed, in this period there was 'virtually no trace of sympathy for the new regime among the Dutch, despite the eclipse of the pro-Stuart House of Orange'.[8] But, although there were Anglo–Dutch wars during the Commonwealth, and during the reign of Charles II (1660–85), history tended to confirm Burghley's comments to Elizabeth on the long-term Anglo–Dutch relationship: 'the one cannot well live without friendship of the other.' For, as Hugh Paget has written, 'The disputes in the seventeenth century arose largely out of the fact that each wanted to do the same things in the same places at the same times. . . .'[9]

This common ambition was united with the marriage (1677) of William III of Orange, Stadtholder of the Dutch Republic, to Charles II's niece, Mary. With the ousting of James II, in 1689, William III accepted the invitation to become King of England and the dynastic unification of the two countries was complete.

The historical links between the two countries, particularly those between East Anglia and the Netherlands, were described with simple truth by R.W. Ketton-Cremer in the following terms: 'From early times the strongest bonds of sympathy have existed between the people of East Anglia and their neighbours of the Low Countries. All through recorded history there has been a steady coming and going

across the North Sea, and a constant exchange of ideas and techniques. In periods of trouble, whether civil or religious, the fugitives from either region have sought and found protection in the other. In art and architecture, commerce and agriculture, the draining of marshland and the defence of their soil against the ever-encroaching sea, the traditions of the two communities are intimately linked.'[10] This relationship also has its roots embedded in a common landscape.

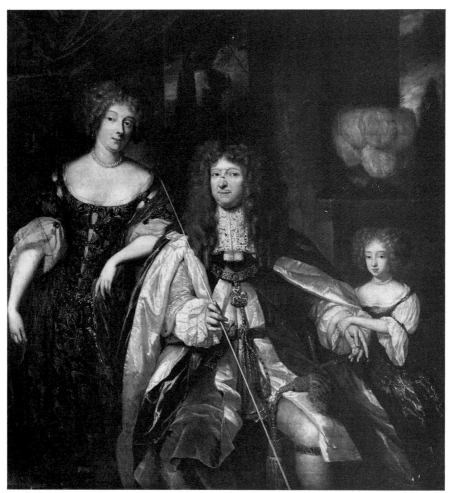

cat. no. 17 Attributed to Caspar Netscher *Henry Bennet, 1st Earl of Arlington, With his Wife and Daughter c. 1675*

There are three main types of landscape in the Netherlands: the clay area of North and South Holland; the low peat district of Friesland and the glacial-drift upland of the East. The first is mainly flat, fertile silt land, much of it reclaimed by drainage and the building of sea banks. In East Anglia the region of The Wash and the flood plains of Suffolk and the East Norfolk rivers owes much to the adoption of Dutch methods of land reclamation begun in the seventeenth century. Similarly, much of the low-lying Dutch coast, like that of Norfolk, is protected by sand dunes. The Friesland Meres resemble the Norfolk Broads, as does the area around the Zuiderzee. Sandy heathland extends over much of North Holland which is comparable to West Norfolk and Breckland in appearance. The boulder-clay landscape of central Norfolk resembles certain parts of Holland, white hills formed by the glacial moraine in the area between Cromer and Holt mirror the contours of ridges similarly formed by glacial action in the eastern part of Guelderland.[11]

The common landscape between the two regions was accentuated by the work of the Dutch engineers in the reclamation of the landscape. In 1634 Cornelius Vermuyden, a Zeelander, was engaged to drain the southern part of the fens. Indeed, Dutch drainage experts are recorded at work in Norfolk as early as the sixteenth century. At Haddiscoe church there is a Dutch inscription which mentions Peter Peterson a 'dyke-reeve' in 1525. In 1568 a Dutchman, Joas Johnson, was called in to supervise the new harbour works at Great Yarmouth and it was he who established the harbour mouth in its present position.[12]

The similarities of the landscape between the two regions, particularly the low flat vistas dominated by windmills and dramatic skies, are particularly significant when attempting to identify similarities in the work of their respective schools of landscape painting. The undoubted similarities of composition and subject-matter between Dutch seventeenth-century landscape paintings and those of the Norwich painters of the early nineteenth century testify to the influence of the former upon the latter. That influence, however, is not necessarily a direct art-historical or stylistic one, but is rooted in a common affinity with the landscape. It is this affinity that shapes the work of the Norwich School and prevents it from simply being derivative. When Gainsborough's *Cornard Wood* was exhibited at Boydell's gallery in London in 1790 *The Gazetteer* commented that 'many of our landscape painters, never having lived out of the Metropolis, . . . form their trees from Hobbema, their water from Wynants . . .'[13] The East Anglian painters could hardly be criticized for 'never having lived out of the Metropolis'. By contrast, their study of the Dutch Old Masters was informed by a real observation of a common, native landscape.

Some account should also be taken of the development of the taste for Dutch and Flemish painting over this period which falls broadly into three separate phases. The first phase is dominated by the Dutch portraitists, such as Michiel Miereveld (1567–1641) and Daniel Mytens (*c.* 1590–*c.* 1648) who visited or settled in England. Their style was developed by van Dyck (after 1632) and then Lely, before the English tradition in portraiture became established in its own right during the eighteenth century. Similarly, it was visiting Dutch 'landskip' painters or estate painters such as Hendrick Danckerts (*c.* 1630–79) who helped to establish the taste in England for landscape in its own right, rather than as a portrait background. It is difficult to determine just how many Netherlandish paintings were imported into England in the seventeenth century as there are few surviving records. It does seem that the taste for still-life pictures in particular developed, but the genre scenes or 'drolleries' at which the Dutch painters were so adept were also popular. The works which may be most readily evaluated today are the commissioned paintings which survive to tell something of the circumstances or aspirations of their owners (cat. nos. 4, 15, 19).

English travellers to Holland in the seventeenth century had been impressed by the extent to which still lifes, tavern scenes and 'drolleries' were bought by the middle classes. During a visit to Holland in 1641 John Evelyn 'arrived late at Rotterdam, where was their annual mart or fair, so furnished with pictures (especially landscapes and drolleries, as they call those clownish representations), that I was amazed. Some of these I bought, and sent into England. The reason of this store of pictures, and their cheapness, proceeds from their want of land to employ their stock, so that it is an ordinary thing to find a common farmer lay out two or three thousand pounds in this commodity. Their houses are full of them, and they vend them at their fairs to very great gains'.[14] The previous year another English traveller, Peter Mundy, also commented on the extent to which the Dutch chose 'to adorn their houses, especially the outer or streete roome, with costly pieces . . . yes, many tymes blacksmithes, coblers etc., will have some picture or other by their forge and in their stalle. Such is the generall notion, enclination and delight that these countrie natives have to painting.'[15] Netherlandish artists were well-placed to find a market for their pictures, whether selling them personally at exhibitions and fairs, or through dealers.

The phenomenon of the 'amateur' collector developed at the end of the seventeenth century in England. The thrust of the collecting ambitions of the average gentleman throughout the eighteenth century took him to the continent mainly in search of classical antiquity. However, the Northern Schools were not universally spurned, but seem to have held their own as gentlemanly or even 'curious' acquisitions. At the same time, the grandest styles of the Flemish painters such as Rubens and van Dyck were suitable adornments for London palaces or country seats. The anonymous writer of the additional lives to *de Piles* in 1754 makes some interesting observations on the changes of taste which he has witnessed in the previous decades: 'There is a fashion in paintings as well as in clothes. Teniers had a long reign. Poelenberg, Wouwermans, Gerard Dou, Mieris and Schaalken succeeded him . . . at present it is Adriaen Ostade, Metsu, Potter, Vandevelde, Vanhuysum and van der Werff. The curious not only set these matters now above the former, but eagerly bid upon one

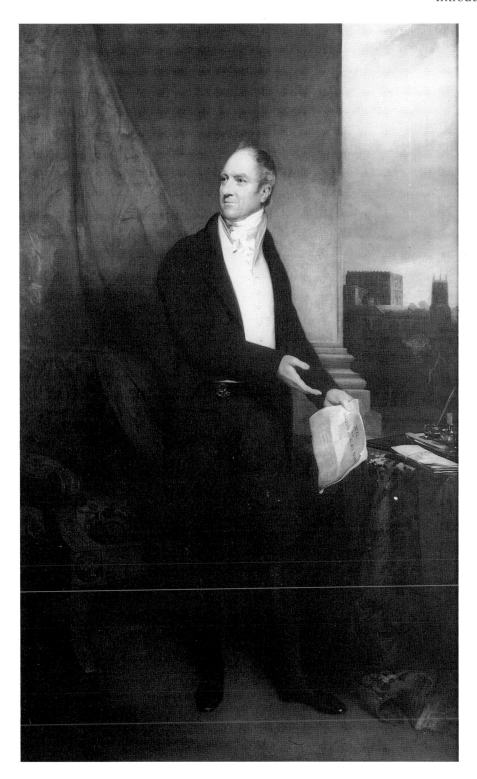

figure 3:
Henry Thomson (1773–1843)
William Smith MP (1756–1835)
oil on canvas 241 × 149.5 cm
City of Norwich Civic Portrait Collection

another for them at sales and run them up to an extravagant price.'[16] It seems that it was not until the 1740s that prices for Dutch pictures in particular began to rise.

The third phase in the English love affair with Netherlandish painting was perhaps the natural consequence of the rise of the English mercantile classes during the course of the eighteenth century. The middle class merchants who travelled overseas in search of trade, or who simply stayed at home, were arguably mirror-images of those Dutch artisans and merchants who had happily collected contemporary art a century earlier. The dispersal of so many of the French and Italian

aristocratic collections in the last years of the eighteenth century and the beginning of the nineteenth century, as a direct result of the French Revolutionary wars and the Napoleonic campaigns, resulted in a glut of pictures on the market. The result was a new form of currency, in which Dutch and Flemish paintings became an increasingly valuable commodity for the British collector. Buchanan, in his *Memoirs of Painting* recalled with pride that: 'The late Mr President West used to remark, that next to the merit of having painted a picture which should do honour to the art, and become an ornament to the state where in it was produced, was the credit of having brought from foreign countries works of the great masters. – The importation of such works tends to enrich the nation which receives them, it holds out a bright example for imitation, and rouses and calls into action the native talents of those who feed the sacred flame of emulation.'[17]

William Buchanan was well-placed to hold such an opinion, coloured as it was by self-interest as much as by personal observation. He regarded the dispersal of the collection of King Charles I by the 'Commonwealth Sale' initiated in 1649, and the sale of Robert Walpole's collection from Houghton Hall in 1779, as the two most significant losses sustained by the nation's art collections, making 'the public . . . prepared to avail itself of the first opportunity which should occur, to remedy in part these heavy losses'.[18] In Buchanan's view the disposal of the Duke d'Orleans' collection in 1792 was a happy remedy: 'The storm of Revolution at last burst forth with all its terrors, and with it sprung up those causes, which in a measure forced upon us a species of remuneration in the Arts, for our former heavy losses'.[19] The nucleus of the Orleans Collection, primarily of Italian and French works, was purchased by the Duke of Bridgewater in 1798, while the Dutch and Flemish part of the collection was brought to England by the dealer Thomas Moore Slade who sold it to the leading collectors at that time. The Dutch and Flemish collection consisted of major works by Rubens, van Dyck, Teniers, Rembrandt, Dou, Wouwermans, Frans van Mieris, Netscher and van der Werff. Slade exhibited the pictures for sale at the old Academy Rooms in Pall Mall. The collection was so popular that over one hundred pounds a day was taken at the doors, where a shilling was charged for admission. Among those collectors who would subsequently own Dutch and Flemish works from the Orleans collection were Thomas Penrice of Great Yarmouth (cat. no. 61) and William Smith, MP for Norwich (fig. 3).

The final issue that should be considered at this point is that of attribution. Problems of attribution bedevil any attempt to give a definitive account of the influence of Dutch painting upon the Norwich School artists in general and upon John Crome in particular. In this context a painting owned by William Smith MP (1756–1835) provides an interesting case in point. William Smith's connections with Norwich may conceivably provide a link between the Norwich artists and the London art scene.[20] The most celebrated painting in his collection, which had formerly been in the Orleans collection, was *The Mill* by Rembrandt.[21] Smith lent the painting twice to the British Institution, in 1806 and 1815, and it became one of the most influential landscape paintings to capture the imagination of English artists, including John Constable.[22] The first occasion Smith loaned the painting to the British Institution Gallery in Pall Mall it was specifically for students and artists to copy. Such was its reputation when Smith lent *The Mill* to the British Institution in 1815, that a scurrilous pamphlet[23] commented of it: 'Well known, and now better understood than when it acquired its high reputation. It is a good, but not an extraordinary picture'. The attribution of the painting to Rembrandt has been disputed in this century and Rembrandt's authorship continues to be a debating point.

The debate over *The Mill* may be mirrored in a similar discussion over an oil version (fig. 4) now in the collection of Norwich Castle Museum. This has traditionally been considered the work of John Crome which, in many ways, is an attractive attribution. The copy is a well-observed interpretation of the original, and does show some techniques which may be associated with the work of John Crome, notably the use of the handle of the brush in the left foreground. Equally, the panel consists of five rough planks which would be typical of Crome's experimental use of materials.[24] Nevertheless, there is little real evidence upon which to attribute the work to Crome. At least one version is recorded, for example, by a copyist, Miss

figure 4:
British School, early 1800s
The Mill, after Rembrandt
oil on panel 82.3 × 100 cm
Norfolk Museums Service (Norwich Castle Museum)

Hay,[25] which was finished by Benjamin West, and it is just as tempting to ascribe the Norwich version to West.

In the final analysis problems of attribution will always remain, although not necessarily over works of the highest quality. When considering the influence of Dutch painting upon the Norwich School artists, uncertainties of attribution do, however, lose something of their significance if it can be established which paintings may have inspired the Norwich painters, rather than which artist's work in general terms may have been influential. It is the intention of the following chapters and the accompanying catalogue sections, to attempt to establish not only the artists whose works were admired in the region but also the specific works traceable from local collections. At the same time, the influence of Netherlandish art can be seen to have been part of the history of the region since at least the beginning of the sixteenth century.

INTRODUCTION

1 I am grateful to Robert Wenley for his help in preparing the following historical sketch.

2 The population of Antwerp halved, to 42,000, in 1585–89, through emigration and famine.

3 J.R. Jones, *Britain and Europe in the Seventeenth Century*, London, 1966, p. 38.

4 *Ibid.*, pp. 40–1.

5 C.B. Jewson, 'Transcript of three Registers from Great Yarmouth to Holland and New England: 1637–1639', *Norfolk Record Society*, XXV, 1954, p. 14.

6 *Ibid.*, p. 36, no. 237.

7 *Ibid.*, p. 45, no. 346.

8 J.R. Jones, *op. cit.*, p. 31.

9 *The Orange and the Rose*, exhibition catalogue, Victoria and Albert Museum, 1964, p. 19.

10 R.W. Ketton–Cremer, *East Anglia and the Netherlands*, exhibition catalogue, Norwich Castle Museum, 1954, p. 5.

11 This account is based upon that given in *East Anglia and the Netherlands*, Norwich Castle Museum, 1954, *op. cit.*, p. 11.

12 Charles Lewis, *Norfolk in Europe*, Norfolk Museums Service, 1980, p. 37.

13 W.T. Whitley, *Gainsborough*, London, 1915, p. 300.

14 William Bray (ed.), *The Diary of John Evelyn*, 2 vols, London, 1966, pp. 21–2.

15 R.C. Temple (ed.), *The Travels of Peter Mundy*, IV, London, 1924, p. 71.

16 Quoted in Ellis K. Waterhouse, 'British Collections and Dutch Art', *The Museums Journal*, vol. 56, no. 6, September 1956, p. 142.

17 Buchanan, p. 9.

18 *Ibid.*, p. 10.

19 *Ibid.*, p. 11.

20 *The Dictionary of National Biography* states that Smith was a patron of both John Opie and John Sell Cotman.

21 Smith's collection included Ruisdael's *The Castle of Bentheim* (fig. 51); a fine landscape by Berchem (de Groot, IX, 1926, no 159e; Sotheby's, London, 25 June 1969, lot 46); a sea piece by Willem van de Velde; Aelbert Cuyp's *Horseman and Herdsman with Cattle* (National Gallery of Art, Washington); a Hobbema *Watermill* (Rijksmuseum). Smith lent all these to the British Institution (apart from the Hobbema) in 1815 (37, 94, 96, 99, 108). See also cat. no. 99, n.3.).

22 John Constable, *Lectures on Landscape Painting*, 1836. Constable was particularly impressed by the simplicity of the chiaroscuro.

23 See p. 54.

24 I am grateful to Cathy Proudlove for her comments upon this painting.

25 W.T. Whitley, *Art in England 1800–1820*, 1928, p. 111.

cat. no. 25 Studio of Frans Snyders *Macaws and Parrots* (opposite)

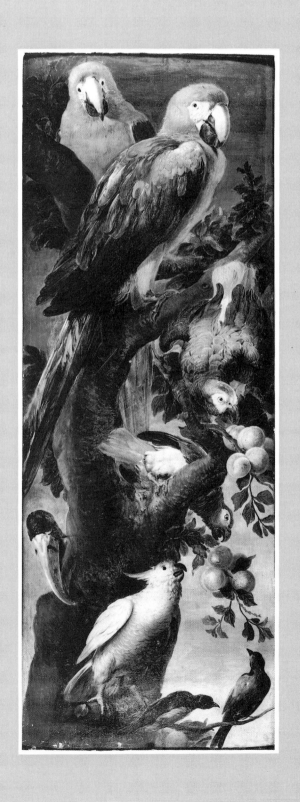

figure 5:
The Master of the Magdalen Legend
Christopher Knyvett
Detail of cat. no. 4: infra-red photograph showing underdrawing

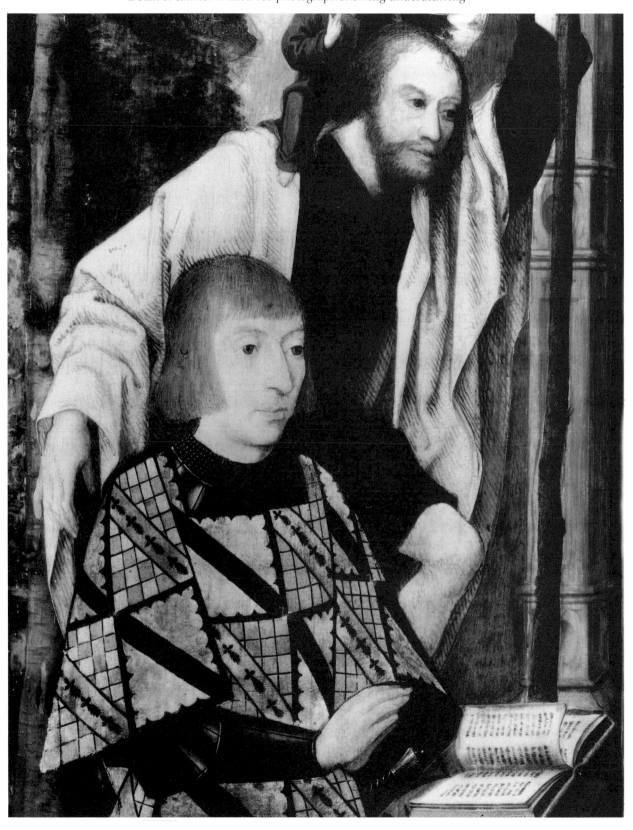

I Norfolk and the Netherlands

In this section some of the historical and geographical origins of the taste for Netherlandish art and culture, which establish a pattern for East Anglia in general and Norfolk in particular, will be examined. A pattern of cultural interchange does emerge, but a complex one. The fact of Christopher Knyvett's marriage with a lady from the Low Countries and his commissioning of a Netherlandish altarpiece *c.* 1512–20 are presumably the product of his court connections as much as any geographical proximity between Norfolk and the Netherlands (fig. 5). Meanwhile the use of Flemish engravings by local craftsmen when designing the roodscreen of Worstead church is indicative of the widespread migration of prints and pattern books across Europe and into England by numerous routes. Johannes Doetichum's chart of the Norfolk coastline was just one of a comprehensive series of maps of the English coastline for the information of mariners (cat. no. 5).

Monumental brasses made in Norwich show evidence of the influence of Netherlandish portraiture which is quite absent from their London-made contemporaries (cat. no. 1). Norwich, England's second city in the medieval period, played host to a significant number of early immigrants, notably from the Netherlands. The population of Norwich is thought to have almost doubled from an estimated 12,000 or 13,000 in *c.* 1600 to some 20,000 inhabitants in the 1620s, a level at which it remained until the late 1670s. This was partly due to the influx of immigrants from the Netherlands as a result of religious persecution. Some of the earliest evidence for the impact of these settlers upon the cultural life of Norwich lies in the pottery excavated recently within the city walls.

Excavations in Norwich have revealed much new information about the influence of Flemish and Dutch settlers in the city from the late fourteenth century onwards. As there are no Norwich Port Books which could give details of imports into the city at this period, the archaeological evidence is particularly significant.[1] New types of vessel were apparently introduced from the Low Countries, such as the frying-pan which may have been brought in by Flemish settlers as early as the late fourteenth century. The new vessel must have caused quite a revolution in eating habits, and soon became so popular that it was copied by local potters in the fifteenth century. Excavations on Pottergate have produced examples of these local copies.[2]

The most conclusive evidence of Dutch and Flemish occupation comes from seventeenth century contexts excavated on Alms Lane. Here, the immigrant families rented houses, as they were not permitted to own property at this time. They were probably textile workers. Large numbers of dishes and cooking vessels of a type not known in English households of that time, were found in rubbish in the yards here, almost certainly personal possessions of immigrant families, rather than brought in by trade.[3]

Groups of tin-glazed earthenware vessels reflect the cultural interchange in the sixteenth and seventeenth centuries, some vessels imported, some brought in as personal possessions, some made here by Dutch potters, or copied by English potters (cat. nos. 10, 11). Tin-glazed earthenware was first produced in Flanders before 1500. By about 1510 the Italian Guido Andries is known to have been working in Antwerp and is credited with having introduced the art of tin-glazed earthenware to that city. Antwerp became a major centre for pottery in the northern Netherlands. The origins

of tin glaze in England can be traced to 1567 when two of Guido Andries's sons, Jasper and Joris, came to Norwich with a compatriot from Antwerp, Jacob Jansen, and began to make tiles and pharmacy jars. It was Jansen who shortly left for London, to set up a workshop in Aldgate.[4]

It seems that the immigrant families brought their own wares because the local markets did not provide all that they required: a letter by Claus van Werveken from Norwich in 1567 to his wife, still living in Antwerp, requested that she 'Bring a dough trough, for there are none here . . . Buy two little wooden dishes to make up half pounds of butter: for all the Netherlanders and Flemings make their own, for here it is all pigs' fats'. Similarly, the Dutch immigrants in the period 1610–25 evidently brought with them the current fashions of costume. At that period in Holland head-dress pins were used with a type of hair-cap. Made of gold, silver or copper-alloy, these were pinned underneath the cap through the hair, the visible end usually decorated with a pendant. Pins of this type, represented in Dutch portraits of the period, have recently been excavated in Norwich (cat. no. 9), and represent a further example of cultural interchange in the early seventeenth century.[5]

One of the most important, direct Flemish influences upon local craftsmen is to be found in the selection and painting of images on Norfolk roodscreens (cat. nos. 2, 3). The screens at one south Norfolk church (figs. 7, 51) and at Worstead (fig. 2) are cases of direct, and exact copying. The artists who painted the screens, who may themselves have been trained in the Netherlands, apparently possessed copies of Netherlandish engravings, which they could show to patrons and reproduce as required. The copies on the screens are quite able, but somewhat cramped. The artists did not fully take into account the differences in proportion between the panels at their disposal and the prints they took as their models.

The strong influence of contemporary Netherlandish and north German painting is evident on other screens in Norfolk painted in the decades around 1500. Indeed one or two may well be the work of foreign artists, for example at Aylsham. The influence

figure 7:
After Lucas van Leyden (1494–1533)
The Temptation of St Anthony
oil on panel 34.2 × 20.25 cm
A South Norfolk Church

cat. no. 3b Lucas van Leyden *The Temptation of St Anthony* 1509

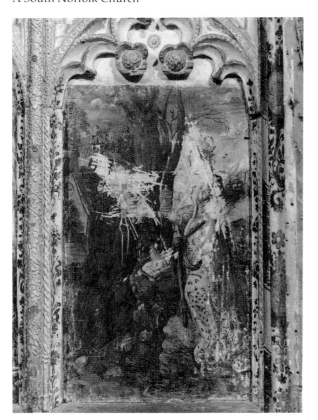
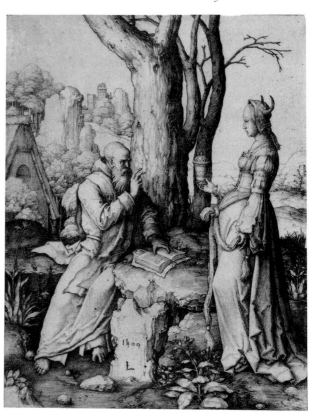

of imported engraved Apostle sequences can also be traced on other screens, but so far no other instance of the exact and complete reproduction of a composition has been identified.[6]

The screen representing the Annunciation and The Temptation of St. Anthony (colour plate 5) appears to have been specially designed to take images which corresponded in proportions, more or less, to the engravings used, rather than to take the tall narrow images of saints commonly found on late Gothic screens in East Anglia. Although it appears that only two were completed, presumably all the panels were to carry scenes, rather than single figures. The result would have been a veritable gallery of scenes taken from recent engravings imported from the Netherlands and northern Germany, all in the latest fashionable taste.

One may reasonably ask quite what the connection may be between such discoveries and the early collections of pictures which were to be found in Norfolk. Little is known of the collecting habits of even the wealthiest Norwich merchants in the seventeenth century. Probate inventories reveal that many merchants possessed a portrait of the Duke of Norfolk or an escutcheon of the King's Arms, but a survey of inventories of the period identifies only one wealthy gentleman, Samuel Newson of St Margaret's Parish, Norwich (died 1637) whose collection included 'four Dutch pictures'. These hung in his 'dyning chamber', together with two maps, and 'The King's Armes'.[7] This was a gentleman of some wealth, who owned property in Suffolk as well as his house in Norwich. The inventory shows his house to have been a large mansion, luxuriously furnished and belonging to a cultured household, since virginals and books are listed, as well as pictures. The most comprehensive lists of pictures named in Norfolk wills are those of Henry Bell of King's Lynn (see p. 7) and Nicholas Helwys, a brewer by profession, who was a citizen and mayor of Norwich.[8] The latter includes 'one flower piece & a dealboard picture', seven 'landskips' and two 'fruitpieces', *Lot and his daughters* and *Abraham offering Isaac* as well as numerous prints. It is, however, difficult to be certain as to whether any of these were Netherlandish in origin.

Norwich was a major centre of textile manufacture from the medieval period onwards and the trade benefited from an influx of Dutch and Flemish weavers. The Stranger community in *Ultra Aquam* or 'Norwich over the water', rose from 1,471 in 1568 to 4,679 in 1583, and a significant proportion of these were cloth workers. The first Netherlandish weavers to settle in Norwich had been encouraged to do so in 1554 by Thomas Marsham, a mercer, who saw the benefits of importing new techniques from abroad to supplement the traditional Norwich worsted in the overseas market.[9]

The Dutch or Flemish-speaking section of the Strangers in Norwich was the largest, far outstripping the French-speaking Walloons, and the city corporation granted them a separate church in which to hold their own services. According to a calendar, printed in Norwich by Anthony de Solempne (himself a Stranger) in 1570, the Church of the Black Friars was first opened to the Dutch congregation on Christmas Day, 1565.[10] A set of silver beakers for Holy Communion, made for the Dutch Church (fig. 8) by the goldsmith William Cobbold of Norwich, survives as testimony to the strict Protestantism of the Netherlandish Strangers (cat. no. 6). The use of sets of beakers for Holy Communion was a Calvinist practice, in strong contrast to the use of a single, stemmed cup in the Church of England. In this respect the Dutch practice represented a more extreme brand of Protestantism.

The cultural interaction between England and the Low Countries continued throughout the seventeenth century, but with a change of emphasis. Previously the main trade links were with the southern Netherlands, centred upon Catholic Antwerp, but in the early seventeenth century Protestant Amsterdam gradually became the focus of England's mercantile and cultural interchange.

In retrospect, the single most remarkable product of the cultural interchange between Norwich and Amsterdam in the seventeenth century arguably lies in the survival of two portraits by Rembrandt. Rembrandt's life-size portraits of the preacher of the Dutch Reformed Church in Norwich, Johannes Elison, and his wife Maria Bockenolle are now in the Museum of Fine Arts, Boston (figs. 9, 10).[11] The circumstances of this singular early commission for Rembrandt deserve some attention here, not least because the portraits passed by inheritance into the possession of Daniel Dover of Ludham, near Norwich, and then again by descent to

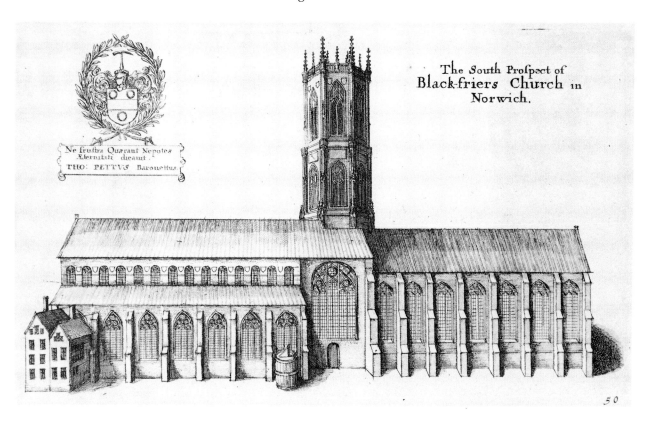

The South Prospect of
Black-friers Church in
Norwich.

Ne frustra Quærant Nepotes
Æternitati dicauit.
THO: PETTVS Baronettus

50

figure 8:
Unknown
Blackfriars Church, South Prospect
engraving 17.4 × 29 cm
Norfolk Museums Service (Norwich Castle Museum)

Reverend Samuel Colby, Rector of Little Ellingham. The family finally sold the portraits in 1860.[12]

Johannes Elison was born *c*. 1581 and enrolled at the age of seventeen at Leiden University on 14 October 1598.[13] He is mentioned as minister of the Dutch Reformed Church in Norwich in documents from March 1604 until April 1639. His name appears regularly, except between 17 August 1633 and 26 January 1635, in the Register of Attestations preserved in the Dutch Reformed Church in London. Elison died in 1639 and Jan Cruso, an elder of the Dutch Church and captain of the Strangers militia in Norwich, published a volume three years later which contained an 'Elegy on the premature decease of the most Learned and God-fearing Dominus Iohannes Elisonius, faithful minister of the Dutch Congregation of Christ in Norwich'.[14] A monument to Elison, with inscriptions in Latin, Dutch and English, remains today in Blackfriars Hall, Norwich.[15]

Johannes Elison and his wife Maria had two daughters and four sons, among whom were Theophilus, who succeeded his father as minister at Norwich, and Johannes. Johannes the Younger (*c*. 1606–77), married Josina Backer in Amsterdam in 1628, at the age of twenty-two. Johannes the Younger was a well-to-do merchant and it seems most likely that it was he who commissioned Rembrandt to paint portraits of his parents on their visit to Amsterdam in 1633–34. In his will dated 17 March 1635, he instructed that after his and Josina's death 'the two likenesses of the testator's father and mother' should go to his brothers and sisters in Norwich. This provision was repeated in subsequent wills. He died childless in 1677 and after Josina's death the two portraits came into the possession of his sister Anna. Her husband Daniel Dover, the executor of the estate, had the portraits shipped to Yarmouth, where Horace Walpole reported seeing them in his *Anecdotes of Painters in England*, 1763.[16]

It is truly remarkable to find a minister and his wife portrayed life-size and full-length. Such a depiction was usually indicative of the social standing of the wealthy. Johannes the Elder appears in the sombre dress of a minister and adopts the characteristic gesture of his profession with the left hand held to the chest, bearing

witness before God. Maria's portrait, meanwhile, shows her sporting a hat which is thought to be totally English in style.[17]

It is also possible that two other members of the Elison family had their portraits painted by Rembrandt. The grounds for this assertion can be deduced from a potentially important source of 1772 which refers not only to the Elison portraits then at Yarmouth, but also to two other family portraits believed at that time to be by Rembrandt. On Wednesday, 26 August 1772, Sylas Neville of Scratby, Norfolk, recorded in his diary a visit to Samuel Colby, a Yarmouth surgeon:

> Went to Yarmouth – took Mr & Mrs Hide to see Mrs Ramey's drawings with the poker & afterwards to see 4 original pictures of the celebrated Rembrandt in the possession of a Mr Colby. Two are large pieces representing an old man & woman admirably finished in the dark manner of this famous painter. The two others are small full-lengths said to be the son & daughter of the former. Mr Colby has been offered £300 or £400 for these pictures, which I wonder he does not accept, as they are almost lost in the little parlour where they are now kept.[18]

Neville's account is interesting in that it is the earliest record of two additional 'full-lengths' by Rembrandt, of members of the Elison family, ever having existed. The Yarmouth historian C.J. Palmer referred to the additional pair in 1874, but did not then know their whereabouts.[19] The Rembrandt literature has not taken Neville's diary entry into account. It therefore seems that one can with some justification expect to identify here two early 'full-length' portraits by Rembrandt of c. 1633–34, which although at present regarded as of unknown sitters, may be of Johannes the Younger and his sister.[20] It is certainly reasonable to expect that Johannes the Younger would have engaged Rembrandt to paint his own portrait as well as that of his parents.

figure 9:
Rembrandt Harmensz. van Rijn (1606–1669)
Johannes Elison 1634
oil on canvas 171 × 122.5 cm
Museum of Fine Arts, Boston, Mass., USA

figure 10:
Rembrandt Harmensz. van Rijn (1606–1669)
Maria Bockenolle, wife of Johannes Elison 1634
oil on canvas 173 × 125 cm
Museum of Fine Arts, Boston, Mass., USA

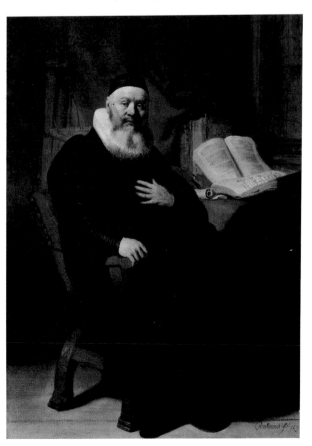

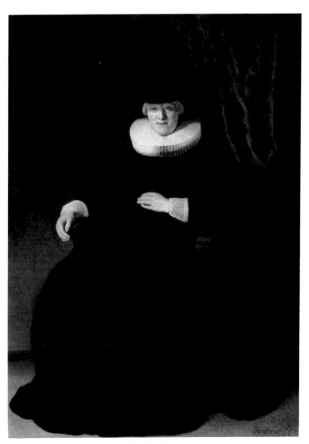

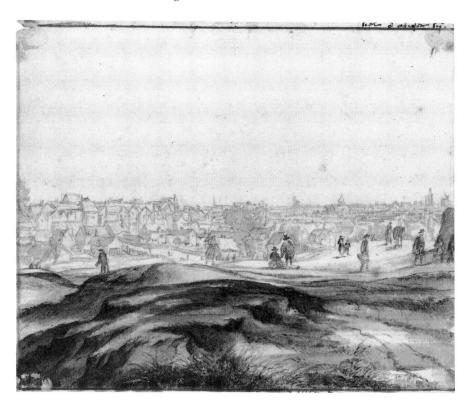

figure 11:
William Schellinks (1627–1678)
View of Norwich c. 1662
black chalk, grey ink and watercolour 14.9 × 18.2 cm
Reproduced courtesy of Sotheby's

Only two unrecognised portraits of *c.* 1633–34 by Rembrandt appear to fit this possibility: *Portrait of a man rising from his chair*, now in the Taft Museum, Cincinnati, and its pair *Portrait of a Woman in an armchair*, now in the Metropolitan Museum of Art, New York.[21] Although these would today be regarded as three-quarter length rather than full-length portraits, they are the only works in Rembrandt's oeuvre of this period which could be so described. Both portraits, although of fair size, are markedly smaller than the pair now at Boston. Neville describes 'these pictures' as 'almost lost in the little parlour', but this need not refer to the size of the smaller portraits so much as the inaccessible location of all four. They were not recorded, for example, by Horace Walpole in his brief note of 1763, yet were sufficiently regarded locally for Neville to make a special visit to see them as a group.[22] Neville was himself capable of making qualitative judgements: on that same day he visited the Lowestoft 'China Manufactory', whose wares he judged 'most of it . . . rather ordinary'. The possibility remains, however, that the portraits said to be of the son and daughter, and said to be by Rembrandt, were not by Rembrandt at all. In most such cases a Rembrandt attribution of this period should be treated with absolute caution, and the conundrum must for the present remain unsolved.[23]

Norfolk links with the Netherlands were not necessarily direct. The first ports of entry for immigrants could be Yarmouth or King's Lynn, but equally anyone could make the journey to East Anglia from London. One Dutch traveller and artist to visit the region was Willem Schellincks (1627–78) who was in England from 14 July 1661 to 18 April 1663 to provide drawings for Laurens van der Hem, a wealthy Amsterdam merchant who was intent upon amassing a major collection of topographical material. While in England Schellincks kept a journal, which duly records his visit to East Anglia in October 1662.[24] Leaving London on 1 October he had reached Cambridge on 4 October. He reached King's Lynn via Newmarket, staying there for four days before moving on to Norwich. His recently-identified, two-sided drawing of Norwich (inscribed, in Dutch, 'taken from life near Norwich') may therefore be dated 11–12 October (fig. 11).[25] He moved on to Yarmouth, 13–16 October, before returning to London via Ipswich, Colchester and Chelmsford.

The existence of so-called 'Dutch' or 'Holborn' gables throughout East Anglia has

always been cited as evidence of the strong Anglo–Netherlandish architectural influence. H.J. Louw has recently argued for caution in this field, however, as has F.A.J. Vermeulen who pointed to the strong influence which the publications of the Flemish Vredeman de Vries had in both England and Holland.[26] The nature of the interchange of architectural influence can be complex. It has been suggested, for example, that Pieter Noorwitz (died 1669), the master carpenter in charge of the building of the Nieuwekerk, The Hague, begun in 1649, could have come from Norwich, the son of a Dutch immigrant.[27]

cat. no. 22 Henry Bell *The Exchange at Lynn Regis in Norfolk*

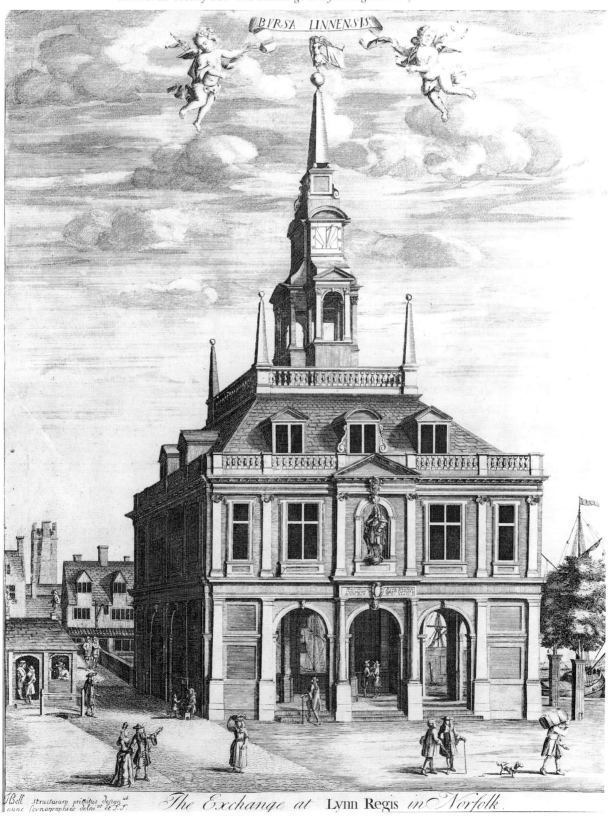

The Exchange at Lynn Regis in Norfolk

It should not be forgotten that there are significant differences between Dutch and East Anglian architecture, to the extent that at least one contemporary visitor failed to notice any particular 'Dutch' influence. The Dutch merchant Abram Booth, who was in England in 1629–30, visited eighteen East Anglian towns, noting Norwich, Colchester and Sandwich as important refugee centres. Booth found only Great Yarmouth in any way to resemble a Dutch town, having 'the greatest likeness in building and neatness of streets with our Netherlands cities of all places in England'.[28] It is really only later in the century that the Dutch influence becomes more prevalent in the market towns. One should look instead for a Flemish influence as more likely in East Anglia.

The gables of the outbuildings of Blickling Hall have long been recognised as the earliest of the kind in the area. Louw has pointed out that the Blickling gable is almost certainly the result of borrowing from – and simplifying – a design from Vredeman de Vries *Architectura* (1565).[29] The interior decoration at Blickling similarly relies upon a free use of Flemish print sources. Vredeman de Vries is almost certainly the source for some of the frowning and screaming mask heads on the staircase at Blickling.

The architecture of Henry Bell (1647–1711), of King's Lynn, best embodies Netherlandish influence.[30] Bell's principal building is the Customs House at King's Lynn (cat. no. 22), but he was also concerned in the rebuilding of Northampton after the disastrous fire which destroyed the centre of that town on 20 September 1675. His other known architectural works are all in King's Lynn and its immediate vicinity. Bell's Customs House owes much to Dutch weigh-houses in its groundplan, and the work of Pieter Post.

Bell's knowledge of Netherlandish architecture was almost certainly the result of having visted the Low Countries. Having gained his B.A. degree at Caius College, Cambridge in 1665, he 'discovered a promising Genius, and strong Inclination to the Study of Liberal Arts and Sciences; and being Heir to a considerable Personal Estate, he had an opportunity of improving himself, by travelling over most of the politer Parts of Europe'.[31] The latter surely included the Low Countries and his grand tour appears to have stimulated his interest in all the arts. His inheritance on the death of his father in 1686 allowed him to operate in a small way as a merchant as well as architect and collector.

An indication of Bell's collecting interests is to be found in a clause of his will in which be bequeaths his son William 'all my Books relateing to Painting, Sculpture, Architecture and Statuary to the Mathematicks Perspective and Surveying with all manner of Instruments Utensills and appurtenances thereunto belonging. And also all my Copper Plates Engraveings Prints Mapps and printed Pictures whatsoever and also twelve of my Paintings according as they shall be named and specified here underneath.'[32] The paintings included a version of Rembrandt's *Our Saviour disputing with the Doctors in the Temple* and one of the numerous versions of *The Quaker Meeting* by Egbert van Heemskerck. Heemskerck had possibly come to England as early as 1674 but was certainly in Oxford by 1687. Bell's version may well have subsequently entered the collection of Sir Andrew Fountaine of nearby Narford Hall.[33]

Another of Bell's Dutch paintings was a version of Godfried Schalcken's *The Boy blowing the Coal*. This was almost certainly a version of a picture first recorded as in the Sunderland collection at Althorp in 1746.[34] Schalcken spent some years in England and Vertue records that Lord Sunderland employed him a good deal at Althorp. It is quite possible that Bell became acquainted with the artist's work – if not the artist himself – when involved in the re-building of Northampton. Bell's art collection also included *Three Fryars at Cards* by Egbert van Heemskerck senior and *The Dutch Kitchen* by Heemskerck junior. While it is reasonable not to doubt these attributions, those paintings attributed to Holbein (*St. Edward the Confessor*) and Rembrandt are probably more suspect. Bell's will also listed works by Hendrick Goltzius, Isaac Sailmaker, 'Lark' and 'Schrowder' as well as a painting of Mary Magdalen, after Tintoretto, by Bell himself. Bell's own style as a draughtsman owed something to contemporary topographical engravers such as Wenceslaus Hollar.

The collections of the landed gentry similarly indicate a taste for Netherlandish art which was initially influenced by fashions in the court circle and only subsequently by the example of growing collections in neighbouring country seats. One of the

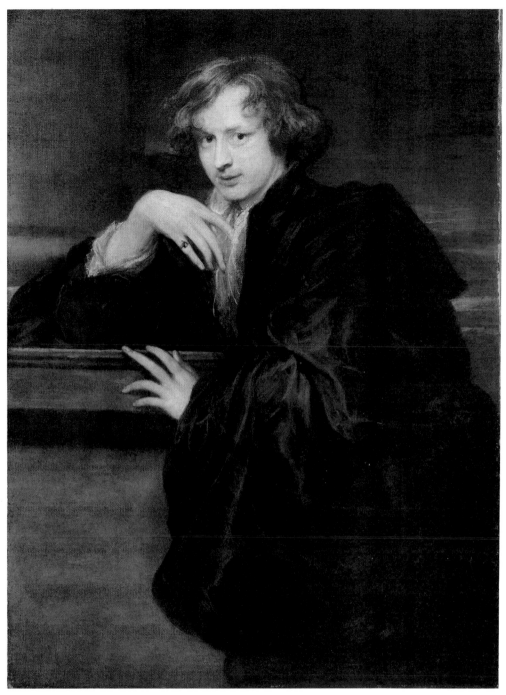

cat. no. 13 Anthony van Dyck *Self-Portrait c.* 1621

most important collections of notable portraits by artists of the stature of Miereveld, Mytens, van Dyck and Lely was at Euston Hall on the Norfolk–Suffolk border. Henry Bennet, made a baron by the title of Lord Arlington in 1663, became Earl of Arlington and Viscount Thetford in 1672. John Evelyn records dining with Lord Arlington, then the Lord Chamberlain, in London where he saw his picture collection, including 'two of Vandyke's, of which one was his own picture at length, when young, in a leaning posture; the other an eunoch, singing. Rare pieces indeed!' (see cat. no. 13).[35] Evelyn also spent some ten days at Euston in October 1671, finding the Earl's country seat 'a very noble pile . . . with a vast expense made not only capable and roomsome, but very magnificent and commodious, as well within as without, nor less splendidly furnished'. Lord Arlington's collection, gathered together during the years 1666–85, whether originally intended for Arlington House (on the site of Buckingham Palace, demolished in 1703) or for his country seat, have in fact been housed at Euston for over three hundred years.[36]

figure 12:
John Theodore Heins (1697–1756)
Robert Walpole, Earl of Orford (1676–1745) 1743
oil on canvas 240 × 150 cm
City of Norwich Civic Portrait Collection

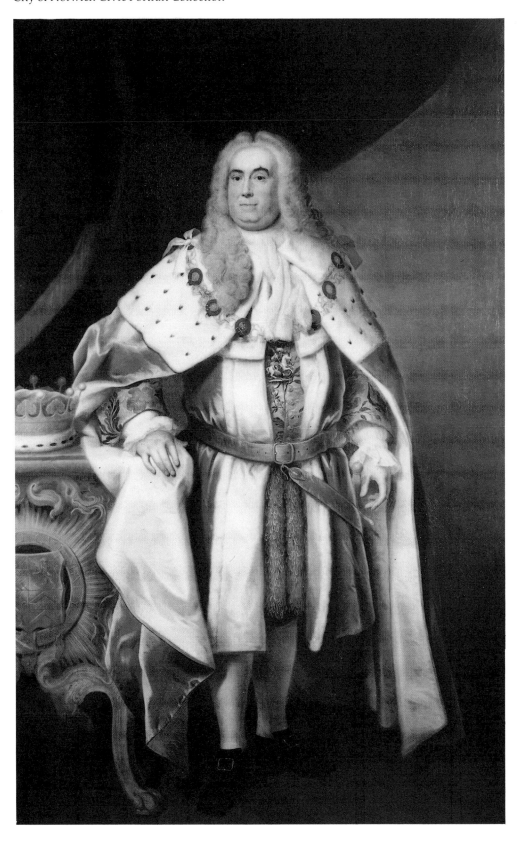

II The Great Collectors

The object of this section is to examine the extent to which some of the great Norfolk collections built up in the eighteenth century did or did not include works of the Netherlandish schools. So much of the character of the great Norfolk houses of this period is the product of the Grand Tour, with a predilection for all things Italianate and Classical, that it would be no surprise to find that few Dutch and Flemish paintings found their way into the Norfolk collections. Nevertheless, a survey of the most notable collections reveals a good number of important works, not only large-scale canvases, but also small cabinet room paintings.

It was the practice in the great English country houses of the eighteenth century for paintings of the Netherlandish schools to be arranged in a small cabinet room or closet, separate from the larger saloons in which the Italian Old Masters were hung. This practice can still be seen in some country houses today, such as at Corsham Court in Wiltshire, Woburn Abbey in Bedfordshire, and Saltram House in Devon. In many respects this was simply in recognition of the smaller scale of Dutch and Flemish panel paintings.

Not every collector arranged his Dutch and Flemish paintings in a cabinet room. The larger Flemish canvases, particularly those of Rubens and his studio, hung in pride of place in the state rooms alongside the Italian masters. This was the case both at Holkham Hall and at Houghton. Large still lifes or hunting scenes, such as those by Rubens' pupil Frans Snyders (1579–1657) and his studio, were often hung in the Dining Room, their subject-matter determining their status (cat. no. 25). The overall impression, when viewing those records of interiors which survive, is that the decorative effect achieved by a symmetrical arrangement was the overriding factor to be considered. In this respect, picture frames played as important a role in furnishing the walls as the paintings themselves. Nowhere is this more apparent than in the careful arrangement of pictures worked out by William Windham together with his architect James Paine in 1751–2, or in William Kent's plans on behalf of Sir Robert Walpole, for the picture gallery at Houghton (frontispiece and fig. 14).

Before considering the great Norfolk collections it is as well to investigate the status of Netherlandish painting in the less patrician local collections of the eighteenth century. This is no easy task for the simple reason that little evidence survives. Certainly no collection remains intact, while the evidence of probate inventories is scant (see p. 3). Norwich was, however, probably the earliest provincial city to be served by a local press.[1] The advertisements of auctioneers in the Norwich press give a brief, albeit tantalizing, sketch of the nature of local collections, but do hint at the relative importance of Netherlandish painting.[2]

The earliest advertised auction to contain Dutch paintings was an anonymous 'curious collection of prints and pictures, designed by the best Italian, French, Dutch and English Masters' at Mr Blackwell Dixon's, King's Arms Inn, Norwich, 15 January 1735.[3] Joseph Cooper of King's Lynn owned a significant collection which included works attributed to 'Vandyke, Vandervelt, Brugenall, Ostade, Legar, and other capital hands, with a very great number of prints'. Cooper practised as an early colourman and the sale included 'oils, dyes, varnishes, brushes and utensils in the colour trade'. He had, however, been declared a bankrupt.[4] A sale at the White Swan, Norwich, on 9 February 1768 included 'some fine pieces of cattle by Vogelsang'.[5] William Chase

auctioned at his Repository at the Back of the Inns, Norwich, on 4–5 August 1772: 'a good collection of paintings from Rembrandt, Teniers etc . .'.[6] The antiquarian and collector, Thomas Martin, FAS, of Palgrave, Suffolk, sold his entire collection of pictures at the King's Head in Diss, Norfolk on 29–31 October 1772. This included 'chiefly Heads of illustrious Personages, some pictures by the following great masters, Holbein, Wissing, Palamedes, Ostade, Van Herp, Wouverman, Hemskirk etc. A large collection of prints, Books of prints and Drawings'.[7] It is tantalizing to consider just how these collections came to be amassed. One clue is to be found in the advertisement placed by a Norwich Bookseller, Martin Booth, on 23 April 1774: '. . . a large & valuable assortment of prints & books of prints, lately imported, consisting of a great variety of Rembrandt's etchings, foreign heads etc . . .'.[8] This certainly suggests that dealers were importing direct from Holland rather than through London and that local collections were being built up by this means.

In the 1780s the information concerning minor local collections becomes only slightly less scant. On 9 August 1780 William Chase auctioned 'a valuable collection of paintings, the works of the following masters, and in fine preservation late the property of a gentleman deceased . . . by Rembrandt, Gaspar Poussin, Cornelius Jansen, Van Goyen, Holbein, Hobbima, Ostade, Hemskirk, Tillemans, Rysbrack, Viviani, Maltose, Scalken, Carlo Dolci, Peters, Vernet and others . . .'.[9] This mixture of schools and attributions was fairly typical. On 18 April 1781 the Norwich auctioneer Richard Bacon sold a similar group of paintings by artists who included 'Vandyke, D. Teniers, Hemskirk, . . . Verelst, Scalkin . . . and Vandermulyn'.[10]

The collection of one local bookseller, Thomas Hunt of Harleston, is of particular interest as the catalogue of his collection sale, held on 29–30 November 1781, has survived.[11] His collection included paintings, drawings, prints, medals, coins, shells and 'rare curiosities'. His pictures included a landscape attributed to van Goyen, four paintings attributed to Heemskerck, one 'an original card playing and drinking very fine . . .' and 'two Dutch markets, very curious for the great number of small figures in them, done with a remarkable neatness . . .'. There was also a copy after Berchem by Joseph Browne (?1720–1800), the Norwich landscape painter, and paintings attributed to Brouwer, van Huysum, Ostade, Poelenburgh and Rembrandt, the latter a self portrait.

Although the great collections such as those at Narford, Holkham and Houghton by no means survive intact, some documentation does exist whereby we can begin to test preconceptions concerning the nature of those collections. One of the most fascinating houses for any eighteenth century visitor was Narford Hall, the home of Sir Andrew Fountaine (1676–1753). Sir Andrew (fig. 13) was a well-known virtuoso and amateur architect who was knighted by William III in 1699. He later became Vice-Chamberlain to Caroline, Princess of Wales, and tutor to her son William, Duke of Cumberland, and in 1727 became Master of the Mint. Although Sir Andrew's collections were greatly influenced by his two grand tours of Europe in 1701–03 and 1714–16, his taste was not exclusively for the Italianate. The earliest record of Fountaine's collection is of a sale of eighty-three pictures in London, in 1731–2, prior to his removal to Narford.[12] Netherlandish painting was well represented, and included works attributed to Brueghel, Bril, Jordaens, Netscher, Ostade, Poelenburgh, Rubens, Teniers and van Dyck, and also a *Nativity* attributed to Rembrandt. It should not necessarily be inferred that these were artists unpopular with Fountaine, but perhaps that their quality was felt to be too low to justify their removal to his country seat.

An inventory made at Narford in 1738 reveals that the interior was furnished in the grand manner, a Netherlandish influence visible only in the portraits by van Dyck and Lely, with two notable 'whole lengths' by Rubens. The three portraits by van Dyck were of *Lenox Duke of Richmond* in the Parlour, a self portrait 'over the chimney' in the Drawing Room (probably a copy) and a version of *Three children of King Charles 1st* in the Billiard Room. Also in the Billiard Room was the only Dutch picture which can be identified as such at that time, *Picture of a Dutch Sermon*.[13]

The inventory taken on Sir Andrew Fountaine's death in 1753 provides a more complete picture of those Netherlandish pictures acquired by Sir Andrew after his removal to Norfolk. These included 'The Portrait of Theodore Rombouts tuning his Lute with music &c on a Table, painted by Himself' and a good example of *Dogs, Greyhounds & Spaniels* by Fyt in the Drawing Room.[14] This was also where the

Narford 'Rembrandt' hung (cat. no. 23) opposite *The Children of Israel gathering manna* attributed to Bloemaert.[15] Narford had a 'Picture Closet' but this was by no means solely devoted to Netherlandish painting. There was a version of *Rubens' Wife's Head* by 'Himself' and also 'a fine Landskip, with figures, Orpheus & Eurydice' by Poelenburgh. Over one door hung two landscapes attributed to Brueghel, and over another, 'two Boys' Heads' thought to be by Frans Hals. Now in Glasgow Art Gallery, these two portraits are regarded as works by an imitator of Hals.[16] These were the only Netherlandish paintings at Narford, apart from a number of portraits by Lely and his studio, and by or after van Dyck. Among the enormous print collection in the Library Closet were 'fifteen prints of Rubens', thirty prints by Ostade and 'eleven prints of Hemskirck'. The ever popular Heemskerck was represented in another print drawer which contained 'twenty six prints of Martin de Vos & Hemskirck'. Although these may seem large numbers, in comparative terms they are not. Narford, celebrated for its collection of Italian maiolica and Hall hung with canvases by Pellegrini, was not really the place to view Dutch and Flemish painting.[17] To an extent this was to change in the nineteenth century with acquisitions made by subsequent members of the family (see cat. nos. 115–117).

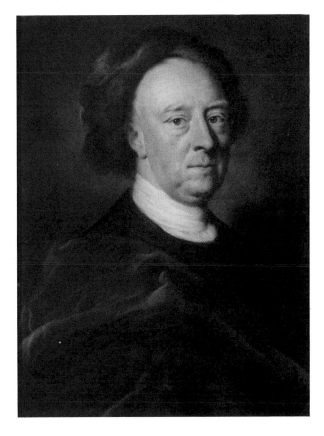

figure 13:
William Hoare (1706–1799)
Sir Andrew Fountaine (1676–1753)
pastel 59 × 44.5
The Earl of Pembroke

Another great collection in Norfolk was that of England's first Prime Minister, Sir Robert Walpole (1675–1745) at Houghton Hall. Sir Robert (fig. 12) began to purchase at auction in 1717 and did so voraciously. By 1736 he possessed 421 paintings of which he himself had acquired at least 400.[18] His pictures hung in Arlington Street, at Chelsea, in his rooms at the Treasury, but predominantly at Houghton. He was able to spend a considerable personal fortune as a result of successful speculation on the Stock Exchange, where he bought Royal African Company and insurance shares, which rose more rapidly than those of the South Sea Company. He also indulged in smuggling, while soliciting the help – and sometimes gifts – of his children, friends, ambassadors and even spies. His celebrated country house at Houghton was designed by Colen Campbell and completed by Ripley in 1725, giving added purpose to his collecting.

Among Walpole's earliest acquisitions were the four great market pieces by Frans Snyders. These provided a focus for William Kent's design proposal for the Saloon at Houghton (frontispiece and fig. 14). Kent's designs were not, however, followed. On

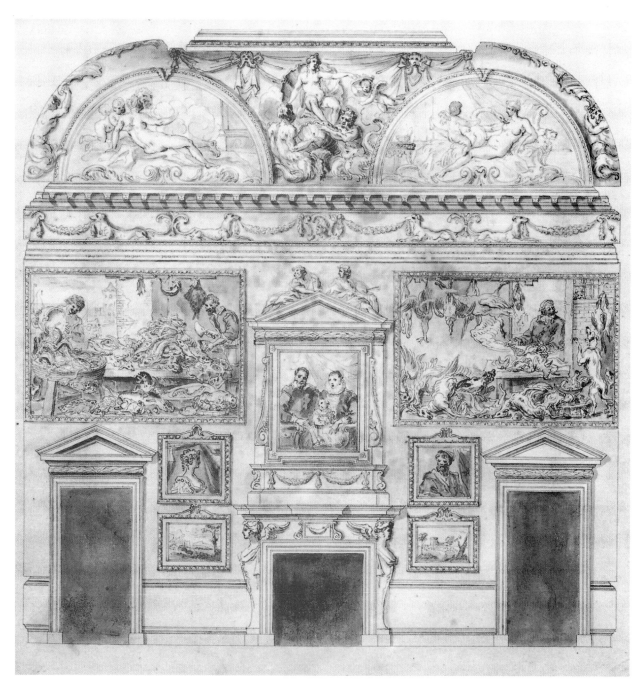

figure 14:
William Kent (1684–1758)
Project for the decoration of the Saloon, Houghton Hall – Elevation of the South Wall
pen and black ink with grey and brown washes 25.7 × 25.7 cm
Private Collection

19 September 1732 the second Earl of Oxford visited Houghton while on his tour of
the Eastern Counties and remarked: 'In the saloon are a great many fine pictures,
particularly the famous Markets of Snyder, but I think they are very oddly put up,
one is above the other and joined in the middle with a thin piece of wood gilt. It is
certainly wrong because as these pictures of the markets were painted to one point of
view, and to be even with the eye, they certainly ought not to be put one above
another, besides that narrow gold ledge that is between the two pictures takes the
eye and has a very ill effect.' Kent's two designs for the arrangement of the North and
South walls of the Saloon are amongst the earliest works by Kent to have survived.[19]
It is likely that he submitted the drawings to Sir Robert as an indication of his ability
to create a complete interior. The drawings show his arrangement of some of
Walpole's finest Flemish paintings in specially designed frames (with alternatives)
which are in turn linked with the furniture and the painted and stucco architectural

details. In the event, these paintings were hung in the much larger picture gallery. The Gallery had originally been intended as a greenhouse, but on Sir Robert's resignation as Prime Minister in February 1742, it was fitted up with those paintings that had been hanging in Downing Street.

In 1747 Sir Robert's son, Horace, published his *Aedes Walpolianae*, a catalogue of the Houghton Collection. It quickly becomes apparent from this catalogue that the greatest Netherlandish works were those of the Flemish painters, Rubens and van Dyck, but there were works by other notable artists. In the Common Parlour were works typically attributed to Wouwermans, Teniers and Steenwyck, as well as to Rubens and Rembrandt. These included, as at Narford, a portrait of *Rubens' Wife*.[20] In the Drawing Room hung some of the portraits by van Dyck which had belonged to the last Duke of Wharton, purchased by Walpole in 1725. The only Netherlandish work to hang in the Saloon was van Dyck's *The Holy Family*, sold by the Princess of Friesland, mother of the Prince of Orange, during the latter's minority.

Houghton was notable for its Cabinet Room which housed the smaller oils in Sir Robert's collection. A large proportion of these were Netherlandish works, but not exclusively so. *Rubens' Family* by Jordaens, which had belonged to the Duke of Portland, hung in the Cabinet. This early acquisition can be seen as a central feature of Kent's design for the Saloon (frontispiece). Other oils included two *Boors at Cards* by Teniers, *The Adoration of the Magi* by 'Velvet' Brueghel and a *Boors drinking* by Ostade. Also in the Houghton Cabinet were 'two Flower-pieces, most highly finished, by van Huysum; his Brother lived with Lord Orford, and painted most of the Pictures in the Attic Story here'. This was also where Sir Robert arranged his six oil sketches for Triumphal Arches by Rubens. These were all *modelli* by Rubens for the decorations of the Festival of the Entry of the Infant Ferdinand of Austria into Antwerp, and of high quality.[21] One other Rubens hung in the Cabinet, the original design for the central compartment of the ceiling for the Banqueting House in Whitehall, representing the assumption of King James I.

Forty-nine oils hung in the Gallery at Houghton and the arrangement on the walls, recorded by Thomas Kerrich in sketches made during a visit to Houghton,[22] was dominated by the four great market pieces by Snyders[23] and the enormous *Meleager and Atalanta*, a Rubens-school cartoon for a tapestry design.[24] This had been brought out of Flanders by General Wade. The other Netherlandish works were attributed to Rubens, Paul Bril and Teniers. The most notable were the Rubens *Landscape with a Cart overturning* and Rembrandt's *Abraham's Sacrifice*. Virtually all these works were included in the notorious sale of pictures to the Empress Catherine of Russia in 1769.

Horace Walpole, in his introduction to the *Aedes Walpolianae*, had little that was good to say of Dutch painting. His judgement was certainly coloured by the fact that he had never visited Holland and Flanders but it is interesting to consider whether his opinion may be seen as idiosyncratic rather than typical. He himself asked the question: 'as for the Dutch Painters, those drudging Mimics of Nature's most uncomely coarsenesses, don't their earthen pots and brass kettles carry away prices only due to the sweet neatness of Albano, and to the attractive delicacy of Carlo Maratti?' One must conclude that, even if they disgusted Horace Walpole, in the 1740s the Dutch painters were already achieving sale prices as good as those of the ever-popular Carlo Maratta.

One of the finest surviving examples of a cabinet room is that at Felbrigg Hall. This was remodelled by William Windham II (1717–61) specifically to house the majority of the paintings he had purchased abroad while on the Grand Tour. Many of these were Italian works, notably a series of gouache views by G.B. Busiri, but on his journey home through Holland in the late summer of 1742 it is likely that Windham (fig. 15) acquired a number of Dutch pictures, notably Jean van Kessel's *Bleaching Ground near Haarlem* (fig. 16). Jean van Kessel (1641–80) was a follower of Ruisdael, influenced by Philips Koninck and not to be confused with the painter of still life of the same name (cat. no. 28). Windham's was an important version of a subject painted on a number of occasions by van Kessel.

While in Rome Windham had purchased a number of works by Netherlandish artists painting in an Italianate manner (cat. no. 41). But in Geneva in 1741 his appetite was whetted for what Holland had to offer. He had commissioned his friend Thomas Dampier (who was to become Dean of Durham in 1774) to purchase prints for him while in Holland. On 11 April Dampier sent Windham 'a short account of

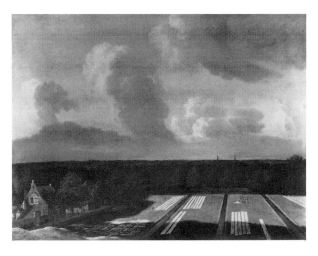

figure 15:
Barthelemy du Pan (1712–63)
William Windham II (1717–61)
pastel 30 × 39.4 cm
The National Trust (Felbrigg Hall)

figure 16:
Jean van Kessel (1641–1680)
Bleaching Ground near Haarlem
oil on canvas 75 × 100 cm
The National Trust (Felbrigg Hall)

what Prints I have purchased for you . . . I have got a great many heads by Rembrandt
. . . They are ye dearest Prints that are in Holland'.[25] He recommended that Windham
visit the dealer De Bary himself when he reached Amsterdam. Dampier considered
that De Bary 'contents himself with a very reasonable Profit in selling . . . He has
lately sent to [Consul] Smith at Venice a compleat collection of Rhembrandts to ye
value of 340 Florins . . . you may lay out with him, if you please, 5 or 600 pds. in
nothing but Prints. He has nothing but what are good or curious and all fine *epreuves*.
I have desired him to write down a catalogue of some of his best Prints with their
Prices to send to you . . . If you are advised by me, you will reserve all ye money you
intend laying out in Prints, 'till you come to see what *De Bary* has at Amsterdam.'

William Windham also commissioned another of his friends whom he had met
abroad, Robert Price of Foxley in Herefordshire, this time to purchase prints in Paris.
Price reported back to Windham, then still in Geneva, on 9 November 1741: 'I was
afraid to send you any Wouvermans though I thought I had seen some new ones. You
have so many already that I should run great Risque of sending you Duplicates. I
have therefore look'd out after some old prints, & chose for you those that pleased me
most, in case you should have duplicates of any of them, I'll take them off your hands
with great pleasure. The prints I have sent you are three large ones & a little one of
Rubens, six of Bloemaert . . . the four Elements, the five senses & the temptation of St.
Anthony by Teniers. I have sent you a print of the same picture of Wouvermans
Laurent has engraved so well, done by Beaumont, to show how differently the same
piece may be rendered, & how infinitely superior our countryman's work is to that of
the other Engravers.'[26] Windham had evidently amassed a considerable print
collection by the winter of 1741, but was also well informed to seek out picture
dealers on his way home.

The most important surviving Norfolk collection is that at Holkham Hall, built by
Thomas Coke (1697–1759), first Earl of Leicester (fig. 17). Thomas Coke's taste for
Dutch and Flemish art was fashioned exclusively by the experience of his grand tour.
Matthew Brettingham, in *The Plans, Elevations . . . of Holkham* of 1773 provides a
guide to the collections amassed by and on behalf of Thomas Coke. Following
Brettingham's progress through the state rooms and family apartments it becomes all
too apparent that there was no specific taste for Netherlandish art. The first and
grandest room, after the Hall, was the Saloon, which contained exclusively
contemporary Italian pictures. In the adjacent Drawing Room hung 'two large
Bird-Pieces, emblematical Representations of King William's Wars, by Hendicooter'.
Still there today, these were purchased on behalf of the Earl of Leicester by Matthew
Brettingham (figs. 18, 19). The invoice was paid on 1 April 1749.[27] It is almost certain
that these were the selfsame pair of 'large piece(s) of Birds, hieroglyphical' by

figure 17:
Francesco Trevisani (1656–1746)
Thomas Coke, First Earl of Leicester (1697–1759) 1717
oil on canvas 200.7 × 161.3 cm
Viscount Coke and the Trustees of the Holkham Estate

'Hondicooter' sold at Lord Orford's sale of 1748.[28] Unusual works in Hondecoeter's oeuvre, the goose is emblematic of England, the Cockatrice of France, the Eagle of Austria, the Stork of Holland, the Raven of Denmark, the Serpent of Turkey and the Brown Eagle of Russia. In the same room hung a set of four classical landscapes by Jan Frans van Bloemen, better known as Orizonte (see cat. no. 29).

The most spectacular painting by van Dyck in the region also hung in the Drawing Room at Holkham (colour fig. 2). Brettingham described the picture as 'Portrait of the Duke of Arembourg on Horseback; figures as large as Life; a most capital Picture by Vandyke: the background (Troops marching to the siege of a Town) is very fine. This noble Picture is said to have formerly belonged to the Duke of Bavaria'. This large equestrian portrait had been purchased in Paris at the end of Coke's grand tour, in February 1718, for 4,500 French *livres*.

Following Brettingham's progress through the Statue Gallery and the Great Dining Room one reached the State Bed-Chamber Apartment, dominated by the only other truly magnificent Flemish painting at Holkham, *The Return from Egypt* by Rubens and his studio (colour fig 1).[29] Brettingham describes the painting as follows: 'Between the Doors, on the side towards the Saloon, is a large capital Picture representing the Flight of the Virgin and St Joseph into Egypt, by Rubens. The figures are as big as the Life. The Head of the St Joseph is equal to any thing of that Master: the Figure of the Young Christ; the Drapery of the Virgin, which is red; and the picturesque Head of the Ass (that makes a part of the Centre Group) are all painted with admirable Force, and Brilliancy of Colouring. There is one at Blenheim, in every respect like this, excepting that the colour of the Virgin's Drapery is Blue instead of Red, by the same Master'. The version at Blenheim, now at Hartford,

figure 18:
Melchior D'Hondecoeter (1636–1695)
Emblematic representation of King William's Wars
oil on canvas 150 × 185 cm
Viscount Coke and the Trustees of the Holkham Estate

figure 19:
Melchior D'Hondecoeter (1636–1695)
Emblematic representation of King William's Wars
oil on canvas 150 × 185 cm
Viscount Coke and the Trustees of the Holkham Estate

Connecticut, had been purchased by the Duke of Marlborough in Brussels from the Chateau of Terveuren, in 1708.

A Holkham account book reveals that the Rubens was purchased from G. Campbell, for £300 in the week ending 29 June 1745. The painting is likely to be that commissioned by Nicolas Rockox, Burgomaster of Antwerp, for the Chapel of St Joseph in the Jesuit church at Antwerp, and painted by Rubens and his studio *c.*

cat. no. 27 Attributed to David de Coninck *Still Life with Fruit, Flowers and Parrot*

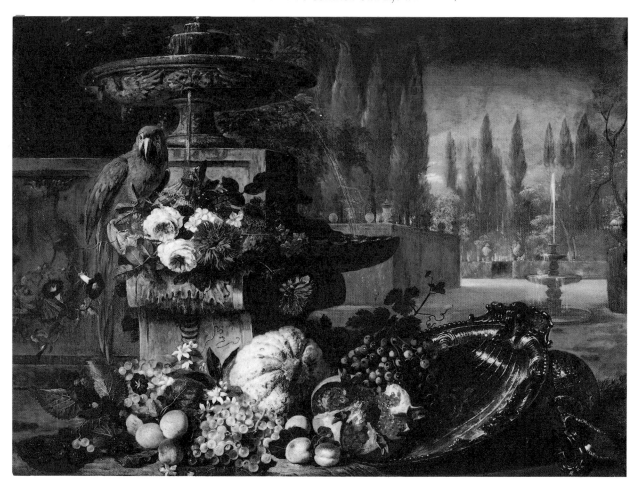

1618. It appears that the painting was subsequently removed from the chapel and replaced by a copy.[30] Rubens' original altarpiece was subsequently enlarged by the addition of canvas strips along the edges, presumably in order to give the composition, divorced from its architectural setting, a greater sense of perspective.[31] This was not done by Rubens himself, but possibly in the early eighteenth century. The enlarged format follows the engraving made by Lucas Vorsterman in 1620, who had himself enlarged the composition at the edges.[32] *The Return from Egypt* at Holkham was certainly the most impressive canvas from Rubens' studio in the region during the eighteenth century. There were a large number of works by or attributed to Rubens in Norfolk collections, the largest collection being that at Houghton.

The State Dressing Room at Holkham, otherwise known as the Landscape Room, contained just two classical landscapes by Orizonte, in the company of highly-regarded works by Claude, Gaspar Poussin and even two Locatellis 'much superior to the Horizontes' according to Brettingham. However it was the smaller, more private rooms that housed the cabinet pictures at Holkham. The State Bed-Chamber Closet contained *Macaws and Parrots* attributed to Rubens with Snyders (cat. no. 25), as well as two Italian views attributed to van Wittel, called Occhiali (cat. no. 30), and a copy of a Rubens landscape. In the adjacent closet were hung five more Occhialis, in the company of two Canalettos, and a supposed *Portrait of Rubens' Daughter*, attributed to Rubens. The North State Bedchamber was hung with Brussels tapestry depicting the signs of the Zodiac, the still life elements acknowledged by Brettingham as 'probably copied from Paintings of Snyders'. This was a suitable setting for the *Still Life* attributed at that time to Hondecoeter (cat. no. 27). Apart from a portrait of *Mrs Price* by Lely in the Dressing Room and a full-length portrait of the *Earl of Warwick* by van Dyck in the Green-Damask Bed Chamber, there was little else by Netherlandish artists at Holkham, apart from another three Occhialis in Lady Leicester's closet and a *Moonlight* by van der Neer, hung adjacent to the Flemish *Thistles* and *Poppies* (cat. no. 28) in Lady Leicester's Dressing Room.

It is interesting to note the additions to the collection at Holkham which are cited by J. Dawson in his *Stranger's Guide* of 1817 but which are not specified by Brettingham. These include a *Landscape and Figures* by Poelenburgh,[33] and a *Battlepiece* by Wouwermans,[34] and also *Poultry* by Hondecoeter (cat. no. 26). It is

cat. no. 33 Frans Snyders *A Boar at Bay*

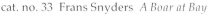

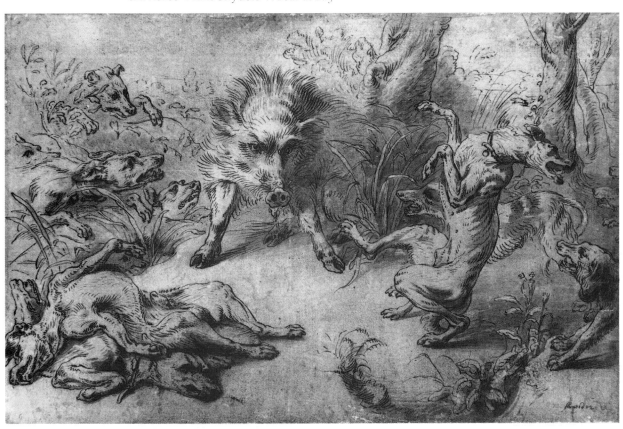

possible that the Poelenburgh and the Wouwermans were purchased by Thomas William Coke in the early nineteenth century.

Thomas Coke also acquired a considerable collection of old master drawings. Some 140 framed works remain today at Holkham Hall, together with 188 in portfolios. A number of the framed drawings have hung on view in the Family and Strangers' wings since the eighteenth century. Some of these are listed in Brettingham's *The Plans, Elevations . . . of Holkham* of 1773 and once again the emphasis was almost entirely upon Italian old masters. The largest group of drawings was hung in the Blue-Satin Dressing-Room.[35] Most of these had been purchased in Rome for Coke by Gavin Hamilton. The only Flemish works to be hung were a 'coloured drawing' by van Lint and *Christ Carrying The Cross*, attributed to Lucas van Leyden (cat. no. 31). The finest Netherlandish drawings in the collection were Frans Snyders' *A Boar at Bay* (cat. no. 33) and Willem van de Velde's *Men of War at Anchor* which have remained in the portfolios (cat. no. 37). The majority of the drawings, however, were by Italian baroque masters.

One notable collection housed from the mid eighteenth century on the Norfolk–Suffolk border, was that at Herringfleet Hall. The collection was formed by Mr William Leathes (1674–1727) of the County of Antrim in Ireland who served in the Netherlands as assistant to Lieutenant-General William Cadogan from March 1715. Cadogan was Envoy Extraordinary and Plenipotentiary to The Hague, 1714–15. Leathes was appointed Secretary at Brussels 1715–17 and then Resident from the following year. He is recorded as having taken leave of absence at The Hague in December 1716–May 1717 and on other occasions. When he left on leave in April 1722 he never returned, resigning his appointment on 1 May 1724. It was presumably during this period that he developed a taste for Netherlandish painting, particularly the work of Herman van der Myn (cat. no. 58). His full-length portrait by van der Myn (fig. 20) shows Leathes when His Majesty's Ambassador in Brussels. Dressed in green with a richly embroidered waistcoat, Leathes cuts a dash as a man of taste abroad. His collection passed by descent to Carteret Mussenden (1698–1787) who took the name Leathes. He was bequeathed Herringfleet Hall by its builder, his younger brother Hill Mussenden (1701–1773).

The collection was notable for its works by Netherlandish artists. A century later, in 1826, pictures attributed to artists who included Rubens (cat. no. 56) Dusart, van

cat. no. 56 School of Peter Paul Rubens *Atalanta and Meleager in pursuit of the Calydonian Boar* late 1600s

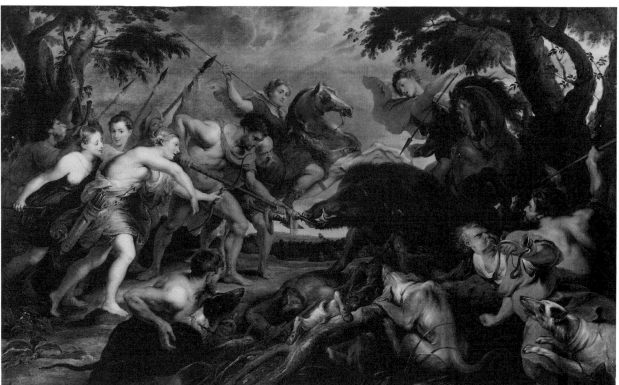

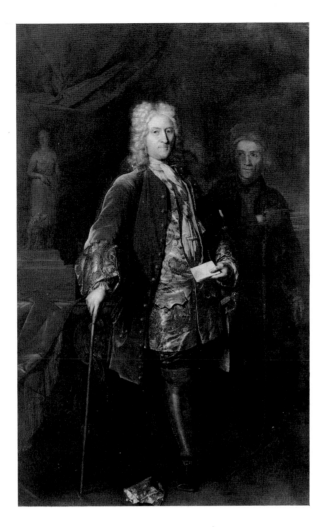

figure 20:
Herman van der Myn (1684–1741)
William Leathes (1674–1727)
oil on canvas 240 × 147.5 cm
Ipswich Museums and Galleries

de Velde, de Koninck, Snyders, Momper, Teniers, Berchem, Ostade, Heemskirck, Hondecoeter, and Michiel van Musscher were all recorded at Herringfleet Hall. At that time it was described as 'a very superior collection of paintings, which to be admired, needs only to be seen'. Herringfleet Hall was sold in 1919 and the collection has subsequently been split up. The core of the collection remains, however, and it is possible to make some judgements about Leathes' collection. The quality was not high, except for the works of van der Myn, which were particularly admired for their high degree of finish. Leathes' early position as Master of Ordinance in the armies of Marlborough was presumably behind his ownership of Verdussen's *Assault on the Town of Oudenarde* and also a portrait of Marlborough by S. van Helmont, dated 1714.[36]

One of the most eclectic Norfolk collections formed during the second half of the eighteenth century was that at Langley Park. Built by Richard Berney, Recorder of Norwich, Langley was only partly complete when Berney's estates were sold to George Proctor in *c.* 1740 to pay his debts. The architect was Matthew Brettingham senior and he was later employed to enlarge the house. George Proctor's collection was influenced by his time abroad, particularly in Venice, but he died in 1744 when his nephew Sir William Beauchamp-Proctor K.B. succeeded him.

It was Sir William's son, Sir Thomas Beauchamp Proctor who was largely responsible for the rapid growth of the collection. Succeeding his father in 1773, he became High Sheriff of the County of Norfolk in 1780. According to Dawson Turner, Sir Thomas was advised in his picture purchasing by the artist and connoisseur, Henry Walton. Dawson Turner commented of Walton (1746–1813) that he 'was no ordinary judge in such matters. On the contrary, there were few men whose opinions were more valued. In the purchasing of their pictures, many of our nobility and leading commoners were in the habit of being guided by his advice: Lord Fitzwilliam was greatly so in the formation of the Gallery now at Cambridge: the choice collection formed by the late Sir Thomas Beauchamp Proctor, at Langley-Hall, Norfolk, was mainly, if not altogether, made by him; and I have been told that the

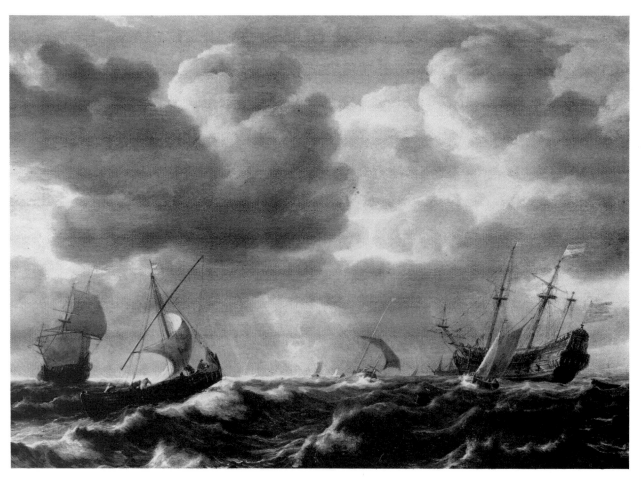

cat. no. 47 Simon de Vlieger *Sea View, a Squall c.* 1640s

first Lord Lansdowne placed such dependence upon him, that he never bought a picture without his sanction'. It is perhaps unfortunate that Dawson Turner's eulogy upon Walton's connoisseurship was occasioned by the memory of his having mistaken an oil by John Crome as the work of Gainsborough.[37]

The manuscript catalogues of the Langley collection still survive as a record of the eclecticism exercised by Sir Thomas under the guidance of Henry Walton (cat. no. 46). The earliest dated catalogue is that of 1815, in the handwriting of Sir Thomas's wife, Lady Mary. The collection was as notable for its sculpture as for its paintings, but the latter were markedly balanced between the Italian, Dutch and Flemish Schools. Of the twenty-four paintings on display in the Drawing Room, fourteen were attributed to Dutch and Flemish masters, including Teniers, Ostade, Both, van Goyen, Dirck Maas, de Vlieger, Bakhuizen and Steen. The Library was fitted out with fifteen portraits, but the prizes among the Netherlandish collection were hung in the Cabinet Room. The majority of the thirty-six paintings in the Cabinet were Netherlandish, including eleven attributed to Teniers. The artists represented included van der Velde (cat. no. 54), Wijnants, Wouwermans (cat. no. 50), de Vlieger, (cat. no. 47), Pynacker (cat. nos. 51, 52), Ruisdael, Slingelandt, Steen, van Goyen (cat. no. 48) and Dirck van Delen.[38] In the North Eating Room were a fine panel by Balthasar van der Ast, signed and dated 1625, depicting peaches, grapes and other fruits[39] (fig. 21) and another still life of oranges and lemons in a Delft Ware bowl by Jan Pauwels Gillemans I, signed and dated 1659.[40] Here also hung a fine Berchem (cat. no. 49) and an oil attributed at that time to de Heem (cat. no. 53). It appears that the Langley collection may well have been among the first to benefit from the influx of cabinet pictures from the continent, resulting from the many aristocratic collection sales of post-revolutionary France in particular. This was a phenomenon which was to raise the quality and increase the numbers of the cabinet pictures available on the market, as well as to inform the taste of the middle-class collector.[41] At Langley was one of the first of the paintings to reach Norfolk from the collection of Philippe, Duc d'Orleans, a panel by Pieter Cornelisz. van Slingelandt, *An archway with a Seated Youth*, dated 1677 (fig. 22).[42]

figure 21:
Balthasar van der Ast (before 1590 – after 1656)
Still Life: peaches, grapes, etc. 1625
oil on panel 44.5 × 60.9 cm
Private Collection

figure 22:
Pieter Cornelisz. van Slingelandt (1640–1691)
An archway with a seated Youth 1677
oil on panel 26.8 × 19.8 cm
Private Collection

cat. no. 49 Nicolaes Berchem *Landscape* 1656

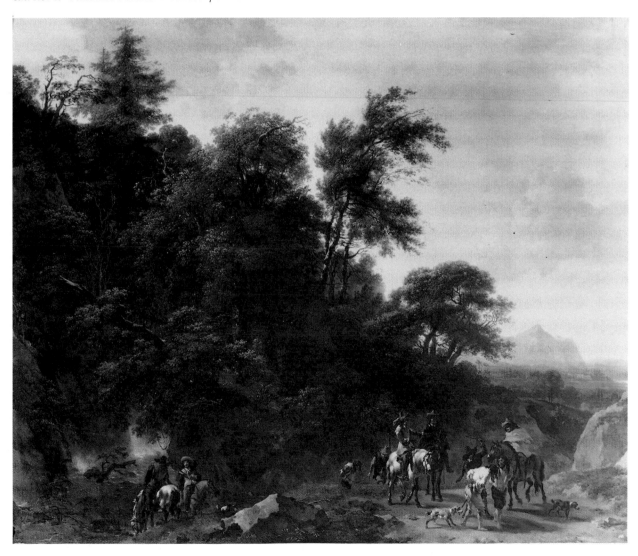

figure 23:
After John Opie (1761–1807)
Thomas Harvey (1748–1819)
oil on canvas 58.5 × 50 cm
Norfolk Museums Service (Norwich Castle Museum)

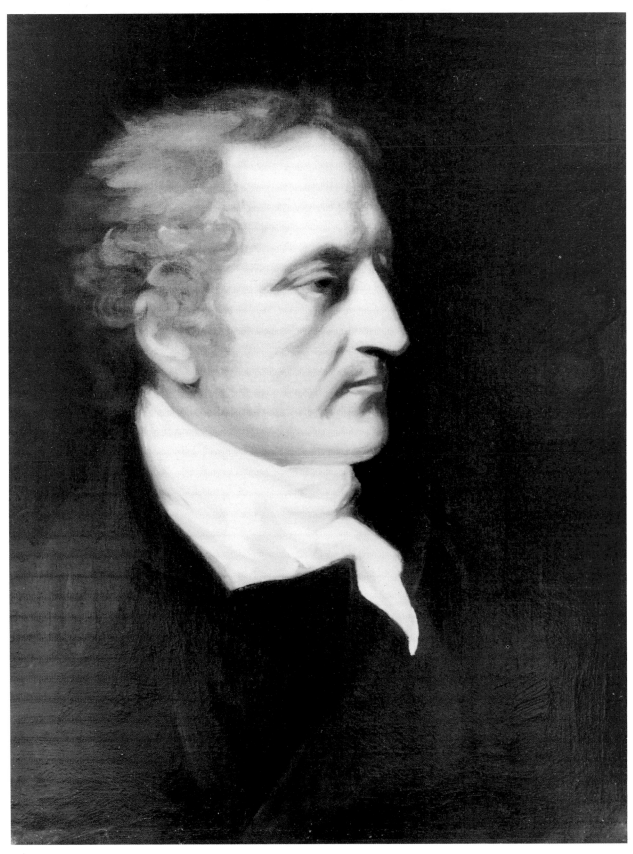

III Merchants and Dealers

The purpose of this section is to explore those middle-class collectors in Norfolk who formed their collections at the turn of the eighteenth century. The period is notable for the influx of old masters from the continent, primarily as a result of the French Revolutionary Wars and the subsequent Napoleonic Wars. The break-up of the aristocratic French collections led to opportunities not only for middle-class collectors with aspirations as men of taste, but also for a new breed of art dealer. The relationship between the *dilettante* and his agent, such as that of Thomas Coke and Matthew Brettingham, receded as a more businesslike relationship took over. Pictures were hawked around the county by London dealers, while more canny collectors such as Thomas Harvey of Catton tried to cut out the British middle-men by communicating with art dealers direct, for example, by letter to Antwerp. The Norfolk contemporary artists were no less sharp: John Crome and Robert Ladbrooke took up collecting, dealing and selling by auction to supplement their precarious livelihoods as artists.

An interesting example of an eighteenth century dealer and collector was Daniel Boulter of Yarmouth.[1] Daniel Boulter (1740–1802) was born at Worstead, Norfolk, 'of honest Pearants',[2] the son of a butcher. Born into a Quaker family, he was buried at Great Yarmouth 'in the burial ground belonging to the Society of Friends'.[3] In April 1764 after a period as an apprentice tallow chandler, he learnt of a 'situation in Trad. at Yarmouth of the late Jacob Master Decesd.', and 'agreed to take the stock & pictures by for Aprisement with a Leice for 11 years at £14 pr. annum . . .'.[4] In fact, he held on to this business[5] until July 1794 when he sold it to his brother Joseph. By this time he was offering 'wholesale and retail, great choice of the best London made, Birmingham, Wolverhampton, Sheffield, and Pontipool Goods, in the newest taste, selected from the principal manufactories, in the Silversmith, Jewellery, Cutlery and Toy Line. Also a great variety of Books of all kinds, new and second-hand, *Stationery Wares, Haberdashery, Gloves, Perfumery, & Patent Medicines.*'[6]

More significantly, if in the same magpie fashion, on 8 August 1778 Boulter 'opened the Museum in the Markett place Yarm[t] for Publick inspection, consisting of Natural and Artificial curiosities which I had been colecting about 10 years, & was thought to have been a work of much longer time than I was about it by many of the curious observers'.[7] Amongst the more than 4,400 itemised objects listed in the *Museum Boulterianum* catalogue printed in *c.* 1794 were preserved birds, fish, shells, minerals, 'antiquities', coins, hundreds of books (many now very rare), and a 'collection from the new discovered Islands in the South-Seas, by Capt. Cook and others.'[8] The 'curiosities' also included, 'some capital Paintings by the first masters' and 'Rare old Prints, including a large Collection of Engraved Portraits'.[9]

A feature of the museum was that nearly all the exhibits were available for purchase, at a price listed in the catalogue. Of approximately one hundred and fifty paintings listed in his 'collection', Boulter valued the thirty-nine pictures attributed to Dutch or Flemish masters at a total of £106.4.6. The pictures ranged from one shilling to ten guineas in price, with works attributed to Bril, Dou, J. Davidsz. de Heem, A. van der Neer, A. van Ostade, Ruysdael, and Wouwermans, all being offered at three guineas or less. It is difficult to be certain whether these low prices reflect Boulter's ignorance of current auction values or whether they simply indicate rather optimistic attributions attached to works of low quality.

Nevertheless, six pictures in Boulter's catalogue commanded relatively high prices. Three of these were small candlelight scenes by Godfried Schalcken, valued (complete with frames) at five, six and eight guineas. A larger painting attributed to Brueghel, entitled *A very antique Painting of a Cardinal embracing a Crucifix, with a great number of Figures of different Animals*,[10] was priced at five guineas. The highest price of any painting in the catalogue, which also listed works by Wilson, Giordano, Spagnoletto, Hubner, Titian, Holbein, Canaletto, and Guido, was ten guineas, for a large panel of a *Dutch Kitchen* attributed to Frans Snyders, with figures by Jordaens.[11] A 'VERY CAPITAL PORTRAIT OF REMBRANDT, BY HIMSELF'[12] was not given a price, suggesting that either it was not for sale, or that an unusually high bid was required.

Boulter also offered over two hundred prints by or after Dutch and Flemish artists – including Lucas van Leyden, Rembrandt, Rubens and van Ostade, all priced at a few shillings. However, the significance of Daniel Boulter's 'Museum' lies not in the quality or breadth of its collection but, rather, as an early example of what was available at the lower end of the art market in Norfolk – in a period that saw the birth of significant expenditure on pictures by the middle class. Furthermore, the *Museum Boulterianum* anticipated by several decades early London Museums such as that at Dulwich, and appears to have been the first in the East Anglian region. Had it been allowed to flourish in the nineteenth century it might well have provided a touchstone for local taste, but Daniel 'resined the Museum'[13] to his nephew John in October 1794, and the collection seems shortly to have been dispersed through the family.

Another eighteenth century Norfolk collector who also dabbled as a dealer was Thomas Harvey (1748–1819) of Catton.[14] Thomas Harvey (fig. 23) is best known as the earliest patron of John Crome, whom he probably met in the 1780s.[15] Dawson Turner records that he was also 'the intimate friend of Mrs. Siddons, of Kemble, of Beechey, and of Opie'.[16] The range and quality of Harvey's pictures, some of which were later bought by Dawson Turner, and, more particularly, the methods by which he acquired them, have not been fully appreciated. These can, however, be at least partially reconstructed through a series of letters from Harvey's dealers in Antwerp, Messrs. Pilaer and Beeckmans, which have survived for the period February 1785 to July 1790.[17]

Harvey came from a line of rich merchant-weavers in the Norwich area, and both his father, Thomas, and grandfather John, had been mayors of Norwich.[18] Thomas himself was a master worstead weaver but presumably was able to live largely off an inherited fortune. His wealth was no doubt further increased by his marriage[19] to Anne (sometimes wrongly called Lydia) Twiss. As Dawson Turner commented:

> The marriage of this gentleman with Miss Twiss, the daughter of one of the principal [English] merchants in Rotterdam, gave him many advantages in his researches after works of art in Holland; and such advantages his taste and knowledge and fortune enabled him to turn to the best account.[20]

Unfortunately, it has not been possible to undertake a full account of Harvey's collection because a copy of the sale catalogue at his death has yet to be traced. However, Dickes, writing in 1905, recorded that he had seen a copy of the catalogue, which 'shows that Thomas Harvey had spent many delightful years copying pictures in the galleries of Holland, Flanders and Germany. He seems to have been partial to reproducing Claude, Ruysdael, Teniers, Hobbema, and Wilson; to have been blessed with the means to buy good original pictures when they offered, and with an enthusiasm for landscape painting for its own sake.'[21] An advertisement for the sale in the *Norfolk Chronicle and Norwich Gazette* (5 June 1819) mentioned 'many original Pictures by Wilson, Cuyp, Teniers, Salvator, Jordaens, Fyt, Hondikooter, Ruysdael, etc, etc'. There is also still extant the 1821 sale catalogue of Harvey's collection of drawings and prints. The drawings included works attributed to Cuyp, Berchem and van de Velde; while the prints included works by or after Potter, Cuyp, van der Neer, Wijnants, Wouwermans, Ruisdael and Bakhuizen.[22]

Several of Harvey's pictures can, however, be traced through other Norfolk collectors, principally Dawson Turner. Turner bought at least eleven pictures from Harvey – 'a man for whom I entertained a sincere regard'[23] – in the decade before

figure 24:
Jan Steen (1625/6 – 1679)
The Christening Feast
oil on canvas 86.5 × 106.5 cm
The Wallace Collection, London

Harvey's death. It has been suggested that Harvey sold these works, and others, because of the disruption of trade caused by the Napoleonic wars, but he was something of a dealer himself, and he might simply have wished to raise funds for fresh purchases. Dawson Turner secured four Dutch and three Flemish works, accounting for a third of his collection in those schools. Paramount amongst these were the Hobbema landscape (see cat. no. 59), an early purchase by Harvey of the 1770s, perhaps via his Rotterdam contacts, and Jan Steen's *The Christening Feast* (fig. 24 christened *The Gossiping* by Dawson Turner), now in the Wallace Collection. There was also Cuyp's *A Man Giving Provender to a Horse*, a Fyt game piece, and three small panels attributed to Teniers – especially popular by this period – representing three of the senses (smell, sight and speech); Dawson Turner noted that a fourth in the series was also owned by Harvey.[24]

Harvey's pictures entered a number of other nineteenth-century Norfolk collections. Joseph Muskett acquired two large animal pictures – *Fighting Cocks* by Hondecoeter and *Four Red and White Spaniels . . .* by Fyt.[25] Charles Weston, the Norwich brewer, owned another Fyt (a joint work with Weenix) and a van Goyen *Fishing-boats*, both bought from Harvey.[26] The late-nineteenth century collector Thomas Turner of Mill Hill Road, Norwich, owned an oil sketch, then attributed to Rubens and regarded as the original sketch for the 'Triumphal Entry of Henry IV . . . the large picture in the Uffizi at Florence.'[27] This picture can be identified as that in the Prince's Gate collection at the Courtauld Institute of Art. Now regarded as by

Rubens' pupil, Gaspar de Crayer, the sketch is recognised as depicting *The Triumph of Scipio Africanus*, albeit based upon Rubens' *Triumphal Entry of Henry IV into Paris*.[28]

Harvey was in regular contact with dealers abroad. A number of letters survive from the period 1785–90 which dramatically demonstrate just how he set about amassing his collection. The Scottish dealer-painter in Rome, Jacob More, seems to have provided Harvey with several Italian and French works, but also offered him, in April 1790, twelve 'astonishingly clever' landscapes by Momper – 'seven large – five feet four inches by three feet nine inches – and five small ones – three feet by two feet three inches. If any of them would suit you, I can let you have them very reasonable . . . the colouring is brilliant'. He also mentioned that they were 'fine examples for massing' – an indication of the scale of Harvey's collecting ambitions.[29] A more important source for Harvey's collection of Dutch and Flemish works were the dealers Pilaer and Beeckmans of Antwerp. An almost complete series of some thirty-one letters to Harvey survives, covering the period 1 February 1785 to 6 July 1790.[30] However, while twenty-five were sent in the first three years, in 1789–90 only two letters were despatched. This dramatic decline in business can best be explained in their own words – 'The reason we didn't reply earlier has been the troubled times in our country', although, 'since being attacked, things are presently very quiet, it's only at Namur and Luxemburg that they [the French Army of the Revolution] are still there' (6 July 1790).[31]

Harvey appears to have had dealings with the firm from at least 1784 when he actually visited them in Antwerp,[32] and 'saw at our establishment a painting by Ruysdael'. In their first extant letter, dated 1 February 1785, they mention 'our previous letter addressed to you under cover of Thom. Scott & Sons', which suggests that they had already shipped at least one crate over to Harvey. In the same letter they acknowledge payment of '£36.15.00 in settlement of the painting by Hondekoeter',[33] and state that 'we deeply desire to begin, Sir, long term business dealings that will be mutually beneficial'. Harvey's purchase of a Hondecoeter was therefore one of the first from this source. In fact this seems to have been Harvey's third purchase from Pilaer and Beeckmans. In the next letter (25 February 1785) they refer to 'a large chest' marked 'TH [in monogram] No.3 . . . bound for Ostende in the care of Messrs. Bine Overman & Co', thence to be 'despatched for Yarmouth'. In this crate, for which 'all risks for the sea crossing' were to be borne by Harvey, was a copy of van Dyck's *Christ Carrying the Cross*. The Hondecoeter mentioned in the first letter presumably formed the contents of chest No.2, but there is no record of the paintings in the first delivery.

The usual procedure in dealings between Harvey and his Antwerp agents was for the latter to send him lists of their 'latest acquisitions' – from Paris, Brussels, Liege and sales elsewhere, of about a dozen pictures a time. Harvey would then select a few in which he was interested, usually for reasons of artist, subject-matter and cost. Pilaer and Beeckmans would send sketches[34] of these works back to Harvey as a final means of helping him to decide whether or not to purchase. By August 1785 these sketches, and any paintings actually bought would be sent in chests or crates,[35] marked with Harvey's monogram, via Henry Lathom and Robert Twiss of Rotterdam. Harvey seems to have had a form of credit with the dealers, from which they deducted the price of purchases, although Harvey's account was not necessarily always sufficient. On one occasion he was informed that the '23,000 silver pieces' named as the price of a version of Rubens' *Rape of the Sabines* exceeded 'the 2000 guineas in your account' (15 May 1785). Consequently Harvey tried to reduce the prices from those originally offered: 'You beat us down a great deal on the picture by Devos [*Foxhunt and Dogs* – in a landscape by Wildens], which we are passing on to you however for the present, but from now on, Sir, we beg you not to knock us down anymore, since the prices are always estimated most fairly before offering them to you and that includes the packing' (30 May 1786). Harvey's business tactics were often successful, and he frequently complained elsewhere if he doubted the authenticity of a picture.[36] However, he was not always successful in his attempts to make purchases.

Harvey's correspondence shows a decline in the number of big sales from which the Antwerp dealers made up their lists, a decline from four in 1785 to just one each in 1788 and 1789. At the end of a list sent on 14 June 1785, was the comment: 'If

amongst these pictures there are none that suit you, we would be infinitely obliged if you would send the sketches back, and since it's the season when paintings are selling more quickly, we would ask you to let us know your decision as soon as possible.' In March 1786, Harvey was urged to visit Antwerp, 'since we have at least 30 good pictures which would suit your taste'. Again, in July 1786, Harvey was requested, 'to make your decision as quickly as possible since at this time of year there are rarely any weeks when we do not sell pictures'. By February 1787, Harvey was being told, 'We hope, Sir, you will not have misunderstood the Salvator Rosa and the Ruysdael being sold when you had asked us for the sketch. It is a situation from which a dealer cannot absent himself'. However, by October of the same year, in discussing the sale of a Weenix game picture, the Antwerp dealers wrote that 'these paintings have gone down in price drastically, due solely to a whim since they have plenty to merit them'. Between June 1788 and July 1789, they sent no letters, 'as there has been no need'. By July 1790, the supply had almost dried up: 'paintings are not selling here and if they do, it's a very good buyers' market'. Clearly people were not putting their pictures on the market during this period of turmoil, knowing that they could only fetch low prices.

Other insights into this cross-channel relationship emerge from the correspondence. A picture by Annibale Carracci could not be sent in May 1786, 'because the fees and entry permit into England are excessive'. Elsewhere, Harvey is flattered and prices are lowered 'since you are a connoisseur'. On another occasion Harvey is offered first refusal on a group of recent purchases: 'we are pleased to give you news of this wonderful acquisition first . . . we will only wait a fortnight before releasing the news in Paris' (11 October 1787).

Harvey's dealings with Antwerp were not simply those of a collector selecting purely for himself. In a letter of February 1787, Harvey's role as a dealer becomes apparent. The Antwerp firm had 'a couple of landscapes by the modern painter Mr van Regemorter and a couple of flowers on glass by Liesel. We shall be infinitely obliged to you if you would sell them on our behalf.' In return, Pilaer and Beeckmans accepted a number of pictures from Harvey to be sold on *his* behalf. Unfortunately, some of these were of rather poor quality, including a large Weenix, 'which ought to be touched up . . . because it could not be sold like that here' and a painting by Le Duc 'beyond redemption and . . . not worth a sou'. The firm did, however, have the grace to congratulate Harvey on a picture he had painted himself: 'very well painted. We have the honour to congratulate you on it.' Harvey was offered just forty pounds for the Weenix, given a Regemorter in exchange for his own picture, and with the Le Duc: 'there is only one course of action to take, and that's to sell it publicly to amateurs, perhaps not even for 6 florins, because it's a total write off'.[37]

The correspondence between Pilaer and Beeckmans and Thomas Harvey also reveals something of Harvey's taste for certain artists and subject-matter. The Antwerp dealers of course dealt largely with Dutch, and especially Flemish masters – mainly because 'Italian pictures are so excessively rare in this country', but also since, 'no-one here flatters themselves as knowing anything about Italian pictures'.[38] In total Harvey was offered some one hundred and fifty pictures during this six year period, attributed to some fifty-seven different Dutch and Flemish artists, although nearly half the works were by just eight painters, namely Rubens (including several oil sketches), Teniers, J. van Ruisdael, Philips Wouwermans, Rembrandt, van Dyck, Jordaens and Cuyp. Besides these artists Harvey also showed strong interest in Paul de Vos, Wijnants, Weenix, van Herp, ter Borch, Boeckhorst, Snyders, Hondecoeter and Brouwer, either requesting sketches, or buying works. He specifically enquired about 'the subject of pictures . . . [by] Jacob Ruysdael, Minderhout Hobbema and Mr Hondekoeter', and also seems to have been concerned to secure works by Snyders.[39] On the other hand, his dealers did not send him details of pictures by artists 'such as G. Schalken, Poelenbourgh and other masters which we didn't think would suit you'.[40]

In fact twelve purchases of Dutch or Flemish pictures are recorded in the correspondence, at a total cost of about six hundred and fifty pounds. Besides three works by, or after, van Dyck, there were three mythological pictures by Jordaens, animal pieces by de Vos and Hondecoeter, the *Blessing of Isaac and Jacob*, by van Herp, a Brouwer interior scene, an *Adultress* attributed to Rembrandt but disputed by Harvey, and – Harvey's most expensive purchase – a Teniers landscape, from the

figure 25:
Robert Dighton (1752–1814)
Charles (1756–1843) and John Harvey (1755–1842) 1779
watercolour, pencil and ink 41.1 × 34.1 cm
Norfolk Museums Service (Norwich Castle Museum)

Comte de Proli sale (July 1785) costing some £155. Unfortunately none of these works have yet been traced. It is possible that they were quickly resold in England by Harvey given that he once rejected a Hondius for, as the Antwerp dealers put it, 'lack of demand in your country'.[41]

Nevertheless we do know that the Harvey collection was regarded locally as a highly significant one. Harvey's ownership of a picture was stressed as a guarantee of quality, if it reappeared in a later nineteenth-century Norfolk sale. His close friend and fellow collector Dawson Turner commented: 'no one who knew this valuable friend of mine will hesitate to acquiesce in the remark, that to have belonged to him was always considered a presumptive evidence in favour of the merit of any work of art'.[42]

Mention should also be made of two cousins of Thomas Harvey, who also built up important collections. Charles (1756–1843) and John (1755–1842) Harvey (fig. 25) were brothers – great-grandsons of John Harvey (1666–1742) by his first marriage, and cousins of Thomas, who was his grandson by his second wife. The younger brother

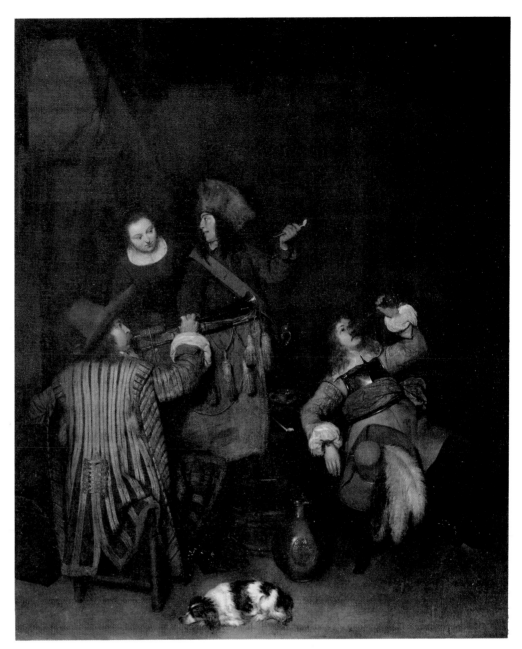

figure 26:
Gerard Ter Borch (1617–1681)
The Trumpeter 1658
oil on canvas 98.2 × 83.2 cm
Philadelphia Museum of Art (John G. Johnson Collection)

Charles was Recorder of Norwich from 1801 till his death, and became MP for the city in 1812 (and later for Carlow, Ireland). Charles spent his years as an MP living at 21, Norfolk Street, Strand and in 1822 inherited the estate of his maternal uncle, the Rev. Charles Onley at Stisted Hall, Essex. He then took the name Savill-Onley and lived the rest of his life at Stisted. Nevertheless, he spent the majority of his life in Norfolk, and it was there that this 'great amateur of paintings' must have begun his 'good collection'.[43] His collection can be at least partially reconstructed from his son's picture sale.[44] The collection included some important Norwich School paintings, and also over twenty Dutch works. These were generally minor works, predominently landscapes, but included *An Interior, with an alchemist* by Willem van Mieris,[45] and the fine *Trumpeter* (then called *Drinking the King's Health*), by ter Borch (fig. 26),[46] and a *landscape* attributed to Rembrandt, exhibited by Charles at the British Institution in 1835.[47]

John Harvey, 'a Hamburgh merchant' in 'early life' (*c.* 1783–1787), bought the estate of Thorpe Lodge near Norwich in December 1787, 'and settled down soon after this

date as a merchant in Norwich, when he entered into partnership with his father and [eldest] brother Robert'.[48] He became Mayor of Norwich in 1792 and High Sheriff for Norfolk in 1825. He was regarded as the 'Weaver's Friend', but 'few men, throughout a long life, have been more universally respected and esteemed by all parties and all classes'. He was a most energetic man, actively supporting 'all the [local] institutions . . . that had benevolence for their object, or that promoted literary or scientific improvement'. Furthermore, besides riding and sailing (he began the Thorpe 'water frolics' held in the 1820s and 1830s), he was a keen traveller to the last: 'when between sixty and seventy years of age, he made several tours through Italy, Switzerland and Germany'; and, 'in 1825, at the age of seventy, he made an ascent [in a balloon] with the wife of Mr Graham, an aeronaut, alighting safely at Brundall'. It is difficult to know whether the picture collection of this 'ardent connoisseur of the fine art' reached such heights, insofar as it can be reconstructed from the *Norfolk Tour*[49] and the sale catalogue at his death.[50] About half his collection of sixty or so pictures were by Flemish or Dutch artists. These included four works by Jan 'Velvet' Brueghel, Landscapes by Salomon and Jacob Ruisdael, van Bloemen [Orizonté] and Cornelis Saftleven. There was also a Jan Steen Tavern interior, battle scenes by Wouwermans and Wyck, three works by (?Willem) van Mieris, a picture of *Boar Hunting* given to Rubens, and *Christ in the garden* attributed to van Dyck and Snyders. None of these paintings can now be traced.

figure 27:
Unknown
Dawson Turner (1775–1858)
lithograph 25.5 × 20.5 cm
Norfolk Museums Service
(Norwich Castle Museum)

While the majority of the picture collectors at the turn of the nineteenth century were merchants and businessmen, the most business-like of them all was Dawson Turner (1775–1858). A botanist, bibliophile and banker, Dawson Turner (fig. 27) made collecting as much a business as the dealers who served him. In 1838 J.W. Burgon, later Dean of Chichester, wrote in his diary that for Turner, of all his qualities, 'The business habit *usque recurrit*; he tells you how much this is and that cost; what he has been offered, and what he has refused; what he would give and what he would not give for other men's, and take some of his own treasures . . .'.[51] Turner combined a professional approach to finance, with a meticulous and systematic attention to the details relating to his collections. Benjamin Robert Haydon describes Turner's existence as 'one incessant scene of fact collecting. At a Collection of Pictures, he never stopped to consider the beauties of anything, but noted down who it was by, what I thought of it, and then turning instantly to another, would ask, what d'ye think of this? Then he would have the whole collection

by heart and could tell every Master & Picture & Portrait in the House if you asked him next day. He was an immense, living Index.'[52]

Turner's personal catalogue of his collection, totalling fifty-one paintings and entitled *Outlines in Lithography*, was published in 1840. Each painting was illustrated in lithographic outline by one of his daughters. The collection was almost entirely of old masters, excluding seven oils by John Crome, two family groups by Thomas Phillips, two small oils by David Wilkie and a sketch by Prud'hon. The Netherlandish artists represented were Brouwer, Jan 'Velvet' Brueghel, Gaspar de Crayer, Aelbert Cuyp, Gerard Dou, Joannes Fyt, Cornelis de Heem, Meindert Hobbema (cat. no. 59), Melchior d'Hondecoeter, Jan van Boeckhorst, Isaac Moucheron, Adam Pynacker, Rubens, Jan Steen, David Teniers, van Dyck, and Adriaen van der Werff. These attributions, though sometimes optimistic, were never casually applied by Turner. He assiduously tested each attribution against not only the opinions of others but also his own experience of gallery visits and study. He acquired a large collection of exhibition and gallery catalogues, from both Britain and abroad, to which he constantly refers in the pages of *Outlines in Lithography*. When cataloguing his painting by Cuyp, *A Man giving Provender to a Horse*, he discovered in Smith's *Catalogue Raisonné* that D.W. Acraman of Bristol owned an almost identical painting. Acraman 'very kindly procured the assistance of his accomplished lady to color one of these outlines; so that I know there is no difference between them in regard to tints'.

figure 28:
Isaac de Moucheron (1667–1744)
Rocky Landscape
oil on canvas 53.5 × 45.5 cm
Private Collection: photograph, Courtauld Institute of Art

figure 29:
Peter Paul Rubens (1577–1640)
Peace Embracing Plenty 1633–4
oil on panel 62.9 × 47 cm
Yale Center for British Art
Paul Mellon Collection

Dawson Turner took pains to improve his eye. In 1815 he embarked upon a tour of France. His account of his visit to the Netherlandish paintings hanging in the Louvre reveals some of his prejudices: 'To the French masters succeed those of Germany, Holland & Flanders, in passing thro' which it is impossible not to feel astonished at the numbers who to day, as well as on Saturday, Sunday & yesterday, were collected round the earliest specimens of art, the works of Van Eyck & his immediate followers, distinguished by bad drawing, violent coloring, & absurd figures: wherein, unless it be in their oddity, their attraction can lie I own I have no idea. In this apartment it is extraordinary to observe how the coloring of Cuyp outshines that of the rest & even dazzles by its brilliancy. The great Paul Potter from the Hague is a wonderful picture, composed of a man & cattle all as large as life, but, as was justly observed by one of our party, so extremely natural as to be fit only for a stable.'[53]

Dawson Turner and his companions found the number of small cabinet pictures 'so great as at first sight to confound' and perhaps inevitably found themselves drawn to the larger, more celebrated works: 'A single painting of Ruysdael's however, a landscape known by the name of the *coup de soleil*, too strongly claimed attention to be passed unnoticed; &, while looking at this, we were naturally led to enquire for the works of another great Dutch artist in the same line, Hobbima, which in England fetch a price superior perhaps to those of any other; & we were surprized that this immense collection has not a single one of his performances.' Turner was to return to this observation when writing up the catalogue entry to his own *Landscape* by Hobbema: 'Strange, that not a single specimen of the works of so eminent a master should be found in the Museums of Amsterdam or the Hague or the Louvre'. Hobbema evidently held a special place in Turner's mind, and he was later to express the view that Hobbema was also of especial importance to John Crome (see cat. no. 59).

Approximately half of Turner's collection was purchased in Norfolk. He had obtained paintings by Dughet and Wilson from Harvey, as well as his Cuyp, Hobbema, three small Teniers and Jan Steen's *Christening Feast* (fig. 24). His Hondecoeter and de Heem he obtained from the Rev. John Homfray, together with his *Crucifixion* by van Dyck and a portrait of Katherine Parr attributed to Holbein.[54] The Norfolk art trade was a hive of industry and exchange. Turner's one painting from the Orleans collection was van der Werff's *Fish-Woman* which he had from his friend the Rev. Thomas Ellison, Rector of Hadiscoe (who had originally purchased it from the London dealer Thomas Moore Slade, who personally brought it to Norfolk). John Crome managed to sell Turner at least two old masters, including a *Rocky Landscape* by Isaac de Moucheron (fig. 28), while Robert Ladbrooke sold him a similar subject by Adam Pynacker. The London dealer Philip Panne sold him *Peace Embracing Plenty* by Rubens, the *modello* for one of the scenes from *The Benefits of the Government of James I* commissioned by Charles I to decorate the ceiling of the Banqueting House in Whitehall (fig. 29).

The Rev. John Homfray (1768–1842), from whom Dawson Turner acquired some of his pictures, was himself a notable Yarmouth Collector. He sold one art collection by auction in 1827, only to begin another almost immediately.[55] In 1829 Chambers recorded works attributed to artists including Netscher, van Goyen, Wijnants, van Craesbeeck, Matthew Withoos and Adriaen van de Velde.[56] It seems that a good number of his works sold by auction were acquired by other local collectors such as Robert Cory (1776–1840) who was Mayor of Yarmouth in 1815, William Delf and the Norwich attorney Charles John West. Homfray married Hetty, only daughter of the Rev. James Symonds of Ormesby who also owned a choice collection of old masters.[57] These included notable works attributed to Molinaer, Jordaens, Abraham Storck, Droochsloot, and works that echo those belonging to his son-in-law, such as *A Dock, Reptiles, Butterflies etc* attributed to 'N. Morrell'. Both Homfray and Symonds also patronised the local Yarmouth sea painters William and John Cantiloe Joy. Another Yarmouth collector of note was William Yetts (1796–1863), who established an Iron Foundry and was the inventor of the patent apparatus for securing ships' windlasses. In common with his fellow Norfolk collectors, he acquired the work of local artists as well as of old masters. His picture collection included works attributed to Wildens, Wertemberg, Poelenburgh and Jan Steen. His most notable painting by a local artist was John Crome's *View of Mousehold Heath*, which Yetts purchased in the 1830s and eventually sold to the National Gallery in 1862.[58]

figure 30:
Peter Paul Rubens (1577–1640)
The Judgement of Paris
oil on panel 133.9 × 174.5 cm
The National Gallery, London

Probably the single most important British provincial collection of paintings formed in the early years of the nineteenth century was that of Thomas Penrice of Yarmouth (1757–1816). Originally an apothecary at Great Yarmouth, Penrice came into a large fortune through befriending Lord Chedworth, who died in 1804. Chedworth had achieved some notoriety as a result of being 'grossly insulted at the grand stand at Epsom Races' and Penrice was evidently on hand to assist him in the subsequent affray. Penrice became a good friend of Lord Chedworth and a co-executor of his will.[59] According to Walter Rye, Penrice benefited to the extent of some £300,000. With this sudden fortune, Penrice employed the architect James Hakewill to build him a fine town residence on St George's Plain in Yarmouth.[60]

Penrice systematically acquired an important collection of old master paintings, a number of which came from some of the most celebrated continental collections including the Giustiniani Gallery and the Lancelotti Palace, Rome. Just how he acquired some of his pictures is detailed in a series of letters to Penrice from chosen advisers and dealers during the years 1808–14. This correspondence was later published by his son, John Penrice, who felt that 'they prove the opinion entertained of his taste, his judgement, and his liberality, as evinced by the quality of the objects alone submitted to him'. John Penrice made no mention of the fortune that enabled his father to act with such liberality.[61]

On 5 July 1808 Thomas Lawrence, the Royal Academician, wrote to Penrice concerning two paintings, by Rubens and Titian, then belonging to the art dealer William Buchanan. He considered Rubens' *Raising The Brazen Serpent* especially fine, but in the event Penrice did not purchase the picture.[62] The letter is of interest in that it details Lawrence's understanding of his role as adviser: 'I shall have the greatest

pleasure in giving you what judgement I am able to form, on any works which you may consult me upon. I shall give it fearlessly; because I depend on your silence, and because I am uninfluenced by any but the fairest motive. I know enough of my art to be *certain* that, to be able to SEE, it is necessary to be able to DO . . . If my voice be opposed to Mr Hoppner's, I shall not quarrel with you for taking *his*. If to Mr West's (though not a *popular* painter, a great *master* of his art), I shall quarrel with you for *not* taking his; but, these excepted, (and against all picture dealers, or artists connected with picture-dealers) you are to consider my opinion as the best, or I shall think you in the wrong'.

Lawrence was true to his word in guiding Penrice through the pitfalls of building up an art collection from scratch. On 13 August 1808 he advised Penrice: 'You will find out, before your Collection is formed, that it is the universal practice of picture-dealers to undervalue the property of others, for the purpose of future views of their own. This will come under its proper expose and lash, one day or other, in one of the works in hand; while real genuine pictures will always, when they have GOT THEIR PLACES, find their level of estimation of the public.' The first picture that Penrice bought was David Teniers' *Dice and skittle Players before an Inn*, known as *Par ou non Par*, formerly in the Duc d'Orleans collection (cat. no. 61). During the negotiations between Buchanan and Penrice it seems that doubts as to its authenticity had been raised. Buchanan sent Penrice a letter of authentication from Thomas Slade who had originally negotiated the purchase of the Flemish paintings in the Orleans collection. Slade had informed Buchanan, in 1808:

> I can assure you that the Orleans Teniers, *Par ou non Par*, as *engraved* in the Orleans Collection, was brought from France BY ME, along with the rest of the pictures purchased for Mr Morland, Lord Kinnaird, Mr Hammersley, and myself. That picture was always esteemed the best Teniers in the collection; and, I can assure you, required no repair at that time, nor ever was repaired *by me, who was the importer.*
>
> The person, therefore, who told your friend this, has told him a falsehood: probably he may have had A COPY of this picture, to which he alludes; but I believe it to be a trick.[63]

Penrice proved quite a discriminating purchaser. Buchanan would sometimes send him sketches of the works he thought Penrice might like, but the collector was glad to rely on Lawrence's judgement. In 1809 the dealer S. Erard, whose daughter married the eminent French dealer A. Delahante, brought Rembrandt's *Visitation*, Gerard Dou's *Nursery* and van der Werff's *Holy Family* to Yarmouth for Penrice's perusal.[64] Lawrence at first recommended the Rembrandt as one he would buy for himself, but finally counselled against it, asking not to be implicated by name when Penrice finally declined to purchase the painting in February 1811, not wishing to be seen as 'the sole objector to so celebrated a work'.

Lawrence also tried to encourage Penrice to purchase contemporary work: 'While you are meditating on the purchase of pictures of the Old Masters, what say you to setting an example to your rich friends, of patronage to living artists? I have just been at the gallery of Mr Turner, (indisputably the first landscape-painter in Europe) and have seen there a most beautiful picture, which in my opinion would be very cheaply purchased at two hundred guineas . . . The subject is a *Scene near Windsor*, with young Etonians introduced . . . If the expression can apply to landscape; it is full of sentiment, and certainly of genius. If you dare hazard the experiment, you must do it quickly, and authorize me to secure it for you . . . The size of the picture is (by guess) about three feet in length and a little less in height. It is in his own peculiar manner, but *that* at its best: no Flemish finishing, but having in it fine principles of art, the essentials of beauty, and (as far as the subject admits it) even of grandeur.'[65] This is one of the earliest references to that concept of Dutch or Flemish 'Finishing' which was to dominate the taste of collectors during the 1810s–20s. Penrice did not purchase the Turner nor, indeed, any of the contemporary works of Crome. Thomas Penrice appears to have been unmoved by the work of the Norwich School artists, despite the fact that a number of his Yarmouth neighbours had purchased their works. Penrice's only contemporary pictures were his own portrait and that of his wife by Thomas Lawrence.[66]

In November 1809 Buchanan tried to tempt Penrice with pictures from Spanish royal collections, most of them having been 'destined for Buonaparte's own private cabinet'. The pictures included a Murillo and a *Hawking Party* by Wouwermans and Buchanan suggested that Penrice might seek Henry Walton's opinion. However, it was Lawrence who again advised Penrice, commenting that he was 'more and more convinced that Spanish art will disappoint us'.[67] In the summer of 1811 Penrice purchased a second major Teniers, this time from the French dealer Bonnemaison (cat. no. 60). Bonnemaison also undertook to look out for works by Rubens and van de Velde for him.[68] It was, however, from a different source that Penrice made his most magnificent purchase, the celebrated *Judgement of Paris* by Rubens, formerly in the collection of the Duc d'Orleans (fig. 30). Penrice was approached by the dealer Thomas Alldridge on 27 February 1813, who suggested that either Penrice or Andrew Fountaine might be interested in the painting, 'it being a picture worthy of either of your hospitable mansions: a chef-d'oeuvre of the greatest of masters; and being furniture fit for a palace, it will no doubt hereafter, in the event of peace with France or Europe, produce a mint of money, if ever you should be disposed to part with it'. Alldridge did not in fact own the painting, but was proposing to approach the owner at that time, Lord Kinnaird. In the event, it was Delahante who negotiated the sale to Penrice. Lawrence's advice to Penrice was quite simply: 'mortgage your *estate* (I mean *one* of the fifty that you have) for the Rubens. It has recently gained considerably in reputation, by its being exhibited and examined by the artists.'[69] The painting remained in the Penrice family collection until its purchase for the National Gallery in 1844.

When the Penrice collection was sold at Christie's, London on 6 July 1844 there were just seventeen old masters, of which seven were by Netherlandish painters, all of the highest quality. Besides the works of Teniers and Rubens, Penrice had purchased two oils by van Os, a *Hawking Party* by Wouwermans, again from the Orleans collection,[70] and an *Interior* by Adriaen van Ostade, formerly in the Le Brun Gallery.[71] The collection was a tribute to a quite stunning opportunity which had been grasped by collector, dealer and adviser alike.[72] Thomas Penrice died at Narford Hall in 1816 when on a visit to his daughter Harriet and son-in-law, Andrew Fountaine.

One other Yarmouth collector from the first quarter of the nineteenth century is worthy of brief notice here, the Reverend William Trivett (1776–1863) rector of the Church of St Nicholas. Trivett had the adjacent parsonage built, which was described by Druery in 1826 as 'a moderately-sized genteel-looking Parsonage-House'.[73] Druery also outlined Trivett's 'small but choice collection of pictures and prints, and a library of about 2000 volumes, classical and theological, chiefly collected many years ago'. The picture collection included works by or attributed to Jan Fyt, Johannes Lingelbach, Jan Steen, David Ryckaerts, van Goyen, Schalcken and Wouwermans. Trivett's residence was also notable for his collection of framed reproductive prints in the dining room, which included an etching after Rembrandt's *Descent from the Cross*, by the local Yarmouth artist Edmund Girling.

One important Norwich collector of the early nineteenth century was Joseph Salusbury Muskett (1784–1860). Intwood Hall, near Ketteringham just outside Norwich was built of red brick in 1807 by Arthur Browne on behalf of the Musketts. The building stands on the site of the former Elizabethan Hall built by Sir Thomas Gresham. Muskett's collection of paintings seems to have been speedily acquired to furnish the Hall. A man of inherited wealth, he is the one early-nineteenth-century collector who, although a member of the professional classes, did not pursue a profession himself. His father, Joseph Muskett of Easton, was a land agent and it was he who bought Intwood. Joseph Salusbury Muskett inherited Intwood from his father in 1808 and thereafter acquired the status of a man of taste. His portrait depicts him in the dual role of landowner and philanthropist, holding a copy of the first annual report of the Poor Law Commission, 1836 (fig. 31).

The catalogue of Muskett's collection (see cat. no. 62) lists a total of sixty-two oils, covering an impressively wide range of artists. He patronised local Norwich artists including John Crome, James Stark, George Vincent and Henry Bright. Contemporary British artists from further afield included John Constable, William Shayer and George Romney as well as artists with Norwich connections such as Sir William Beechey and John Opie. His collection featured works attributed to Netherlandish

figure 31:
British School
Joseph Salusbury Muskett (1784–1860)
oil on canvas 91.3 × 71 cm
Private Collection

figure 32:
E. U. Eddis (1812–1901)
Meadows Taylor (1755–1838)
oil on canvas 91 × 70.5 cm
Commander P. H. B. Taylor

artists such as Abraham Begeijn, Lingelbach, Pieter Neefs, Meindert Hobbema, Isack van Ostade (cat. no. 62), Jan Davidsz. de Heem, Jacob van Ruisdael and Aert van der Neer and included an enormous *Bear Fight* by Snyders.[74] He purchased a number of oils from local collections, including works attributed to Wijnants, van Goyen and A. van de Velde from John Patteson in 1819, and a Fyt and a large Hondecoeter from Thomas Harvey of Catton.[75] The collection at Intwood was sufficiently highly regarded for Sir John Boileau to take the art historian and connoisseur Gustave Waagen there in 1854. Waagen commented: 'I saw one of Hondekoeter's largest and finest poulty-pieces, and a pleasing picture by Willem van de Velde', but made no further comment.

The history behind little-known collections can usually be unravelled, at least in part, through family documents and tradition. However, in many cases no documentation survives and that of the Meadows-Taylor family is a case in point. This collection may serve, however, to illustrate the point that many townhouse owners in the late eighteenth and early nineteenth centuries began to collect Dutch and Flemish works alongside those of the local Norfolk painters. It was rare for works to be of high quality and most were presumably purchased from local dealers, artist-dealers and artists alike. The Meadows-Taylor collection was begun in the eighteenth century by Philip Meadows, the son of Philip Meadows, Sheriff of Norwich in 1724 and Mayor in 1734. Philip Meadows the Younger was an attorney who moved from Norwich to practice at Diss, where he built a fine Manor House. The main collector in the family seems to have been his nephew, Meadows Taylor (fig. 32) who was the grandson of Dr John Taylor, the first Minister of the Octagon Chapel in Norwich. The collection partially survives and is of interest as a typical mix of family portraits and minor works by Dutch, Flemish and Norwich School artists (see cat. nos. 63–5).

figure 33:
William Beechey (1753–1839)
John Patteson (1755–1833) 1788
oil on canvas 239.3 × 147 cm
City of Norwich Civic Portrait Collection

IV John Patteson

This section focuses upon a single collection, that of the Norwich merchant and brewer, John Patteson (1755–1833). The intention in doing this is to highlight some of the factors which may affect the development of a single family collection and its dispersal, particularly in the case of a middle-class collector whose taste may be regarded as typical, or whose means may dictate the quality of his acquisitions. As a case study, John Patteson is representative of many of those businessmen who acquired picture collections in the period following the French Revolutionary Wars. In common with many of his class, he embarked upon the Grand Tour as much for its business potential as for its promise of a rapid classical education. Patteson's picture purchasing power was restrained by his limited means when abroad: he chose not to have his portrait painted in Italy purely because he 'would not be amongst the number of those who pay 30 Guineas at Rome for what they could have as well if not better done for 10 or 15 in London.'[1] His collection featured a significant number of Netherlandish works, many of which he had himself bought. He was also the fortunate inheritor, by marriage, of the core of another collection, that of the Suffolk antiquary, Cox Macro. A significant part of that collection was a group of works by Peter Tillemans (1684–1734) of Antwerp. The fact of Cox Macro's patronage of Tillemans, and Patteson's inheritance, through marriage, of those paintings adds lustre to the Patteson collection.

John Patteson's father, Henry Sparke Patteson, had married Martha Fromanteel, whose family were probably of Dutch extraction.[2] Henry Sparke Patteson died in 1764 when only thirty-nine years old and his widow and her two sons moved to live with his brother John who had built himself a substantial house in Surrey Street, Norwich, later to become the Norwich Union Fire Office. John Patteson the elder was a widower, without children, and when he was elected Mayor of Norwich in 1766 his sister-in-law Martha acted as Mayoress. He entered into a partnership in a wool-stapling business, and the firm Patteson and Iselin became a prosperous company with considerable dealing abroad.

John Patteson the Younger received his early education at a school in Greenwich which was then run by the Rev. Dr Burney. He was sent, in 1768, at the age of thirteen, to Leipzig where he stayed with a German family, in order to learn foreign languages – in which he seems to have made good progress. A good number of letters between him and his mother, Martha Patteson, survive to tell something of his early years, particularly when away from home.[3] John Patteson was taken to Leipzig by James Smith, a local merchant-manufacturer whose son was to become Sir James Edward Smith, the celebrated botanist and founder of the Linnaean Society. It was a common practice at this time for local merchant-manufacturers to send their sons abroad to learn languages for commercial purposes. Castres Donne (later the Rev. Castres Donne) was also at Leipzig in the winter of 1768–9. John Patteson returned to England in 1771, well-versed in both French and German. He later gained valuable experience in London and letters to his mother in April 1776 tell of his various visits to the play-house and the opera, and of the seven hour sojourn in Westminster Hall witnessing the trial of the notorious Duchess of Kingston for bigamy.

When his uncle died in 1774 John Patteson succeeded to the family business. It was, therefore, with an eye open for business as well as for the sites of the Grand Tour that John Patteson again left Norwich for the Continent in the spring of 1778.[4]

He set off on 2 April and was not to return home again until November the following year. His tour took him through Holland, Germany, Switzerland and Italy, including Sicily and Malta, and he again visited the Low Countries on his return home. The surviving correspondence with his mother Martha not only provides details of his tour, but also reveals the number of important early friendships he formed abroad, notably with the young architect, John Soane (1753–1837). An early letter home was from Rotterdam on 7 April 1778 when he commented: 'It has been my lot to fall in with honest civil people amongst the lower class who did not attempt to impose upon me in that gross manner I imagined they would . . .' He also acquired a 'very cleaver servent. I guess him to be between 30 & 40. A Scotchman, speaks Dutch, German & a little French, has been many years used to travelling with such Geniuses as we; he will not do for Italy but will go all round if we please or leave us whenever we happen of a person we like better, he has a wife and large family here who depend greatly for their support on the English . . .' Within a week Patteson was in Amsterdam and by 24 April had left Holland and reached Hamburg. He had travelled on to Leipzig by 27 June and reached Frankfurt by 19 August.

Patteson's time in Frankfurt is of interest in relation to his picture collecting, in the light of a statement on the title-page to the catalogue of his collection sale in 1819. This asserts that 'the greater number were purchased by the Proprietor at the commencement of the French Revolution, at Frankfurt and elsewhere on the Continent'. There is, however, no detailed information concerning his picture purchasing in his letters home to Martha Patteson. His stay in Frankfurt was relatively short: he was writing from Mannheim on 12 September, which suggests that he spent less than one month at Frankfurt. The fact that Frankfurt is singled out specifically as a source for some pictures must for the present remain a puzzle. It is perhaps a reference to one of Patteson's strongest trading links.

Patteson was certainly keenly interested in the galleries that he visited. When visiting the Elector's collections at Dresden he commented: 'I who have not the least Pretension to that kind of knowledge have stood with astonishment & admiration for half an hour together wondering at the power of art, so naturally to express the Passions; nothing but speech is wanting.'[5] When he reached Italy that autumn Patteson was quite clear in his own mind that business came first, but thereafter he was free to enjoy himself. At Milan he 'determined to stop only a few days & see what

cat. no. 68 Attributed to Jan Both *A Southern Landscape with Muleteers on a Roadway*

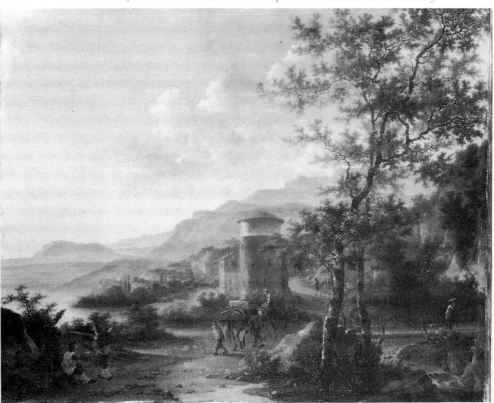

kind of creatures we were connected with & to whom I had letters. Once for all I must tell you that all Business is despised by the nobility in Italy, & that the People we send to are in the second & third class of those in Trade, so that nothing is to be expected from them in point of Amusement . . .'[6] He continued his tour with visits to Florence, Rome, Naples, Pompeii and Herculaneum, the latter in the company of John Soane and other friends with whom he also visited Sicily and Malta. His journey home took him through the Low Countries and France.

It does not appear that Patteson acquired much of his collection while travelling abroad. His mother advised him on 11 June 1779 that some friends and relatives would be pleased to have 'some Trifling Trinket' while 'H.P. [his brother Henry] wish'd to have a Antique'. She continued: 'I by no means advise you to lay out much money or to buy such Things as you will have Difficulty in getting over, & as to me, bring me nothing but yourself.' The following month she advised Patteson that 'nothing better than seals' would suffice for four acquaintances.[7] It seems that, like Thomas Harvey, once back in England Patteson purchased abroad through agents. On 6 April 1780 he wrote to John Soane who was still in Italy: 'Pray let Moore do me the picture & recommend its Execution al Sommo.'[8] Jacob More was a Scottish landscape painter who had considerable success in Rome as a classical landscapist. He painted a view of Mount Vesuvius for Patteson and subsequently a view of Lake Albano as its pair in 1787. Patteson also acquired three paintings by Jan Frans van Bloemen in a similar vein, representing a taste fashioned by the experience of the Grand Tour.

Before leaving for the continent John Patteson had become betrothed to his future wife Elizabeth Staniforth (1760–1838). They were married in the year 1781 and this is presumably the date of the earliest portrait of him as a young man by Philip Reinagle, who also painted Elizabeth's portrait as a pair (figs. 34, 35). Elizabeth was the daughter of Robert Staniforth, whose brother had married Mary, the daughter of the Rev. Cox Macro, DD. Elizabeth was the heiress not only of Cox Macro's estate at Little Haugh Hall, Norton, near Bury St Edmunds, Suffolk, but also of her great-uncle's

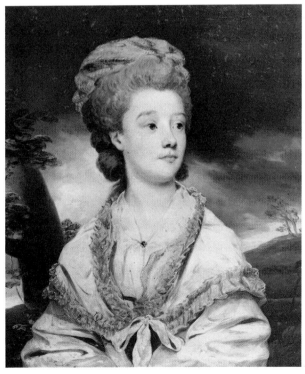

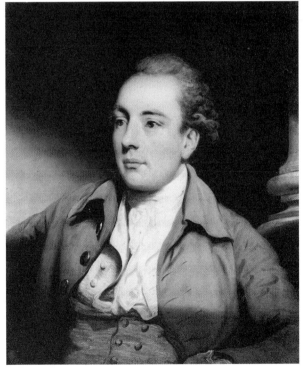

figure 34:
Philip Reinagle (1749–1833)
Elizabeth Patteson (1760–1838)
oil on canvas 76.1 × 63.3 cm
Private Collection, on loan to Norfolk Museums Service
(Norwich Castle Museum)

figure 35:
Philip Reinagle (1749–1833)
John Patteson (1755–1833)
oil on canvas 76.4 × 63.6 cm
Norfolk Museums Service (Norwich Castle Museum)

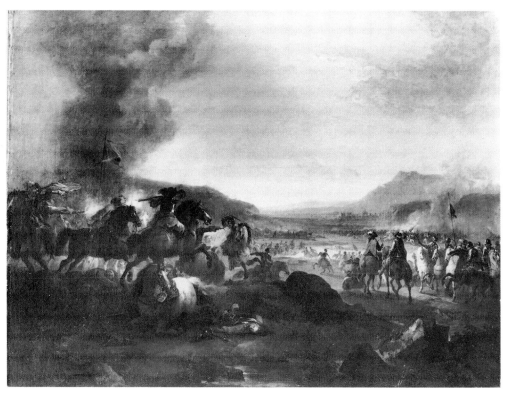

cat. no. 81 Peter Tillemans *Battle Scene*

important collection of paintings. The Macro collection gave John Patteson's own collection an early boost, in both quantity and quality.

Cox Macro (1683–1767) was an antiquary, the eldest son of Thomas Macro, a grocer, alderman and chief magistrate of Bury St Edmunds. Cox Macro's unusual Christian name was after his mother's maiden name, Susan Cox, the daughter of the Rev. John Cox, rector of Risby, near Bury. Cox Macro himself studied Divinity, at Cambridge and Leiden, becoming the senior Doctor in Divinity at Cambridge and also Chaplain to George II. His own manuscript catalogue of his picture collection survives, and lists ninety-five paintings at Little Haugh Hall, approximately half of which were Netherlandish works.[9] These included *A Bridge with Water* attributed to Ruisdael, which may be the painting now attributed to Cornelis Decker (cat. no. 73 and colour plate xxiii). One particularly fine painting in Cox Macro's collection and subsequently inherited by John Patteson was *The Stag Hunt* by Abraham Hondius (cat. no. 72 and colour plate xxiv). Another important painting, *Birds & Beasts assembling to go into Noah's Ark* attributed to Hondicoeter was inherited by Patteson, but sold in 1819 to Dr Philip Martineau.[10]

The most important aspect of Cox Macro's picture collection was his group of works by Peter Tillemans (1684–1734) of Antwerp. Little is known of Tillemans' early life. George Vertue records that he was born in Antwerp, the son of a diamond-cutter and that 'after 7 years Study under indifferent Masters, he took to the manner of Van Meyren, in small figures, landscapes, Sea ports, Views, wherein having some success'. Robert Raines has charted what little is known of Tillemans career and has identified 'Van Meyren' as probably Jan Baptiste van der Meiren (1664–c. 1708), master in the Antwerp guild in 1685, who painted battlescenes, landscapes, and staffage for other painters.[11] This provides some insight into Tillemans' attitude towards the current studio practices of copying and collaboration, both of which he continued after arriving in England in 1708. According to Vertue, Tillemans: 'having a mind to travel, one Turner, a picture dealer comeing to Antwerp engag'd him and his Brother Casteels to come to England', in June 1708.[12] Pieter Casteels was in fact Tillemans' brother-in-law, and became one of the twelve elected Directors of Godfrey Kneller's new Academy of Painting. Tillemans himself joined the Academy in 1711. By 1715 Tillemans had acquired 'his most faithful if not his most generous patron, Dr Cox Macro'. Macro can be seen standing behind the easel in Tillemans' painting of his own studio, dated c. 1715–16 (cat. no. 78 and front cover). By 1719 Macro was living at Little Haugh Hall and was planning a series of alterations and redecorations

to the Hall. Macro employed Tillemans in his decorative schemes, which included commissioning an overmantel prospect view of Little Haugh Hall itself (cat. no. 80 and colour plate xxv). He also purchased a number of paintings direct from Tillemans, both in the painter's own style and after the works of other artists (see cat. no. 78). Tillemans was the guest of Cox Macro at Little Haugh Hall when he died suddenly in November 1734. The overmantel of a *Horse and Groom* on which he was working was left unfinished and Macro recorded his death with an inscription on the canvas (see cat. no. 83 and colour plate xxvi).

Cox Macro's friendship with Tillemans was such that, within a few weeks of the artist's death, he had ordered his terracotta bust from Michael Rysbrack. Raines records that Macro had ordered the bust on 14 December 1734 and at the same time a self-portrait bust of the sculptor. He received the Tillemans after about three months and this is presumably the bust now at the Yale Center for British Art.[13] Macro subsequently nurtured the idea of a museum in honour of Tillemans. In 1757 Sir Edward Littleton of Teddesley Hall in Staffordshire, wrote to Macro offering him a drawing by Tillemans: 'Your imaginary Temple in honour of Tillemans I am much pleased with but can never think it will be complete without the Borromeo Island, as I know you have no Picture in that style. Considering you have his last Picture his best Picture & many others of his various styles, besides the Connection he had with yr Family you have surely a natural right to one at least of his Productions in every way yr Friends can supply you with.'[14] The offer was presumably accepted as the *Borromeo Islands* is one of the twenty drawings recorded in Macro's catalogue. The only drawing to remain in the Patteson family collection into the twentieth century was *The Newmarket Watering Course* (fig. 36), which was engraved by Joseph Simpson senior. This watercolour, together with the surviving group of oils which remained in the Patteson family collection, go some way to realize Cox Macro's original vision for an 'imaginary Temple in honour of Tillemans'.

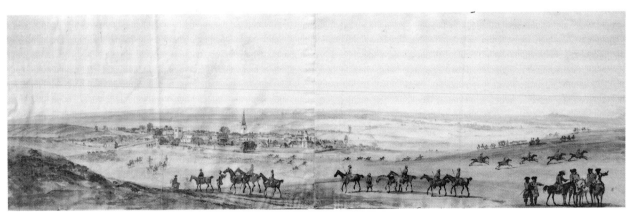

figure 36:
Peter Tillemans (1684–1734)
The Newmarket Watering Course
pencil, watercolour and ink 29.8 × 93.9 cm
Norfolk Museums Service (Norwich Castle Museum)

John Patteson's marriage with Elizabeth Staniforth proved to be only one of a number of steps towards increasing prosperity and status. He became an Alderman, and, in 1785, Sheriff of Norwich. Three years later Patteson was elected Mayor of Norwich. In 1793, John Patteson purchased Greaves' Brewery and later he extended this side of his business with the purchase of the breweries of Messrs Postle and Beevor. Later, in 1830 and 1837 the breweries of Messrs Morse and Finch were added to the family business, to become the Pockthorpe Brewery. John Patteson was equally successful in fostering Royal connections. In 1797 William Frederick, Duke of Gloucester, then in command of the Eastern District of the Norfolk Militia, took lunch at the Pockthorpe Brewery on one occasion, and a new vat was named in his honour. A more flattering token was paid in November 1801 when the Duke of Gloucester took the role of godfather to John Patteson's youngest son, duly named William Frederick. John Patteson himself became a Colonel in the newly re-organised Loyal Military Association in 1803. He was also active in the political sphere and from

1802–06 was M.P. for the pocket borough of Minehead, Somersetshire. In the 1806 election he stood as Tory candidate for Norwich and gained the seat with 1733 votes, beating Robert Fellowes (1370 votes) and William Smith (1333 votes). The following year he was re-elected for Norwich, but with a shift in the votes that signalled the beginning of the end for the Tories. The returns showed John Patteson with 1474 votes, William Smith with 1155 votes and Robert Fellowes with just 542 votes. Patteson's political fall duly came in 1812, when William Smith polled 1544 votes, Charles Harvey 1107 and Patteson 1050 votes. He had been toppled by a candidate who, in the context of this survey, is of interest for his own position as a patron of the arts, whose collection included the celebrated *Mill* by Rembrandt (see p. xix).

The year 1819 was a watershed for Patteson's fortunes. His popularity may be judged by the inscription on a silver candelabrum presented to him that year: 'Presented the 26th day of May, 1819, by several gentlemen, members of the Norwich Union Societies for Fire and Life Insurance, to John Patteson, Esq., Mayor of Norwich, AD 1788, M.P. for Norwich 1806 to 1807, and 1807 to 1812, as a grateful acknowledgement of the urbanity, firmness, and impartiality evinced by him on some recent occasions, upon which he stood forward as the advocate of these valuable institutions, and took a leading part in maintaining the correctness of the principle upon which they are founded; defending those concerned against unjust aspersions, and restoring the reputation of the societies to that rank in the estimation and confidence of the public which they so justly deserve.' This vote of confidence in Patteson evidently came too late. The expenses of a Parliamentary career, combined with the failure of a number of English and foreign ventures made by the firm of Patteson and Iselin and also the failure of a London bank with which he was associated, left Patteson virtually bankrupt. His first sacrifice was his picture collection, which was put up for sale on 28–29 May 1819 by Mr Christie, at Patteson's house in Surrey Street.

A copy of the sale catalogue, marked up by Patteson's son William Frederick, survives among the family papers. The catalogue clearly distinguishes the paintings inherited from Cox Macro's collection, a total of forty-two works. This represents a relatively small proportion of the total collection, which consisted of two hundred and eight lots during the two day sale. Some ninety lots were attributed to Netherlandish artists. Only two works by Tillemans were included in the sale, perhaps indicating that Patteson could not bring himself to part with them. Nevertheless, not all the works put up for sale during these two days were lost to the Patteson family. A good number appear to have either been bought in, or purchased by other members of the family or friends, and subsequently remained in the family's possession.

An analysis of William Frederick Patteson's copy of the catalogue gives a good impression of the extent of John Patteson's own collecting. Although Cox Macro's collection was an important part of the whole, Patteson emerges as a significant collector in his own right, and not simply as the beneficiary of an accident of genealogy. The collection included works by or attributed to the following Netherlandish artists: Ludolf Bakhuizen, Nicolaes Berchem, Adriaen Brouwer, Aelbert Cuyp, Cornelis Decker, Aert de Gelder, Jan van Goyen, Egbert van Heemskerck, Johannes Lingelbach, Gabriel Metsu, Adriaen van Ostade, Paulus Potter, Jan Steen, David Teniers, Willem van de Velde and Philips Wouwermans. This list is not exhaustive, but indicates the roll of honour which could be enlisted by a middle-class collector at the turn of the eighteenth century. The relatively high proportion of Netherlandish works in the collection as a whole does lend credibility to the statement on the title-page of the catalogue that 'the greater number' had been purchased abroad. The following year Patteson sold his collection of manuscripts formed by Cox Macro, at Christies, Pall Mall. Forty-one lots were purchased by the indefatigible Dawson Turner and the rest by Hudson Gurney, for seven hundred pounds. In addition, Patteson was forced to sell his various properties at Colney and Bawburgh, while his son John Staniforth renounced his claim to the Norton estate. The Surrey Street house was taken over by the Norwich Union Fire Office, which retains it to this day.

John Patteson effectively retired from public life after 1820, spending his last years first at Mangreen Hall, near Norwich and then as a tenant in the house adjacent to that of his youngest son, William Frederick Patteson, Vicar of St Helen's, Norwich

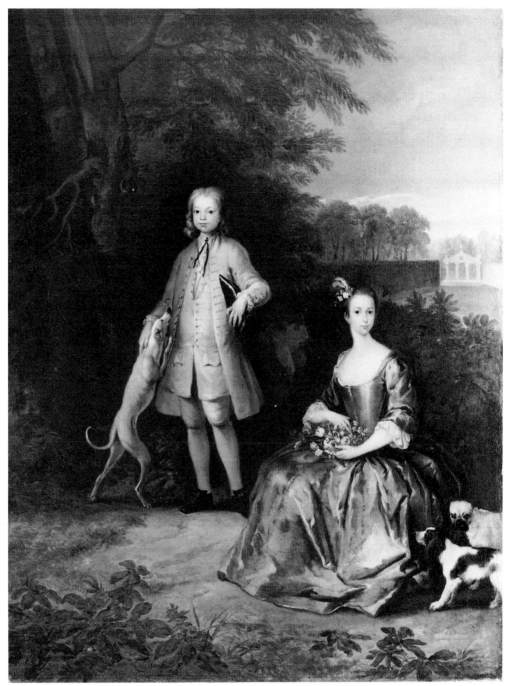

cat. no. 82 Peter Tillemans *Master Edward and Miss Mary Macro c.* 1733

and Chaplain of the Great Hospital. He died in October 1833, just five years before his wife Elizabeth. Despite his change of fortune and the sale of his possessions, a good part of the family picture collection survived intact into the twentieth century.

The Patteson collection is important as an example of a middle-class collection almost certainly known to the early Norwich School artists. There is, however, little documentary evidence to suggest just how well-known or visited the collection was by local artists. In 1819, in addition to his Netherlandish paintings, Patteson owned two landscapes by Robert Ladbrooke (1769–1842),[15] a landscape by George Frost (*c.* 1744–1821)[16] of Woodbridge and three landscapes by Philip Reinagle (1749–1833),[17] in addition to Reinagle's portraits of himself and his wife Elizabeth. The family support of the local art scene becomes more appreciable in 1828 when Patteson's son, John Staniforth Patteson (1782–1832) lent his two classical landscapes by Jan Frans van Bloemen to the first Old Masters Exhibition organised by the Norwich artists.[18] J.S. Patteson also lent the splendid *Stag Hunt* (cat. no. 72 and colour plate xxiv) which his father had originally inherited from the Macro collection.

figure 37:
Hannah Gurney (1786–1850)
John Crome (1768–1821)
pencil, grey wash and white bodycolour 39.9 × 32 cm
Norfolk Museums Service (Norwich Castle Museum)

V Norwich and London

This section sets out to explore the relationship between Norwich and London because the Metropolis provided a source of influence for patrons, collectors and artists alike. For the Norwich artists of the early nineteenth century in particular, London provided a rich source of artistic ideas. The Norwich artists were the first provincial group to follow the example of the Royal Academy by forming their own Society of Artists, in 1803, and founding their own series of annual exhibitions of contemporary art from among members, in 1805. From the evidence of the many pictures in all mediums by the Norwich Society artists which survive today, it is possible at a glance to perceive some similarities between their works and those of the Dutch artists of the seventeenth century in particular. The virtual impossibility of establishing direct influence is one of the themes of this chapter, but when looking for possible influences upon the Norwich artists it is surely the case that they would have had as much access to Dutch paintings in London as in their native county.

The first four chapters of this book have attempted to identify the degree to which Netherlandish art was disseminated through the region. Geographical and historical links with the Low Countries established an early taste for Netherlandish art in the area. The fashion for the painters of the Netherlands led to some early influences upon the region's own artists, to the extent that today we do not know for certain whether some local painting was the work of visiting or local artists (for example, cat. nos. 19, 20). As the taste for collecting developed in England during the eighteenth century, so the sheer numbers of works of the Netherlandish schools grew. By the close of the eighteenth century the local artist might have had access to a wealth of paintings from which to educate himself into his own style. The Royal Academy acted as the national basis upon which standards were set and yet the Norwich artists did not overwhelmingly embrace the Classical, Italianate fashions which had been promulgated by the Royal Academy's first President, Sir Joshua Reynolds. The Norwich Society of Artists was among the first to look elsewhere for its models and found much of appropriate resonance in the Dutch painting that was both locally available and on view in London at this time.

There is little documentary evidence to determine whether the local artists necessarily had access to the great collections of Norfolk or even the increasing number of middle class collections housed in Norwich and the local towns, but they almost certainly did. One of the most significant influences upon John Crome during the last decade of the eighteenth century was Thomas Harvey of Catton. His acquaintance with Harvey almost certainly encouraged Crome himself to take up collecting. When he held a three day sale of his collection at Yarmouth, he advertised 'a collection as is well worth the attention of connoisseurs, amateurs, artists, and the public of every description, and such as, it is presumed, was never before exposed to sale in the County of Norfolk'.[1] Crome also took up dealing: Dawson Turner records having purchased his Rocky Landscape by Isaac Moucheron from Crome for twelve pounds (fig. 28). Crome developed another profitable enterprise as a picture restorer, and was the first among his contemporaries to do so. In short, Crome took every opportunity to develop his career locally, whether as an artist, dealer, collector or restorer and there is every reason to suppose that he would have been familiar with local collections. Similarly, John Crome, John Sell Cotman and many of their Norwich contemporaries advertised as drawing masters and were prepared to travel

throughout the county to teach individual pupils in their homes many of which contained significant collections. Cotman was forever travelling the county with sketchbook in hand. In February 1808 he wrote to Francis Cholmeley and informed him of a visit to Holkham: 'I have been on a visit to North Creak, consequently saw Mr. Cook's house at Holkham, which is really a fine one, so is the hall of Derbyshire marble, but it wants a dome, and the house *fine* pictures to make it really worth the attention of an artist.'[2] This last remark may well mean that Cotman had not seen very much of the interior at Holkham: it is difficult to believe that he would have been quite so dismissive of, for example, the Claude landscapes, had he seen them.

The question arises as to the degree to which the Norwich artists were only influenced by the local collections that they knew. Although they were a regional group insofar as their base was in Norwich, individual artists within the group had strong metropolitan connections. John Crome's leading pupils, James Stark and George Vincent, both lived in London for considerable periods. John Sell Cotman lived in London for the period of his early and rapid development as an original watercolourist before returning to Norwich in 1806. Crome, Cotman and a number of their contemporaries exhibited their work in London and visited London exhibitions. It may also be assumed that they would have visited the London auction houses, particularly the rooms of Mr James Christie in Pall Mall. For most of these artists London was as important a source of artistic ideas and influence as was their native county.

C.M. Westmacott, in his *British Galleries of Painting and Sculpture . . .*, published in 1824, surveys the picture galleries then established in London. These included the Royal collections at Carlton House, Buckingham House, St. James's Palace and Kensington Palace, and also the Angerstein collection which, by a Treasury minute of 23 March 1824, became the basis of the National Gallery.[3] The Royal Academy at Somerset House boasted its collection of works presented by Academicians on their election. The most important collections to include Netherlandish works besides that of the King were those of the Marquis of Stafford in the Galleries at Cleveland House and Mr Thomas Hope's collection in Duchess Street. The Marquis of Stafford 'was the first great patron of the arts in the metropolis who opened his valuable paintings to the public view, and, like Pericles, gave a new epoch to the arts of his country; an example which has since been laudably followed by many others, who are equally emulous in improving the taste of society, and cultivating the fine arts. This event, which reflects so much honour on the noble Marquess, took place in May, 1806, since which time, the public have been, for four months in the year regularly admitted, by tickets, to view these superlative specimens of the great masters.'[4] Nevertheless, prospective visitors had to be quite single-minded if they wished to be admitted. The regulations stated that 'The visitors are admitted on the Wednesday in each week, during the months of May, June and July, between the hours of twelve and five o'clock. Applications for tickets are inserted in a book, kept by the porter, at the door of Cleveland-house, any day, (except Tuesday), when the tickets are issued for admission on the following day. The applicants should be known to some member of the family, or otherwise produce a recommendation from some distinguished person, either of noble family or of known taste in the arts . . . In wet weather, it is suggested, that all visitors will proceed thither in carriages.' There could be little clearer demonstration of the select nature of the so-called public nature of these collections. Practising artists, however, were almost welcomed with open arms by comparison: 'Artists desirous of tickets for the season will obtain them on the recommendation of any member of the Royal Academy.' Crome, Cotman, Stark and Vincent would all have been in a position to obtain tickets. Stark's patrons, for example, included the Marquis of Stafford, Sir John Grey Egerton and the Countess de Grey as well as the Academicians Thomas Phillips, Francis Chantrey and Sir George Beaumont.

Another important London collection open to the public in the early years of the nineteenth century was that at Dulwich College Picture Gallery.[5] The Gallery opened to Royal Academy students in 1815 and to the public in 1817. At that time almost all the paintings bequeathed in 1811 by Sir Francis Bourgeois were on show. The collection included representative works by the major schools of painting and featured important examples (of the Dutch and Flemish Schools) by Cuyp, Wouwermans, Both and Berchem, Rubens, van Dyck and Teniers, as well as a host of

Dutch cabinet pictures. The collection had in fact been available to visitors from the early 1800s when kept in the two adjacent houses at nos. 38 and 39 Charlotte Street, Portland Place (now Hallam Street). Two inventories of the contents, of *c.* 1802 and 1813, reveal a spacious interior which featured a 'Berchem Room' and a 'Cuyp Room'.[6] This was the home of Francis Bourgeois and Noel Desenfans and his wife. Their circle of friends included William Beechey, Joseph Farington, Benjamin West and John Soane. When Desenfans died in 1807, he bequeathed the pictures to Bourgeois who in turn determined that the collection should become as public as possible. The reputation of the collection may be measured by the assertion of Louis Simond, in his *Journal of a Tour and Residence in Great Britain, During the Years 1810 and 1811* (published in 1817), that it formed the largest in London. On Bourgeois' death in 1811 he bequeathed the paintings to Dulwich College. However, although the Dulwich Gallery was open every day from 1817, except Fridays and Sundays, access was no easier than the arrangements for Cleveland House. Admission tickets had to be obtained in advance from one of four print sellers in London, an arrangement which was criticised but survived until 1857.

We may be sure, however, that the collection was known to artists. The College made a particular point of encouraging artists to study and to copy works in the collection: 'In July 1815 the College wrote to inform the Council of the Royal Academy that the collection was now arranged and on view, and that although "owing to unforeseen delays" it was not yet accessible to the public, every Academician might visit it on weekdays as often as he felt inclined, and that "free access" would be "at all times afforded" to students.'[7] In addition the College offered an annual loan of 'a few pictures at a time in the Royal Academy for the use of the students'. As a direct consequence of this offer, in November 1815 the Council of the Academy resolved 'to establish a school for the express purpose of instructing the students in the practical part of the art of Painting'.[8] Although drawing had been taught at the Academy since its foundation, this was the first time that painting was included in the curriculum. Two Norwich artists who presumably benefited from this tuition were George Vincent and James Stark. From 1816 a group of up to six Dulwich pictures was selected annually by Academicians and sent to Somerset House. Although the records of paintings lent are not complete for the 1820s, it is evident that from the first

figure 38:
Aelbert Cuyp (1620–1691)
A road near a river c. 1660
oil on canvas 113 × 167.6 cm
By permission of the Governors of Dulwich Picture Gallery

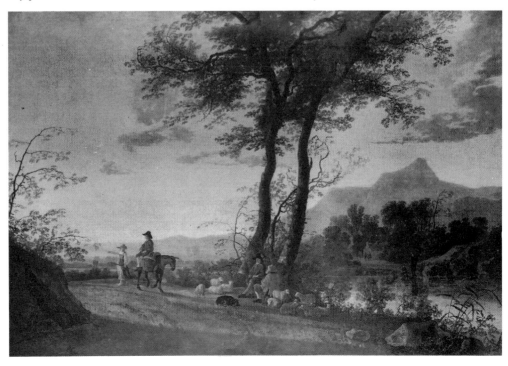

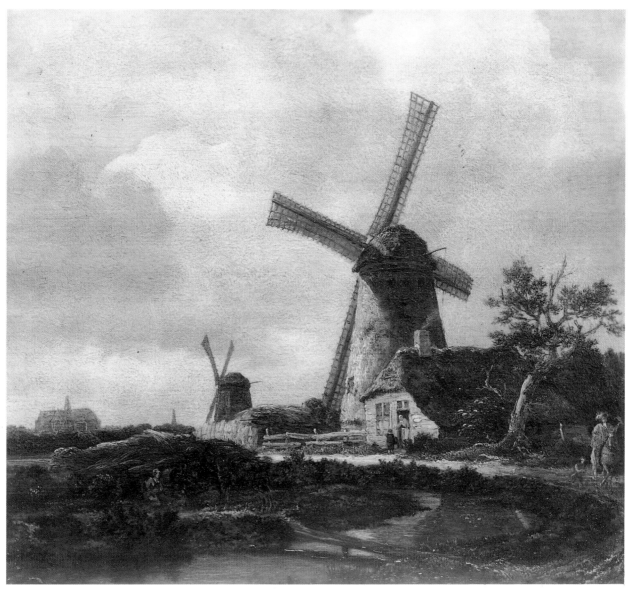

figure 39:
Jacob van Ruisdael (1628/9–1682)
Landscape with Windmills near Haarlem c. 1650–2
oil on panel 31.5 × 33.9 cm
By permission of the Governors of Dulwich Picture Gallery

the work of Aelbert Cuyp in particular was the most important choice from the Dutch School for the Academicians. The artists whose works were most frequently borrowed were van Dyck, Nicolas Poussin, Cuyp (including Calraet then attributed to Cuyp), Murillo, Guido Reni, Claude, Rubens, Rembrandt, Watteau and Velasquez. This was very much a choice that one might expect of the Academicians and on the whole their selection seems to have been of works of quality. Although the Cuyps are not always specified in detail, we may assume that the grandest composition, *A Road near a River* (fig. 38), was the *Landscape with Figures* lent to the Academy in 1816 and 1817.[9] Although Cuyp featured often among the loaned artists, Both did not and it was not until 1830, when Constable was among the selectors, that the choice included Hobbema's *Wooded Landscape with Water-mill* and Ruisdael's *Landscape with Watermills near Haarlem* (fig. 39). This last painting is fairly unusual in Ruisdael's oeuvre for its sombre tonality, but it was precisely the kind of Dutch landscape that seems to have appealed to leading landscape artists at the beginning of the nineteenth century. Constable himself copied it.[10]

Artists were also given permission to copy in the Dulwich Gallery. The Gallery archives record the 'permissions to copy' granted between 1820 and 1833, but none of these were Norwich artists. The fact that it was customary for artists to copy at

Dulwich is an important point in the light of the traditional attribution to John Crome of a watercolour copy after Adam Pynacker's *Landscape with Sportsmen and Game* at Dulwich. In recognition of the fact that this bears hardly any stylistic affinity to John Crome, the watercolour copy (now in Norwich Castle Museum) has been attributed, by default, to his son John Berney. Inscribed 'John Crome' this remains a mystery. The truth is that numerous artists, quite often of indifferent ability, followed the fashion of copying the old masters in their efforts to improve their powers. Their taste was often in marked contrast to that of the Academicians, and they happily pursued the examples of Teniers, Wouwermans, Potter and Ruisdael as

figure 40:
Ludolf Bakhuizen (1631–1708)
Boats in a storm 1696
oil on canvas 63 × 79 cm
By permission of the Governors of Dulwich Picture Gallery

opposed to the type of work selected by the Academicians. The conclusion must be that the Norwich artists would almost certainly have known the Dulwich collection, but there is no evidence to suggest that John Crome and his contemporaries actually copied works there. The marine artist William Joy of Yarmouth appears to have visited the Gallery, where he would certainly have studied Ludolf Bakhuizen's *Boats in a Storm* (fig. 40).[11] This trip was part of a mission undertaken by Joy's patron, Captain William Manby to show Joy the work of particular artists from which he might learn. Manby wrote to Dawson Turner on 18 November 1829:

> On Monday, a day illuminated by a bright sun I took William Joy to a gallery in Pall Mall near the British Institute. There were only a few pictures of merit, but two of W. Van de Velde, certainly not of his best, yet they answered my purpose. I was able not only to point out sufficient merits, but also to impress upon Joy's mind what was defective in his painting – namely a hardness of penciling, and to show Van de Velde exhibited no determined line, but softened it as is seen, in an attentive observance to nature. We spent some time there in examination of what was best adapted to afford Joy improvement and I let him spend the remainder of the day in the National Gallery, where he was as long as the daylight lasted and then he dined with me.

The most important facility for the study of the Old Masters in London was the British Institution. Their first major exhibition of Dutch and Flemish Old Masters was held in 1815 at their Gallery in Pall Mall. This private society of aristocratic and wealthy collectors held high-minded ideals which on the whole they successfully maintained from the beginning. In 1809 Martin Archer Shee commented: 'that part of the plan of the British Institution, which offers to the student an opportunity, so much at ease, to profit by the work of the old masters, is particularly entitled to commendation. It supplies a want which has long been felt, and were no other benefit to be derived from that establishment, this advantage alone is sufficient to make its permanence and promotion of the greatest importance.'[12] The Directors of the British Institution were keen to be seen to be working on behalf of contemporary artists and not just indulging in a reactionary or out-moded taste. In the preface to the catalogue of the 1815 exhibition of works by the Dutch and Flemish Masters they made the following statement:

> The Directors of the Institution, therefore, in submitting this Collection to the Public, do not present it merely for the purpose of amusing the curious, or of delighting the judicious; they hope that such productions may excite in the British Artist the ardour of emulation. They offer them to him not that he may copy, but that he may study them. They wish him to catch the spirit, rather than to trace the lines; and to set his mind, rather than his hands, to work upon this occasion . . .[13]

These worthy sentiments led to an outcry in some circles. The idea that contemporary artists could find inspiration in the gathering of 'Black Masters' was attacked by a self-styled 'Incendiary' as being: 'not only a number of the very worst specimens they could obtain of the works, but actually rubbed-out Pictures, *things* that if they are not copies, are admirably calculated to pass as such, and imitative daubs, so wretched as to be disgraceful in the extreme to the reputation of those great men whose names they are fated on this occasion to bear . . .'[14] It was not lost on those who cavilled 'that many of the specimens which we have taken upon ourselves to assert have been liberally chosen by the Directors for the favourable contrast they will afford to Modern Art, belong to these very Directors themselves.' These criticisms are taken from a scurrilous pamphlet printed within weeks of the exhibition opening. The pamphlet was styled a *Catalogue Raisonée*, as if coming from the Directors themselves. The newly gilt staircase rails and velvet hangings of the Gallery also came in for criticism. These 'gorgeous trappings', it was asserted, were intended to be so overwhelming in their effect that 'Rembrandt's ladies and gentlemen of fashion look as if they had been on duty for the whole of last week in the Prince Regent's new sewer', thus keeping 'the old masters under' to 'the Encouragement of the Modern Arts'.

It seems to have been the presumptive paternalism of the Directors that caused this outraged response. The exhibition of Italian and Spanish Masters received the same treatment in 1816, but the pamphleteer presumably felt unable to burst into print in the same vein the following year when the exhibition was of 'Deceased British Artists'.

The study of old masters had been in fact a well established provision for artists at the British Institution since its inception. In 1815 each student who had attended for fourteen days or more during the previous year 'for the study of the Pictures' was automatically presented with an admission ticket. At the end of the exhibition on 29 July 1815, a number of paintings were retained until the end of November 'for the study of the artists attending the British School'.[15] The works selected were by van Dyck, Rubens, Rembrandt, Wouwermans, Teniers, Ostade, Cuyp, Frans Mieris and van de Velde. The regulations were quite strict as to how students should proceed, to make certain that there was no intention to defraud. Regulation number six was: 'That no copy be made of any Picture lent to the Institution, it being the opinion of the Committee, that the objects of the Institution may be best obtained by Imitations, Studies & Sketches, and by the endeavour at producing companions to the Pictures lent.'[16]

The Norwich artists George Vincent and James Stark both studied at the British Institution Gallery. The minutes of the meeting of the Directors on 5 February 1818 received the Keeper's report for the previous year. Among those reported as having

'previously exhibited specimens of their drawing, or painting [and] attended throughout the season' was 'G. Vincent Exhibitor'. The following year he was joined by 'Mr Starke'.[17] It is interesting to see the list of pictures available for students to copy that year. These included Cuyp's *River Landscape with horseman and peasants* belonging to the Marquis of Bute, the Prince Regent's *Philip baptising the Eunuch* by Jan Both, two mature Hobbemas lent by G.W. Taylor Esq., a *Moonlight* by Aert van de Neer lent by R. Colborne Esq., two *Seapieces* by Willem van de Velde lent by H.P. Hope Esq. and a *Rocky Landscape* by Berchem lent by George Hibbert of Clapham. Other Dutch and Flemish paintings included works by or attributed to Jan Steen, Rubens, Wijnants and Adriaen van de Velde. Also included was Rembrandt's *Portrait of Margaretha de Geer*, lent by Lord Charles Townshend.

In the private world of the few patrons and collectors to hold office within the British Institution it is of some interest in the context of this study to find Lord Charles Townshend, whose country seat was at Raynham Hall, Norfolk. Lord Townshend was proposed for election as an Hereditary Governor of the Institution on 7 June 1816 and unanimously elected on 3 July 1816.[18] Lord Charles Vere Ferrars Townshend (1785–1853) was the third and last son of George, second Marquis Townshend (1753–1811) and might not have been expected to inherit the family seat. However, the second son, Thomas Compton, died in infancy, and Charles' eldest brother, George Ferrars (1778–1855) ('a despicable wretch')[19] was disinherited by his father and, being accused 'of impotency and of not being formed as a man shd. be,' by his wife (of one year) found it, 'undesirable . . . to reside in the realm'.[20] As a consequence, the control of the estate at Raynham (the Norfolk seat of the Townshends since the twelfth century) was devised by the second Marquis to Charles, 'together with all the furniture, plate, and pictures, to which his lordship added much of the valuable library collected by his father'.[21]

In fact, Charles seems to have spent much of his time away from Norfolk, preferring rather to live at his London residence. Certainly, this is indicated by his fine collection of pictures, which seems to have been kept entirely separate from the huge assemblage of family portraits at Raynham, and thus is not listed in the *Norfolk Tour* survey of 1829. The collection was begun in about 1814, after Charles had served as an army officer in the Napoleonic period, and was continued, with regular sales and purchases, right up to the year of his death, in 1853.

Charles Townshend's father had 'devoted much of his life to literary pursuits, and was considered the best genealogist of his time',[22] becoming President of the Society of Antiquaries in 1784, and a trustee of the British Museum three years later. Charles appears to have inherited his father's interest in the Arts: he is recorded as a subscriber to the British Institution between 1818–1824, at which time he was also an MP. He was well placed to pursue his interest in paintings, and lent a total of thirty-one pictures, including sixteen Dutch and Flemish examples in nine British Institution exhibitions between 1818 and 1853. He also contributed six Dutch works to the Norwich show of 1829.

It appears that Charles Townshend treated pictures almost as a form of investment for, almost as a matter of course, his paintings were sold again within a few years of their purchase. Indeed, he retained only a handful of pictures for more than ten years, and even these had been bought in for failing to reach their estimate. Nevertheless, some important pictures passed through Lord Townshend's hands over the years, most of which were exhibited at the British Institution. The two major sales of his paintings during his lifetime, in 1819 and 1835, reveal a taste for landscapes, seascapes and still lifes, but relatively few portraits or genre pictures, although these include some of exceptional quality.

Townshend's 1819 sale saw thirty-three pictures auctioned, and over 2500 guineas raised – almost all accounted for by thirteen Dutch pictures (with another six bought in). Of those offered, seven were outstanding. Amongst these were Rembrandt's *Agatha Bas* (1641), sold to King George IV (fig. 41), and the later portrait of *Margaretha de Geer* (1661), now in the National Gallery, London (cat. no. 85 and colour plate xiii). Also destined for the Royal Collection (bought by Lord Yarmouth for the King) was Schalcken's *Girl with a Candle* (fig. 42). A rare genre scene, Adriaen van Ostade's *Peasants in an Interior* (signed and dated 1663), sold for 410 guineas,[23] and three other works made over 300 guineas. Two were marine pictures: Philips Wouwermans' *View on a Seashore*, once in the possession of Queen Elizabeth Farnese of Spain (cat.

figure 41:
Rembrandt Harmensz. van Rijn (1606–1669)
Agatha Bas 1641
oil on canvas 105.2 × 83.9 cm
Reproduced by Gracious Permission of
Her Majesty The Queen

figure 42:
Godfried Schalcken (1843–1706)
Girl with a Candle, drawing aside a curtain
oil on panel 32.6 × 25.4 cm
Reproduced by Gracious Permission of
Her Majesty The Queen

no. 86) and Willem van de Velde's fine *Calm, Vessels laying at Anchor*.[24] This latter, together with the major painting by Teniers, *Bonnet Rouge*,[25] went to George Byng, later Earl of Strafford. All of this group, apart from *Agatha Bas*, had been exhibited at the British Institution in 1818.

Townshend seems to have bought many of these pictures, and a number of others which he was also to sell subsequently, from the major London dealers of the day, such as John Smith and Nieuwenhuys. Many of them can be traced back further to the period of the French Revolution, in the sales of such aristocrats as de Calonne and de Wille. Indeed, one of the masterpieces of the 1835 sale, Teniers' *Village Fête* (1646) had been sold by Mme de Wille in 1784.[26] As a whole, the fifty-one pictures auctioned in 1835 raised over 6400 guineas, with the seventeen Dutch and Flemish works contributing to more than half that sum. Apart from the Teniers *Village Fête* and the Rembrandt portrait of *Margaretha de Geer*, two paintings stand out: Jacob van Ruisdael's *Waterfall near a Village*, bought by Sir Robert Peel (cat. no. 87), and Berchem's *Ancient Ruins near Rome*, which had left Holland as recently as 1824.[27] Other notable pictures included a pair of van de Cappelle seascapes, probably bought together from the Brentano Collection (cat. no. 84), Wijnants' (with Wouwermans) *Hilly landscape and robbers* (1663),[28] and another marine picture, Bakhuizen's *Shipping on a Rough Sea*.[29] As with a number of other pictures in the 1835 sale, it too had been exhibited at the British Institution.

Lord Townshend sold several other pictures in much smaller sales between 1824 and his death. In 1824, he sold Steen's *Wedding Party* to William Wells of Redleaf, having only just purchased it in the previous twelve months.[30] Another picture from the Brentano Collection, Jan Baptist Weenix's *Garden-scene, with dead game* was sold in 1849.[31] Two years later, and two years before his death, Townshend sold Pynacker's *Rustic Bridge*, having exhibited it at the British Institution in 1847.[32]

Although Charles Townshend only bought about forty Dutch and Flemish pictures, a high proportion were of excellent quality. However most were sold within

his lifetime and, although he married his cousin Charlotte Loftus in 1812, he left no children, and the remaining paintings were sold after his death in 1853. It is perhaps indicative of a diminishing taste for Dutch and Flemish works that just three minor examples amongst a plethora of English works were included in the posthumous 1854 sale.[33]

Lord Townshend was to play a significant role in the second Old Masters exhibition organised by Norwich artists in direct emulation of the British Institution. Just two exhibitions were held, in 1828 and 1829, in the recently-opened exhibition gallery at the new Corn Exchange in Norwich. The Norwich Society Artists, who had renamed themselves the Norfolk and Suffolk Institution for the Promotion of the Fine Arts held their first exhibition of *Works of Ancient and Modern Masters* in the autumn of 1828. The Patron was HRH the Duke of Sussex and the catalogue to the exhibition listed a full roll of local honour, including patrons and artists as Donors, Subscribers, Members and Honorary Members. The title page of the catalogue[34] carried the following four lines by Martin Archer Shee:

Give me the critic bred in Nature's School,
who neither talks by rote nor thinks by rule,
who feeling's honest dictates still obeys,
and dares, without a precedent, to praise.

The message was clear enough. The exhibition, by showing the works of old masters and contemporary masters together, was not meant to suggest that the Norwich artists were anything other than 'bred in Nature's School' themselves. The catalogue

cat. no. 87 Jacob van Ruisdael *A Waterfall at the Foot of a Hill, near a Village c.* 1665–9

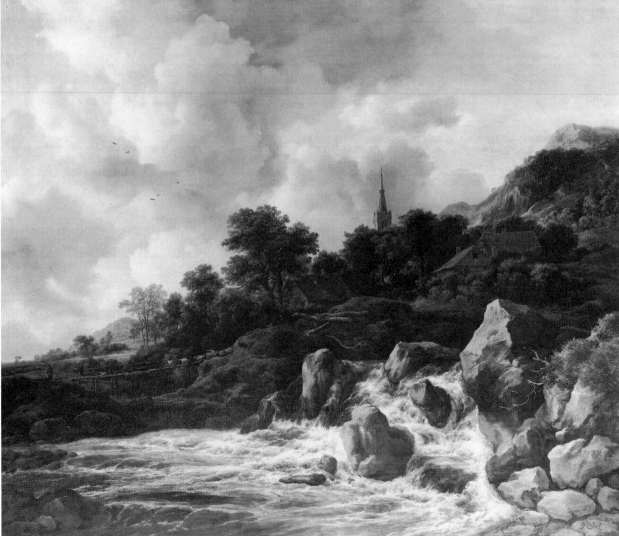

carried an Address which identified 'a two-fold object in view: first, the giving the Public an opportunity of viewing many splendid Specimens of the Antient Masters which are possessed by various Noblemen and Gentlemen in the County and City, and next, the cultivation of true Taste. The result of this experiment, it is hoped will fully answer the most sanguine wishes of its Projectors. . . .' A total of seventy three works in the exhibition were attributed to Dutch and Flemish artists, out of one hundred and nineteen exhibits. The experiment was repeated the following year with the notable addition of Lord Charles Townshend among the Donors, who provided a handsome donation of fifty guineas as well as six paintings including his *Portrait of Margaretha de Geer* by Rembrandt (cat. no. 85) and a seapiece by van de Cappelle (cat. no. 84).[35] The *Norwich Mercury* rose to the challenge: 'We are proud to say that it comprises a display of talent which has hitherto been unequalled except at the British Institution, and we feel the more gratified as we find in fair competition a few of the works of our own fellow citizens . . . That the Public taste will be improved there can be no question, and it is equally certain that Artists will be benefited in proportion as the public mind is enlightened by the exposition of beautiful productions in art.'[36]

The organisation of these two exhibitions in Norwich may be seen as the culmination of a continuous period of artistic interchange between Norwich and London. Artists, patrons, collectors and public all benefited from a wealth of opportunities to see the work of both old masters and contemporary artists, locally and in the metropolis. Many of the middle-class collectors of Dutch and Flemish paintings mentioned during the course of this survey also acquired works by John Crome and his followers.

The question remains as to the extent the Norwich artists may be regarded as influenced by the Dutch seventeenth-century schools. There is no single answer, nor is it a simple task to identify specific influences upon the leading painters, John Crome and John Sell Cotman. For the latter, a few memoranda when visiting exhibitions was all that he required for his own art, despite teaching others through endless copying exercises (cat. no. 99). Crome, meanwhile, has historically been saddled with a long-standing belief that his work was strongly influenced by that of Hobbema (cat. no. 59). Yet the taste for Hobbema's work only truly began to take hold in the 1820s after Crome's death. The taste for Hobbema was entirely based upon the public exhibition of his late works, with which James Stark was the more familiar (cat. no. 92). Crome had more opportunity to see the work of Ruisdael than of Hobbema, both locally and in London. In addition he was familiar with Ruisdael's etchings (cat. no. 97), yet those of Waterloo have an equal claim to have influenced him in terms of their sense of composition. There is perhaps a closer connection between Hobbema's early work and that of Crome, yet it remains uncertain as to whether any such works were in England before Crome's death in 1821.[37] In the final analysis Crome's oils are individual statements that must contain a synthesis of influences, of which the work of the Dutch Old Masters is only one strand.

The one written critique on the matter of style made by Crome that has survived, is in a letter to his pupil Stark, written in January 1816.[38] He encourages Stark to aim for 'a much less too-picture effect' and makes direct comments upon his pupil's painting of clouds: 'I think the character of your clouds too affected, that is, too much of some of our modern painters, who mistake some of our great masters because they sometimes put in some of those round characters of clouds, they must do the same; but if you look at any of their skies, they either assist in the composition or make some figure in the picture, nay, sometimes play the first fiddle. I have seen this in Wouwerman's and many others I could mention.' These are the assertions of the true artist, whose serendipity will help him to pick and choose, but whose final product will be totally of his own creation. In his letter to Stark, Crome continued to give one more piece of advice: 'Brea[d]th must be attended to, if you paint but a muscle, give it brea[d]th. Your doing the same by the sky, making parts broad and of a good shape, that they may come in with your composition, forming one grand plan of light and shade, this must always please a good eye and keep the attention of the spectator and give delight to every one. Trifles in Nature must be overlooked that we may have our feelings raised by seeing the whole picture at a glance, not knowing how or why we are so charmed.' Crome's advice was for 'breath', or breadth, both in terms of technique and composition, to maintain 'one grand plan of light and shade' and not

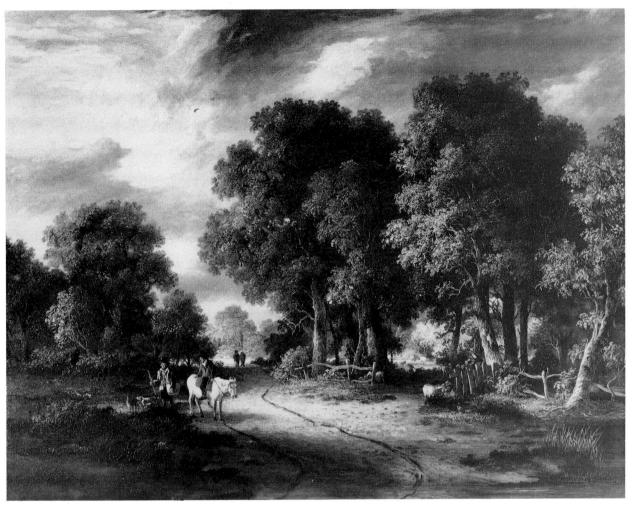

cat. no. 92

to dwell overmuch upon 'Trifles in Nature'. By this he certainly did not mean that Nature should be ignored.

In considering the influence of Dutch painting on the Norwich School it is clear that a direct relationship can be established in the work of the artists of the second generation, such as James Stark (cat. nos, 92, 93) and also the Stannard family (cat. no. 109) and the Norwich painter-etchers who followed John Crome (cat. nos. 104, 105). At the same time they themselves were strongly influenced by Crome and Cotman and questions of influence are not easily answered. The greatest Norwich School artists, John Crome and John Sell Cotman, synthesize their influences beyond the derivative. In Cotman's work there is little sense of the Dutch School. Meanwhile, it is evident that the landscapes of John Crome owe as much to the landscape of his native county as to any received artistic influence. The geographical similarities – the wide, flat landscapes, the open skies, the windmills – are reflected in the similarities of composition adopted by both the seventeenth century Dutch School artists and the early nineteenth century painters of the Norwich School. The art historical exercise of identifying specific stylistic influences should be seen within the context of this geographical unity. It is in this sense that the early work of Hobbema may be seen as similar to that of Crome: they both portray an individual response to their environment with an economy and immediacy which records a direct, raw, response to nature.

figure 43:
Alfred Edward Chalon (1780–1860)
Andrew Fountaine IV (1808–1873) 1838
watercolour 54.5 × 33 cm
Andrew Fountaine

VI Later Collectors

The previous chapters have examined the development of Norfolk collections of Netherlandish painting with a view to establishing the extent that local taste may have influenced local painting as well as collecting. The metropolitan example has also been seen to be a consistently important feature in establishing local patterns. The purpose of the present chapter is to identify some of the later collectors who may be seen as responding to established fashions of collecting. They should perhaps be regarded as part of a received pattern rather than as important innovators. The break-up of the great aristocratic collections on the continent after the Napoleonic wars provided new opportunities for middle-class dealers and collectors and the second quarter of the nineteenth century saw collectors from different walks of life faced with opportunities of purchasing from the complete spectrum of Dutch and Flemish painting. The choice available was of an increasingly high quality, while the publication of John Smith's prodigious *Catalogue Raisonné* of Dutch and Flemish Masters and William Buchanan's *Memoirs*, published in 1824, helped to promote an informed taste which took account of provenance as well as quality.

The first collector to be considered in this context is Sir Jacob Astley (1797–1859) of Melton Constable Hall, sixth baronet, and sixteenth baron Hastings.[1] Jacob Astley was one of the most notable members of a family which (having held lands in Norfolk since 1264) was 'connected by descent with nearly every Norfolk family of note, [and] must be taken to be the oldest and most important family in the county'.[2] Links with the Low Countries dated back (at least) to the seventeenth century, an era of the greatest fame for the Astleys, when their fortune was made serving Charles I and II. An earlier Jacob Astley, created Lord Astley of Reading in 1644, spent much of his career in the Low Countries in the service of Queen Eleanor, Regent of the Netherlands, and married a Flemish lady, Agnes Impel of Bloumerckem (see cat. no. 14). Two of their five sons were killed in the Netherlands. His nephew, Edward (died 1653), also fought in Flanders, and married his daughter. Their son, another Jacob, 'began a new era, and . . . may be described as a second founder of the family'.[3] He was appointed Standard Bearer to Charles II on his Restoration and created a baronet in 1660; when Melton Constable Hall was rebuilt in 1670, 'the King gave him a fine marble bust of himself and a great painting of Windsor Castle by Vostermans from the Royal Collection'.[4]

Apart from some family portraits, the Vostermans was the only recorded Dutch or Flemish picture to be associated with Melton Constable,[5] until Jacob (sixth baronet) began collecting, probably in the mid-1820s. His great-grandfather, the third baronet (another Jacob), 'was a man of letters, a musician and a patron of the arts', while Edward, the fourth baronet, was a collector of books and prints (see cat. nos. 44, 45). But it seems that it was Jacob who was largely responsible for the notable, if not outstanding, collection that hung at Melton Constable for most of the nineteenth century, and until its dispersal during this century.[6]

The eleventh baronet, in his survey of the Astley family through seven hundred years, has left an account of his forebear.[7] He describes Jacob as 'a small man whose stature and great good looks earned him the soubriquet of "the pocket Adonis", but looks and size only served to accentuate a dynamic personality'. He succeeded to the baronetcy in 1817, aged twenty, and 'threw himself at once into politics [as MP for West Norfolk, 1832–37], local affairs and sport [as Master of the Norfolk foxhounds],

cat. no. 111 Abraham Begeijn *Landscape with Waterfall* 1664

and also made himself an expert art connoisseur'. With all these interests, 'it would be hard to say whether his art collection, his hounds, his estates or his political enthusiasms held first place in his thoughts'. Despite 'an autocratic disposition' and 'a certain intolerance' of those 'not so energetic as himself . . . his friendships were many and strong'. A judgement of the House of Lords in 1840 found him to be a coheir (via the third baronet's marriage to Lucy Le Strange) of the Barony of Hastings, 'the abeyance thereof was terminated in his favour, 18 May 1841 . . . whereby he became LORD HASTINGS'.[8] He married Georgiana Dashwood in 1819, in London, where he was also to die of a stroke in 1859.

Although it is known that Sir Jacob, 'was a buyer of works of art at the Paris revolutionary sales',[9] there are no records of the collection between 1829 and 1929, and so details of purchases and sales in this period must remain incomplete. Nevertheless, some idea of its quality, if not its ultimate size, can be found in the *Norfolk Tour* of 1829.[10]

Amongst the forty or so pictures ascribed to Dutch or Flemish masters at Melton Constable, were seapieces by van de Velde,[11] van de Cappelle, Potter and Bakhuizen and generally rather Italianate landscapes by Wijnants,[12] van Bloemen ('Orizonté'),[13] Potter, Poelenburgh,[14] Salomon Ruysdael (*Scheveling Church*), and Hobbema. There were several animal or flower pieces, including Snyders' *Wolves and Dogs* and *Monkey and Fruit*,[15] Fyt's *Hawks and Poultry* (dated 1625) and *Turkeys Fighting*, Hondecoeter's *Animals assembling at the Ark*, and a van Os *Flower piece*. A fourth group of pictures included several genre scenes, by 'Ochtavelt' (Ochtervelt), *Interior with Child and Cradle*, *A Conversation Piece* by D. Ryckaert, an *Interior* by Steen, Teniers' *Man and woman weighing money*, a *Girl Holding a Candle* by Schalcken, and a *Woman drinking* by ter Borch.[16]

Provenances for most of these pictures are difficult to establish, but a number are recorded as from the collection of Count Pourtalès, whose sale took place in May 1826. However, they were not bought directly from this auction, since the London dealers John Smith and Thomas Emmerson purchased the entire Dutch and Flemish section of the Count's collection. Potter's *Pied Horse* can be traced back through the Pourtalès sale to that of Chevalier Lambert in Paris, 1787, on the eve of the revolution.[17] A *Small Landscape* attributed to 'vander Heyden and Van de Veldt' may plausibly be traced back even further, to the sale of van der Heyden's daughter in 1712.[18] In 1829 Chambers also listed three pictures by Wouwermans – *Rendezvous de Chasse*, *The Gypsies*,[19] and *La Partie de Chasse* – which 'were in the Collection of Count Portalis', together with a fourth, *The Baggage Waggon*.[20]

The most notable provenance of any picture collected by Astley is, however, reserved for a nineteenth-century work by B.P. Ommeganck. Listed as '*Landscape and Cattle* – Ommegank, 1812', in *Norfolk Tour*,[21] it 'was painted for and presented to the empress Josephine [by the States of Antwerp], and came from Malmaison'. It too passed through the hands of Count Pourtalès. A final picture of importance mentioned in the *Norfolk Tour* is *Minerva protecting the Arts*, listed as by Frans van Mieris, but in fact by Jan van Mieris (see cat. no. 112).[22]

A crop of other paintings, not mentioned in the *Norfolk Tour*, but sold in the twentieth century from Melton Constable, can also be regarded as purchases of Jacob Astley, given that his nineteenth-century heirs seem to have had little interest in collecting. Amongst these were pairs of works by B. van den Bossche (*Interior of a Sculptor's Studio*) and J. van Hughtenburg (*A Battle Scene near a town*),[23] a de Koninck landscape (*A Wooded valley . . .*),[24] D. Vinckboons, *A Village Kermesse*, and other landscapes, by A.F. van der Meulen,[25] and by A.J. Begeijn (see cat. no. 111). A group of portraits is recorded by Duleep Singh in March 1908, which does not, it seems, appear in the *Norfolk Tour*. Amongst works by Pourbus,[26] van Somer[27] and Wyck,[28] a portrait of Isabella of Austria by Rubens[29] is perhaps the most interesting. In May 1829, the same Thomas Emmerson who bought from the Pourtalès sale sold a portrait by Rubens of 'Infanta Isabella. From Town house at Brussels', and, with the buyer unknown, Sir Jacob Astley, sixth baronet, could well fit the gap.

figure 44:
Peter Paul Rubens (1577–1640)
Landscape with a Rainbow
oil on panel 136.5 × 236.5 cm
The Wallace Collection, London

The fortunes of the Astley family suffered somewhat in the years after Jacob's death – not helped by the behaviour of his daughter-in-law, Frances Corsham, who 'made use of her position and influence solely for her own financial benefit'.[30] Most of Jacob's collection was sold in a long series of sales this century, and the great Hall (the setting for Joseph Losey's film, *The Go-Between*) was sold in the 1950s.

A notable later Norfolk collector who followed a family tradition of collecting was Horatio Walpole (1783–1858), the third Earl of Orford by the second creation, whose family seat was at Wolterton Hall. Wolterton had been built by Horatio Walpole, first Baron Walpole of Wolterton and the brother of Sir Robert Walpole. Built between about 1726–40, from designs by Thomas Ripley, Wolterton was described by Horace Walpole as 'one of the best houses of the size in England'.[31] When Horatio Walpole, the third Earl of Orford inherited Wolterton in 1822 he embarked upon a series of quite radical alterations to the house. He employed George Stanley Repton, fourth son of Humphry Repton, to add an arcade flanked by steps and an east wing, between 1827–32. He also purchased a choice number of paintings.

The third Earl of Orford's most important purchase was Rubens' famous *Landscape with a Rainbow* (fig. 44), purchased for 2,600 guineas in 1823 and now in the Wallace Collection, London. Chambers recorded in 1829: 'Lord Orford has recently placed here the celebrated Landscape, by Rubens, well known under the name of "The Rainbow", late in the collection of Mr Watson Taylor, generally considered as the *chef*

figure 45:
Philips Koninck (1619–1688)
An extensive Landscape with a Windmill 1655
oil on canvas 130 × 165 cm
The Trustees of the Firle Estate Settlement

d'oeuvre of this great master, in the department of landscape.'[32] This painting alone made a visit to Wolterton an essential requirement. On 12 November 1841 the Rev. James Bulwer took his friend John Sell Cotman to Wolterton specifically to see this painting. From the steps of the Hall Cotman paused in the portico to sketch 'A remarkable & beautiful coincidence a fine rainbow appearing at the very moment we alighted under the portico of Wolterton to see the glorious one painted by Rubens.'[33]

Horatio Walpole purchased another magnificent landscape, a large and characteristic panoramic view by Philips Koninck (1619–88). When Gustav Waagen saw this painting (fig. 45) in 1850 he described it as 'of great truth and power, and uncommon effect'.[34] Philips Koninck's large panoramas were much admired by British collectors during the second half of the eighteenth century and into the mid-nineteenth century. The Earl of Orford's canvas had been in the collection of the Comte de Pourtalès, being sold with that collection in 1826.[35] Walpole hung the painting in the Saloon, where there was also a portrait head attributed to Rembrandt, *A Jew Convert*.[36] One other Dutch painting in the Saloon by 1829 was a painting of a dead hare suspended from a carved stone pedestal, a typical piece attributed to Weenix.[37] Chambers recorded a number of other Dutch paintings at Wolterton in 1829, including a *Wedding Dance*, later attributed to 'van Lunden', and also a seapiece at that time believed to be by Ruisdael, but now regarded as a copy by another hand.[38] Paintings attributed to Wouwermans, Moucheron, Lingelbach, van Kessel, J. Miel, Poelenburgh, and de Heem (cat. no. 113) were most probably all purchased by the third Earl.[39] His earliest recorded purchase was an Italianate landscape by Berchem which he bought at John Patteson's sale in Norwich in 1819.[40] This was described by Chambers in 1829 as 'a cabinet picture by Berghem, in his finest manner'.

Another important Norfolk collector who was similarly continuing a family tradition of collecting was Andrew Fountaine IV (1808–73) of Narford Hall. Andrew Fountaine IV (fig. 43) was a notable collector of maiolica and objets d'art as well as paintings. He recorded in the 'Family Book': 'I added many fine pictures & majolica, especially lustred specimens to the collection; also marble busts, marquetrie, Venetian chairs, old French furniture, jewels, medals, coins, plate, fine clocks & watches, ivories, books, mss, arms, armour, & musical instruments.'[41] He also embarked upon extensive renovations at Narford which continued until 1868 when the clock tower and conservatory were completed.

In the context of this study Andrew Fountaine IV is of interest for his evident taste for the work of Jacob van Ruisdael (cat. nos. 115 and 116). He purchased a total of four works by Ruisdael, each of high quality. An early purchase was *A View on the Brill River*, formerly in the collection of de Heer van Eddekinge, Amsterdam, which Fountaine purchased from the dealer John Smith in 1839.[42] Smith described this picture in glowing terms (see cat. no. 116) in 1842, as did Andrew Fountaine: 'Large seapieces by this master are extremely rare. Nothing can exceed the grandure of effect & the management of lights, the clouds are really drifting & the sea seems to move as you look at it. It is as crisp & perfect as the day it was painted.'[43] At about the same time, shortly after inheriting the family seat at Narford, he also purchased a superb example by Jan van Huysum (cat. no. 117) and a fine Rubens, *Interior of a Barn, with the Prodigal Son*, a picture which Smith records had been mentioned by Reynolds when, on his tour of Flanders, he saw the panel in the collection of M. Pieters, in 1781.[44] Andrew Fountaine IV is remarkable for the systematic way in which he built upon the collection of his illustrious forebear, Sir Andrew Fountaine, enhancing the collections already at Narford rather than attempting to collect in an entirely different sphere.

A similar story may be followed, in a smaller way, at Felbrigg Hall. William Windham III (1750–1810) had poured his energies into national politics and, at home, into the large-scale planting of the park and estate, carried out by Nathaniel Kent. Apart from the Library, he showed little interest in the collections at Felbrigg. With his death the line established by Thomas Windham, the builder of the original Jacobean house, came to an end. The estate passed to Vice-Admiral William Lukin (1768–1833) in 1824 and he adopted the name of Windham.

Lukin had lived at Felbrigg Parsonage until 1812 and then at Metton Parsonage, but he and his wife also lived in Brussels in the early 1820s. It is probably then that he

figure 46:
Abraham Storck (1644–after 1708)
An Italian Seaport with the Ruins of a Classical Temple 1673
oil on panel 25.4 × 36.8 cm
The National Trust (Felbrigg Hall)

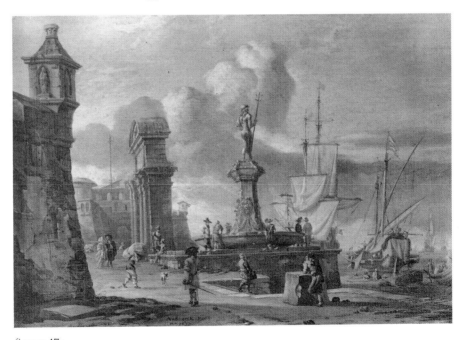

figure 47:
Abraham Storck (1644–after 1708)
An Italian Seaport with a Fountain of Neptune 1673
oil on panel 25.4 × 36.8 cm
The National Trust (Felbrigg Hall)

acquired a small group of paintings which reflected his own passion for the sea and also that of William Windham II (see cat. no. 42). William Lukin seems to have purchased three oils by Abraham Storck, which consisted of a pair of seaport scenes (figs. 46 and 47) and a *View of Amsterdam* (cat. no. 114). He also acquired a seascape by Ludolf Bakhuizen. A set of plans dating from 1835 shows three of these paintings incorporated into the Cabinet at Felbrigg, where they remain to this day. These modest acquisitions reflected a taste established by Lukin's distant forebear, as much influenced by a love for the sea as for art.

There is one East Anglian collector who perhaps should be noted in this context. One of John Sell Cotman's patrons during the 1830s was Francis Gibson of Saffron Walden, Essex, a partner of Gibson's Bank which later amalgamated with Barclay's. Gibson's collection was primarily of Dutch old masters as well as contemporary works and he built a gallery in which to display his pictures at Saffron Walden. Although it would be tempting to conclude that Cotman had an opportunity to view Gibson's growing collection, the patron's account book[45] reveals that his most celebrated purchases took place in the late 1840s and 1850s. For example, his celebrated Vermeer, *The Music Lesson*,[46] he purchased for £42 in 1853 and his Aelbert Cuyp, *Sunset after Rain* (fig. 48),[47] just two years earlier. However, Cotman would have seen the Cuyp when it was lent by William Wells of Redleaf to the British Institution in 1819.[48] Gibson's championship of Cotman, despite being late in the artist's career, shows him responding to the 'most nobly square, bold, characteristic and expressive'[49] qualities of Cotman's work at an early stage in his career as a collector. It is not difficult to recognise a subtle restraint common to both Cotman's *Greta Woods*[50] and Vermeer's *The Music Lesson*, when both purchased by the same collector.

figure 48:
Aelbert Cuyp (1620–1691)
Sunset after Rain
oil on panel *c*. 82.5 × 69.5 cm
Fitzwilliam Museum, Cambridge

figure 49:
Frans Hals (1580–1666)
Three Children with a Goat Cart
oil on canvas 152 × 107.5 cm
Musées Royaux des Beaux-Arts de Belgique, Brussels

The Palmer family at Yarmouth owned a number of Dutch and Flemish paintings, the majority of which were acquired in the first quarter of the nineteenth century. Druery listed a typical group of works in 1826, recording that 'some of the best of these pictures were bought of Mr. Isaacs, who has imported from Holland and Flanders, some of the finest specimens of *Hobbima, Ruysdael*, &c. in the kingdom'.[51] These were housed at no. 4, South Quay, owned since 1809 by John Danby Palmer (1769–1841), Mayor of Yarmouth in 1821 and again in 1833. Druery does not list a later but important acquisition by Palmer of a painting known as *Three Children with a Goat Cart*, by Frans Hals (fig. 49). This important picture presumably reached Yarmouth shortly after its sale by Professor J.A. Bennet of Leiden University in April 1829. Seymour Slive has convincingly argued that this attractive early work by Hals, painted *c.* 1620 is in fact part of a larger family group.[52] The painting very probably travelled direct from Leiden to Yarmouth where it remained until sold by Charles John Palmer in February 1867.

The history of collecting in Norfolk by the second half of the nineteenth century is somewhat haphazard insofar as acquisitions may be described as indicators of taste or fashion. An antiquarian taste was perhaps the single most obvious motive behind the acquisition of early Flemish paintings such as the *Portrait of a Man* which appears to have been acquired by the Rev. James Bulwer (1794–1879) by 1850 at the latest (cat. no. 118). Formerly attributed to Memling, this is now considered to be by Rogier van der Weyden. It is distinguished as a portrait of high quality which sets it in the mainstream of similar works of the period, which it became fashionable to collect by the mid nineteenth century. In this instance the portrait was admired by the young Norwich Pre-Raphaelite artist Frederick Sandys (1829–1904), whose unfinished copy (cat. no. 119) is further evidence of the growing recognition of early, or 'primitive', painting. A difference of purpose may be seen between the copying of this early Flemish work by Frederick Sandys (*c.* 1850) and the copying of Lucas van Leyden's work by a Norfolk artist nearly three hundred and fifty years previously (cat. nos. 2 and 3). The earlier artist was fulfilling a commission, the later artist was learning by example. Yet both artists, in their separate times, were in the vanguard of contemporary fashion.

cat. no. 118 Rogier van der Weyden *Portrait of a Man*
c. 1460

cat. no. 119 Frederick Sandys *Portrait of a Young Man,*
after Rogier van der
Weyden before 1850

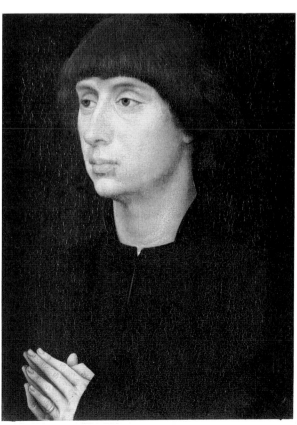

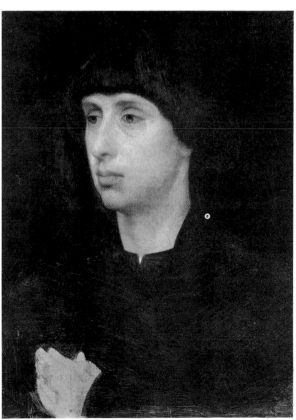

I NORFOLK AND THE NETHERLANDS

1 I am grateful to Dr Sue Margeson for her help and guidance in presenting the archaeological evidence.

2 Atkin *et al.* 1985, p. 80.

3 Atkin *et al.* 1985, pp. 198, 260.

4 Wilson 1987, p. 164.

5 Evidence for the use of Netherlandish pottery and glass in the sixteenth and seventeenth century by the Norfolk gentry comes from Baconsthorpe Castle, owned at that time by the Heydon family. These and much other material was recovered during the clearance of the moat and other work carried out by the Department of the Environment. This is to be published in a forthcoming volume of *East Anglian Archaeology*. Information kindly supplied by Barbara Green.

6 I am especially indebted to John Mitchell for making available to me the results of his research on the two screens in question, and for writing the catalogue entries, nos. 2 and 3.

7 I am grateful to Ursula Priestley for communicating to me her findings in connection with NRO, Consistory Court Probate inventory, INV 43/193. It is uncertain whether St Margarets Parish refers to St Margaret Westwick, or St Margaret Fibridge.

8 NRO, NCC INV 74 A/256, dated 20 Jan. 1720.

9 Green and Young 1981, p. 22–3.

10 Moens 1887–88, p. 23.

11 Acc. nos. 56.510 and 56.511; oil on canvas; *Johannes Elison*, 173 × 124 cm; *Maria Bockenolle*, 174.5 × 124 cm.

12 Christie's, London, 30 June 1860, lot 22.

13 The following account is based upon Haak *et al.* 1986, cat. A 98, A 99.

14 Woods 1979, pp. 71–3.

15 The complete inscription is given in Tingay 1932, p. 5. A translation is given by Kent 1926, pp. 97–8.

16 Wornum [ed.] 1862, p. 428 note 2.

17 Haak *et al.* 1986, cat. A 98.

18 Cozens-Hardy 1950, pp. 176–7.

19 Palmer 1874, II, p. 356, referring to Neville's diary entry.

20 Also possible, given Neville's uncertainty on this point, is that the second female portrait is of the son's wife, Josina.

21 Cincinnati, Ohio, The Taft Museum, Acc. no. 1931.409; oil on canvas, 124 × 98.5 cm; first recorded in the collection of the Earl of Ashburnham, sold Christie's, 20 July 1850, lot 47. New York, Metropolitan Museum of Art, Acc. no. 43.125; oil on canvas, 126.2 × 100.5 cm; first recorded in the collection of Vincent Donjeux, sale Paris, 29 ff April 1793, lot 147.

22 The two smaller portraits had presumably left Norfolk by 1829 as they were not recorded alongside the larger pair in Chambers 1829, I, p. 306. Palmer makes no mention of them when he states that in 1808 Dawson Turner was commissioned to offer £2,800 for *Johannes Elison* and *Maria Bockenolle* (Palmer, 1872, II, p. 356).

23 I am grateful to Dr Christopher Brown and Dr Walter Liedtke for their helpful comments on this suggestion.

24 Hulton 1954–56, I, pp. 53–4.

25 Sotheby's, Amsterdam, 25 April 1983, lot 36; *Recto*: Figures on a Road near Norwich; *Verso*: View of a Town, probably Norwich. Drawn with the brush in grey ink and watercolour over black chalk (*recto* and *verso*). Inscribed in brown ink on the *recto*: *na*

t'leven getejken buiten nowrvitz. in engelant. (top); *2 tekeninge. siet d ander sij* (bottom); and on the *verso*: *siet d ander sij* (top); *2 tekeninge* (bottom).

26 Louw 1981, pp. 1–23. The following summary is based upon Louw's work.

27 Louw 1981, note 3.

28 Louw 1981, notes 26 and 30.

29 Specifically, plate 146.

30 The following account draws upon Colvin and Woodhouse 1961, pp. 41–62.

31 The Preface to Bell's *Historical Essay on the Original of Painting*, 1728; Colvin and Woodhouse 1961, Appendix I.

32 Colvin and Woodhouse 1961, Appendix II.

33 For recorded versions see White 1982, no. 61.

34 'Catalogue of the Pictures at Althorp', *The Walpole Society*, 1974–76, p. 76; de Groot 1913, V, no. 227; Exhibited Royal Academy 1952–3 (595).

35 16 Nov. 1676; see cat. no. 13. The 'eunoch singing' is a reference to van Dyck's portrait of Henri Liberti, organist to the cathedral at Antwerp.

36 Farrer 1908, p. 100.

II THE GREAT COLLECTORS

1 *The Norwich Post* was probably the first provincial newspaper. The *Norwich Mercury* began in 1726 (formerly *The Norwich Weekly Mercury of Protestant Packet* which began *c.* 1720). The first issue of *The Gazette* appeared 18 July 1761; this became *The Norfolk Chronicle and Norwich Gazette* in 1770.

2 I am grateful to Dr Miklos Rajnai for making available to me the fruits of his research into eighteenth century Norwich newspapers. What follows is entirely based upon his findings.

3 *Norwich Gazette*, vol. 29 no. 1474, 28 December 1734.

4 *Norwich Mercury*, 26 April 1755.

5 *Ibid.*, 6 February 1768.

6 *Ibid.*, 1 April 1772.

7 *Ibid.*, 24 October 1772.

8 *The Norfolk Chronicle and Norwich Gazette*, 16 April 1774.

9 *Ibid.*, 5 August 1780.

10 *Ibid.*, 14 April 1781.

11 NCM 181.946.

12 Houlditch MS. English 86.00.18–19, Victoria and Albert Museum.

13 Later identified as by H. Steenwyck, Fountaine Sale 1894, lot 13.

14 Waagen 1854, III, p. 430.

15 This painting is possibly the unattributed *Israelites catching manna in the Wilderness* itemised in the 1738 Inventory. It was later identified as by Honthorst (Narford 'Family Book').

16 Slive 1970, pp. 129, 131.

17 The Narford 'Family Book' identifies other Netherlandish paintings as formerly in Sir Andrew Fountaine's collection. These were *Birds, Reptiles, Insects, Plants, etc*, canvas, by Melchior d'Hondecoeter; *A Man on horseback on the brow of a hill accompanied by several dogs . . .*, panel, by P. Wouwermans; *A Man in profile in a high crowned slouched hat, with moustaches & Beard . . .*, a 'very small oval picture' by Adrian Brouwer; a *small portrait of an old man . . .*, panel, attributed to Jan Lievens and portraits after Mor of *Princess Elizabeth of England* and *Philip II of Spain*. The latter is now in the collection of the Fitzwilliam Museum, Cambridge.

18 Pierpont Morgan MSS. Plumb 1960, pp. 85–7.

19 Sotheby's, London, 7 July 1983, lot 100.

20 *Helene Fourment* is now in the Gulbenkian Museum, Lisbon.

21 Martin 1972, nos. 1a, 34a, 40a, 44a, 46a, 52a.

22 Photographs of the sketchbook are in the Witt Library.

23 According to Horace Walpole, they were joint works with Jan Boeckhorst, known as Lange Jan, or 'Long John'.

24 Christie's, London, 10 July 1953, lot 152, bt Reda.

25 Norfolk Record Office wkc 7/46/17.

26 Norfolk Record Office wkc 7/46/11.

27 Holkham Archive. I am grateful to Mr Frederick Jolly for drawing my attention to the Holkham picture receipts. The Hondecoeters were purchased from G. Campbell.

28 Houlditch MS, English 86.00.19–19, Victoria and Albert Museum; Lord Orford's Sale of Pictures, 1748, lots 54 and 55, sold for seventeen guineas and sixteen guineas respectively. They were both marked up as bought by the virtuoso, Dr John Bragge.

29 When the picture first came to Holkham in 1760, it was hung opposite the *Duke of Arenberg*, in the West Drawing Room. Holkham Archive MS 765. It now hangs in the saloon.

30 This version, perhaps by Gaspar de Crayer, is now in the Metropolitan Museum, New York. The possibility remains that the version now at Connecticut was the original altarpiece.

31 I am grateful to Sarah Jennings for sharing her observations as a result of her conservation work on the painting in 1987. A careful measuring of the 'seams' of the canvas reveals that the original size is close to the dimensions of the altarpiece attributed to de Crayer, now at the Metropolitan Museum, New York (2.59 × 1.77 m). The painting of the additional strips is eighteenth century.

32 As, indeed, did van Dyck in his version, now in a private collection.

33 Dawson 1817, p. 45.

34 Dawson 1817, p. 126.

35 Called the Brown or the Yellow Dressing Room in the nineteenth century.

36 Still in family ownership, this portrait is now on loan to Christchurch Mansion, Ipswich. According to a plaque on the frame, this was painted for Leathes at Ghent. Palmer 1875, III, p. 379, states 'Among these pictures there is an original portrait of the Duke of Marlborough. Preserved with the family papers was a letter announcing the gift of this portrait, but the picture itself was for many years not to be found; until at length it was discovered in an upper chamber, where it had long been used as a chimney board, and was then so covered with dirt that the subject could scarcely be discerned'.

37 Turner 1840, *View near Norwich* by John Crome.

38 Sterling and Francine Clark Art Institute, Williamstown, Massachusetts (1981.63).

39 Proctor-Beauchamp *et al.* Sale, November 1974, lot 43; Private Collection.

40 Proctor-Beauchamp *et al.* Sale, December 1974, lot 92.

41 The majority of the Langley collection is now dispersed, the Netherlandish pictures most notably through Proctor-Beauchamp *et al.* Sales: 1946, lots 57, 62, 65, 66; November 1974, lots 42, 43; December 1974, lots 89, 91; 1975, lots 121, 122; May 1980, lots 67–70, 73, 74–6; July 1980, lots 74–8. June 1947, lot 24; 11 June 1969, lots 6, 7; 25 June 1969, lots 6–8.

42 Proctor-Beauchamp *et al.* Sale, November 1947, lot 42.

III MERCHANTS AND DEALERS

1 I am indebted to the research into the life and collection of Daniel Boulter undertaken on my behalf by Robert Wenley. What follows is entirely based upon his work.

2 From Boulter's autobiography, 'copied from the original in the handwriting of Daniel Boulter, & now in the possession of his great nephew, Jos. Boulter, Chaplain at Yarmouth – D.T. [=Dawson Turner?] Feb. 1830'. In Gurney Buxton MSS Coll., NRO MS 4415, pp. 519–27.

3 Quoted by T. Southwell 'Notes on an Eighteenth Century Museum at Great Yarmouth', in *Museums Journal*, vol. 8 (July 1908–June 1909), p. 110.

4 From Boulter's Autobiography, see note 2 above.

5 By 1777 at 19 Market Place, Great Yarmouth.

6 D. Boulter *Museum Boulterianum* Catalogue (Yarmouth, 1794), from a plate stuck on to the back of the title page (Norwich Castle Museum).

7 From Boulter's Autobiography, see note 2 above.

8 Boulter [1794], p. 76.

9 *Ibid.*, title page.

10 *Ibid.*, p. 161, no. 101. 'Pannel, 2 feet 8 by 1 foot 11'.

11 *Ibid.*, p. 82, no. 23. See also cat. no. 24.

12 *Ibid.*, p. 161, no. 108, 2 ft. 4 in × 1 ft. 11 in.

13 From Boulter's Autobiography, see note 2 above.

14 I am grateful to Robert Wenley for undertaking an analysis of Harvey's correspondence on my behalf. The following account is entirely his work.

15 As such, see particularly Hawcroft 1959, pp. 232–7, which does, however, cover other areas of Harvey's life and collection, and is the basis of the following.

16 Turner 1840, under the description of his Cuyp.

17 Now in the Rembrandt–Huis, Amsterdam. Photographic copies are in the National Gallery Library, London, box AX1 69.

18 Harvey's brother, Jeremiah, became Mayor of Norwich in 1783.

19 Date unknown, but probably early 1770s.

20 Turner 1840, under the description of his Hobbema. He adds that Miss Twiss 'was the sister to Richard Twiss [author of 'Travels in Portugal, Spain, Ireland and France'] . . . and to Francis Twiss, who published the "Verbal Index to Shakespeare", and married the sister of John Kemble and Mrs. Siddons; and she inherited the talents of the family with their name'.

21 Dickes 1905, p. 126.

22 Harvey Sale 1821.

23 Quoted by Hawcroft 1959, p. 232.

24 Turner 1840, as note 16.

25 Unthank *et al.* Sale 1897, lots 180 and 146 respectively.

26 Weston Sale 1864, lots 149 and 157 respectively.

27 Turner Sale 1897, lot 190.

28 See Held 1980, p. 130; *The Princes Gate Collection*, Courtauld, 1981, p. 9, no. 12.

29 See Whitley 1928, vol. ii, pp. 201–3.

30 There are references to at least twenty-two letters from Harvey in reply.

31 For this, and all subsequent quotations, see note 17 above. I am indebted to Liz Buckton and Sara Barton-Wood for translating these letters.

32 See postscript of letter dated 9 May 1786.

33 Possibly that later in the Muskett collection. See cat. no. 26.

34 Eg. letters dated 5 August 1785, and 28 March 1778.

35 At least eight were sent.

36 Eg. see letter dated 30 May 1786.

37 Letters dated 31 August 1787, and 25 October 1787.

38 Letters dated 2 May 1786, and 14 June 1785 respectively.

39 Letters dated 2 May 1786, and 27 February 1787 (postscript).

40 Letter dated 23 June 1789.

41 Letter dated 25 February 1785.

42 Turner 1840, included in his description of Cuyp's *Man giving Provender to a Horse*.

43 Harvey 1912, p. 52.

44 Onley Savill-Onley Sale, Christie's, 16 June 1894.

45 Savill-Onley Sale 1894, lot 81; de Groot 1928, X, no. 158.

46 Savill-Onley Sale 1894, lot 88; de Groot 1913, V, no. 199. Now John G. Johnson Coll., No. 504, in the Philadelphia Museum of Art.

47 British Institution 1835 (139). De Groot 1916; VI, no. 966. This cannot plausibly be traced in Bredius.

48 Harvey 1912, pp. 48–50; the source of these and the following quotations.

49 Chambers 1829, I, p. 21a.

50 Harvey Sale 1842, lot nos. 235–311.

51 Quoted in Fawcett 1974, p. 104.

52 Haydon's *Diary*, August 1817, quoted in Fawcett 1974, p. 104.

53 Dawson Turner MS, *Journal of a Tour to France*, 1815–16, Woodward Arley Gift, Norwich Castle Museum, 1970.

54 Turner 1840 is the source of most of this information.

55 Palmer 1872, I, p. 337.

56 Chambers 1829, I, pp. 305–6.

57 Druery 1826, pp. 116–20. Fawcett 1974, p. 100, misread this collection as belonging to Sir Edmund Knowles Lacon. See also Chambers 1829, I, pp. 251–3.

58 Palmer 1872, II, pp. 363–4; Chambers 1829, I, pp. 306–7.

59 Rye 1913, p. 662.

60 The house was later demolished and became the site of a Congregational Chapel and St George's Hall.

61 J. Penrice (ed.), *Letters Addressed to the late Thomas Penrice Esq. 1808–14* (n.d.). The following account is based upon these letters.

62 Now in the National Gallery.

63 Enclosed in a letter from Buchanan to Penrice, 16 November 1808.

64 All subsequently bought by the Marquis of Westminster, according to John Penrice.

65 26 April 1809.

66 Chambers 1829, I, p. 305.

67 10 January 1810.

68 30 July 1811.

69 12 July 1811.

70 Engraved by F. Dequevauvillers; drawn by Mancet; Christie's, London, 6 July 1844, lot 8.

71 Engraved by R. Daudet 1789; *ibid.*, lot 15.

72 An account of the sale appears in the *Athenaeum*, 1844, pp. 650–1.

73 Druery 1826, pp. 151–52.

74 His paintings by Hobbema (de Groot 1912, IV, no. 45), Ruisdael (de Groot 1912, IV, no. 787) and attributed to van Goyen (de Groot 1927, VIII, no. 691) were all purchased from G. Morant's collection sale, 1832.

75 The collection was already quite considerable when published by Chambers 1829, II, p. 803.

IV JOHN PATTESON

1 John Patteson, to Martha Patteson, Senigallia July 1779, Norfolk Record Office (see note 3 below).

2 The following account of John Patteson's life is entirely based upon Isabella K. Patteson's first chapter of *Henry Staniforth Patteson, A Memoir*, 1899, pp. 4–31.

3 Norfolk Record Office, Patteson papers, Q171B, box 3.

4 The following brief account of Patteson's grand tour is based upon Moore 1985, pp. 69–73, 157–8.

5 Leipzig, 1 August 1778.

6 Bologna, 22 November 1778.

7 19 July 1779.

8 Moore 1985, pp. 157–8.

9 Raines 1978–80, p. 34, Macro A.

10 Patteson Sale 1819, 1st day, lot 122; Dickes 1905, p. 126.

11 Raines 1978–80, p. 21.

12 *Ibid.*, p. 21.

13 *Ibid.*, Appendix D.

14 *Ibid.*, p. 23.

15 Patteson Sale 1819, 1st day, lots 70, 71.

16 *Ibid.*, 1st day, lot 112.

17 *Ibid.*, 2nd day, lots 18, 29.

18 Norwich 1828 (72, 75).

V NORWICH AND LONDON

1 *Norwich Mercury*, 12 September 1812.

2 22 February 1808, North Yorkshire County Record Office.

3 Westmacott 1824, p. 75.

4 *Ibid.*, p. 176.

5 I am indebted to Giles Waterfield for supplying me with proofs of his important survey, *'Rich Summer of Art': Dulwich College Picture Gallery 1817–1918 A Georgian picture collection seen through Victorian eyes* 1987. Much of what follows is based upon this work.

6 *Collection for a King: Old Master Paintings from the Dulwich Picture Gallery*, exhibition catalogue, 1985. Introduction by Giles Waterfield, p. 12.

7 Waterfield 1987, *op. cit.*

8 *Ibid.*

9 Aelbert Cuyp was particularly influential for British artists. In this respect it is important to record examples by or attributed to Cuyp in Norfolk collections (Cuyp's influence upon Crome is also arguably filtered through the work of Richard Wilson): Crome Sale 1821, 1st day, lot 60 *Fishmarket, at Scheveling* and lot 85 *Camp Scene*; Patteson Sale 1819, 2nd day, lot 80; Symonds Collection, Druery 1826, p. 120; Stacy Collection, exhibited Norwich 1828 (60); Curr Collection, exhibited Norwich 1829 (61); Muskett Collection, Unthank *et al.* Sale 1897, 2nd day, lot 142; Dawson Turner Collection, Turner 1840, no. 14 (de Groot 1909, II, no. 510); West Collection, West Sales 1835, lot 53, and 1843, 1st day, lots 33, 43 and 2nd day, lot 38; Gunthorpe Collection, Gunthorpe Sales 1842, lot 14, bt in, and 1853, lot 105; Weston Collection, Weston Sale 1864, 1st day, lot 174.

10 Murray 1980, no. 168.

11 Dawson Turner correspondence, Trinity Library, Cambridge. I am indebted to Charlotte Crawley (née Miller) a copy of whose unpublished dissertation, 'Captain Manby and the Joy Brothers', she kindly deposited with Norwich Castle Museum.

12 M.A. Shee, *Elements of Art*, 1809, p. 86.

13 Victoria & Albert Museum, National Art Library, 200.B.23: British Institution exhibition catalogues 1813–24.

14 *Ibid.*

15 Victoria & Albert Museum, National Art Library, RCV 12, British Institution, Minutes, vol. II, 18 July 1815.

16 *Ibid.*, 23 July 1812.

17 *Ibid.*, 25 January 1819.

18 *Ibid.* I am indebted to Robert Wenley for his researches undertaken on my behalf into the life and collecting of Lord Charles Townshend. What follows is entirely based upon his work.

19 Rye 1913, p. 932.

20 White 1926, XII, pt 1, p. 812.

21 Chambers 1829, I, p. 543.

22 *Ibid.*

23 Townshend Sale 1819, lot 27. De Groot, 1910, III, no. 650.

24 Townshend Sale 1819, lot 31. De Groot 1923, VII, no. 230. Charles Townshend owned another van de Velde, National Gallery, London, no. 872.

25 London 1818 (94); Townshend Sale 1819, lot 30.

26 Townshend Sale 1835, lot 50, bt Woodin; A. de Rothschild; exhibited L. Koetser Gallery, 1953. London 1828 (80); Norwich 1829 (20). Waagen 1854, III, p. 439 mentions 'a fine village festival by TENIERS', at Raynham Hall. Although this is probably a reference to the picture sold in 1835, Waagen never visited Raynham and was possibly using out-of-date information. See also Durham 1926, 1810 Inventory: 'A Capital picture of Boors at Play. D. Teniers . . . 100.00', which might well be the *Village Fête* sold in 1835. It was not included in the Townshend 1904 sale.

27 Townshend Sale 1835, lot 48. De Groot 1926, IX, nos. 215 and 696.

28 Townshend Sale 1835, lot 41. De Groot 1923, VII, no. 297.

29 Townshend Sales 1819, lot 25, bt in; 1835, lot 40, bt in; 1836, lot 53. De Groot 1923, VII, no. 378.

30 Townshend *et al.* Sale 1824, lot unknown. De Groot 1907, I, nos. 478, 463, 697, 614d, and possibly 420. Maurice Kann Sale, Paris, 9 June 1911, lot 69; Fischof Sale, Paris, 14 June 1913; Agnew's, by 1946; R.P. Silcock, by 1974; Australian collection (private). London 1974 (10).

31 Townshend *et al.* Sales 1836, lot 55, withdrawn; 1849, lot 110.

32 Townshend *et al.* Sale 1851, lot 75. De Groot 1926, IX, no. 128.

33 Townshend Sale 1854, 61 lots. Another (Townshend *et al.* Sale) 1860, 2 lots.

34 Norwich Castle Museum.

35 Norwich 1829 (16, 20, 22, 31, 36, 72).

36 *Norwich Mercury*, 17 October 1829.

37 I would like to record my gratitude to Dr Christopher Wright for a number of observations he made during discussions concerning the early work of Hobbema and the question of Hobbema's influence upon Crome.

38 Clifford 1968, pp. 90–91.

VI LATER COLLECTORS

1 I am indebted to Robert Wenley for his research into the life and collecting of Sir Jacob Astley: what follows is entirely his work.

2 Rye 1913, p. 8.

3 *Norfolk Archaeology*, 1923, XXI, p. xxvi.

4 Astley 1936, unpaginated.

5 See also cat. no. 14, footnote no. 1 for a portrait, dated 1617, possibly of Agnes Impel, or more probably of her mother. According to Palmer 1872, I, p. 361, the Astley family 'obtained a number of portraits', which were arranged at Melton Constable in 'The Bransby Room', as well as 'an important addition of fortune' by the marriage of Sir Philip Astley (second baronet, died 1738) to the daughter of the merchant Thomas Bransby. Whether any of these pictures were Dutch or Flemish is, however, unclear.

6 See Appendix II.

7 *Ibid.*

8 *White 1926, VI, pp. 367–8.*

9 *Norfolk Archaeology*, 1923, XXI, p. xxvii. He also collected 'French furniture and china . . . [and] Oriental porcelain'.

10 Chambers 1829, II, pp. 786–791.

11 That listed in 'North Dining-Room', Chambers 1829, II, p. 788, possibly de Groot 1923, VII, 575a; and possibly exhibited by H.P. Hope, London 1818 (102 or 104).

12 Hastings *et al.* Sale April 1975, lot 53. Now private collection, Germany.

13 Hastings *et al.* Sales October 1975, lot 132 (pair), bt in; 1976, lot 121 (pair). Exhibited Norwich 1958 (11 and 12).

14 Hastings *et al.* Sale April 1975, lot 49. Exhibited Norwich 1966 (33).

15 Hastings *et al.* Sale July 1931, lot 105.

16 Possibly de Groot 1913, V, 96, given its Paris provenance.

17 De Groot 1912, IV, 141; Graves 1970, II, p. 341.

18 Possibly de Groot 1927, VIII, 284. Hastings *et al.* Sale April 1975, lot 48.

19 Hastings *et al.* Sale 1945, lots 87 and 88.

20 Hastings *et al.* Sale April 1975, lots 55 and 56.

21 Graves 1970, II, p. 295. Hastings *et al.* Sale 1945, lot 83; Sotheby's, 25 March 1981, lot 11.

22 Two other Dutch works were, Chambers 1829, II, p. 790: 'Portico Room. A Head – Rembrandt', and p. 791: 'Bird-Room. Interior of a Church – Bassan.' For the latter: see Keyes 1984, p. 178, no. xxv.

23 Hastings *et al.* Sale 1945, lots 78 and 79 respectively (both pairs).

24 Hastings *et al.* Sale 1950, lot 86.

25 Hastings *et al.* Sale April 1975, lots 50 and 51 respectively.

26 Duleep Singh 1927, II, p. 38, no. 151; Hastings *et al.* Sale 1950, lot 91.

27 *Ibid.*, p. 34, no. 137. Hastings *et al.* Sale 1950, lot 97.

28 (?) *Ibid.*, p. 44, no. 174. Hastings *et al.* Sale 1950, lot 98.

29 *Ibid.*, p. 36, no. 143. Hastings *et al.* Sale 1950, lot 95. Graves 1970, III, p. 117.

30 Astley, *op. cit.*

31 Quoted by G. Nares, 'Wolterton Hall', *Country Life*, July 1957, pp. 116–19, 166–9.

32 Chambers, I, p. 217e.

33 British Museum, 1902–5–14–158.

34 Waagen 1854, III, p. 436.

35 Comte de Pourtalès, Phillips, London, 19 May 1826, lot 59.

36 Walpole Sale 1856, 3rd day, lot 268, purchased by Walpole.

37 *Ibid.*, lot 266.

38 National Gallery, Dublin, no. 916; Slive and Hoetink 1982, p. 89.

39 Walpole Sale 1856, 3rd day, lots 220, 232, 242, 243, 244, 252 and 272.

40 Patteson Sale 1819, 2nd day, lot 82.

41 Narford library MS. p. 332.

42 Fountaine Sale 1894, lot 34.

43 Narford Library, 'Family Book', p. 91.

44 Smith 1830, II, no. 804, and 1842, Supplement, no. 205; now Antwerp, Koninklijk Museum voor schone Kunsten, no. 781.

45 Private Collection.

46 Frick Collection.

47 Fitzwilliam Museum, Cambridge.

48 British Institution 1819 (40).

49 Gibson's diary, quoted Kitson 1937, p. 297.

50 Private Collection.

51 Druery 1826, p. 80.

52 Slive 1970, I, pp. 63–6 and I, no. 16.

Colour figures

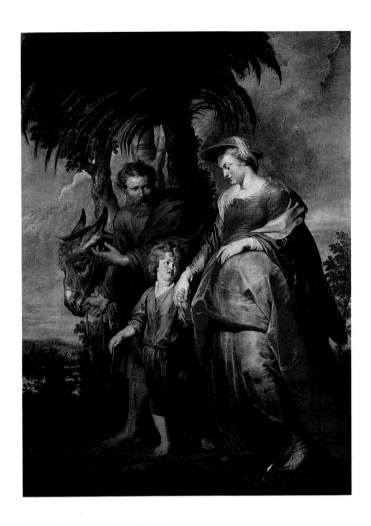

colour figure 1
Peter Paul Rubens (1577–1640)
The Return from Egypt *c.* 1618–19
oil on canvas 287 × 208 cm
Viscount Coke and the Trustees of
the Holkham Estate

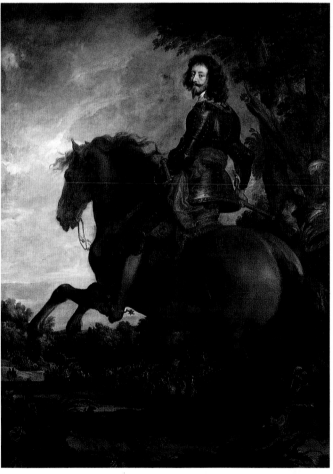

colour figure 2
Anthony van Dyck (1599–1641)
The Duke of Arenberg
oil on canvas *c.* 300 × 222.5 cm
Viscount Coke and the Trustees of
the Holkham Estate

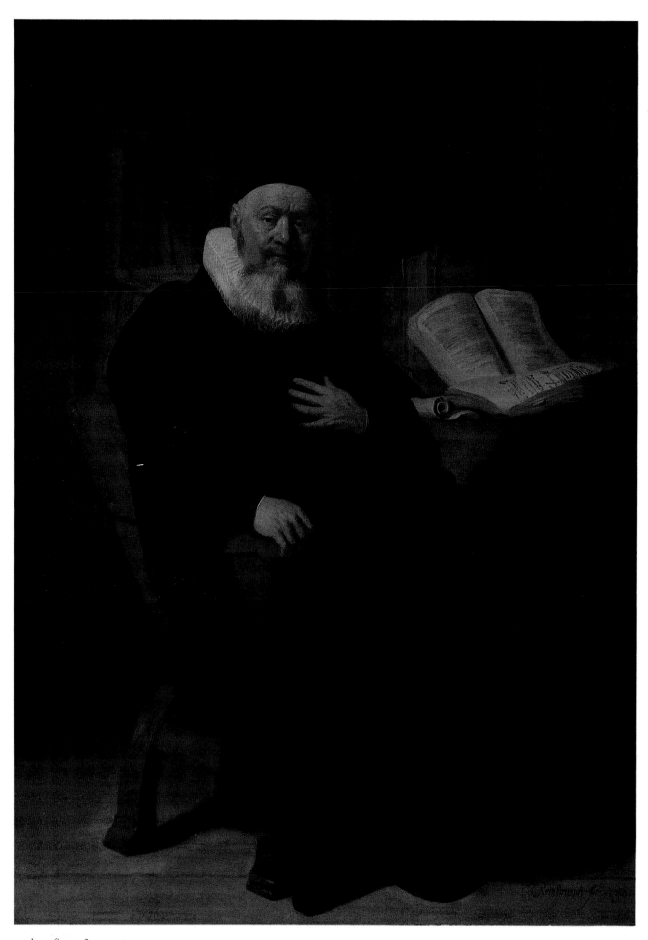

colour figure 3
Rembrandt Harmensz. van Rijn (1606–1669)
Portrait of the Reverend Johannes Elison 1634
oil on canvas 171 × 122.5 cm
Museum of Fine Arts, Boston, Mass., USA

colour figure 4
Rembrandt Harmensz. van Rijn (1606–1669)
Portrait of Maria Bockenolle, wife of Johannes Elison 1634
oil on canvas 173 × 125 cm
Museum of Fine Arts, Boston, Mass., USA

colour figure 5
Unknown artist
The Annunciation and *The Temptation of St Anthony* *c.* 1510–20
oil on panel
A South Norfolk Church

Colour plates

pl. i cat. no. 4
Master of the Legend of the Magdalen
The Seven Sorrows of Mary (The Ashwellthorpe Triptych) *c.* 1512–20

pl. ii cat. no. 10
Tin-glazed earthenware vessels made in the Netherlands early 1500s – mid 1600s,
excavated in Norwich

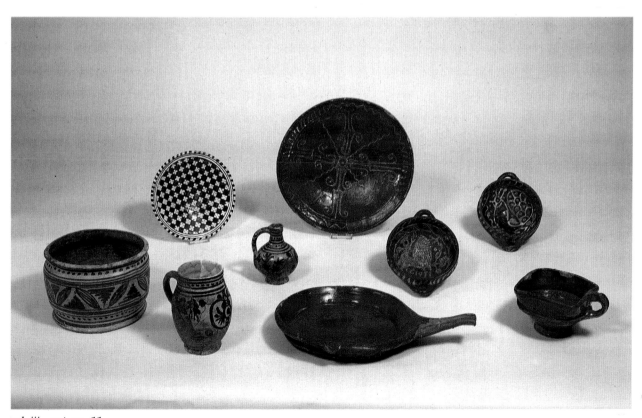

pl. iii cat. no. 11
Tin-glazed earthenware made in the Netherlands or England and Glazed red earthenware
made in Holland early–mid 1600s, excavated in Norwich

pl. iv cat. no. 113
Jan Davidsz. de Heem and Daniel Seghers
Head of Christ 1641

pl. v cat. no. 117
Jan van Huysum
A group of fruits and flowers

pl. vi cat. no. 15
Dutch School
The Yarmouth Collection c. 1665

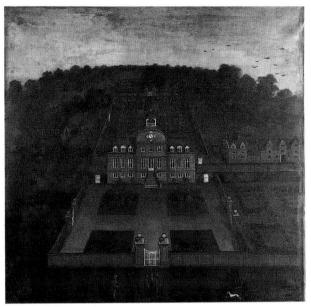

pl. vii cat. no. 19
Anglo–Dutch School
Ryston Hall, Norfolk c. 1672

pl. viii cat. no. 20
Anglo–Dutch School *View of Norwich c. 1707*

pl. ix cat. no. 24 Studio of Frans Snyders *A Fruit Stall c. 1650s*

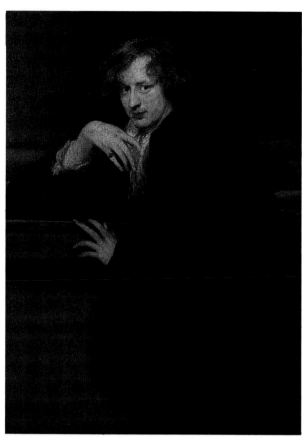

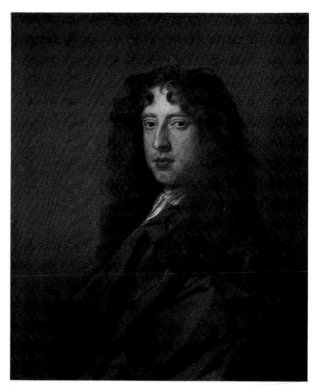

pl. xi cat. no. 18
Peter Lely
Roger North c. 1680

pl. x cat. no. 13
Anthony van Dyck
Self-portrait c. 1621

pl. xii cat. no. 23
Aert de Gelder
Esther and Mordecai c. 1685

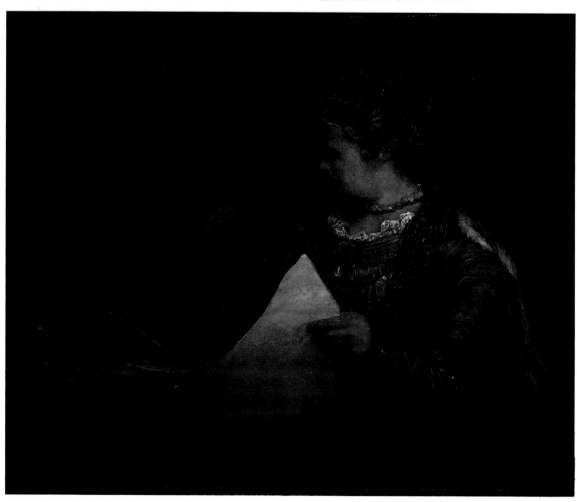

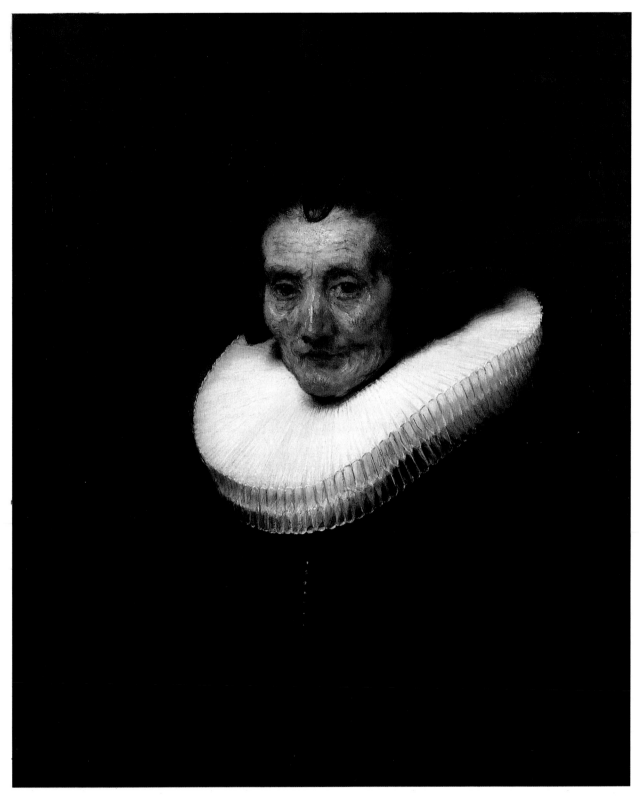

pl. xiii cat. no. 85
Rembrandt Harmensz. van Rijn
Portrait of Margaretha de Geer, wife of Jacob Trip 1661

pl. xiv cat. no. 48
Jan van Goyen
Landscape with travellers arriving at a wayside inn 1643

pl. xv cat. no. 67
Attributed to Jan van Goyen
Estuary scene with shipping c. 1650s

pl. xvi cat. no. 51
Adam Pynacker
A Landscape, evening c. 1660s

pl. xvii cat. no. 65
Jacob van Ruisdael *Landscape*

pl. xviii cat. no. 115
Jacob van Ruisdael *Landscape with a cloudy sky*

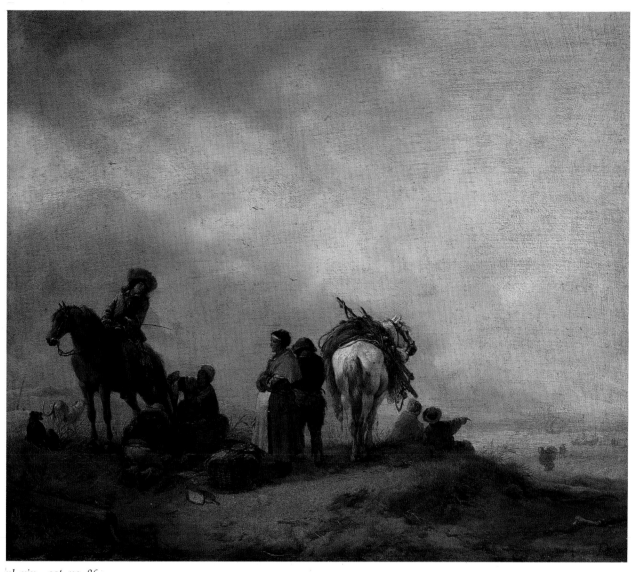

pl. xix cat. no. 86

Philips Wouwermans *A view on a seashore, with fishwives offering fish to a horseman*

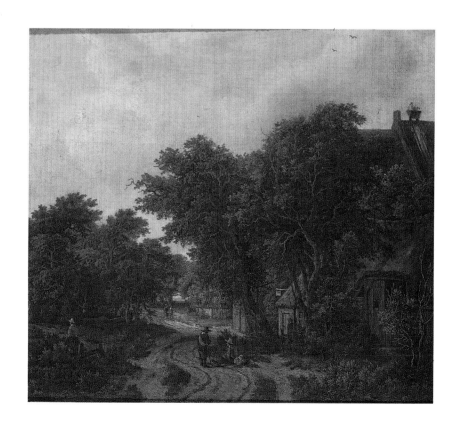

pl. xx cat. no. 59

Meindert Hobbema

Road-side inn c. 1660s

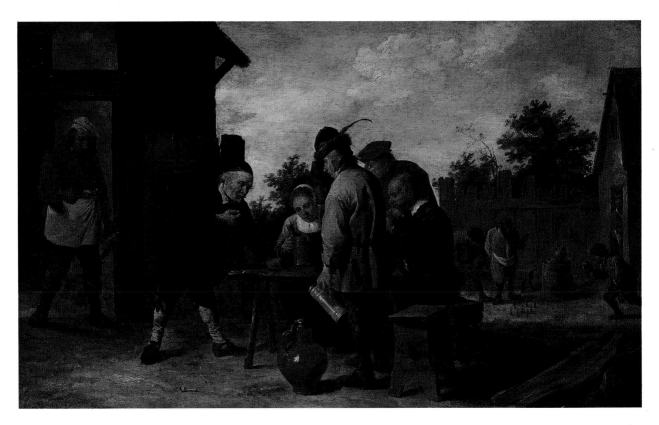

pl. xxi cat. no. 61
David Teniers II
Dice and skittle players before an inn

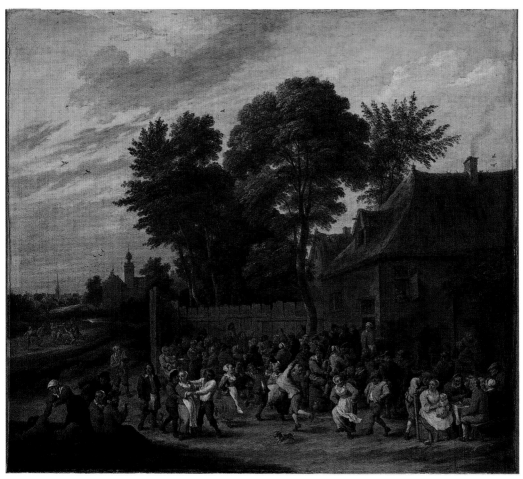

pl. xxii cat. no. 60
David Teniers II
Peasants dancing and feasting

pl. xxiii cat. no. 73
Cornelis Gerritsz. Decker
A Sluice – wooded landscape with figures on a path

pl. xxiv cat. no. 72
Abraham Hondius
The Stag hunt c. 1675

pl. xxv cat. no. 80
Peter Tillemans
Little Haugh Hall, Suffolk c. 1720s

pl. xxvi cat. no. 83
Peter Tillemans
Horse with groom and hounds 1734

Catalogue

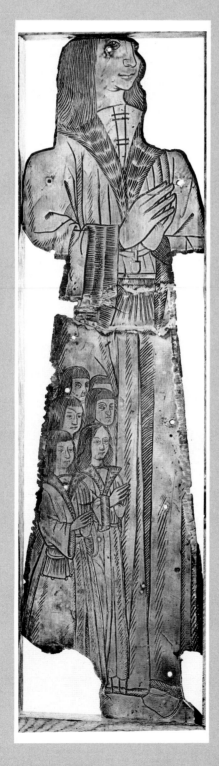

cat. no. 1 *Monumental Brass of a man with six sons*
Norwich *c.* 1495

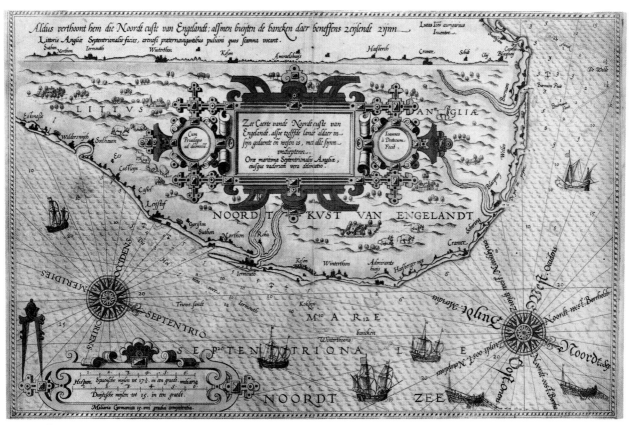

cat. no. 5

cat. no. 21

I Norfolk and the Netherlands

cat. no. 1

Abbreviations

bt	bought	Lit.	Literature	
cat. no.	catalogue number	max. w.	maximum width	
coll.	collection	NCM	Norwich Castle Museum	
d.	died	NRO	Norfolk Record Office	
diam.	diameter	p.	page	
Exh.	Exhibited	pl.	plate	
ht.	height	Prov.	Provenance	
illus.	illustrated	t.r.	top right	

1 Monumental Brass of a man with six sons[1]

Norwich, *c.* 1495

Replica 82.5 cm

Original *illustrated* above and p. 79

Original in a Norfolk church

Lit: J. Page-Phillips, *Palimpsests: the Backs of Monumental Brasses*, London, 1980, p. 82 and pl. 149 (no. 43N1–3).

This figure was re-used for another brass *c.* 1560 by turning it over and engraving on the reverse. Such brasses are known as palimpsests. The figure was presumably taken from a tomb during the stripping of church goods at the Reformation, and sold to a brass-engraver for re-use. The figure on the earlier side, shown here, belongs to a group engraved in Norwich around 1500 which show the influence of Flemish brass-engraving. Compared with the stilted drawing of brasses made in London at this time, the depiction of the semi-profile pose and the details of the hair are impressively naturalistic. The absence of such treatment in London-made brasses suggests that Norwich was not dependent upon the capital for influences from the Low Countries, but was assimilating them more directly. The naturalistic impression was originally striking in such figures, because the engraved lines 'read' as dark and the polished surface as light.

There are close stylistic links between this group of brasses and stained glass made in Norwich. It has been suggested that a glazier, William Heyward, from whom a brass was ordered in about 1503, was involved in their design.[2]

1 I am indebted to Robin Emmerson for writing this catalogue entry.

2 R. Greenwood and M. Norris *The Brasses of Norfolk Churches*, Norfolk, 1977, p. 28.

2 Lucas van Leyden[1]

Leiden 1494 – Leiden 1533

St Peter *c.* 1511

Illustrated p. 82
Engraving 10.5 × 7.05 cm

Lit: *Lucas van Leyden*: Friedlander 1924, p. 40; Lavalleye 1967, pl. 51; Vos 1978, no. 86; Amsterdam 1978, exhibition catalogue, B. 87.
Martin Schongauer: Shestack 1969, nos. 45 and 46; Hutchison 1980, nos. 34 and 35.
Israhel van Meckenem: Koreny 1981, nos. 52 and 53.

Trustees of the British Museum

This engraving of St Peter, from a series consisting of Christ and the twelve Apostles, was used for the figure of St Simon Zelotes on the chancel screen in the church of St Mary, Worstead, 1512. The painted panel[2] is one of a series of sixteen which form the principal imagery of the chancel screen, the twelve apostles in the central bays, St William of Norwich and St Wilgefortis in the extreme southern bay, and in the northernmost bay, Christ and a second St Peter. The two last-mentioned panels at the far northern end of the screen date from the early nineteenth century, and replace lost originals. The sixteen panels are the work of six different hands. The figures were all painted out in the mid-sixteenth century. A number of the panels have been cleaned recently by Pauline Plummer, but overpaint still adheres to the image of St Simon in places.

Lucas van Leyden's engraving of the Apostle St Peter shows a magnificent figure striding towards the right,

cat. no. 2

figure 50:
after Lucas van Leyden
(1494–1533)
St Peter
oil on panel 59.5 × 23 cm
Worstead Church, Norfolk

dish artists of the day, and the Worstead painter was taking the latest and most fashionable Continental example for his model. It is, however, possible that the panels did not receive their images until some years after the screen was constructed.[3]

The other figures by this master on the Worstead screen reveal Continental influence in the heavy colour-saturated material and the angular broken folds of their garments, and there is a distinctly Netherlandish caste to some of their faces. But none of them can be shown to have been copied directly from a particular foreign model. However, one of the four other artists responsible for the original figured panels on this screen did make use of Continental prints. The figures of Saints Peter and Andrew are taken line for line from an engraved Apostle series copied from the Apostle sequence of the great Colmar artist, Martin Schongauer, probably from the versions by Israhel van Meckenem.

1 I am indebted to John Mitchell for writing this catalogue entry.

2 The surface carrying the image, within its ogee frame, measures *c.* 59.5 × 23 cm. However the painted panel continues both upwards behind the elaborate openwork blind tracery above the ogee, and downwards behind the tracery at the foot of the screen, and its full height is something over 109 cm.

3 Cotton 1987, p. 45.

3 (a) The monogrammist FVB[1]

The Annunciation c. 1490

Illustrated p. 83
Engraving 20 × 15.7 cm

(b) Lucas van Leyden

Leiden 1494 – Leiden 1533

The Temptation of St Anthony 1509

Illustrated p. 2
Engraving 18.2 × 14.5 cm

Lit: *The monogrammist FVB*: Bartsch 1886, pp. 77–90;
Lehrs pp. 121–3; Hollstein n.d., p. 144; Thieme and Becker 1949, p. 395; Hutchison 1980, p. 166, no. 3.
Lucas van Leyden: Friedlander 1924, p. 39, pl. XVI; Lavalleye 1967, pl. 33; Amsterdam 1978, exhibition catalogue, pp. 30–1, no. 18; Marrow *et al.* 1981, p. 251, no. 117; Jacobowitz and Stepanek 1983, pp. 74–5, no. 18.

Trustees of the British Museum

supporting a large book in the crook of his left arm, and holding up a key in his right hand. His mantle, which is fastened at the neck by a cord, and gathered up in his left hand, billows around him as if caught by a strong wind. The painter of the Apostle on the screen at Worstead quite clearly had Lucas's print in front of him when he designed his figure. The only substantial changes he made were in the characterization of the head and in the saint's emblem, now the fish of Simon. In all else he followed his model in almost every line and turn, so much so that he ended up cramping his figure uncomfortably within the bounds of his panel. The flying cloak, which has ample space on the relatively wide field of the engraving, cuts behind the frame which surrounds the painted panel. The proportions of the panel on the late Gothic screens were incompatible with the full and ponderous Renaissance proportions of Lucas's figure.

In 1512, the date recorded on the Worstead screen, Lucas van Leyden's Apostle series was only a year or two old. Lucas was the brilliant rising star among Netherlan-

The painter of the chancel screen in a South Norfolk church, took as his model these two engravings for the panels of the Annunciation and the Temptation of St Anthony. A bequest was left by one Stephen Brom, in 1500, for the construction of the screen, but the panels cannot have been painted until *c.* 1510–1520.[2] These are the only two surviving painted panels of the chancel screen. They were set in the bay of the screen which stood immediately to the south of the central doorway. The other twelve remaining panels of the screen are now plain and unadorned. Some carry scant traces of paint, but it is

cat. no. 3 (a)

figure 51:
After the monogrammist FvB
The Annunciation
oil on panel 34.5 × 19.75 cm
A South Norfolk Church

unclear if these date from the same time as the painting on the two surviving panels. It is possible that the decoration of the screen was never completed. The two surviving images have suffered grievous damage, presumably at the hands of iconoclasts in the sixteenth century.

For both panels the screen painter reproduced the original engravings detail for detail and line for line. However, as was the case with the Apostle at Worstead, the proportions of the panels in the screen led the artist to cramp the compositions. In the Annunciation, the magnificent crumpled train of the Virgin's robe overrides the Angel's tunic, the expanses of tiled floor in the background are no longer visible, and the *prie-Dieu* at which Mary kneels has been reduced and simplified. In the Temptation of St Anthony, the ascetic of the Egyptian desert and the traditional founder of the Christian monastic way of life, the various elements have been brought closer together. The left-hand edge of the composition has been curtailed, the beetling crags and hanging woods of the left horizon rise higher up the picture, and delicate little clouds and a few birds now drift across the sky. But, in other respects, the painter has followed the prints with extraordinary fidelity. Of course he has added colour, and has given the Annunciate Angel and the horned temptress magnificently decorated robes for which there was no cue in his models.

The bays of the screen are remarkable for the way in which almost equal space is given to the cusped and crocketted blind ogees and lancets above, and to the painted fields below. The rectangular areas reserved for the painted compositions are extraordinarily squat for a late Gothic screen. It is as though the carpenter had designed the screen, with its relatively broad and short panels, specifically to take images whose proportions were similar to those of these engravings, in which the width of the plate is roughly three-quarters of its height,

rather than for the tall swaying figures of saints found on the great majority of screens in East Anglia. It seems probable that the fence of the screen in this south Norfolk church was specially designed to carry a gallery of images, apparently scenes rather than single figures, copied directly from engravings imported from across the North Sea. To judge from the two surviving compositions, these were a mixed bag, but were of the highest quality. The monogrammist FVB had been the leading graphic artist in the area of Bruges in the last quarter of the fifteenth century, and Lucas van Leyden was preeminent in the northern Netherlands in the second decade of the sixteenth century, the very years in which this screen was probably constructed and painted. The identity of the artist is not known, but to judge from his manner of painting, it is likely that he had been trained in the Netherlands.

The relationship between the Annunciation on the screen and Lucas van Leyden's engraving was first noticed over eighty years ago by E.F. Strange.

1 I am indebted to John Mitchell for writing this catalogue entry.

2 Dimensions: painted field – 34.5 × 19.75 cm (Annunciation); 34.2 × 20.25 cm (Temptation of St Anthony). Height of panels, including the traceried upper half – 62.5 × 20.25 cm. Overall height of the fence of the screen – 240 cm.

4 Master of the Legend of the Magdalen[1]

c. 1490 – c. 1525

The Seven Sorrows of Mary *c. 1512–1520*

'The Ashwellthorpe Triptych'
Illustrated colour plate i

Panel: central panel, 83.9 × 64.2 cm; wings 83.8 × 26.7 cm

Prov: By descent to Edmund Knyvett of Ashwellthorpe;
by descent to the Wilson family of Didlington
Hall; at Keythorpe, Leicestershire in 1908;
Viscount Lee of Fareham by 1923; Private
collection; T. Agnew & Son Ltd; from whom
purchased by Norwich Castle Museum, 1982.
(46.983)

Exh: London 1982 (16)

Lit: Chambers 1829, III, p. 1343 as by John de Mabuse;
Borenius 1923, no. 28; Friedlander 1975, XII, p. 91,
no. 9, pl 6.

Norfolk Museums Service (Norwich Castle Museum)

This altar-piece, commonly known as the Ashwellthorpe
triptych, survives as a remarkable testimony to the
earliest known commission of a Flemish painter by a
Norfolk family. The name-saints depicted on the wing
panels identify the donors as Christopher and Catherine.
Christopher's arms are Knyvett quartering Clifton, differ-
enced by a martlet (or swan). Knyvett quartering Clifton
was borne by Sir William Knyvett from 1491, when at the
age of 51 he was found to be cousin and heir to Sir Robert
Clifton. These arms were depicted in the south chapel
window of New Buckenham Church along with the
paternal arms of Sir William's wives.[2] His descendants
were therefore able to bear the arms in this form.
Catherine's arms are her paternal arms impaled by his:
hers are not English, for they have a saltire broaching
upon a fess, such as borne by the Brabanter house of
Grimberghen and its various branches and vassals,
including Assche and some patrician houses in Brussels.[3]
The identification of both coats is complicated by the fact
that areas of the tinctures now appear, inaccurately, to
contain no silver, being coloured gold. According to the
recorded arms of the family these areas should be silver
and not gold. However, recent stereo microscopic analy-
sis of the arms has confirmed that the appropriate areas
were indeed once silver. The silver leaf areas, long since
oxidized black, have now disappeared, leaving only odd
traces over the original ground. These 'gold' areas look
quite different from the gold leaf visible where the arms
should be gold, in the chequered pattern.[4]

Little is known of the life of Christopher Knyvett.
Surviving records suggest that his livelihood was depen-
dent upon his court connections. He no doubt owed his
place at court to his two elder brothers Thomas and
Edmund. Sir Thomas was made Master of the Horse in
1510, and married the daughter of Thomas Howard, Duke
of Norfolk and Lord High Admiral. Edmund Knyvett as
Sergeant Porter to Henry VIII was exceptionally well
placed to secure appointments and favours for his
relatives. Christopher was in the Netherlands in 1512 on a
mission to Margaret of Austria and the following year
took part in the military campaign which captured
Tournai. In 1515 the King rewarded him with a grant of
lands in Tournai. Throughout the period 1514–1520 he
seems to have received an annual salary of twenty
pounds as a royal official.[5] After 1520 Christopher

Knyvett ceases to figure in the records and this is
probably to be explained by his death.

The triptych provides the only evidence of Christopher
Knyvett's marriage. Catherine's arms suggest that she
was a member of either the related van Grimberghen and
van Assche families (who were centred on Brussels) or
from a Flemish group of families who have been
identified as Maelstede-Moerseke-Lessinghers. Cather-
ine Knyvett's arms provide a further problem in that her
escutcheon, hanging on the tree, is lozenge-shaped.
English heraldic practice suggests that the lozenge shape
denotes the lady to be a widow. However, Andrew
Martindale has argued that virtually all female arms
painted in early Netherlandish works in similar circumst-
ances at this period are in lozenges, suggesting that the
shape was simply normal practice.

The triptych has been attributed by Friedlander to an
unidentified artist whom he calls the Master of the
Legend of the Magdalen. He also tentatively identifies the
artist as Pieter van Coninxloo, a member of a prolific
Brussels family of painters. Friedlander points out that,
despite the very conservative style of the Master, he
attracted court patronage over a considerable period and
accounts for this by the artist's reliability in the accurate
depiction of heraldry.[7] Martindale has, however, pointed
out that the artist showed considerable originality in
depicting the Seven Sorrows of the Virgin Mary in the
form of a visual pilgrimage through the landscape.[8] This
approach to the iconography of the subject is unique, the
usual solution in the early years of the sixteenth century
being to surround the Virgin with seven small roundels
each containing a scene. The popularity of the subject in
Flanders seems to have been given impetus by the
foundation of a Confraternity in Bruges, which received
papal authorisation in 1495, whose object was the
veneration of Our Lady of the Seven Sorrows. The seven
sorrows are echoed, in the Triptych, in the grisaille figure
of David lamenting over the head of Absalom, featured in
the architecture above the Virgin Mary.

Recent examination of the triptych under infra-red
light revealed the truth of Friedlander's perceptions with
regard to this artist. In his judgement 'the master was
heavy-handed – but his hand was also sure in its graphic
emphasis of the main features while neglecting detail. He
worked with a certain routine born of long experience'.
The underdrawing displays all the 'graphic emphasis'
one would expect to find in the drawing of his Flemish
contemporaries, but with an economy that is indeed
routine (see fig. 5). Nevertheless, his underdrawing does
also show a concern for natural realism: only under
infra-red light is it possible to discern the care with
which the artist outlined the branch structure of the
bushes and trees behind the Virgin.

The precise date of the triptych remains a matter of
debate. 1520 is perhaps the latest date that may reason-
ably be suggested given the probable date of Christ-
opher's death and the possibility that the commission
might commemorate that fact. It is, however, perhaps
more probable that Christopher himself commissioned
the painting when in Brussels, conceivably in 1512.[9]

1 I am indebted to my colleague Robin Emmerson for the
greater part of the original research connected with the
Ashwellthorpe triptych, together with the substance of
much of this catalogue entry. I am also most grateful to
Professor Andrew Martindale for his sustained interest

in the triptych and for providing me with a copy of his paper 'The Ashwellthorpe Triptych' in advance of publication.

2 Thomas Martin's church notes, NRO Rye Ms 17 p. 1 and cf. *Norfolk Archaeology*, XV, 1904.

3 Van de Put quoted in Borenius 1923, no. 28. See also Martindale 1988.

4 I am grateful to Robert Bruce-Gardiner for having undertaken to examine the triptych, taking micro-photographs, X-radiographs and infra-red sectional photography (see fig. 5).

5 Martindale 1988 acknowledges the help of Dr Roger Virgoe of the University of East Anglia over the history of the Knyvetts for this period.

6 Friedlander 1975, XII, pp. 13–17.

7 The two closest parallels to the Ashwellthorpe Triptych are an *Annunciation* (Musées Royaux des Beaux-Arts de Belgique, Brussels) and a *Lamentation* (whereabouts unknown).

8 The seven sorrows are, in turn, the Presentation, the Flight into Egypt, Christ seated amongst the Doctors, the Road of Golgotha, the Crucifixion, the Deposition and the Entombment.

9 David King has pointed out that Thomas Martin records a label formerly on the frame, with the date 1519.

5 Johannes Doetichum

Dutch School *fl.* 1580s

Chart of the Norfolk-Suffolk Coast 1586

Illustrated p. 80

Engraving with bodycolour 33.3 × 51.5 cm

Prov: Bequeathed to Norwich Public Library by Walter Rye, 1912.

Lit: Koeman 1969, pp. 465–9.

Norfolk County Library

This early chart of the Norfolk-Suffolk coastline was first printed by Lucas Janszoon Waghenaer (*c.* 1533/4–1606), author of the first atlas of engraved charts, published in 1584. This atlas gave details of coastlines from Scandinavia to Southern Spain, but did not include Wales, Northern Scotland and Ireland.

Published in Holland, 1584–1605, as *Spieghel der Zeevaert*, the first English edition appeared in 1588 as *The Mariner's Mirrour*. A feature of these maps is the silhouettes of coastlines as they appear from out at sea. The extravagant strapwork of the central cartouche and the inland aerial view are typical of the series.

This impression is from the Latin text edition of 1586, (which included a dedication to Queen Elizabeth of England) identifiable by the page number *ij* on the reverse.[1] This was printed by Frans van Raphelengen, son-in-law of Christoffel Plantijn, at Leiden. The typography of the Plantijn printing house added to the quality of Waghenaer's celebrated charts, as did the skill of the leading engravers Baptist and, in this case, Johannes Doetichum. There is no evidence that Waghenaer copied his charts from existing sources and one may infer that

this chart was based on his personal observation as a navigator. It is of interest to note the prominent 'Admirants huijs' near Winterton. Rye comments that this was Waxham Hall, the home of the Wodehouses which must have stood out as a prominent feature of the coastline.[2]

1 I am indebted to G. Armitage of the Map Library, The British Library, for identifying the correct text edition (cf. BL pressmark Maps c8.b.2). I am also grateful to Barbara Green for her guidance.

2 *Eastern Daily Press*, 21 December 1911.

cat. no. 6

6 *Silver Beaker*, partly gilt[1]

Maker: William Cobbold Norwich, *c.* 1572–86

Illustrated above

Height: 17.6 cm; depth: 10 cm.

Engraved: *THE GIFT OF MR RYCHARD BROWNE OF HEIGHAM*

Prov: 'Sold by order of the Trustees of the church', Christie's, 18 June 1891, lot 150, bt by Levine for J.J. Colman, £80; by descent to his daughters, Ethel M. and Helen C. Colman, by whom presented to Norwich Castle Museum in memory of their father, 1926 (110.926).

Lit: *Norwich Silver in the Collection of Norwich Castle Museum*, Norfolk Museums Service, 1981, p. 37.

Norfolk Museums Service (Norwich Castle Museum)

This is one of four surviving beakers made as a set for Holy Communion at the Dutch Church, Norwich. One is now in the Rijksmuseum in Amsterdam, and the other two are in the Ashmolean Museum, Oxford. The maker, William Cobbold, was the best Norwich goldsmith and a superb craftsman.

The use of sets of beakers for communion was a Calvinist practice, in sharp contrast to the use of a single, stemmed cup in the Church of England at that period.[2] In this respect the Dutch practice represented a more extreme brand of Protestantism, and the use of sets of beakers or cups was followed in England by many

Non-conformist congregations during the seventeenth century.[3]

The Dutch immigrants worshipped in what is now Blackfriars' Hall, which had been the chancel of the medieval church of the Blackfriars (fig. 8). Services in Dutch were held there until the twentieth century. Richard Browne, the donor of the beakers, was Sheriff in 1595 and had no official connections with the Dutch church.

The choice of Cobbold as goldsmith was probably due to George Fenne, a Dutch goldsmith who was warden of the Norwich goldsmiths in 1570, 1576 and 1587. In that year he became the leading Elder of the Dutch Congregation in Norwich. He was evidently on good terms with Cobbold, since the latter apprenticed his son Matthew to him.[4]

The beaker bears the Norwich hallmark of the castle and lion, Cobbold's mark of an orb and cross, and a tiny mark of a wyvern's head whose meaning is unknown.[5]

1 I am indebted to Robin Emmerson for writing this catalogue entry.

2 Oman 1957, pp. 191 ff.

3 Jones 1908, p. xii.

4 Barrett 1981, p. 84.

5 See Lit. above.

7 Book of Dutch Orders 1581

Not illustrated

een keurboek van de draperie van de Nederlandse en Waalse gemeente van Norwich

Manuscript volume in parchment wrapper, 31.7 × 21.5 cm

Prov: Norwich City Records, 17D.

Norfolk Record Office

This 'Book of Dutch Orders' contains the rules and regulations of the Corporation of Drapers of the Dutch and Walloon Community of Norwich and dates from 1581–2. It is written in Dutch in the script commonly used throughout the Low Countries in the late sixteenth century. Each entry bears a decorated initial letter, often describing a small caricature head and face. The rulebook contains many technical details about the cloth trade. Although written in Dutch, the writing was almost certainly done in Norwich, which is mentioned twice. The numerous fines itemised are given in 'penningen' (pennies) and 'schellingen'. The latter is usually written as 'sh. stx', presumably to distinguish between 'schellingen sterlincx' (shillings sterling) and Dutch shillings.

The rulebook is signed by the clerk and the 'Four' (see cat. no. 8) and consists of five sections concerning: the valuation of wool; regulations of the overseers; orders of the assessment hall; orders concerning the fullers; and orders concerning the nappers.[1] The immigrants, with their successive regulations and systematic controls for the textile industry, effectively restored the prosperity of the Norwich woollen industry.[2]

1 This 'Book of Dutch Orders' has been transcribed and translated by P.A. Harthoorn (1970). This entry is entirely derived from that translation (and introduction of 1974), a copy of which is in the Norfolk Record Office, MS 21539.

2 Hudson and Tingey, *Select Records of the City of Norwich*, II, lxxviii – lxxxviii, 332–338.

8 Norwich Strangers' Book 1583–1600

Not illustrated

One volume in four gatherings, 49 folios
With original page cover, 32.5 × 22 cm

Prov: Purchased, 1988

Norfolk Record Office

The Strangers were licensed to settle as a community in Norwich in 1565, subject to certain economic restrictions and under the general oversight of the City government. This important early record was unknown until its discovery early in 1988. A record of the *politijcke mannen* or *hommes politycques* (the officials of the Stranger Community in Norwich), it dates from April 1583–July 1590, with additions and notes 1591–1600. Entries are in Dutch or French, apparently according to the language of the community concerned. The officials are described as the 'Eight' and 'Four', the eight elected by the Dutch community and four by the Walloon community, who were presented to the mayor annually, according to regulations of 1571.[1]

The clerks who wrote the entries are named in the manuscript. The 1583 list of officials names the clerk as Langehelets and in 1584 the new clerk is Pieter Weynoet.[2] The clerks were probably fluent in both Dutch and French, although they themselves appear to have been Dutch. Most of the entries concern arrangements for the care of children who had lost one or both parents, and detail the guardians (*voochds* or *tuteurs*) who appeared before the officials. The document details many names hitherto unknown at this date. Among the list of the 'Eight' and 'Four' are those of 'M gleyn' (Thomas Gleane, mayor in 1583) and 'Mr John Suckeling ye baker' (John Suckling Mayor 1584).[3] The manuscript appears to have been unknown to Moens, the chronicler of the French-speaking Walloons.

One entry which is of particular interest lists an inventory of goods of Jacob Somerman, made by Jan Bar and Pieter Hoybant, 3 April 1585.[4] The goods in total were valued at £16-11-6d and included a feather bed ('een plume bedde met den vorpullen ende deckfels') at one pound; a woman's long cloak or garment ('een vrauwen samarie') at one pound, ten shillings; some silver ('een clein selvere schaelken') at twelve shillings, gold ('in gelde') at one pound, and a quantity of pewter ('een deel tinnewerck') at sixteen shillings.[5]

1 Moens 1887–8, part I, p. 29 and part II, p. 256.

2 ff. 9 and 41. Weynoet is also known as clerk in 1608–12. The British Library has a register of the *Politijke Mannen* 1605–15, chiefly concerned with debts and other commercial matters, Add. MS. 43862.

3 ff. 9 and 17.

4 ff. 24, 24b.

5 I am grateful to Paul Rutledge for drawing my attention to this document.

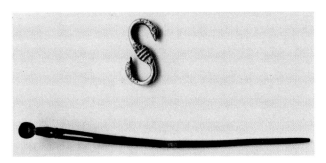

cat. no. 9(a) and 9(b)

9 (a) *Gold belt or bandolier fastener*[1]

Probably Dutch
c. late 16th or early 17th century
Length: 2.9 cm
Illustrated above

Prov: Stray find from Bradwell, Norfolk (County
number 17949) (35.988)

Norfolk Museums Service (Norwich Castle Museum)

This gold s-shaped fastener has each end in the form of a
swan's head and neck. Fasteners of this type, often made
of copper alloy, were used on belts and bandoliers. They
are shown in use in contemporary paintings. Examples
have been excavated in Amsterdam[2] and several have
been found recently in Norfolk.

(b) *Copper alloy head-dress pin*

Dutch
First quarter 17th century
Length: 12.9 cm
Illustrated above

Prov: Excavated on Market Avenue, Norwich (site
150N, layer 108, Period 5, 17th century) (646.975
(SF500))

Norfolk Museums Service (Norwich Castle Museum)

This copper alloy head-dress pin has a scoop-shaped
terminal, with a pierced hole for the suspension of a
pendant, and a rectangular eye. Pins of this type were
used with a head-dress or cap fashionable in Holland in
the first quarter of the seventeenth century. The pin was
sometimes further decorated with a pendant suspended
from the hole in the terminal. They are shown in use in
contemporary portraits, and examples have been exca-
vated from Amsterdam.[3] Some were highly ornamented,
and made of gold or silver.

It is likely that this pin was brought from home by a
Dutch immigrant to Norwich as a treasured possession,
as the fashion was apparently not adopted by English
women. Several pins of this type have been found in
Norwich, on sites where there is other evidence (such as
pottery) of the Dutch living there in the seventeenth
century.

1 I am grateful to Dr Sue Margeson for writing this
catalogue entry.

2 Baart *et al.* 1977, no. 196.

3 Baart *et al.* 1977, nos. 401–2.

10 *Tin-glazed earthenware vessels made in the Netherlands*

Illustrated colour plate ii

(a) Flower vase, handles restored. Dark and light blue
decoration on white glaze; the monogram IHS (the
first three letters of 'Jesus' in Greek).

Netherlands, early to mid 16th century, ht: 9.3 cm
Prov: 14–20 London St. Norwich (262N)
Lit: Jennings 1981, cat. no. 1424

(b) Bowl with two handles. Mid-blue and lemon
yellow decoration, off-white glaze.

Dutch, early 17th century, ht: 6.45 cm

Prov: Davey Place (54N)
Lit: Jennings 1981, cat. no. 1414.

(c) Porringer. Mid-blue decoration, off-white glaze.

Netherlands, early 17th century, ht: 5.7 cm, diam:
16.5 cm

Prov: 13–25 London Street (215N)
Lit: Jennings 1981, cat. no. 1413

(d) Spouted vessel. Blue decoration on white glaze.

Dutch, early 17th century, surviving ht: 12.2 cm

Prov: Botolph Street (281N)
Lit: Atkin *et al* 1985, 135, no. 49

(e) Dish. Dark blue decoration, pale blue glaze.

Dutch, mid 17th century, ht: 3.3 cm

Prov: 13–25 London Street (215N)
Lit: Jennings 1981, cat. no. 1423

(f) Dish. Mid blue, orange and light emerald green
decoration, off-white glaze. Trivet marks and
hanging hole.

Netherlands *c.* 1640, ht: 6.6 cm

Prov: 22–24 All Saints Green (132N)
Lit: Jennings 1981, cat. no. 1378

(g) Blue dash charger. Mid and dark blue, pale leaf-
green decoration with orange and opaque brown-
ochre motifs outlined in blue. Trivet marks and
hanging hole.

Netherlands, probably Dutch, *c.* 1640, diam: 32.7 cm

Prov: 13–25 London Street (215N)
Lit: Jennings 1981, cat. no. 1377

(h) Dish. Dark blue decoration, white glaze.

Dutch, possibly Makkum or Harlingen, late 17th
century, diam: 27.6 cm

Prov: Bethel Street (12N)
Lit: Jennings 1981, cat. no. 1380.

Norfolk Museums Service (Norwich Castle Museum)

For a discussion of these vessels, see the following entry.

11 Tin-glazed earthenware made in the Netherlands or in England [1]

Illustrated colour plate iii

(a) Plate. Dark blue decoration, white glaze.

1630–40, ht: 3.15 cm

Prov: 26–32 Exchange Street (56N)
Lit: Jennings 1981, cat. no. 1390

(b) Drug-jar. Orange, leaf-green and mid-blue decoration on greyish-white glaze.

c. 1625–50, ht: 13.35 cm

Prov: 13–25 London Street (215N)
Lit: Jennings 1981, cat. no. 1479

Tin-glazed earthenware made in England

(c) Mug. Dark blue decoration, off-white glaze.

Probably English, but painted in a Continental style, 1630–40, ht: 14.55 cm

Prov: 13–25 London Street (215N)
Lit: Jennings 1981, cat. no. 1512

(d) Jug. Dark and light blackish-blue decoration

English, 1630–50, ht: 12 cm

Prov: 13–25 London Street (215N)
Lit: Jennings 1981, cat. no. 1501

Glazed red earthenware vessels made in Holland

(e) Slipware dish with three pinched feet on reverse. White slip decoration, glazed interior.

North Holland, 17th century, diam: 23.1 cm

Prov: 46–58 Botolph Street (170N)
Lit: Jennings 1981, cat. no. 625

(f) Slipware bowl with 'sgraffito' lion design, dated 1614

North Holland, early 17th century, diam: 14.8 cm

Prov: 46–58 Botolph Street (170N)
Lit: Jennings 1981, cat. no. 585

(g) Slipware bowl with peacock design, sooted on exterior

North Holland, early 17th century, diam: 12.4 cm

Prov: 13–25 London Street (215N)
Lit: Jennings 1981, cat. no. 584

(h) Foot-warmer. Red earthenware, brown-orange glaze.

Dutch, mid 17th century, ht: 9 cm, max. w. 13.4 cm

Prov: Trawled up from North Sea
Lit: Jennings 1981, cat. no. 940

(i) Frying-pan. Clear orange glazed interior, sooted exterior from use on fire.

Dutch, 17th century, ht: 3.8 cm

Prov: 16 Charing Cross (41N)
Lit: Jennings 1981, cat. no. 986

Norfolk Museums Service (Norwich Castle Museum)

Much of the pottery from Norwich sites was made in the Netherlands, and some can be identified more specifically as having been made in Holland. But some was made in England, copying these traditions. It is not always possible to tell where a particular vessel was made, so close are the links, or whether the pottery was the work of Dutch potters in England, or English potters.

The archaeological evidence suggests that some of the pottery came direct from the Netherlands, rather than via London, some brought over as the personal possessions of the immigrants, others imported as trade items. The foot-warmer dredged up from the North Sea emphasises the direct nature of this link, as it was presumably *en route* to Norfolk when the ship foundered. Fragments of similar foot-warmers have been found in Norwich.

Tin-glazed earthenware, often called 'delft' in England, has a distinctive opaque white glaze, made by the addition of tin oxide to a lead glaze. This ware illustrates particularly well the influx of new ideas from the Netherlands, as it was first produced by Dutch potters in Norwich and London, and then copied by English potters. An important group of tin-glazed earthenware was found at the rear of the shop of John Birch, the apothecary (Swan Lane, see cat. nos. 10e, 11b, 11c, 11d). This site produced fragments of over 60 drug-jars and ointment pots, as well as other vessels.

Glazed red-earthenware vessels made in Holland: the frying-pan, made in Holland (cat. no. 11e) was a type copied by local potters.

The slipware vessels, though chiefly decorative, were probably used for everyday purposes, perhaps even for cooking, as the sooting on the exterior suggests. The form of the bowls was copied locally, though without the elaborate slipware decoration.

1 I am grateful to Dr Sue Margeson for writing this catalogue entry.

12 Cornelis Engelszen

Gouda 1575 – Haarlem 1642/53

The Supper at Emmaus 1612

Illustrated p. 89
Oil on canvas 102.2 × 153.7 cm
Signed (t.r.): *CE* (in monogram) *Fecit ao 1612*

Prov: ? Sir Nicholas Bacon (d. 1624) of Gillingham Hall; then by descent to present owner.

Lit: *Burlington Magazine*, November 1955, pl. 36, opposite p. 360; F.W. Hawcroft, ' "The Supper at Emmaus" by Cornelis Engelszen', *Burlington Magazine*, March 1957, pp. 95–6.

Exh: Norwich 1955 (16)

Private Collection

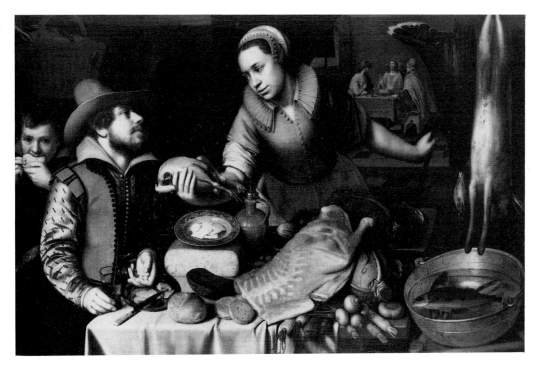

cat. no. 12

The Supper at Emmaus is a mature example in the known oeuvre of Cornelis Engelszen. It is likely to have been in Norfolk since the seventeenth century, and represents a transitional phase in the painting of still life. The subject was a popular one in sixteenth century Venice but it was in Netherlandish painting of that period that it came to be depicted in the background of a scene otherwise devoted to the preparation of a meal or feast. At first glance it is easy to miss the figure of Christ breaking bread with the two disciples in the adjacent room in the background. This type of composition leans heavily upon the examples of Pieter Aertsen (1509–75) and his Flemish pupil Joachim Beuckelaer (*c.* 1535–74), who treated the subject of *Christ in the House of Martha and Mary* in the same way. Engelszen himself painted this subject in a comparable composition now at Uppark in Sussex.[1] It is tempting to seek symbolic meaning in the detail of the still life. For example the bread on the table and the fish on the plate may be intended to symbolise Christ and the Resurrection, or simply miraculous multiplication and the spreading of the word. Indeed, the potential for interpretation, dependent perhaps upon the piety of the viewer, was probably one reason for the popularity of such imagery.

1 Of similar size and composition, this canvas was presumably acquired by Sir Matthew Fetherstonhaugh in the eighteenth century. Exhibited Haarlem 1979 (8).

13 Anthony van Dyck

Antwerp 1599 – London 1641

Self-Portrait c. 1621

Illustrated p. 9 and colour plate x
Oil on canvas 119.7 × 87.9 cm

Prov: Henry Bennet, 1st Earl of Arlington (by 1676); his daughter, Isabella, Duchess of Grafton; then by descent to the 8th Duke of Grafton KG; by whom sold Christie's, London, 13 July 1923, no. 143;

?Hopkins, 1923; Duveen Brothers, 1924; Jules S. Bache, New York, 1924–44; The Jules Bache Collection, Metropolitan Museum of Art, New York, 1949 (49.7.25).

Lit: for full references see Liedtke 1984, pp. 67–71.

Exh: *Ibid.*

Metropolitan Museum of Art, New York, The Jules Bache Collection

Van Dyck had rapidly achieved a high reputation by the time he painted this early self-portrait, almost certainly completed in Antwerp before he left for Italy in the autumn of 1621. A pupil of Hendrick van Balen, he entered Rubens's studio as an assistant when aged about eighteen. His self-portrait even at this early stage of his career, with its reference to Rubens and to an Italianate composition and execution, reveals the confidence of an artist adopting the air of a gentleman. The portrait shows a more sensitive and subtle style than that of Rubens – a style which was to transform the stiff Elizabethan tradition of English portraiture.

Van Dyck paid a brief visit to England in 1620–21, but established himself in London in 1632, at the invitation of Charles I. The taste for his work is well evidenced by the number of copies throughout Great Britain, and Norfolk collections are no exception. Duleep Singh's two volume survey of *Portraits in Norfolk Houses* (1927) records twenty works attributed to van Dyck.[1] A survey of Norfolk collection and sale catalogues records at least sixty-one other portraits and thirteen subject pictures attributed to van Dyck. The actual number of autograph works included within such statistics is extremely small, with the exception of major portraits at Houghton (see p. 15). See also p. 9.

1 The leading Norfolk families to have owned works attributed to van Dyck include Astley, Bedingfeld, Bulwer, Blofeld, Coke, Fellowes, Jeningham, Le Strange, Lee Warner and Walpole.

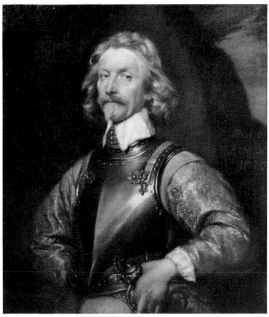

cat. no. 14

14 Attributed to Cornelius de Neve

Netherlands, 1612?–78?

Sir Jacob Astley, Baron Astley (1579–1652)
1640

Illustrated above
Oil on canvas 80 × 71.7 cm
Inscribed and dated: *Jacob Ld Astley/Jacob Astey Genrall Medeton Kent./Aetat; 61, Anno. Do. 1640*

Prov: Sir Jacob Astley; then by descent to present owner.

Lit: Duleep Singh 1927, II (Melton Constable Park no. 52, illus. facing p. 4).

Exh: Manchester 1857 (148, as by an unknown artist); Norwich 1960 (3, as by Sir Anthony van Dyck).

Private Collection

Sir Jacob Astley, the second son of Isaac Astley, of Melton Constable, served in the Netherlands under Prince Maurice of Nassau and his brother Henry. In 1640, when this portrait was painted (according to the inscription) he was Colonel of the 3rd Regiment of Foot in the King's campaign against the Scots. Sergeant Major-General of the Royalist army at the outbreak of the English Civil War, Astley was Commander of the Infantry at Naseby in 1645.

The Astley family in the seventeenth century had strong connections with the Netherlands beyond the military one. Sir Jacob Astley, 1st Lord Astley had married a Flemish lady, Agnes Impel of Bloumerckem.[1] Their children were born abroad and had to be naturalised by Act of Parliament. Their second son, Thomas, born in Holland, later died there. A document in the Public Record Office records that in May 1639 Jacob's kinsman Edward Astley sailed from Yarmouth to Holland to fetch home Lady Astley who had never previously lived in England.[2]

Sir Jacob Astley's portrait has usually been accepted as by van Dyck. Given Sir Jacob's strong court connections the attribution has seemed plausible, but is no longer tenable on stylistic grounds. The portrait survives, rather,

as a good example of the influence of van Dyck upon English portraiture. Parallels in the modelling of the face and rather insubstantial painting of the hand can be discerned in portraits by de Neve such as that of *Richard Sackville, Lord Buckhurst, and the Hon. Edward Sackville,*[3] painted in 1637, or his *Self-Portrait* in the Ashmolean.[4] The attribution to Cornelius de Neve, first suggested by Sir Oliver Millar, must remain tentative.[5] The portrait was etched by Thomas Worlidge in 1759.[6]

1 An unknown Dutch portrait, perhaps of the mother of Agnes Impel, formerly at Melton Constable (Duleep Singh, 1927, II, Melton Constable Park no. 2), survives in the family collection. Recent cleaning has revealed the date 1617.

2 Jewson 1954, pp. 12, 80.

3 Exhibited London 1956–57 (60).

4 De Neve has also been associated with the portraits of two other gentlemen with Norfolk connections, Nicholas Fiske and Sir John Suckling, both now in the Ashmolean Museum.

5 I am grateful to Sir Oliver Millar and Dr Malcolm Rogers for their comments on the van Dyck attribution.

6 BM 1925.5.11.196.

15 Dutch School

The Yarmouth Collection c. 1665

Illustrated p. 91 and colour plate vi
Oil on canvas 165 × 246.5 cm

Prov: Acquired by the Buxtons of Channonz Hall in Tibenham, Norfolk, probably soon after 1732 during the years of the disposal of the contents of Oxnead Hall; presented to the Museum by Mrs M. Buxton in 1947. (170.947)

Exh: Norwich 1953 (49); Norwich 1960 (43); London 1964 (80); Munster and Baden-Baden 1980 (230); Copenhagen 1983–4 (9).

Lit: Gwynne-Jones 1954, pp. 44–5, pl. 32; Ketton-Cremer 1957, pp. 212–22 (The Treasure of Oxnead), pl. facing p. 212; Duyvene de Wit-Klinkhamer, *Rijksmuseum Bulletin* 1960, no. 3, pp. 90–4, 113, figs. 13–16; Hayward 1967, p. 25 with illus.; Hill and Cornforth 1966, p. 44, fig. 41 and p. 45; Berger 1972, illus.; Hayward 1976, illus. pl. 688; *Still Life in Europe*, Milan, 1977, illus.; Hayward 1983, illus.; Harris 1986, pp. 1630–2.

Norfolk Museums Service (Norwich Castle Museum)

The Yarmouth Collection survives as a magnificent record of just a part of the 'world of curiosityes and some very rich ones, as cabinetts and juells'[1] which was once at Oxnead Hall, the home of the Paston family. The original collection of Sir William Paston (1610–62) was significantly added to by his son Sir Robert (1631–83) who became Viscount Yarmouth in 1673 and Earl of Yarmouth in 1679.

The painting was almost certainly commissioned by Sir Robert Paston to record some of the family treasures. In 1844 John Adey Repton published a portion of an Oxnead inventory, compiled before 1673, which lists the contents of a single room, filled with 'ornamental plate and other curiosities'.[2] The latter included family portraits, notably miniatures, and, 'against the chimney . . . the ladies Paston picture in an ovall frame in oyle colour, done by

Mr Lillie'.[3] Many of the shelves upon which the collection was ranged, were 'trimmed with scarlet ribbin'.

The Yarmouth Collection depicts a few of these treasures, a number of which have been identified in existing collections. The strombus shell with gilt and enamelled mounts and brass stem, with the mouth facing the spectator, is an English 'Surrey enamel' now in the collection of Norwich Castle Museum;[4] the silver-gilt flagon, with London date-mark for 1597–8 shown, and held by the black servant, is one of a pair in the Untermyer collection, Metropolitan Museum of Art, New York. The shell-flask on the right beneath the hour-glass consists of mother of pearl segments attached to a silver carcase and mounted in silver-gilt: the cover is surmounted by a cast silver shell. This is now in a London private collection and is either English or Dutch. These pieces are the only ones depicted which are English, the remaining ten being Dutch, Flemish or German. The only pieces by Dutch goldsmiths which can now be located are the two nautilus cups in the right background. The nautilus cup with the one seated stem figure is in the Rijksmuseum, Amsterdam; and the one with two musical satyrs is in the Prinsenhof Museum, Delft.

The Yarmouth Collection survives as evidence not only of a collection long since dispersed, but also of the taste for symbolism in the painting of Dutch and Flemish still life. The composition consists of many items whose representation, well before the middle of the seventeenth century, had come to suggest the transience of life. The so-called 'Vanitas' theme invoked a traditional repertoire of symbolic objects such as the hour glass, watch, clock and guttering candle as a reminder of the passing of time. The terrestrial globe symbolises the worldly power so easily extinguished by death. Any suggestion that the depiction of the family collection itself might seem a form of vanity – in the sense of vainness – is deftly denied by the spirit of the commission. One of the vessels, overturned and facing to the left, emphasises the emptiness of possessions.

The fruits of a still life, for example apples and grapes, are traditional Christian symbols, while the peach could symbolise peace. The evergreen ivy sometimes symbolised immortality. In the case of *The Yarmouth Collection*, symbolism may hold the key to the circumstances of the commission. The young girl, who holds up a carnation, traditionally a symbol of betrothal, is presumably one of the daughters of the Earl of Yarmouth, perhaps recently betrothed. Reality and allegorical meaning traditionally suffused still life painting and *The Yarmouth Collection* is no exception, although there remains a danger of reading metaphorical meaning beyond the artist's original intention.

The painting has consistently defied a positive attribution. Ingvar Bergstrom has recently commented upon its 'mixed Flemish-Dutch character . . . to some extent based on devices, which Jan Davidsz de Heem created in Antwerp from 1640 and onwards' and has ascribed the painting to Franciscus Gysbrechts.[5] The only specific fact known of Gysbrechts' career is that he belonged to the guild of Leiden in 1674. If *The Yarmouth Collection* is indeed by him, it must be inferred that Gysbrechts visited England, and Oxnead. In this context it is notable that another still life, signed by Gysbrechts, was probably in the Paston Family collection. A still life, showing a silver gilt cup and cover, a silver dish, pewter inkstand and numerous other objects in a cupboard was sold by

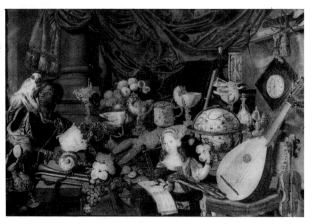

cat. no. 15

the Paston-Bedingfield family in 1951.[6] Gysbrechts is best known for his *trompe l'oeil* still-life paintings.[7]

1 Thomas Knyvett, February 1640; Harris 1986.

2 *Gentleman's Magazine* 21 (2nd NS) 1844, January, pp. 22–4; February, pp. 150–3.

3 Presumably Sir Peter Lely.

4 NCM 2.149.938.

5 NCM file, letter, 28 January 1985. I am indebted to Ingvar Bergstrom for this suggestion.

6 Paston-Bedingfield Sale, Woods, 1 Nov. 1951, 2nd day, lot 681 (38½ × 46 in), sold to Spink. This is possibly the oil now in the collection of Mrs G. Frank. Another Dutch still life which has Paston connections is that now in the coll. of The Paston School, North Walsham (oil on canvas, 42 × 37½ in).

7 Another strong possibility is Peter Gerritz. van Roestraten (Haarlem c. 1631 – London 1700), who 'was apparently in England by 1666, where he developed a new kind of still life with plate, silver and ivory tankards' (White 1982, p. 112).

16 Attributed to Michiel Jansz van Miereveld

Delft 1567 – Delft 1641

Maurice, Prince of Orange (1567–1625)

Illustrated p. 92

Oil on canvas 197 × 139.7 cm

Prov: Henry Bennet, 1st Earl of Arlington ?1667; then by descent to present owner.

The Duke of Grafton.

Although Miereveld lived chiefly at Delft he was much employed at the Stadtholder's court at The Hague where he produced a large number of portraits, often of members of the House of Nassau. There are numerous copies which are often the work of pupils. Miereveld's portrait of Maurice, Prince of Orange is no exception.

The Euston version is a repetition, with differences, of the signed portrait of Maurice now in the Rijksmuseum, Amsterdam.[1] Of all the studio replicas this is the only full-length version and may with some confidence be attributed to Miereveld.[2] Maurice, Prince of Orange was the grandfather of the first Earl of Arlington's wife, Isabella, giving this version the status of a family portrait.

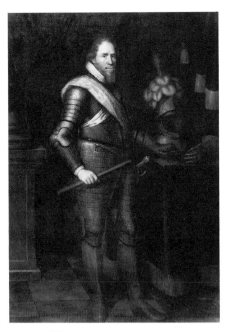

cat. no. 16

Maurice was created a Knight of the Garter by James I in 1627.

A full-length portrait of Maurice, Prince of Orange, was once owned by Charles I of England. Valued for sale on 13 September 1649 at £25, this was sold to Jackson on 23 October 1651. This may well have been the version now at Euston.[3]

1 *All the Paintings of the Rijksmuseum in Amsterdam*, 1976, acc. no. A255: panel, 221.5 × 146 cm, signed *M. Miereveld*.

2 A three-quarter length studio portrait of Maurice is in the collection of the Marquess of Lothian; another is recorded in the T. Ward collection, London. A portrait head of Maurice was engraved by Miereveld's son-in-law, Willem Jacobsz Delff, in 1625.

3 White 1982, p. 73.

17 Attributed to Caspar Netscher

Heidelberg 1635/6 – The Hague 1684

Henry Bennet, 1st Earl of Arlington, with his Wife and Daughter c. 1675

Illustrated p. xv
Oil on canvas 86.4 × 91.5 cm

Prov: In the collection of Lord Cowper, at Panshanger, near Hatfield;[1] sold Christie's, 16 October 1953, lot 103; the Duke of Grafton.

The Duke of Grafton

This is a copy of a portrait by Caspar Netscher which was painted in Holland while Arlington was on a diplomatic mission.[2] In December 1674 he had been sent with Lord Ossory to the Hague to negotiate with William of Orange for peace and to suggest his marriage with King James' daughter Mary, a mission in which he failed. In 1667 Arlington had married Isabella van Beverwaert, the grand-daughter of Maurice, Prince of Orange, and daughter of Louis of Nassau, Baron of Leck and Beverwaert. She died in 1718.[3] The Earl is shown seated in his

Garter Robes, holding his staff of office, his daughter Isabella at his side, 'a sweete child if ever there was any'.[4]

The Earl and his family were in Holland in 1675, presumably the date of this portrait. Although this version is usually regarded as by Netscher and displays the artist's skill in painting textures, the existence of a signed and dated version does suggest this to be a studio replica. By the 1670s Netscher enjoyed a considerable reputation as a portraitist.[5]

1 Lady Arlington's sister married the Lord Cowper of the time.

2 The original portrait was exhibited in London 1960–61 (139), and is signed and dated 1675.

3 A portrait by Netscher of Lady Arlington and her daughter, signed and dated 1682 was once at Chillingham Castle, in the collection of the Earl of Tankerville (de Groot 1913, V, no. 214).

4 John Evelyn, 1 August 1672.

5 Other works attributed to Netscher in Norfolk Collections include: Coke, Chambers 1829, II, p. 377; John Harvey, Chambers 1829, I, p. 21ª, and Harvey Sale 1842, lots 261, 262, 268; his brother, Charles Harvey (took name Savill-Onley, 1822), Savill-Onley Sale 1894, lot 82; also Ladbrooke, exhibited Norwich 1829 (90); Homfray, Druery 1826, p. 804, probably Cory Sale 1841, 2nd day, lot 132; Trivett, Druery 1826, p. 152; and West Sale 1843, 1st day, lot 63.

18 Peter Lely

Soest 1618 – London 1680

Roger North (1653–1734) 1680

Illustrated colour plate xi
Oil on canvas 76.8 × 63.5 cm

Prov: Roger North; by descent to present owner

Exh: London 1960–61 (181); London 1978 (59)

Lit: Collins Baker 1912, II, p. 130; Beckett 1951, no. 388.

Private Collection

The Hon. Roger North, the youngest brother of Lord Guildford, the Lord Keeper, was a lover of painting and advised Lely on his financial and legal affairs. It fell to Roger to become a trustee of Lely's estate and executor of his will. The estate's debts and legacies amounted to almost £9,000 and it was Roger North who organised the celebrated sale of Lely's studio effects, possessions and works of art:

It was during my brother's life that I had devolved upon me a trust and executorship of Sir Peter Lely. It seems my brother and he were great friends, and fell into a way of commuting faculties, whereupon my brother advised him about his estate and settlements, and he made pictures for my brother gratis, of which my own and my uncle Jno. North's I still have are two, and I think as valuable as any he left. I will not change for some I had seen of Vandyke, no, barring relation.[1]

Lely's portrait of Roger North is one of his last paintings and is, according to George Vertue's engraved copy of 1740, dated 1680, the year of Lely's death.[2] In his *Autobiography* Roger North describes the meticulous care he took over the sale of Lely's own pictures and his

collection of prints and drawings, in two parts: 'I caused the best artists in town to value them, such as were of his own painting, with respect to his prices, and the defects of finishing'. North himself moved into Lely's house in Covent Garden and lived there for a number of years before finally purchasing an estate at Rougham, Norfolk, in 1690.

1 Jessopp 1887, p. 190.

2 A copy is in the National Portrait Gallery, no. 760.

19 Anglo-Dutch School

Ryston Hall, Norfolk c. 1672

Illustrated colour plate vii
Oil on canvas 81.5 × 76.5 cm

Prov: Sir Roger Pratt; then by descent to present owner.

Lit: Silcox-Crowe 1985, illus. pl. 11.

Private Collection

The gentleman architect, Sir Roger Pratt (1620–85) inherited his family's Norfolk estates in 1667. He went to Norfolk the following year and in 1669 began to build a new house for himself at Ryston. Ryston Hall was constructed of nine bays in a mixture of classical styles, crowned by a small cupola or bell turret. Pratt's accounts reveal that it cost £2,880 to build and that almost all the craftsmen he employed were either local or East Anglian. Once it was finished, he commissioned this view, which is the only surviving record of its appearance at that time, providing an extensive vista of the planting of the grounds as well as the layout of the Hall itself.

There is some justification in considering that this canvas may well have been painted by Hendrik Danckerts (c. 1630–79). Danckerts was one of the many Netherlandish artists specialising in view pictures as overmantels, who settled in England. The earliest known reference to his work is contained in Sir Roger Pratt's diary when he was working on one of his four known building projects, Clarendon House, Piccadilly, just prior to Pratt's removal to Norfolk.[1] Pratt continued this early patronage of Danckerts in Norfolk. Among the family papers is a manuscript list of 'Pictures bought since Ap 8:1672.'[2] This includes a reference to '2 large chimney peeces of Dankertz 14–0–0'. Another manuscript recording 'Work Done for Sr. Roger Pratt/June the first 1672' includes 'three carved and gilded frames for peece of Mr Danckers (?) painting 05–05–00'.[3] The third painting by Danckerts at Ryston was a 'Dankerts landskippe 4–0–0', probably purchased c. 1670.

It is possible, therefore, that this is a documented piece by Danckerts. The only positively identified house portrait by Danckerts is that of *Ham House, Surrey* painted in 1673, while John Harris has associated one other such painting with Danckerts.[4] John Harris has rightly pointed out, however, that the view of Ham House is very much more sophisticated than that of Ryston Hall.[5] The problem with attempting a firm attribution lies to a degree in its condition. The original quality of the painting barely survives in parts, although the architecture remains in a reasonably good state of conservation.[6] Danckerts' reputation by 1706 was for being 'esteemed the neatest and best Painter, in his way, of that time'.[7] For want of further comparable examples one must conclude that *Ryston Hall*,

if not by Danckerts himself, must have been commissioned and painted in emulation of his example.[8]

1 Gunther 1928.

2 Microfilm 218/7. I am indebted to Jenifer Frost for her work on my behalf, on the Pratt family papers now housed in the NRO.

3 The period carved and silver-gilt frame for *Ryston Hall* survives.

4 Harris 1979, pp. 42–3 and pl. 45.

5 I am grateful to John Harris for his comments, 10 November 1987.

6 I am grateful to Cathy Proudlove for her examination of this painting.

7 Bainbrigge Buckridge, *An Essay towards an English School of Painting*, 1706.

8 A comparable work of a later date in Norfolk is the overmantel panel painting, built into the panelling of a first-floor room of Aylsham Old Hall. This records the house at its completion in 1689, surrounded by a formal garden in the Dutch style.

20 Anglo-Dutch School

View of Norwich c. 1707

Illustrated colour plate viii
Oil on deal panel 133.7 × 125.1 cm

Prov: Purchased from the Rutland Gallery 1966. (341.967)

Exh: London 1966(1)

Norfolk Museums Service (Norwich Castle Museum)

This view shows the south-east prospect of Norwich, from Kett's Castle on Mousehold Heath. There is a certain amount of artistic licence in the disposition of the main buildings. It is quite possible, however, to date the picture from the evidence of the state of the Castle as depicted. Writing c. 1725, John Kirkpatrick records:

Anciently the top of the Hill or Castle-yard was encompassed on all sides by a strong wall, fortified with diverse towers . . . but the earth on the outside of it is settled, or washed away lower than the foundation of it. To this piece of wall the jailor's house on the hill now adjoins: also part of a tower, which jutted out semicircularly, I have often seen there, till, A.D. 1707, it was beaten down when the east part of that house was new built.[1]

In the painting a semicircular tower can clearly be seen on the south side of the east end of the gaoler's house. This tower should not be confused with the drum tower shown in the prospect of Norwich Castle of c. 1738 by Samuel and Nathaniel Buck, which stands considerably lower than the tower seen here.[2] Kirkpatrick also states:

But of late years the beauty of the Castle itself was much impaired, (in about A.D. 1707) by taking down the battlements of it . . .

The battlements appear to have been removed in the painted view. These two pieces of evidence would suggest that this view was painted about 1707 (or a few years before). It is likely that this view of Norwich formed the overmantel of a well-to-do citizen of Norwich, perhaps sited in a house being built or refurbished c. 1707. The quality of the painting is not high and would be

typical of a local or itinerant view painter, versed in the Dutch tradition of bird's-eye-view painting. It is almost impossible to identify such a painter, but it is tempting to ally work of this kind with an artist such as one Henry Munford, who placed an advertisement in the *Norwich Gazette* of 22 March 1707:

> I have a Desire to inform the Country of what I can do; and what I pretend to do I will well perform, to the Judgement of them that understand it. My Profession I will give you an Account of, which is History-Painting; as Landskips, Seaskips and Rooms, that way that pleases the Persons best[3]

A later advertisement by Munford reveals that he had been 'in London, Holland and many other Parts, with Design to inform himself in the secret and mysterious Art of Painting . . .'.[4]

1 Kirkpatrick 1845, pp. 240–1.

2 Another reason for thinking that this semicircular tower is not the drum tower on the east side of the Castle bridge, is that it is impossible to see the fragment of gate tower on the bridge also recorded by Buck. The eastern gable of the gaoler's house is quite clearly plain and the small additional buildings recorded on the Buck engraving have not been built. Information kindly supplied by Barbara Green.

3 Quoted in Fawcett 1976–1978, pp. 71–2.

4 *Norwich Gazette*, 28 June 1712.

21 Hendrick Doncker
Dutch, fl. 1659–67

Mariner's Map 1667

Illustrated p. 80
Printed map, with added bodycolour
Plate size, 42.7 × 53.7 cm
Inscribed: 'Pas-Caert van Texel tot aen de Hoofden vertoonende de Zee-Custon van Vrieslant, Hollant, Zeelant, Vlaenderen, en de Oost kust van Engeland als mede hoemen alle de selve kusten en Havens uyt der Zee fal aendoen. T'AMSTERDAM. By Hendrick Doncker Boekverkoper en Graadbooghma: ker, in de Nieubrugsteegh In't Stuurmans gereetschap'.

Prov: Contained within a unique copy of Hendrick Doncker's *L'Atlas de Mer ou Monde Aquatique*, Amsterdam, 1667, acquired by Sir Richard Ellys of Nocton, Lincolnshire; bequeathed 1742 to the Hobarts of Blickling (on the death of his second wife); probably at Blickling, 1745, certainly by 1756.

The National Trust (Blicking Hall)

This unique survival, bound in gold-tooled reverse calf, comprises a series of mariners' maps showing navigable coastlines for ships' captains and their pilots. It was also aimed at merchants to help them establish trade links.

22 Henry Bell
King's Lynn 1647 – King's Lynn 1711

The Exchange at Lynn Regis in Norfolk

Illustrated p. 7
Engraving, cut to plate mark, 44.2 × 34.8 cm
Inscribed: *H. Bell Structuram primitus design ᵘᵗ nunc Scenographice delni ᵘᵗ et F.F. The Exchange at Lynn Regis in Norfolk*; top centre: *BURSA LINNENSIS*

Norfolk Museums Service (King's Lynn Museum)

The Customs House, King's Lynn, was built of stone in 1683 as a Merchants' Exchange, at the expense of Sir John Turner, a leading member of a prominent Lynn family. The gift is commemorated by a Latin inscription over the entrance. The elegant bell-tower and arches open to the street indicate its original function as a merchants' exchange.

Bell's design is an eclectic one, showing considerable Dutch influence.[1] It owes much to Netherlandish weigh-houses, whose groundplans were entirely conditioned by their function, with large halls to hold huge balances to determine weight, price and excise-duty. Bell's building was sold to the Customs authorities in 1718. The engraving shows the balustraded parapet and the statue of Fame which were blown down in 1741. Although the design may owe something to Wren, the closest parallels are to be found in the weigh-houses of Amsterdam (built 1565, destroyed 1808), of Haarlem (built 1597 by Lieven de Key) but most specifically of Leiden, built in 1658 by Pieter Post.[2] Similarly, the decorative elements recall the Dutch classicist style applied to the Townhall of Maastricht, also by Pieter Post.

1 Colvin and Wodehouse 1961, p. 53.

2 Letter to Elizabeth James, Dr R. de Jong, Rijkadienst voor de Monumenterzorg, 30 May 1979.

II The Great Collectors

23 Aert de Gelder

Dordrecht 1645 – Dordrecht 1727

Esther and Mordecai c. 1685

Illustrated colour plate xii
Oil on canvas 79.5 × 95 cm
Inscribed: *Rembrandt 1659(?)*

Prov: Sir Andrew Fountaine; Fountaine Sale 1894, lot 25, bt Chester (bt in?); Vice Admiral Charles Andrew Fountaine; then by descent to present owner.

Lit: Chambers 1829, p. 640 as *Usurer and Lady* by Rembrandt.

Andrew Fountaine

This painting is recorded in the inventory of pictures at Narford Hall compiled on the death of Sir Andrew Fountaine in 1753. Hanging in the Drawing Room adjacent to the Hall, the description ran: 'An Old Miser writing, with a young Lady holding a Paper to him – Rembrandt'. Waagen accepted the painting as by Rembrandt in his list of the major pictures at Narford in 1854. Nevertheless Andrew Fountaine III (1770–1835) was not himself totally convinced that it was the work of Rembrandt: 'I have my doubts of its being by Rembrandt, perhaps by Arent di Gelder, or Flinck, his imitators, but I may be mistaken.' Indeed he added a postscript, 'I am informed it is a Rembrandt in his silvery manner.'[1]

The painting is here attributed to Aert de Gelder. At the age of sixteen de Gelder had moved to Amsterdam to work under Rembrandt, with whom he remained for approximately two years. In that period he absorbed his master's late style, which he continued to follow until his death in 1727. A number of canvases apparently by Rembrandt are in fact by de Gelder, notably *Jacob's Dream* bequeathed to Dulwich Picture Gallery by Francis Bourgeois in 1811, and previously sold by Le Brun of Paris in 1785 as a Rembrandt.

It is now possible to identify the subject of the Narford painting as 'Esther and Mordecai'. This was in fact a common theme for de Gelder. A similar painting, in style and subject, now in the Budapest National Museum is signed and dated 1685.[2] Other versions attributed to de Gelder are in the North Carolina Museum of Art,[3] the Dresden Gallery[4] and the Hirsch Collection, Buenos Aires.[5]

The other recorded work attributed to de Gelder in a Norfolk collection is *A Hermit*, formerly owned by John Patteson of Norwich and sold in 1819.[6]

1 *Memorandums of various things My property in my House at Narford in the County of Norfolk, Andrew Fountaine Dec. 15th 1829*, p. 2.

2 Exhibited Cologne & Utrecht, 1987.

3 Exhibited Montreal, 1969, cat. no. 70.

4 Inv. no. 1792a.

5 *Cicerone*, 1930 XXII, 10, May, p. 269.

6 Patteson Sale 1819, 1st day, lot 5.

24 Studio of Frans Snyders

Antwerp 1579 – Antwerp 1657

A Fruit Stall

Illustrated colour plate ix
Oil on canvas 207 × 225 cm

Prov: ?Baron de Vicq Sale, London 1748/49, 2nd day, lot 129, '*Rubens's second Wife at a Fruit Shop* . . . ditto [Rubens and Snijders]'; Sir Andrew Fountaine; Fountaine Sale 1838, 1st day, lot 111; bt Penrice; by descent to Emma Penrice; from whose sale purchased (by 1854) by Edward Fountaine (d. 1890); then by descent to present owner.

Lit: *Norfolk Tour* 1772, p. 53: 'Fruit-piece by Snyders, the figures by Rubens, very good. By Rubens(?)'; Waagen 1854, III, p. 429; Jaffé 1971, pp. 191–2.

Andrew Fountaine

This canvas was not at Narford by 1738, but is recorded in the 1753 inventory as 'A large Picture of Fruit &c by Snyders, The Figures by Rubens'. This type of subject was highly prized by eighteenth century collectors and such market pieces were traditionally attributed jointly to Rubens and Snyders.[1] Waagen followed this tradition when he noted the picture at Narford Hall in 1854: 'A large fruit piece by Snyders, with three figures by Rubens, which appear to me of unequal value. The nearest, seen in profile, is very attractive for its animation and transparent colouring'.

The taste for such market pieces was already exemplified in Norfolk during Sir Andrew Fountaine's lifetime by the four great compositions, signed by Snyders, each separately depicting Fowl, Fish, Fruit and Herbs, noted by Horace Walpole, in his catalogue of the Houghton Pictures, *Aedes Walpolianae* (1747). The complete set features in William Kent's design project for the north

and south walls of the Saloon at Houghton, which is datable to 1725 by its inscription (frontispiece; see also pp. 13–15). The set formed part of the sale of pictures from Houghton to Empress Catherine of Russia and were in St Petersburg by 1779.[2] The history of this set prior to their installation at Houghton has been confused in the subsequent literature.[3]

It seems likely that *A Fruit Stall* is itself one of a set of paintings following the example of Snyders, although not by Snyders himself. The Fountaine family tradition, noted by Mr Andrew Fountaine in his personal catalogue of pictures at Narford in 1857, is that 'The Lady appears to be the portrait of Rubens' wife Helena Forman & is prettily painted. The other two figures are not equal in merit & were probably painted in the school'. J.F.M. Michel records in 1771 a set of market pieces commissioned from Rubens by Antoine Triest in Bruges, of which copies were made which were later to be found in the house of M. de Vicq, Dean of the cathedral at Brussels.[4] *A Fruit Stall* could well be the painting sold by Baron de Vicq in 1748/49.[5]

Market pieces such as *A Fruit Stall* were often associated with fruitfulness or fecundity. The symbolism of such scenes was practically lost upon the eighteenth century collector, but it should not be forgotten that a sexual dimension was often intended. Onions were considered aphrodisiacs, while lettuce and cabbages were frequently associated with female sexuality.

1 *A Dutch Kitchen*, attributed to F. Snyders, with figures by Jordaens, panel, 64 × 39 ins. is listed in the 1794 catalogue of the Yarmouth dealer, Daniel Boulter, p. 82, no. 23.

2 Now Hermitage Museum, Leningrad; Somof 1901, nos. 1312, 1313, 1315 and 1320.

3 This confusion was first identified by Professor Michael Jaffé, 1971.

4 J.F.M. Michel, *L'histoire de la vie de P.P. Rubens*, Brussels, 1771, pp. 364–5, cited by Jaffé 1971.

5 See Provenance above.

25 Studio of Frans Snyders

Antwerp 1579 – Antwerp 1657

Macaws and Parrots

Illustrated alongside and p. xxi
Oil on panel 124.5 × 47 cm

Prov: see cat. no. 26.

Exh: Norwich 1955(17) as Flemish School seventeenth century.

Lit: Brettingham 1773, p. 9; Dawson 1817, p. 121.

Viscount Coke and The Trustees of the Holkham Estate

Thomas Coke received an invoice from John Blackwood for 'Birds, by Rubens' which was paid on 25 June 1756. The price was £35. Brettingham records the panel as hanging in 1773 in the State Bed Chamber Closet, 'a very fine Piece of Macaws and Parrots, by Rubens and Snyders', but Dawson dropped the reference to Snyders in his *Stranger's Guide* of 1817 and described it as being by Rubens. Another receipt, 'for a picture by Snyders, I say, M. Brettingham' survives in the Holkham Archive, which is dated 19 June 1756.[1] Thomas Coke's Estate

Manager Ralph Cauldwell received forty pounds for this picture, which may well be the same as *Macaws and Parrots*. The discrepancy in the price of five pounds suggests that it may either have been a different painting, or that when Brettingham contested the attribution to Rubens, the price was subsequently reduced.

The *Macaws and Parrots* is an accomplished work which, although not by Rubens himself, is very much the product of Snyders' mature style. Works attributed to Snyders were to be found in a number of Norfolk collections dating from the eighteenth and nineteenth centuries. Large market pieces attributed to Snyders were at Houghton and Narford (see cat. no. 24). The *Wolves and Dogs* and *Monkey and Fruit* at Melton Constable were probably purchased by Sir Jacob Astley in the nineteenth century.[2] It is uncertain when the five large canvases at Gunton Park were acquired.[3]

Most of the works by or attributed to Snyders in local country houses were ferocious hunting scenes. The auctioneer's puff given to W. Delf's *Bear Hunt* in 1846 gives a good idea of the nature of the taste for such pieces: 'The correct and spirited drawing of the dogs and the characteristic ferocity of the animal receiving their attacks fully sustain the reputation of this eminent artist'.[4] The picture hung in Delf's Dining Room. The largest canvas of this type, a version of *The Bear Fight*, hung at Intwood Hall, and was sold in 1897.[5]

1 MS 777.

2 Chambers 1829, II, pp. 788, 790; *Wolves and Dogs* hung over the sideboard in the North Dining Room. *Monkey and Fruit* hung in the South Dining Room: sold, Hastings *et al.* Sale July 1931, lot 105, bt Willis.

3 Gunton Park Sale, Irelands, 16–20 September 1980, 3rd day, lot 1650: 'Snyders. Animals fighting. Set of 4. Each 66″ × 93″ (167.6 × 236.2 cm)'; lot 1709 'Snyders. Dogs attacking a boar 67″ × 114″ (170.2 × 289.6 cms).'

4 Delf Sale 1846, 1st day lot 138, 68 × 39½ ins.

5 Unthank *et al.* Sale 1897, 2nd day, lot 183: 'Snyders. The Bear Fight, A grand Gallery Work. Size, 9 ft 2 by 6 ft 9.'

cat. no. 25

cat. no. 26

26 Melchior d'Hondecoeter

Utrecht 1636 – Amsterdam 1695

Turkey and other Fowls

Illustrated above

Oil on canvas 171.5 × 244 cm.

Signed (on pilaster): *M.D. Hondecoeter*

Prov: Purchased on behalf of Thomas Coke, 1st Earl of
Leicester (1697–1759), 1756; then by descent to
present owner.

Lit: Dawson 1817, p. 131.

Viscount Coke and the Trustees of the Holkham Estate

Paintings of poultry by Melchior d' Hondecoeter were
among the most popular items for the great country
house collections during the eighteenth century. *The
Norfolk Tour* of 1829 itemises the large bird paintings at
Holkham, Narford, Melton Constable, Didlington Hall
and Intwood Hall,[1] while an inventory of 1810 also
records a *Domestuck Poultery by Honderooter* valued at
£21, at Raynham Hall.[2] In addition, Lord Townshend lent
a dead game piece attributed to Hondecoeter to the
exhibition of Old Masters held in Norwich in 1829 and
also a painting entitled *Live Fowls* to the British Institu-
tion in 1842.[3] The key to the attraction of this artist can be
seen in the descriptive puff given to one of Lord
Townshend's Hondecoeters up for sale in 1819: 'Nothing
less than a faithful Representation of Nature can render
these subjects of interest and value; in this walk of Art,
this master stands unrivalled'.[4]

Paintings of fowl by Hondecoeter and his studio were
not the exclusive preserve of the great country houses.
Thomas Harvey of Catton owned a large canvas of two
fighting cocks. This picture had entered Joseph Muskett's
collection at Intwood by 1829.[5] Dawson Turner's Honde-
coeter, rather more modest in scale, had been in the
collections of Mr Smith of Norwich and the Rev. John
Homfray.[6] Other Norwich collectors with similar pictures
included John Patteson[7] and William Stevenson,[8] while

William Freeman's *Hen and Hawk*, lent to the Norwich
Old Masters Exhibition in 1828, was marked up as for
sale.

Holkham Hall is notable for a pair of Hondecoeters
believed to be emblematic of King William's wars (see
pp. 16–18). *Turkey and other Fowls*, meanwhile, is typical
of the painter's grander style, the classical architecture
lending an Italianate ambience. An invoice from John
Blackwood dated 25 June 1756 includes 'Fowles by
Hondecooter' at a cost of £45, but the picture was not
hung at Holkham for a number of years.[9] It was probably
hanging in the London house in Russell Street in March
1760,[10] but then transferred to Holkham in June after the
death of the First Earl of Leicester. However, the picture
was not mentioned by Brettingham as hanging in 1773.
Dawson records it in the Dressing Room to the North
State Bedchamber in 1817.

1 Chambers 1829, II, pp. 577, 640, 786, 803 and 1343.

2 Durham 1926.

3 Lord Charles V.F. Townshend disposed of two dead
game pieces during the nineteenth century: Townshend
Sale 1819, lot 22, *Dead Game in a Landscape* and 1854, lot
50, *A dead pheasant and partridge in a garden. Live Fowls*,
exhibited London 1842 (177), was presumably the oil
entitled *A Bittern, Ducks and other Birds in a garden*, 40 in.
by 39 in., Townsend Sale 1904, lot 118, sold to Lane,
£141.15s.

4 Townshend Sale 1819, lot 12, *Geese and Ducks, in a
Landscape*, 35gns.

5 Unthank *et al.* Sale 1897, 2nd day, lot 180, *Two Cocks
fighting*. This was possibly the *Birds . . . Hondekooeter*
lent by J.S. Muskett, Norwich 1828 (44).

6 Turner 1840; Turner Sale 1852, lot 29.

7 Patteson Sale 1819, lot 122: 'Dining Room. Hondikooter.
An Assemblage of Birds – a truly capital picture'.
According to Dickes 1905, p. 126, this was sold to Dr
Martineau of Norwich for £46.

8 Stevenson Sale 1821, 3rd day, lot 12.

9 MS 777.

10 Holkham Archive MS 765: Pictures in the London House included, in the 'Eating Room below stairs', a 'Piece of Fowls'. The inventory is dated 18 March 1760.

27 Attributed to David de Coninck

?Antwerp c. 1644 – ? Brussels c. 1701.

Still Life with Fruit, Flowers and Parrot

Illustrated p. 18
Oil on canvas 96.5 × 123 cm

Prov: Thomas Coke, 1st Earl of Leicester (1697–1759); then by descent to present owner.

Exh: London 1884 (195); Norwich 1955(8) as by Michaelangelo Pace di Campidoglio.

Lit: Brettingham 1773, p. 11; Dawson 1817, p. 131.

Viscount Coke and The Trustees of the Holkham Estate

The earliest record of this canvas is in a manuscript 'catalogue of pictures & Statues and Busts etc at Holkham House in Norfolk as they were placed in the year 1765'.[1] The painting is identified as Macaw, Fruits and Flowers by 'Incognito' and hung in the North Dressing Room. It was still hanging there in 1773 when Matthew Brettingham identified it as 'by Hondicooter', an attribution which was dropped by Dawson in his Stranger's Guide of 1817.

The present attribution to David de Coninck has recently been made by Fred G. Meijer, who has discounted the modern attribution to Campidoglio.[2] The work of de Coninck and Campidoglio can be remarkably similar and both artists produced still lifes which were eagerly taken up by English collectors in the eighteenth century.[3] De Coninck was also confused with Frans Snyders.[4]

David de Coninck was a pupil of Pieter Boel and was first registered as a master in 1663/4. He travelled to Rome c. 1670, where he apparently built up a successful career, receiving orders from royalty and nobility from all over Europe. He left Rome c. 1696 and returned to Flanders via a long stay in Vienna. In 1699 he is recorded in Brussels, where he joined the St Luke's guild in 1701. It is generally assumed that he died shortly after; no records on later activities nor on his death are known.

According to Meijer, de Coninck signed no more than one in ten works. His oeuvre may be split up into four main groups of subjects: hunting scenes, dogs (sometimes cats) and game, gardens with birds and small domestic animals, and gardens with still lifes of fruit and flowers, usually with one or two birds or small animals. Although it is difficult to determine a chronology in de Coninck's works, these subjects seem to follow this order during his career. The Holkham still life is therefore a relatively late work, showing a strong Italian influence.

Although no direct parallel to this picture in de Coninck's work is known to be signed, it strongly relates to several pictures that, sometimes on a variety of grounds, can be attributed to de Coninck. In a small painting of a dog, parrot and guinea pigs with grapes in Burghley House, Stamford,[5] the grapes were painted in the same manner and we see the vine leaves similarly against the light. A large signed picture of a dog disturbing cocks and hens[6] in the same collection, which was bought directly from the artist, shows the same

grapes again as well as a parrot like the one in the Holkham still life. This last painting also shows de Coninck's characteristic view into a garden with straight walls topped with large vases, surrounded by cypress trees.[7]

1 Holkham archive.

2 The painting will be included in Meijer's forthcoming catalogue of de Coninck's works. I am indebted to him for the substance of this catalogue entry, communicated by letter, 29 February 1988.

3 c.f. two small oils by de Coninck at Corsham Court, Wiltshire. A Fruitpiece by Campidoglio, formerly in the Marble Parlour at Houghton, is now in the Hermitage, Leningrad.

4 A River Scene, purchased in 1759 for Kedleston Hall, Derbyshire by Sir Nathaniel Curzon, then thought to be by Snyders is now recognised as by de Coninck.

5 Burghley House, cat. no. 490.

6 Ibid., cat. no. 111.

7 Also related are two large fruit and flower still lifes in the Musée des Beaux Arts in Nantes (inv. 58106 and 58107) which incorporate the same black metal dish as the still life at Holkham Hall. This same dish appears in some eight paintings which Meijer attributes to de Coninck, two of which are autograph repetitions.

cat. no. 28

28 Attributed to Jan van Kessel I

Antwerp c. 1626 – Antwerp 1679

Poppies

Illustrated above
Oil on canvas 71.2 × 59.7 cm

Prov: Thomas Coke, 1st Earl of Leicester (1697–1759); then by descent to present owner.

Lit: Brettingham 1773, p. 13; Dawson 1817, p. 90.

Viscount Coke and the Trustees of the Holkham Estate

Poppies and its pair, Thistles are first recorded in 'A Catalogue of Pictures at Holkham' dated 1760 when they

hung in Lady Leicester's Dressing Room.[1] Matthew Brettingham attributed them to 'a Flemish Master' in 1773. Little is known of Jan van Kessel, apart from the fact that he specialised in paintings of plants and wild flowers, rather in the manner of Abraham Begeijn (*c.* 1630–97) of Leiden and Otto Marseus van Schrieck of Amsterdam (see cat. no. 64).

1 Holkham Archive, MS 765.

29 Jan Frans van Bloemen, called Orizonté

Antwerp 1662 – Rome 1749

Classical Landscape

Illustrated alongside
Oil on canvas 100.5 × 400 cm

Prov: Thomas Coke, 1st Earl of Leicester (1697–1759); then by descent to present owner.

Lit: Brettingham 1773, p. 3.

Viscount Coke and the Trustees of the Holkham Estate

Jan Frans van Bloemen had moved to Rome in 1681 and specialised in Italianate landscapes. Popular with eighteenth century grand tourists, his work entered countless English collections. The series of four still in the Drawing Room at Holkham are typical of his constructed landscapes, populated with classical rural figures, which earned him the nickname 'Orizonte'. Orizonté's Dutch origins were of little significance to Thomas Coke, whose interest centred upon the classical landscape, rather than the Dutch tradition of landscape painting.

A late eighteenth century collector who also purchased the work of van Bloemen while abroad was John Patteson of Norwich.[1] Patteson later lent two of his Orizontés to the Norwich Old Masters exhibition, 1828.[2] Orizonté's work also hung at Melton Constable,[3] Thorpe House[4] and Intwood Hall[5] in the nineteenth century.

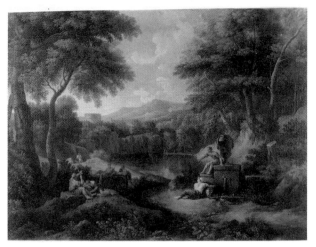

cat. no. 29

1 Patteson Sale 1819, 1st day, lots 43, 79; 2nd day, lot 43.

2 Norwich 1828 (72, 75); Moore 1985, pp. 157–8.

3 Chambers 1829, II, p. 786; Hastings *et al.* Sale 1976, lot 121.

4 Chambers 1829, I, p. 21.

5 Chambers 1829, II, p. 803; exhibited Norwich 1840(32).

30 Hendrik Frans van Lint, called Studio

Antwerp 1684 – Rome 1763

Castel san Angelo

Illustrated below
Oil on canvas 55 × 106.5 cm
Signed

Prov: Thomas Coke, 1st Earl of Leicester (1697–1759); then by descent to present owner.

Exh: London 1977.

Lit: Brettingham 1773, p. 10; Dawson 1817, p. 122.

Viscount Coke and the Trustees of the Holkham Estate

cat. no. 30

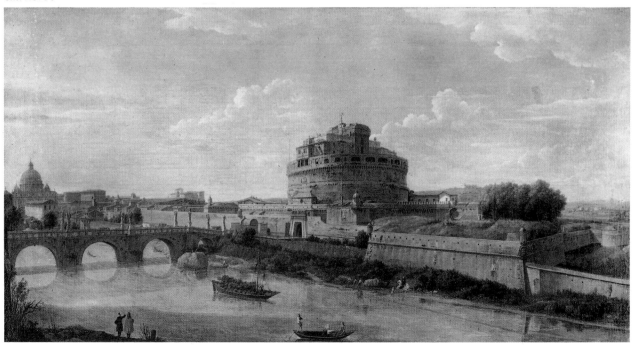

Hendrik van Lint arrived in Rome for the first time *c.* 1703 and, apart from a journey back to his native Antwerp in 1710, remained in Italy for the rest of his life. He was, like Gaspar van Wittel, popular with visitors to Rome, and Thomas Coke must have seen his work while in Rome during his grand tour, 1714–17.

Castel san Angelo has always been associated with a group of works by Gaspar van Wittel, also known as Occhiali. It originally hung, attributed to Occhiali, with a group of three other views by that artist in the Dressing Room of Coke's London house at Great Russell Street.[1] Coke did not live to see the painting removed to Holkham, where it was hung in the closet to the State Bedchamber, alongside the three perspective views by Occhiali. Brettingham praised the 'set' by Occhiali for 'the fine Glow of his Flemish Colouring'. The fashion for these ex-patriate Flemish artists is interesting in the context of the Italianate bias so evident in Coke's taste, fashioned as it was by the Grand Tour. Only one of the van Wittels is specifically itemised in Coke's tour accounts: on 17 July 1716 Edward Jarrett records 'Paid to Signor Gaspar degli Occhiali for a picture Representing the view of the Colysseum – 50 crowns'.[2] Jarrett records the purchase of a painting from 'Studio Van Lint' in Rome on 21 March 1717.[3] This could either refer to the *Castel San Angelo*, or a second work by van Lint formerly at Holkham, *St George Santa Saba, and the Dragon.*[4]

1 Holkham Archive, MS 765.

2 Holkham Archive, MS 734.

3 Holkham Archive, MS 734, p. 123.

4 Dawson 1817, p. 135.

cat. no. 31

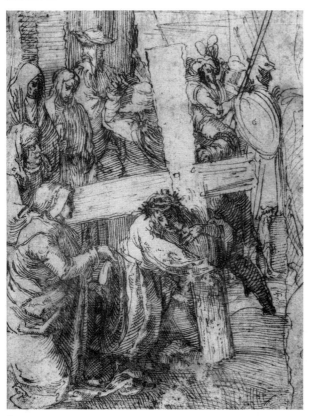

31 After Lucas van Leyden

Dutch School, *c.* 1530

Christ carrying the Cross

Illustrated below
Pen and brown ink 19.6 × 15.4 cm

Prov: Thomas Coke, 1st Earl of Leicester (1697–1759); then by descent to present owner.

Exh: London 1948 (43).

Lit: Brettingham 1773, p. 17; Dawson 1817, no. 69; *The Vasari Society for the Reproduction of Drawings by Old Masters, Second series*, V, Oxford, 1924, p. 9, no. 8 illus.; Popham and Lloyd 1986, no. 309.

Viscount Coke and the Trustees of the Holkham Estate

This drawing is identified by Matthew Brettingham as part of 'a collection of valuable Drawings in Frames and Glasses; the greatest part of which were purchased at Rome, for the Earl, by Mr Gavin Hamilton'. Identified as 'by Luca D'Olanda', the drawing hung, in 1773, in the Blue Satin Dressing Room. The Italianised name certainly suggests that the drawing was purchased in Italy.

The drawing has not been discussed in the recent literature on van Leyden. However, it does correspond with the engraving by Lucas van Leyden which forms part of the Passion of 1521, and M.J. Friedlander is recorded as believing the drawing to be a copy of the engraving.

32 Attributed to Jan Brueghel I

Brussels 1568 – Antwerp 1625

Study of a Tree in full Leaf with Birds

Illustrated below
Gouache 38.1 x 26.4 cm

Prov: Thomas Coke, see cat. no. 31.

Exh: London 1977 (91).

Lit: Popham and Lloyd 1986, no. 298.

Viscount Coke and the Trustees of the Holkham Estate

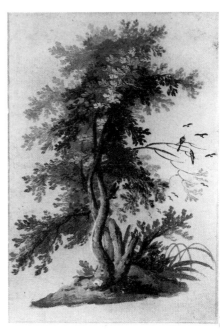

cat. no. 32

This drawing has traditionally been attributed to Paul Bril. The attribution was regarded as untenable by Clovis Whitfield in 1977 mainly on the grounds of its loose handling. Bril's work was well-known in Rome and the traditional association of his name with this drawing suggests that it was acquired in Italy. In the eighteenth century Bril's name was the most common choice for early Flemish landscapes (see also cat. no. 38). The attribution to Jan 'Velvet' Brueghel, while more likely than Bril, should only be regarded as tentative. This is a fine example of an early landscape study, directly observed from nature.

33 Frans Snyders

Antwerp 1579 – Antwerp 1657

A Boar at Bay

Illustrated p. 19
Pen and ink 29 × 45 cm
Inscribed (lower right): *Schneider*

Prov: Thomas Coke, see cat. no. 31.

Exh: London 1948 (45); Norwich 1949 (52); London 1977 (101).

Lit: Popham and Lloyd 1986, no. 319.

Viscount Coke and the Trustees of the Holkham Estate

This is one of the finest examples of a number of comparable drawings by Snyders of similar subject-matter.[1] It is a study for Snyders' painting in the Alte Pinakothek, Munich, of which there is another version.[2] For evidence of the taste for such hunting scenes see cat. no. 25.

1 For another example see *Boar Hunt*, 25.9 × 28.4 cm, British Museum. A closer example was in the De Vries Sale, Amsterdam, 9–10 December 1930, lot 470, black and red chalk, 27.7 × 41.9 cm (corners cut).

2 Sale, Parke-Bernet, New York, 15–16 May, 1946, lot 53.

cat. no. 34

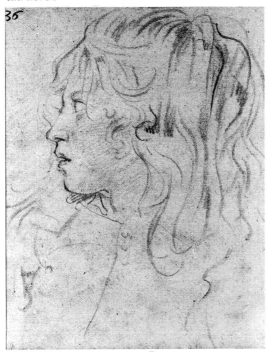

34 Jan Cossiers

Antwerp 1600 – Antwerp 1671

Head of a boy in Profile to Left *c.* 1658

Illustrated below left
Black and red chalk 20 × 15.3 cm
Inscribed (upper left) in ink: *36*

Prov: Thomas Coke; see cat. no. 31.

Exh: London 1948 (44); Norwich 1949 (49); London 1977 (100).

Lit: Popham and Lloyd 1986, no. 303.

Viscount Coke and the Trustees of the Holkham Estate

When this drawing entered the collection at Holkham it was regarded as by van Dyck. The re-attribution is due to Michael Jaffé, who recognised the drawing as one of a series that must originally have come from the same album. Several of the drawings depict members of the artist's family, and a number are dated 1658. Like this drawing, they bear numbers in ink in the upper left corner.

This drawing represents the Netherlandish tradition of figure drawing which was to have a profound effect upon coloured chalk portrait drawing in England.

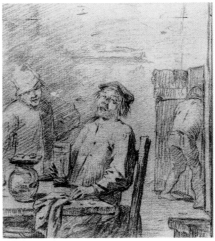

cat. no. 35

35 Attributed to Joost van Craesbeeck

Neerlinter 1606 – Brussels, before 1662

Boors Carousing

Illustrated above
Red chalk with some black chalk 15.7 × 14.3 cm

Prov: Thomas Coke; see cat. no. 31.

Lit: Popham and Lloyd 1986, no. 304.

Viscount Coke and the Trustees of the Holkham Estate

This drawing was formerly attributed to Adriaen van Ostade and Egbert van Heemskerck, the two most common names to be attached to drawings of tavern scenes.[1] The present attribution is that of Popham and Lloyd, and acknowledges van Craesbeeck's debt to Ostade, both in subject-matter and his use of chalk.

1 John Crome, for example, sold two drawings attributed to E. van Heemskerck in 1812: Crome Sale 1812, 1st day, lot 117 *The Cobbler's Kitchen* and 118 *Two men singing*.

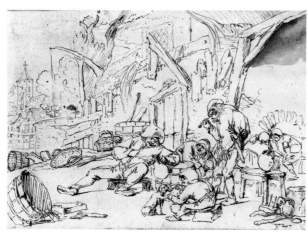

cat. no. 36

36 Attributed to Adriaen van Ostade

Haarlem 1610 – Haarlem 1684

Boors carousing outside a tavern

Illustrated above
Pen and brown ink and brown wash over
black chalk 19 × 26.8 cm

Prov: Thomas Coke; see cat. no. 31.

Lit: Popham and Lloyd 1986, no. 312.

Viscount Coke and the Trustees of the Holkham Estate

This drawing is here given a tentative attribution,
following Popham. A comparable work by van Ostade is
in the Abrams Collection. Both show the artist's use of

mixed mediums to convey expressive general outline and
more detailed work with pen and ink.

Coke's taste for such works as this drawing and that of
Joost van Craesbeeck (cat. no. 35) was not marked. These
were the only Netherlandish genre subjects in his
collection. However, his collection was a predominantly
Italianate one and it is notable that such genre scenes
should be represented at all, presumably acquired before
the mid eighteenth century.

37 Willem van de Velde the Elder

Leiden 1611 – London 1693

Men-of-War at Anchor *c.* 1680

Illustrated below
Black chalk and grey ink 29.5 × 42.3 cm
Inscribed in ink on back of mount: *van der Velt.*

Prov: Thomas Coke; see cat. no. 31.

Lit: Popham and Lloyd 1986, no. 320.

Viscount Coke and the Trustees of the Holkham Estate

This fine quality drawing is of a type that Willem van de
Velde would use as the basis for grisaille oils of the 1650s,
particularly when painting ship portraits. The nearer ship
has a flag at the mizzen signifying a rear-admiral. This
drawing is almost certainly connected with Willem van
de Velde's trips down the Thames to the Medway in the
1680s. The occasion on which he made most drawings
was the visit of Charles II to the *Tiger* before she sailed
under Lord Charles Berkeley to the Mediterranean in
August 1681.[1]

cat. no. 37

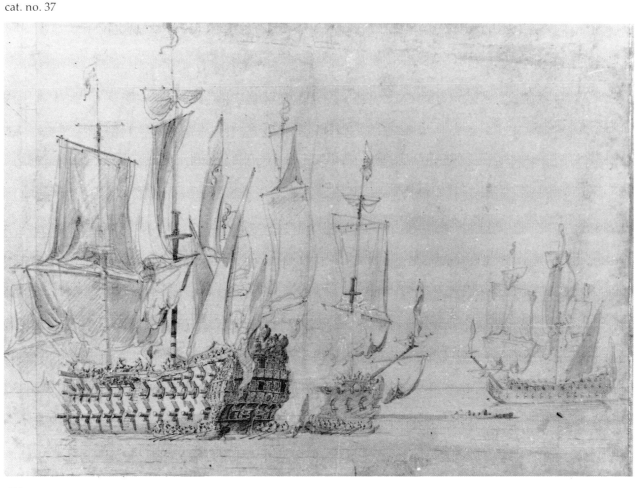

The work of Willem van de Velde and his son was to provide the foundation for the English school of marine painting and drawing. Their work influenced that of their contemporaries such as Samuel Scott and Peter Monamy, but also that of later artists such as John Constable. Constable's work has sometimes been mistaken for that of van de Velde.

1 I am grateful to Michael Robinson for his comments on this drawing.

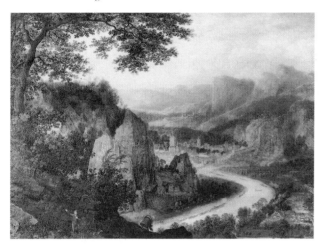

cat. no. 38

38 Lucas van Valckenborch

Malines *c.* 1530 – Frankfurt 1597

A View on the Meuse

Illustrated above
Oil on panel 31.1 × 44.7 cm
Inscribed (lower left): *P. Brill.*

Prov: William Windham II (1717–61); then by descent to R.W. Ketton-Cremer, by whom bequeathed to the National Trust, 1969.

Exh: London 1938 (63); London 1953–4 (304): in both exhibitions as *View on the Danube* by Bril; Norwich, 1964 (73), as by Lucas van Valckenborch; Manchester 1965 (230).

Lit: Stiennon 1954, p. 21, no. 34.

The National Trust (Felbrigg Hall)

Lucas van Valckenborch joined the Malines Guild in 1560 and was in Antwerp in 1565, from where he fled to Aix-la-Chapelle to escape persecution as a Protestant. This work, showing the influence of Pieter Bruegel the Elder, was thought to be by Paul Bril when William Windham purchased it, quite possibly while on the Grand Tour. It is first recorded as at Felbrigg on William Windham's design for the north wall of the Cabinet, *c.* 1751–2, where it is shown as 'View on the Danube by P. Brill'. It is similarly described in the 1764 inventory.[1]

The panel was correctly identified as by Valckenborch by Jacques Stiennon in 1954. Valckenborch specialised in detailed studies of the locale around the river Meuse and this is typical of the series. The figures in the foreground are coal-miners.

1 Other paintings by or attributed to Bril in Norfolk were *Europa* and *Africa* at Houghton Hall (formerly in the collection of the Countess de la Verrue, Paris; *Norfolk*

Tour 1772, p. 42) and a view of ruins (with figures attributed to Carracci) at Intwood Hall, presumably purchased by Joseph Muskett (Chambers 1829, II, p. 803). Daniel Boulter and John Crome both owned landscapes attributed to Bril: Boulter [1794], p. 81, no. 3; Crome Sale 1821, 1st day, lot 47.

39 Egbert Lievensz. van der Poel

Delft 1621 – Rotterdam 1664

Fishermen on a Beach c. 1650

Illustrated below
Oil on panel 25.4 × 31.2 cm

Prov: William Windham II; see cat. no. 38.

Exh: Norwich 1954 (11) as *The Beach at Scheveningen.*

Lit: Hawcroft 1957, p. 106, fig. 6; *The Connoisseur* CXLI, 1958, p. 219, fig. 8.

The National Trust (Felbrigg Hall)

Egbert van der Poel's earliest known oil is dated 1646. Before 1654 he painted mainly cottage and stable interiors,[1] canal and winter landscapes and coast scenes such as *Fishermen on a Beach*. Most of his later work is of nocturnal fires and moonlight scenes, notably views of Delft after a fire caused by the explosion of a powder magazine in 1654. One of the latter was loaned by William Freeman to the Old Masters exhibition held in Norwich in 1828.[2]

The earliest reference to this panel at Felbrigg may be an ambiguous entry in the 1764 inventory: 'A Dutch Piece Scheveling Pinx' was in the second room. This may be a reference to the possibility that the beach scene shows Scheveningen.[3]

1 John Crome owned an *Interior* by van der Poel: Crome Sale 1821, 2nd day, lot 35.

2 Norwich 1828, no. 19 *Fire at Delft in 1644* (misdated). This was exhibited as for sale and could conceivably be the oil subsequently sold Steward Sale 1864, 1st day, no. 165, *Destruction of Sodom* van der Poel.

3 Comparable panels are in the Kassel collection, Staatliche Gemaldegalerie and Hanover, Niedersachsisches Landesmuseum; c.f. also *Fisherfolk on the beach at Scheveningen*, Christie's, 14 December 1984, lot 217.

cat. no. 39

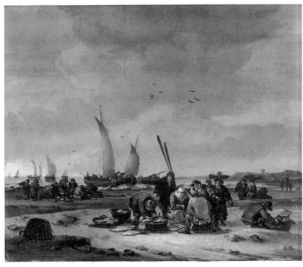

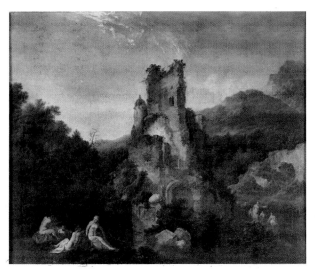

cat. no. 40

40 Cornelis van Poelenburgh

Utrecht 1586(?) – Utrecht 1667

Nymphs bathing near a ruin

Illustrated above
Oil on canvas 60.7 × 74.6 cm

Prov: William Windham II; see cat. no. 38.

The National Trust (Felbrigg Hall)

A pupil of Abraham Bloemart, Cornelis van Poelenburgh was in Rome by 1617 and had returned to settle in Utrecht by 1627. In 1637 he made the first of a number of visits to London at the invitation of Charles I. *Nymphs bathing near a ruin* is typical of his tradition of Italianate landscape which was followed by a number of pupils. The painting is now badly worn, and includes repainting in parts of the left-hand figures, but can be regarded as by Poelenburgh rather than a follower.

Undoubtedly purchased by William Windham II, this oil is first recorded as at Felbrigg, in the 'Second Room', in 1764. As such it is one of the earliest records of an example of this artist's work in the region. Poelenburgh's work was represented at Melton Constable,[1] Langley Park,[2] Holkham,[3] Narford,[4] Saxlingham,[5] and Wolterton,[6] but also in lesser-known middle-class collections. Local dealers, notably John Crome,[7] Daniel Boulter[8] and George Rossi[9] all had work available by or attributed to Poelenburgh. Lesser-known collectors with examples were J. Curr,[10] Matthew Gunthorpe,[11] William Yetts[12] and the Rev. Brereton.[13] (See also cat. no. 70).

1 Chambers 1829, II, p. 790; Hastings *et al.* Sale 1977, lot 22 reattributed to Johan van Haensbergen.

2 Chambers 1829, II, p. 845.

3 Dawson 1817, p. 45.

4 Chambers 1829, II, p. 640, *Eurydice wounded by a Serpent.*

5 Chambers 1829, II, p. 759, *David and Bathsheba.*

6 Walpole Sale 1856, 3rd day, lot 252, *Classical figures in conversation, near a cavern . . .*

7 Crome Sale 1821, lot 48.

8 Boulter [1794], p. 82, no. 16.

9 Norwich 1840 (79).

10 Norwich 1829 (28).

11 Gunthorpe Sale 1842, lot 4, bt in.

12 Chambers 1829, I, p. 306.

13 Brereton Sale 1870, lot 155.

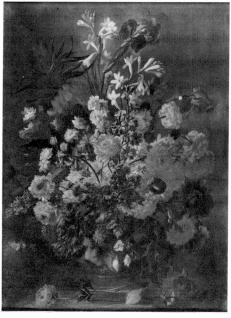

cat. no. 41

41 Karel van Vogelaer

Maestricht 1653 – Rome 1695

Summer Flowers in an Urn

Illustrated above
Oil on canvas 96.5 × 73 cm
Signed: *CAREL DE VOGELAER ROME*

Prov: William Windham II; see cat. no. 38.

Exh: Norwich 1955 (36).

The National Trust (Felbrigg Hall)

This, and its companion picture still at Felbrigg, was almost certainly purchased by William Windham II while in Rome 1739–40, during his Grand Tour.[1] Karel van Vogelaer had left his native country to work in France and Italy and came to be known as Carlo dei Fiori. In 1764 both pictures are recorded as in the 'Third Room': 'Flower piece(s) by Carlo de Fiore'. The summer flowers include roses, stocks and chrysanthemums in an arrangement typical of the artist.[2]

1 A comparable painting is now in the collection of Lord Templemore at Dunbrody.

2 The companion picture at Felbrigg includes lilac, iris and tiger lilies. Exhibited Norwich 1955(35).

42 Willem van de Velde the Elder

Leiden 1611 – London 1693

The Battle of the Texel c. 1674

Illustrated p. 105
Oil on canvas 114.3 × 184.2 cm
Signed: *W.V. Velde.*

Prov: Purchased by William Windham II by 1752; see cat. no. 38.

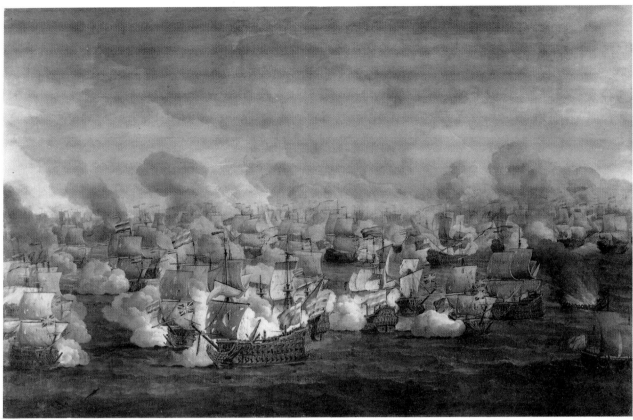

cat. no. 42

Lit: Joseph Farington's Diary; Ketton-Cremer 1962,
 p. 122; *The Connoisseur*, December 1964, vol. 157,
 p. 239; Moore 1985, p. 128; Waterson 1986,
 pp. 438–40, 904–6.

Exh: London 1964 (69).

The National Trust (Felbrigg Hall)

This canvas was one of a pair depicting the Battle of the Texel at different stages. The companion picture shows a view of the battle at a later stage.[1] At the National Maritime Museum, Greenwich there is a careful drawing attributed to van de Velde The Elder (although possibly started by the Younger) which shows the three ships, the *Prince*, the *Gouden Leeuw* and the *St George* in the same positions as in this Felbrigg version of the battle.[2]

Merlin Waterson has recently demonstrated just how much William Windham's love of the sea and for ships and shipping influenced his taste in marine painting. His library contained a number of books on boat-building, including *L'Art de Batir les Vaisseaux, et d'en Perfectionner la Construction*, published in 1719 in Amsterdam by David Mortier, a specialist in nautical maps. Windham's passion for sailing almost certainly influenced his purchase of works by the van de Veldes. Waterson has convincingly suggested that when Windham wrote to his agent Frary, in June 1752, he was referring to this version of *The Battle of the Texel*: 'My great V. Velde I cannot trust to the seas so that alone shall go by land. All my pictures are not done so that in about a month I shall want another cargo'. It is this version that conveys the sense of a highly complex naval engagement involving scores of ships. The companion view, by Willem van de Velde the Younger portrays a greater sense of drama, but less documentary value than this bird's-eye view.

Records show that the taste for paintings and drawings by or attributed to the van de Veldes was strong in Norfolk, reflecting the national pattern. In total William Windham purchased six canvases by the van de Veldes, including the two versions of *The Battle of the Texel* originally hung in the Drawing Room at Felbrigg in 1752. A good example also hung in the Drawing Room at Narford,[3] and two seapieces hung at Melton Constable.[4] There were also seapieces at Saxlingham, Thurning and Didlington Hall.[5]

William Windham's love of the sea and shipping found parallels among other collectors notably William Leathes at Herringfleet Hall,[6] and Captain F. Marryatt R.N.[7] John Patteson owned two storm scenes[8] and John Crome possessed three seapieces at his death.[9] A total of three were borrowed by the Norfolk and Suffolk Institution for the Promotion of Fine Arts for their Old Master exhibitions of 1828–29.[10]

1 National Maritime Museum, Greenwich; Norwich 1985(67).

2 Michael Robinson, unpublished catalogue, no. 409; illus. Waterson 1986, II, p. 905.

3 Chambers 1829, II, p. 640. Now in a private collection, New York.

4 Chambers 1829, II, p. 786.

5 Chambers 1829, II, pp. 759; I, 231; III, 1343 respectively.

6 Druery 1826, p. 209: 'A Sea calm, the water exquisitely managed . . .'.

7 Norwich 1878(347) 'William Vandevelde (The Old). Storm at sea (formerly belonging to Captain Marryatt, R.N.) lent by Robert E. Butcher Esq.'

8 Patteson Sale 1819, 1st day, lot 80, A Sea Storm, ex-Norton collection; 2nd day, lot 81, 'A Fishing Boat at

anchor, and another just standing off to sea in a brisk gale, with several vessels in the distance in pure and genuine state'.

9 Crome Sale 1821, lots 84, 92 and 98. One of these was purchased by C. Weston, and sold Weston Sale 1864, 1st day, lot 144, *Sea Piece*, 27 × 17 inches.

10 Norwich 1828(6), lent by William Freeman; Norwich 1829(40), lent by Curr; Norwich 1829(122), lent by Mason.

43 Johannes Glauber

Utrecht 1646 – Schoonhoven *c.* 1726

Classical Landscape with figures

Illustrated below
Oil on canvas 59.7 × 75 cm
Signed (lower left): *Glauber*

Prov: William Windham II, see cat. no. 38.

Exh: Norwich 1964 (28).

The National Trust (Felbrigg Hall)

A pupil of Nicolaes Berchem, Glauber spent some years after 1671 in both France and Italy. In common with Jan Frans van Bloemen (cat. no. 29) and Hendrick van Lint (cat. no. 30) he was considerably influenced by the classical style of Nicolas Poussin.

Both this and its pair at Felbrigg, display Glauber's favourite motifs, including classical rural figures, oddments of classical remains and a vista of buildings against a dominent mountain range. In the left middle distance nymphs are wreathing a herm. Both canvases by Glauber are shown in William Windham's design for the West wall of the cabinet room *c.* 1751–2, to be hung on either side of Windham's large canvas by de Vlieger, *The Blockade of Amoy*. They are recorded as in the room in 1764. Both canvases by Glauber were almost certainly purchased by Windham while on his grand tour.

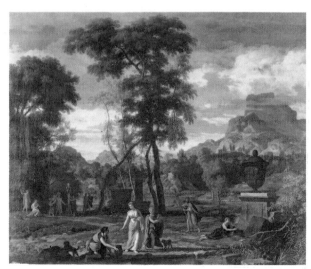

cat. no. 43

44 Thomas Worlidge

Peterborough 1700 – London 1766

Sir Edward Astley as Jan Six

After Rembrandt, 1762

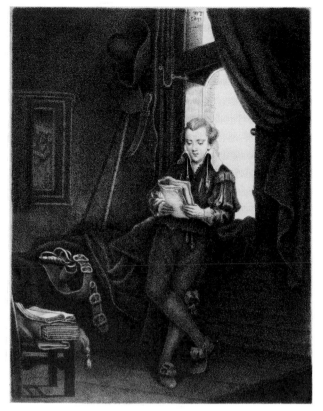

cat. no. 44

Illustrated above
Etching and drypoint 23.6 × 18.3 cm
Signed in monogram: *TW/1762* (in reverse).

Prov: Acquired 1942 (BM 50.8.10.42).

Lit: Lugt 1921, pp. 517–8; White *et al.* 1983, no. 158.

Trustees of the British Museum

Sir Edward Astley, Bt (1729–1802) was the descendant of Sir Jacob Astley (cat. no. 14). He succeeded to the title of fourth Baronet in 1760, the year in which he sold his Rembrandt print collection. He had acquired an important collection in 1756 from the collector Arthur Pond. Pond had himself acquired much of his collection from the engraver J. Houbraken who, in turn, had purchased many Rembrandt prints from the Willem Six sale of 1734. The collection therefore included individual prints which could claim a direct provenance to Jan Six, Rembrandt's friend and patron.

In copying Rembrandt's original etching of Jan Six and substituting the face of Edward Astley, Worlidge was paying a double tribute to Astley.[1] For Astley was also Worlidge's own most important benefactor, as well as owner of part of Six's print collection.[2] When Horace Walpole saw the exhibited impression of this print at the Free Society in 1762 (157) he described it as the 'best piece' of Worlidge's career as a printmaker.

1 A preliminary drawing in pencil, with an added dog is in the D.L.T. Oppe Collection, no. 2655, 20 × 15.5 cm.

2 Lippincott estimates that Astley's nineteen-day sale of 1550 lots included about 10,000 prints from his Pond acquisitions (White *et al.* 1983, no. 158, note 1). Chambers 1829, II, p. 784 notes that by then the library at Melton Constable still contained 'a very fine collection of prints'.

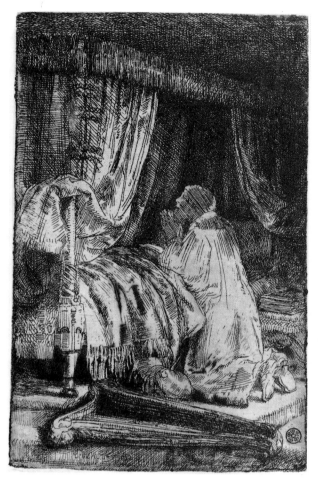

cat. no. 45

45 Rembrandt Harmensz. van Rijn

Leiden 1606 – Amsterdam 1669

David at Prayer

Illustrated above
Etching and drypoint 14.3 × 9.3 cm

Prov: ?Willem Six sale 1734; ?Arthur Pond, 1756;
Edward Astley ?Sale, Langford, 27 March and 18
days following, 1760; Percy Moore Turner; by
whom presented to Norwich Castle Museum 1951
(65.47.951).

Lit: Godfrey 1987, p. 409.

Norfolk Museums Service (Norwich Castle Museum)

The unmistakable collector's mark of Sir Edward Astley is
prominently displayed, bottom right. Although Astley
owned his magnificent Rembrandt collection for only
four years, he carefully recorded his possessions. This
particular impression has recently been appreciated by
Richard Godfrey as 'an exceptionally beautiful example of
a print that is rarely seen in high-quality impressions,
with the burr suggesting the softness of the pillows and
sheets in contrast to the sharp geometric shading on the
figure of the praying David'.[1] See also cat. no. 44.

1 Godfrey 1987, p. 409.

46 Two Manuscript Catalogues

Not illustrated

(a) *A catalogue of Pictures in Langley
House* 1815–32
Marbled covers 20.5 × 16.5 cm

(b) *Descriptive Catalogue of the Pictures &
Pieces of Sculpture at Langley Hall
Norfolk the seat of Sir William
Beauchamp Proctor Bart, 1815*
Marbled covers 23.5 × 19 cm

Prov: Lady Mary Proctor Beauchamp; then by descent to
present owner.

Sir Christopher Beauchamp Bt

These two catalogues provide a valuable record of the
collection at Langley Park. Started in the second half of
the eighteenth century, the collection was added to by
successive members of the family. The *Catalogue of
Pictures*, written in the hand of Lady Mary Proctor
Beauchamp in 1815, has addenda dated 1832. The *Descrip-
tive Catalogue* . . . is a copy of the 1815 catalogue, and is
inscribed on the first page:

> 1815. Copied from the catalogue belonging to the
> family, by permission of Lady Beauchamp who lent it
> to me.
>
> The remarks in my handwriting were made when I
> looked over the collection with J.P. Davis Nov. 22 1816.
> This catalogue is in the hand-writing of Thos. Gent
> Esq. author of *Poems* etc.

47 Simon de Vlieger

Rotterdam 1600/1 – Weesp 1653

Sea View, a Squall c. 1640s

Illustrated p. 22
Oil on panel 59 × 83.8 cm

Prov: In the collection of Sir Thomas Beauchamp Proctor
Bt by 1815; by descent to present owner.

Lit: Langley MS 1815, Drawing Room no. 14.

Sir Christopher Beauchamp Bt

De Vlieger was one of the most distinguished of the
second generation of Dutch sea painters. The pupil of Jan
Porcellis, he broke from the colourful style of the early
Netherlandish sea painters and introduced a more som-
bre tone into his seascapes. The grey-brown tones of this
panel are typical of his work, as is his painting of the
cresting waves. This is an example of his mature style
which was to influence both Jan van de Cappelle and his
pupil Willem van de Velde the Younger.

The Langley manuscript catalogue of 1815 remarks:
'This is a very extraordinary picture, the fleeciness of the
clouds, the flow and transparency of the water, and its
exquisite finish without harshness or heaviness are truly
inimitable; and such as are rarely found in the works of
any other master'. The panel was later moved to the
North Parlour at Langley by 1832. Thomas Gent's com-
ment, in 1816, was typically acerbic: 'Masterly and Grand,
I own, but I do not like it . . .'

Another *Sea View* by de Vlieger in the collection at Langley hung in the Cabinet Room.[1] This was regarded as a truly remarkable example of the artist's talent, 'such as has rarely been equalled by this or any other Master'. A large panel, the composition included some thirty figures. The picture was copied by Harriet, the daughter of Sir Thomas Beauchamp Proctor, and her version was exhibited with the Society of Arts in 1803, where it was awarded the silver medal. In 1815 this version hung in Sir Thomas's Dressing Room. A second panel attributed to De Vlieger hanging in the Cabinet Room in 1815 was *The Cloud Capp'd Tower.*[2]

The most spectacular canvas by de Vlieger in the region was William Windham's huge canvas *The Blockade of Amoy* painted in 1650 and hung as a central feature of Windham's Cabinet Room at Felbrigg Hall since the 1750s.

1 Proctor-Beauchamp *et al.* Sale 1946, lot 66. *A View on the Dutch Coast* . . . signed and dated 1642, panel 32 × 52 inches; private collection by 1987.

2 'A Turkish Galley, also a Boat with four Perpendicular Rocks, rising from the Surface of the water, on one of which stands a Ruin', panel, 9½ × 11½ inches.

48 Jan van Goyen

Leiden 1596 – The Hague 1656

Landscape with Travellers arriving at a wayside inn 1643

Illustrated colour plate xiv
Oil on panel 49 × 66 cm
Signed and dated (left): *VG 1643*

Prov: In the collection of Sir Thomas Beauchamp Proctor Bt by 1815; by descent to present owner.

Lit: Langley MS 1815, The Cabinet Room, no. 34; Neale 1820; Chambers 1829, II, p. 846; Beck 1972–73, no. 1023.

Exh: Norwich 1966 (19); Alan Jacobs Gallery 1977 (18).

Sir Christopher Beauchamp Bt

At the age of nineteen Jan van Goyen travelled to France for a year and on his return spent a year with Esias van de Velde at Haarlem. He worked at Leiden until 1632 when he moved to The Hague. A prolific painter, he specialised in the new monochromatic Haarlem style, painting predominantly in browns or greens.

The Langley manuscript catalogue comments 'This picture has the merit of van Goyen, a light expressive touch with great transparency of colour'. Thomas Gent, in his manuscript version of the catalogue commented in 1816: 'A far more pleasing picture & with far more colour than is common with this master'. A second panel by van Goyen, signed and dated 1640, was also at Langley by 1815, where it hung in the Drawing Room'.[1] The work of van Goyen had a high reputation in England during the late eighteenth and early nineteenth centuries. For other recorded collections in East Anglia which included works by van Goyen, see cat. no. 67.

1 Beck 1972–3, no. 736.

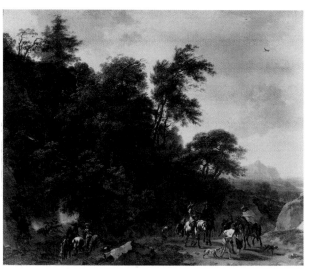

cat. no. 49

49 Nicolaes Berchem

Haarlem 1620 – Amsterdam 1683

Landscape 1656

Illustrated above and page 23
Oil on canvas 82.5 × 99 cm
Signed and dated (b.r.): *Berchem Fc/1656* (the Fc conjoined)

Prov: Greffier Collection (according to Langley MS 1815); in the collection of Sir Thomas Beauchamp Proctor Bt by 1815; by descent to present owner.

Exh: Norwich 1966 (5).

Lit: Langley MS 1815, The North Eating Room, No 12; Neale 1820; *Chambers* 1829, II, p. 845.

Sir Christopher Beauchamp Bt.

Nicolaes Berchem was the pupil of his father Pieter Claesz and then, among others, of Jan van Goyen. The Italianate quality of Berchem's work supports the view that he probably visited Italy *c.* 1653–5, though there is no documentary evidence of his having done so. The subject of this canvas, painted the year after Berchem's presumed return from Italy, is typically Italianate, depicting the capture of three bandits in the Roman Campagna. This is one of the finest examples of Berchem's work recorded in Norfolk collections of the period. The fact that Berchem's work was not universally admired at the beginning of the nineteenth century can be seen from the following remarks made by Thomas Gent who 'looked over the [Beauchamp] collection with Mr J.P. Davis Nov. 22, 1816'. He observed: 'Let what may be said, the monotonous dull heavy green of this picture sadly spoils the effect, which is ruined by its hanging so near R^d. Wilson. The figures are the beauty of this picture. The distance does not in my eyes merit the praise bestowed on it.' The family catalogue written in 1815 records the opposite view: 'This Picture fully justifies the high estimation in which the works of the Master are universally held . . . if the Hill and foreground should be deemed somewhat monotonous in colour, it is a defect that weighs nothing in comparison, with the numerous and striking merits of the Picture on the whole.'[1]

A significant number of works by or attributed to Berchem are recorded as having been in local collections. Two eighteenth century collections were those of William

Leathes[2] at Herringfleet Hall and William Windham of Felbrigg Hall.[3] Two cattle pieces were exhibited at the Old Masters exhibition held at Norwich in 1829.[4] John Patteson's *Man driving cow and man on horseback* was purchased in 1819 by Lord Orford of Wolterton Hall.[5] This picture was later exhibited twice at the British Institution, in 1829 and 1842.[6] Lord Charles Townshend owned three drawings and one oil attributed to Berchem.[7]

1 MS catalogue. See cat. no. 46b.

2 Druery 1826, p. 210.

3 Chambers 1829, I, p. 158.

4 Norwich 1829 (104) lent by Curr; (105) lent by Mason.

5 Patteson Sale 1819, 2nd day, lot 82; Walpole Sale 1856, 3rd day, lot 264, bt Pennell.

6 London 1829 (113) and 1842 (156).

7 Townshend Sale 1835, lots 2, 4, 5, 48.

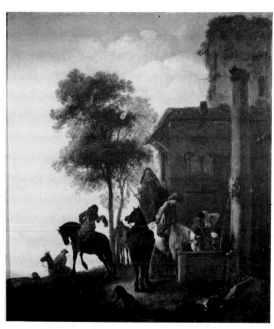

cat. no. 50

50 Studio of Philips Wouwermans

Haarlem 1619 – Haarlem 1668

A halt, at an Inn door

Illustrated above
Oil on panel 34.3 × 31.3 cm

Prov: In the collection of Sir Thomas Beauchamp Proctor Bt by 1815; by descent to present owner.

Lit: Langley MS 1815, The Cabinet Room, no. 28.

Sir Christopher Beauchamp Bt

The Langley manuscript of 1815 describes this picture, then hanging in the Cabinet Room, in glowing terms: '. . . The general hue of this picture has a pleasing warmth in it. Upon the whole, this is one of the most forcible pictures of the master, who is justly celebrated for his exquisite finishing, and for his peculiar skill, in delineating Horses, with spirit and accuracy: together with these his usual merits, this Picture possesses a force and breadth of chiaro scuro, but rarely attained by him, which

renders it one of the most singular, as well as most admirable specimens, of his Powers anywhere to be met with.'

This assessment seems difficult to justify today. Although the subject matter and composition is unmistakably that of Wouwermans, the quality of the painting suggests that it is the work of a follower. Thomas Gent, in 1816, commented on the condition of the panel: 'It is a pity so much writing and ingenuity are wasted on this picture, which has been rubbed and painted upon till it is all out of harmony (if ever it was)'. Nevertheless, the painting was hung in the Cabinet Room alongside some of Sir Thomas's most prized items, a fact which reflects the high reputation that Wouwermans commanded in Britain in the eighteenth and early nineteenth centuries.

51 Adam Pynacker

Pijnacker, near Delft 1621 – Amsterdam 1673

A Landscape, Evening c. 1660s

Illustrated colour plate xvi
Oil on canvas 80 × 69.8 cm

Prov: Purchased by Lady Mary Beauchamp Proctor, wife of Sir Thomas, from a Mr Hill, 1811; then by descent to present owner.

Lit: Langley MS 1815, The Drawing Room, p. 69; Neale 1820; Chambers 1829, II, p. 846; Hawcroft 1957, p. 106 (illus.).

Exh: On loan to Norwich Castle Museum, 1956–58; Cardiff 1960 (62); Norwich 1966(34).

Sir Christopher Beauchamp Bt

According to Houbraken, Pynacker spent three years in Italy. He is known to have been living in Delft in 1649 and in 1658 he is mentioned as in Schiedam. His early work was strongly influenced by Jan Both and Jan Asselijn, but *c.* 1660 he developed his own highly personal style. His compositions often incorporate the characteristic motif of trees leaning towards each other. The Langley catalogue of 1815 noted 'the rich glow of colour and the delicacy of pencilling for which this Painter was celebrated, are in this picture eminently displayed'. For a second work by Pynacker at Langley, see cat. no. 52.

A number of works by Pynacker are recorded in nineteenth century Norfolk collections. Two works attributed to this artist were lent to the exhibition of Old Masters organised in Norwich by the Norfolk and Suffolk Institution for the Promotion of the Fine Arts in 1828, one lent by George Stacy[1] and one by Thomas Brightwell.[2] In 1840 Joseph Muskett of Intwood Hall lent a *Landscape and Cattle* to the Norwich Polytechnic exhibition.[3] Charles John West of Norwich owned a 'small landscape' by Pynacker,[4] as did Dawson Turner. Lord Charles Townshend of Raynham lent a *Landscape and Figures* to the British Institution in 1847.[5]

1 Norwich 1828 (26) *Italian Landscape – Morning.*

2 Norwich 1828 (105) *Moonlight*; *c.f.* also Norwich 1878 (223), Adam Pynacker, *Mountain Scenery*, lent by T. Brightwell Esq.

3 *c.f.* Unthank *et al.* Sale 1897, 2nd day, lot 133 'Pynacker: A Landscape with Shepherd and Shepherdess. On the left a cross with figures on each side in the distance a

valley and high mountains. Signed A. Pynaker. Canvas 23 by 15 in. From G. Morants Collection, 1832.'

4　West Sale 1843, 1st day, lot 59.

5　*c.f.* Townshend *et al.* Sale 1851, lot 75, *Rustic Bridge,* bt Rutley £270.

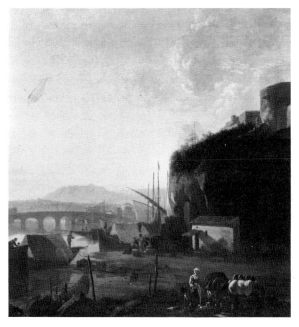

cat. no. 52

52　Adam Pynacker

Pijnacker, near Delft 1621 – Amsterdam 1673

A Southern River Landscape *c.* 1660s

Illustrated above

Oil on canvas　48 × 46 cm

Prov:　In the collection of Sir Thomas Beauchamp Proctor Bt by 1815; by descent to Sir Ivor Proctor Beauchamp Bt; sold Sotheby's, 25 June 1969, lot 6, when acquired by present owner.

Lit:　Langley MS 1815, The Cabinet Room no. 26.

Exh:　Cardiff 1960 (63).

R. Hanbury Tenison J.P.

This canvas was felt, in 1815, to 'exhibit the usual perfections of this master, viz. a luminous sky, delicacy of touch, and mellowness of colouring'. See also cat. no. 51.

53　Attributed to Willem van Aelst

Delft 1625/26 – Amsterdam 1683 or later

Flowerpiece ?*c.* 1660s

Illustrated alongside

Oil on canvas　75 × 62.2 cm

Prov:　In the collection of Sir Thomas Beauchamp Proctor Bt by 1815; by descent to present owner.

Lit:　Langley MS 1815, North Eating Room, no. 14; Chambers 1829, II, p. 845.

Exh:　Norwich 1955 (18) as Jan Davidsz. de Heem.

Sir Christopher Beauchamp Bt

Described in 1815 as 'A very rich and highly finished picture' this flowerpiece was then attributed to the work of 'De Heem' and hung as an overdoor in the North Eating Room at Langley Hall. Such an attribution in the early nineteenth century should be treated with some caution. Jan Davidsz. de Heem (Utrecht 1606 – Antwerp 1683/84) was the head of a quite large studio with a good number of pupils and followers who rapidly disseminated his style. His son Cornelis was one of the most faithful pupils.[1]

It is only in the collection of Joseph Muskett of Intwood Hall, in the family sale of 1897 that one first finds a work firmly identified as by Willem van Aelst, in a Norfolk collection.[2] This indicates something of the vagaries of fashionable attribution that one may expect in the field of nineteenth century attributions.

It is quite possible that works attributed to de Heem could well be by pupils or followers such as Willem van Aelst. Willem studied under Evert van Aelst and became a member of the Guild of St Luke at Delft in 1643. From 1645–49 he lived in France before moving to Italy where he remained until 1656, working for a time as Court Painter to the Grand Duke of Tuscany.

The Langley flowerpiece is typical of van Aelst's work, particularly in its balanced arrangement, broken by the carnation to the lower left and the strong diagonal of fleshy leaves to the upper right. The closest dated parallel arrangement of flowers on a bare marble shelf is possibly van Aelst's *A Vase of Flowers* of 1663, now in the Ashmolean Museum, Oxford.[3]

1　For works by de Heem in Norfolk Collections see cat. no. 113.

2　Unthank *et al.* Sale 1897, 2nd day, lot 166.

3　D.L. Ward Bequest 1961, no. 2.

cat. no. 53

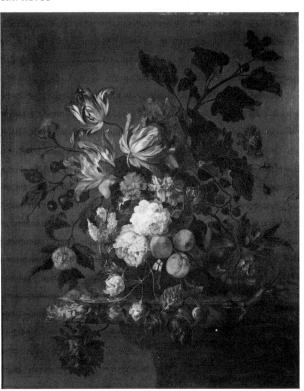

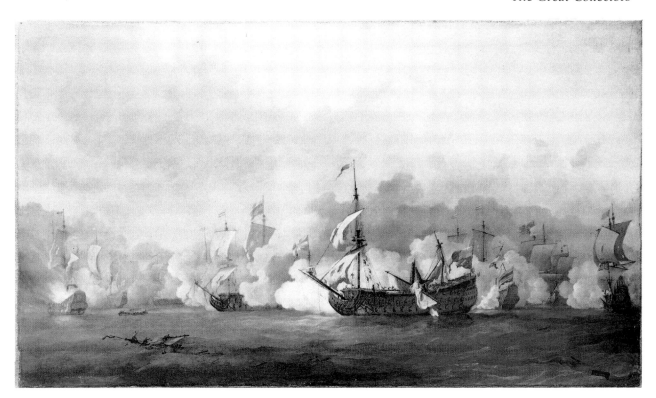

cat. no. 54

54 Willem van de Velde the Elder and Younger

The Elder, Leiden 1611 – London 1693

The Younger, Leiden 1633 – London 1707

The Battle of the Texel (Kijkduin) c. 1674

Illustrated above

Oil on canvas 81.3 × 144.8 cm

Signed, lower right, with indistinct monogram

Prov: In the collection of Sir Thomas Beauchamp Proctor Bt by 1815; then by descent to Sir Reginald Proctor-Beauchamp Bt; Proctor-Beauchamp *et al.* Sale 1946, lot 65, described as 'A naval engagement between the British and Dutch fleets', bt by Spink; bt by National Maritime Museum, through Spink & Son 1948. (NMM 48–521).

Lit: Langley MS 1815, p. 24, no. 9 as *Solebay Fight 1672 by Wm Vandervelde;* Chambers 1829, II, p. 846; National Maritime Museum, Greenwich, *Concise Catalogue of Paintings*, 1958, p. 59, (NMM 48–251).

National Maritime Museum

The battle of the Texel, in August 1673, known in Dutch history as the battle of Kijkduin, was the last battle of the third Anglo-Dutch war. It was the final attempt to disperse the Dutch fleet under de Ruyter, preparatory to an invasion of Holland from the sea. Although the Dutch withdrew, the Allied fleet under Prince Rupert had to return to the Thames to refit. Peace was made the following year.

The composition shows Sir Edward Spragge's flagship the *Prince* defending herself against the repeated attacks of Lieutenant Admiral Cornelis Tromp. Unlike other depictions of this battle, the *Prince* appears well in the foreground, shown with only her foremast standing. This is the most painterly of the finished versions of this composition. A number of inaccuracies in the flags suggests that there is another, earlier, version upon which this has been based.[1]

When in the collection at Langley, this composition was believed to depict the battle of Solebay in 1672. This misidentification may have been based on a comparison with a print of the battle of the Texel by Elisha Kirkall, which was mistitled 'Fight in 1672'. The unusual state of the dismasted *Prince* would have suggested a different battle to that depicted in the two versions of the *Battle of the Texel* at Felbrigg Hall.[2]

1 This is the opinion of Michael Robinson, whose help in cataloguing this painting I gratefully acknowledge.

2 The 1815 MS description and recorded size of the Langley picture help to confirm the identification of this painting with that formerly at Langley.

55 Cornelis Beelt

fl. Haarlem *c.* 1660; died before 1702

Scene on a Frozen River

Illustrated p. 112

Oil on panel 56.6 × 73.2 cm

Signed, bottom right of centre (barely decipherable): *?Beelt.*

Prov: ?William Leathes; ?by descent, to Major Hill M. Leathes (see Exh. below); by descent to present owner; on loan to Christchurch Mansion, Ipswich since 1920 (LUR 1960–172.4).

Exh: Leeds 1868(567) as A. Ostade, *Frost Piece, Figures Skating*, lent by Major Hill M. Leathes.

Ipswich Museums and Galleries

This winter scene has traditionally been regarded as by Ostade but the signature was discovered and the present attribution made by the National Gallery in 1965. Beelt

111

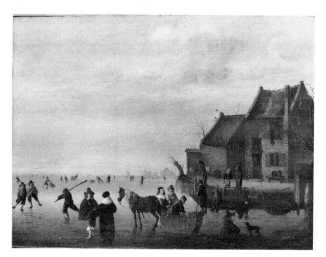

cat. no. 55

1 Ovid, *Metamorphoses*, VIII, 270–418.

2 Whereabouts unknown, but known through copies.

3 Harvey Sale 1842, 2nd day, lot 263.

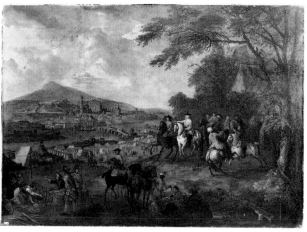

cat. no. 57

57 Peeter Verdussen

Antwerp 1662 – ?Antwerp after 1710

The Assault on the Town of Oudenarde

Illustrated above

Oil on canvas 113.5 × 165 cm

Signed, bottom left: *P. Verdussen*

Prov: William Leathes; by descent to present owner; on
loan to Christchurch Mansion since 1920 (LUR
1960–172.15).

Lit: Druery 1826, p. 210.

Ipswich Museums and Galleries

William Leathes was Master of Ordinance in the Marl-
borough campaign in Flanders. Typical of its genre, this
scene clearly shows the Duke of Marlborough overseeing
the preparation for the assault on Oudenarde in 1708.
Druery, when he noted the painting in 1826, did not
recognise the site, but believed the composition included
'a variety of Portraits'.

was a late follower of Jan van Goyen and Salomon van
Ruysdael. Although the painting is not mentioned by
Druery in 1826, his list is by no means exhaustive.
The picture was almost certainly acquired by William
Leathes, the main collector of the paintings formerly at
Herringfleet Hall.

56 School of Peter Paul Rubens

Flemish School, late 1600s

Atalanta and Meleager in pursuit of the Calydonian Boar

Illustrated p. 20

Oil on panel 66.5 × 105.5 cm

Prov: William Leathes (1674–1727); then by descent to
present owner; on loan to Christchurch Mansion,
Ipswich, since 1968 (L1968–11.22).

Exh: Leeds 1868 (763), lent by Major Hill M. Leathes.

Lit: Druery 1826, p. 209; Balis 1986, p. 157.

Ipswich Museums and Galleries

This is one of the ten recorded copies in oil after *The
Calydonian Boar Hunt* by Rubens, now in the Kunsthistor-
isches Museum, Vienna. This version was recognised by
Arnout Balis in 1986 as 'of rather high quality'. The scene
depicts that moment at which Meleager prepares to deal
the death-blow to the boar, which Atalanta has wounded
with an arrow behind the ear. The boar stands astride the
dead Ancaeus. The introduction of two female hunters
besides Atalanta is a detail not found in Ovid's account.[1]
The composition is based upon Rubens' own earlier
Calydonian Hunt[2] and some apparent borrowings from
antique sarcophagi. Druery, when he noted the painting
at Herringfleet Hall in 1826 commented: 'a genuine
production of the master [Rubens], although the finished
appearance of the picture has induced some connoisseurs
to pronounce differently.'

This panel quite possibly dates from the late seven-
teenth century. It was almost certainly acquired by
William Leathes while at Brussels, 1715–22.

There was one other *Boar Hunt* attributed to Rubens
and recorded in a Norfolk collection in 1829. This
belonged to Thomas Harvey of Thorpe House, and hung
in the Drawing Room.[3]

58 Herman van der Myn

Amsterdam 1684 – London 1741

Danae

Illustrated p. 113

Oil on panel 72.8 × 59.5 cm

Prov: William Leathes; then by descent to present
owner; on loan to Christchurch Mansion, Ipswich,
since 1920 (LUR 1960–172.11).

Exh: Leeds 1868 (864), lent by Major Hill M. Leathes.

Lit: Druery 1826, p. 208.

Ipswich Museums and Galleries

Herringfleet Hall was celebrated for its collection of work
by Herman van der Myn. J.H. Druery, in his *Historical
notices of Great Yarmouth . . .*, 1826, commented: '. . . the
cabinet pictures of Vander Myn claim particular notice. In
elegance of design, chastity of colouring, anatomical
correctness, and superior execution, the Herringfleet
collection of pictures by this master may justly be termed

the Vander Myn Gallery. The works of Herman Vander Myn are but little known: his best pictures are scarce, and the real merit of the master is even now but imperfectly understood. His pieces have frequently been confounded with those of the Vandermines, the elder of whom only was a good portrait painter, and whose clever productions in that branch of the art, in all probability, gave rise to the confusion of his pieces with the portraits of Herman . . .'[1]

Druery records a total of eleven oils by Herman van der Myn at Herringfleet.[2] *The Danae* he regarded as 'a matchless picture'. Paintings on panel in much the same vein were *Tamar and Amnon*,[3] *The Death of Sophonisba*, *Venus and Cupid*, *Cupid and Psyche*[4] and also a *Magdalene*. Of these Druery commented 'These pictures are all in what the painter termed his cabinet style, in which he generally rivalled Gerard Douw, and in many respects eminently surpassed him.' The other paintings by van der Myn at Herringfleet Hall were painted in a different mode, to a larger scale but still demonstrating finesse in the depiction of different textures.

The most splendid of Herman van der Myn's paintings at Herringfleet Hall was his portrait of William Leathes when Minister at Brussels (see fig. 20). There was also a small kit-cat size portrait of Leathes, a 'Flower Piece, *very good*', *St Paul writing his Epistles*[6] and a larger version of *The Danae*.[7] It was quite probably William Leathes' patronage of van der Myn that encouraged the artist to visit England.[8]

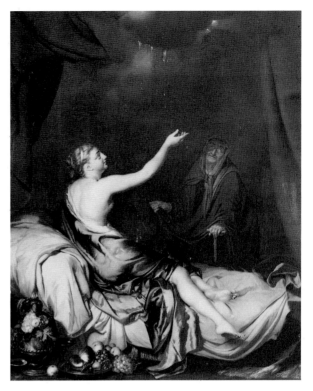

cat. no. 58

1 Druery 1826, p. 208. The possibility of confusion is exacerbated because F. van der Myn painted a number of portraits locally: 'Vandermyn, a painter of considerable excellence, was introduced at Norwich by Mr Bartlett Gurney, and was extensively employed; but he was so attached to his pipe and his beer, that he would not put them aside when at work; and this habit was detrimental to him in many ways. He died in London in 1783. There is a well-engraved portrait of him by Bassett. His son, Robert Vandermyn, was a good painter of still life; but a man of dissolute habits. He died in the Bridewell at Norwich, to which he had been committed as a vagrant.' Palmer 1872, I, p. 197.

2 *Ibid.*, pp. 208–9.

3 A similar panel, 71.5 × 58.5 cm, depicting this subject was in the L. Bloch collection sale; Muller, Amsterdam, 14 November 1905 (Witt Library photograph).

4 These four panels are all now on loan to Christchurch Mansion, Ipswich.

5 Leathes *et al.* Sale 1971, lot 111, *The Penitent Magdalen*, signed and dated 1722.

6 Leeds 1868 (879); Leathes *et al.* Sale 1971, lot 100, *St. Paul writing by Candlelight*.

7 *Leathes et al.* Sale 1971, lot 95, *Danae*, 154.8 × 192.9 cm.

8 Other portraits painted by, or in the style of, Herman van der Myn from the Leathes collection were sold, Leathes *et al.* Sale 1971, lots 84, 85, 106(2) and 109.

III Merchants and Dealers

59 Meindert Hobbema

Amsterdam 1638 – Amsterdam 1709

Road-side Inn

Illustrated alongside and colour plate xx
Oil on canvas 47 × 53.5 cm
Signed, lower left (on fence): *M. Hobbema.*

Prov: Thomas Harvey of Catton: from whom purchased
by Dawson Turner of Yarmouth *c.* 1815; Turner
Sale 1852, lot 74, bt Niewenhuys; Charles
Scarisbrick Sale 1861, lot 46; J.E. Fordham Sale
1863, bt by Niewenhuys; Marlborough Fine Art
Ltd.; from whom bt by E.G. Bührle collection,
1953.

Exh: Norwich 1829 (15); The Hague and London
1970–71 (69).

Lit: Druery 1826, p. 74; Chambers 1829, I, p. 304;
Smith 1835, VI, no. 76; Turner 1840, p. 16; de Groot
1912, IV, no. 224.

Foundation E.G. Bührle Collection, Zurich

Meindert Lubbertsz., called Hobbema, was the pupil of
Jacob van Ruisdael, only ten years his senior. Most of
Hobbema's early themes and indeed compositions derive
from those of Ruisdael, while his later work after *c.* 1662
becomes more atmospheric and heightened in effect.

Dawson Turner, when cataloguing this painting in his
Outlines in Lithography, 1840, commented of Hobbema:
'with respect to his merit there is at present no difference
of opinion'. Throughout the early years of the nineteenth
century Hobbema was regarded with especial reverence
by English collectors and artists alike. According to
Dawson Turner, John Crome's last words were 'Oh,
Hobbima, my dear Hobbima, how I have loved you!'[1]
Hobbema was 'the artist on whom our Norfolk
Landscape-painter endeavoured to form his style'. Again,
it was Dawson Turner who recorded that this particular
picture was 'that which was the great object of his
admiration when in the full enjoyment of his powers, and
the last that floated before his closing eyes'.

It is quite possible that John Crome's debt to Hobbema
is a myth conjured up in these terms by Dawson Turner.
However, it is indisputable that Crome knew this
painting well, when it was in the collection of Thomas
Harvey of Catton. According to Turner, it was Harvey
himself who had imported the painting from Holland and
Turner had acquired it only *c.* 1815, when Crome had

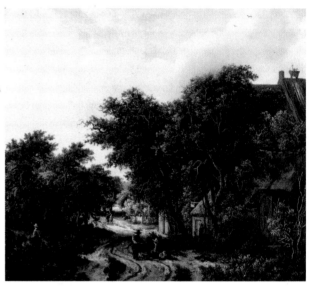

cat. no. 59

long since ceased to act as drawing-master to the Turner
ladies. It is certainly believable that Crome copied the
painting *c.* 1790 as Harvey recounted to Turner.[2] Never-
theless, Crome himself never exhibited a painting 'after
Hobbema', and contemporary critics recognised Hobbe-
ma's influence in the work of James Stark rather than
Crome (see cat. no. 92).

John Crome did own a painting attributed to Hobbema
which was sold after his death for £1:16s.[3] The only other
landscape attributed to Hobbema in a Norfolk collection
that Crome might have known was that at Melton
Constable. However, that painting is first recorded by
Chambers only in 1829 and could well have been a recent
purchase by Sir Jacob Astley (see p. 00).[4] Thomas Osborn
Springfield owned a painting attributed to Hobbema
which was described in 1864 as having been 'presented
by Mr Loombe to Old Crome, by whom it was held in
very high estimation, and was considered by him to be a
genuine work of the artist . . .'.[5] J.H. Sperling of Catton
House bought *A Shady Stream with Watermill and figures in
foreground*, formerly in the Norbury collection, in April
1821, the month in which John Crome died.[6]

Two works attributed to Hobbema were exhibited in
the Norwich Old Masters exhibition of 1829.[7] Charles
John West of Norwich owned three works attributed to
Hobbema, one with figures by Wouwermans.[8] J.S. Mus-
kett of Intwood Hall purchased his Hobbema from the
Morant Collection in 1832.[9] Three later collections with

works attributed to the artist, were those of Christopher Steward of Yarmouth,[10] Rev. Samuel Titlow[11] and the wine merchant Cornelius Harley Christmas.[12] The majority of these works remain untraced but their existence in the nineteenth-century sale catalogues is indicative of the taste for this artist's work, which ran parallel with the taste for the work of the Norwich landscape painters.

1 Turner 1838, unpaginated.

2 Turner 1840.

3 Crome Sale 1821, 1st day, lot 91.

4 Chambers 1829, II, p. 791.

5 Springfield Sale 1864, 1st day, lot 160.

6 Sperling Sale 1886, 2nd day, lot 715.

7 Norwich 1829 (12), lent by Isaacs; (32), lent by C. Turner.

8 West Sale 1835, lot 56; West Sale 1843, 1st day, lot 42; bt by Rossi; and lot 44.

9 Norwich 1840 (29); Unthank *et al.* Sale 1897, 2nd day, lot 156 (Smith 1835, VI, p. 125, no. 39; de Groot 1912, IV, no. 45).

10 Steward Sale 1864, 1st day, lot 203.

11 Titlow Sale 1871, 1st day, lot 158.

12 Christmas Sale 1883, 2nd day, lot 574.

60 David Teniers II

Antwerp 1610 – Brussels 1690

Peasants Dancing and Feasting *c.* 1660

Illustrated colour plate xxii
Oil on canvas 68.3 × 74.9 cm
Signed (on rock, lower right): *D. TENIERS.FEC*[IT].

Prov: Possibly Jeanne d'Albert de Luynes, Countess of Verrue (died 1736): sale, Paris, 27 March 1737; Marquis of Brunoy (Sale, Paris, Joullain fils, 2 December 1776, lot 30); Lord Radstock; from whom purchased by Francois Bonnemaison 2 April 1810; sold by Bonnemaison to Thomas Penrice, August 1811; by descent to John Penrice; Penrice Sale 1844, lot 12; purchased by Nieuwenhuys; Marquis of Salamanca, Madrid and Paris (sale, Paris, 3–6 June 1864, lot 120); Count Cornet de Ways Ruart de Vaneche, near Brussels (1870); William T. Blodgett and John Taylor Johnston, New York (1870–71); Purchased by Metropolitan Museum of Art, New York, 1871 (71.99).

Lit: Druery 1826, p. 79; Chambers 1829, I, p. 305; Smith 1831, III, p. 277, no. 57 & mentioned p. 435 under no. 662; Smith 1842, supplement p. 421, no. 51; Penrice [ed] n.d., pp. 16, 21–24; James 1872; Liedtke 1984, I, pp. 256–7.

Metropolitan Museum of Art, New York

This painting is a pendant to a similar festive scene by Teniers in the collection of the Duke of Sutherland.[1] When Thomas Penrice purchased the painting from the dealer Francois Bonnemaison in 1811 it was entitled *Le Lendemain des Noces*. Bonnemaison, writing to persuade Penrice to purchase the painting suggested that either Henry Walton, or the President of the Royal Academy, Benjamin West, could act as independent experts to authenticate the painting.[2] In the event it was West who confirmed that 'The picture of Teniers is in good condition, and by the Master'.[3] Penrice had himself wanted Sir Thomas Lawrence to advise him, but Lawrence had preferred that West should act on both their behalfs. Lawrence sent West's authentication to Penrice on 6 August 1811, explaining that: 'From your having *concluded* the agreement for these pictures with Mr Bonnemaison, subject only to my pronouncing them genuine or not, I have felt myself precluded from giving any opinion upon them; for, had I believed them not genuine, it placed me in a very awkward situation'.[4] (See also cat. no. 61).

The taste for Teniers among British collectors increased markedly during the early nineteenth century. He was admired for the 'truthfulness' of his depictions of man and nature which became elevated beyond their 'low-life' subject-matter. In 1816 Hazlitt commented, in his article 'Fine Arts' for the *Encyclopaedia Britannica*: 'I should not assuredly prefer a *Dutch Fair* by Teniers to a *Cartoon* by Raphael; but I suspect I should prefer a *Dutch Fair* by Teniers to a *Cartoon* by the same master; or, I should prefer truth and nature in the simplest dress, to affection and inanity in the most pompous disguise. Whatever is genuine in art must proceed from the impulse of nature and individual genius.'[5]

1 Both pictures were engraved by J.P. Lebas when they were in the Brunoy collection. The Duke of Sutherland's painting was engraved under the title of *Les Accords Flamandes* and shows the couples dancing to the bass viol or violin rather than the bagpipes. I am grateful to Hugh Macandrew for providing me with the information by which to identify the version in the Penrice collection.

2 1 August 1811; Penrice [ed.] n.d., pp. 22–3.

3 B. West to Sir Thomas Lawrence, 6 August 1811; *Ibid.*, p. 24.

4 *Ibid.*, p. 23.

5 p. 179; Quoted by Barrell 1986, p. 322.

61 David Teniers II

Antwerp 1610 – Brussels 1690

Dice and Skittle Players before an Inn

Illustrated colour plate xxi
Oil on panel 38 × 61 cm
Signed (lower right): *D. TENIERS F.*

Prov: ?Phillipe Duc d'Orleans (engraving by L. Garreau, entitled *Le Cabaret*, 1808); George Hibbert (via Thomas Slade); William Buchanan, 1808; from whom purchased by Thomas Penrice *c.* 1808; Penrice Sale 1844, lot 12, entitled *Par ou non Par*; purchased by Farrer; Baron Rothschild and then by descent in the Rothschild family; London, Agnew; private collection.

Exh: London 1946 (4); Brussels 1980 (205) with illus.; New York & Maastricht 1982 (26).

Lit: *La Galerie du duc d'Orleans au Palais Royal*, Paris, II, Teniers no. VIII; Penrice [ed.]n.d., pp. 3–5; Druery 1826, p. 80; Chambers 1829, I, p. 305; Waagen 1854, II, p. 503.

Private Collection

William Buchanan experienced some difficulty in selling this painting to Thomas Penrice. He wrote to Penrice on 13 August 1808 to explain how he had obtained the picture: 'Mr Slade was the person, who, for Lord Kinnaird and Mr Morland, as their agent, brought the Teniers and all the Orleans pictures from France; and they never were in the hands of any other. The price of pictures, since the time of the Orleans pictures coming to this country, has nearly doubled; and I declare to you, on the word of a gentleman, that I gave Mr George Hibbert, within these two months, £400 for the Orleans Teniers, *the picture in question*; and that I would do so again.'[1]

Thomas Penrice visited his son-in-law Andrew Fountaine III (1770–1835) at Narford Hall that November and was evidently encouraged to write there and then to Buchanan, who replied: 'I had the pleasure of receiving your letter, dated Narford this morning, and am much obliged to you for the very handsome offer which it contains ... The Teniers has received a very beautiful frame; and I shall send it to your order when I shall have received your instructions.' Buchanan added a postscript: 'would you choose that I should send the Teniers to Narford; where the family might wish to see it?'.[2] Buchanan also enclosed a letter of authentication from Thomas Slade, evidently written in response to doubts which had been raised about the painting (see p. 37).[3]

This painting was held in high esteem in the eighteenth century. The Duc d'Orleans' catalogue records: 'In this picture Teniers has achieved the highest degree of perfection in the charm of the colouring, and the figures are painted with infinite wit. Connoisseurs put this picture in the front rank of the many produced by this skilful master.' Teniers' work continued to be popular in Britain into the nineteenth century, although his 'low-life' scenes did not have quite the same satirical, moralizing bite as the work of, for example, Jan Steen.

Works by or attributed to Teniers in Norfolk collections in the eighteenth and early nineteenth centuries include a number which were early recognised as copies. John Patteson owned four works in his style as well as six firmly ascribed to Teniers.[4] One of these, a *Pastoral Scene*, was sold to John Crome for one hundred guineas. Four works attributed to Teniers were at Houghton Hall, two at Melton Constable, at least seven at Langley Park and one at Runham Hall.[5] The artist became increasingly popular with the advent on the market of important examples from continental collections. Lord Charles Townshend owned 'A capital Picture of Boors at Play', which was at Raynham in 1810. Other Norfolk collectors with works by or attributed to Teniers include the Rev. William Gordon at Saxlingham,[6] Joseph Muskett at Intwood Hall,[7] Dawson Turner with six works, William Delf,[8] Charles John West[9] and Andrew Fountaine.[10] In 1840 William Freeman exhibited *A Dutch Cabaret* at Norwich, which was for sale.[11] (See also cat. no. 60).

1 This provenance makes it unlikely that the painting was in the Simon Clarke Sale, Christie's, London, 14 May 1802, lot 66, as has hitherto been believed (following Smith 1831, III, p. 350, no. 338).

2 16 November 1808.

3 An element of doubt should be recorded. The Orleans catalogue (see Lit.) records the painting as on canvas, not panel. There are two other known versions, neither of which, however, is of sufficient quality by comparison: Follower of Teniers, *Gaming and Drinking in an*

Innyard, oil on canvas, 44.5 × 64.5 cm, Christie's, New York, 14 November 1979. The second version was owned by the dealer J. Denijs, Amsterdam, 1942 (information supplied by Dr Walter Liedtke). I am grateful to Margret Klinge for her observations.

4 Patteson Sale 1819, 1st day, lots 13, 44; 2nd day, lots 11, 12, 28, 31, 32, 65, 77, 78.

5 Chambers 1829, I, pp. 522; II, pp. 790, 846, 252.

6 *Ibid.*, p. 759.

7 *Ibid.*, p. 803.

8 Delf Sale 1846, 1st day, lots 91, 105.

9 West Sale 1843, 1st day, lot 19, 2nd day, lots 25, 42.

10 Waagen 1854, III, p. 430.

11 Norwich 1840 (40).

62 Isack van Ostade
Haarlem 1621 – Haarlem 1649

Landscape with Fortune-Teller c. 1639?

Illustrated p. 117
Oil on panel 58.4 × 75.1 cm
Signed (indistinctly, lower right): *IVO 1639?*

Prov: Joseph Salusbury Muskett; by descent to Colonel Clement Unthank; then by descent to present owner.

Private Collection

Although not recorded by Chambers as being at Intwood Hall by 1829, this panel was included in the sale of pictures from Intwood Hall in 1897.[1] The paintings were then described as 'the property of Col. Unthank, ... collected by his Grandfather many years since, and have never been removed from the Mansion ...' The painting was presumably bought in, as it has remained in the family's ownership.[2]

The composition is a particularly successful one and reveals the artist as particularly deft in populating a landscape view with a genre scene in which a Dutch boor has his pocket picked as he laughs at his fortune being told. Paintings of this type, if not signed, were usually ascribed to the work of Adriaen van Ostade. Works attributed to Isack were in the collections of John Patteson,[3] J.D. Palmer of Yarmouth,[4] George Stacy,[5] Lord Charles Townshend,[6] and J.H. Sperling.[7] See also cat. no. 63.

1 Unthank *et al.* Sale 1897, 2nd day, lot 159. The panel is misdescribed in the catalogue as 'signed on the left centre I.V.O., 1634'.

2 There was a second oil attributed to Ostade at Intwood: Unthank *et al.* Sale 1897, 2nd day, lot 150.

3 Patteson Sale 1819, 1st day, lot 18: 'J.S. Ostade *Boors at Cards.*'

4 Druery 1826, p. 80: 'The Muscle Eaters – Isaac Ostade.'

5 Norwich 1828 (13), '*View of Schavelingen in the Fishing Season.* J. Ostade.'

6 Townshend Sale 1835, lot 26.

7 Norwich 1883 (101), 'Isaac Ostade *Inn Yard*, lent by J.H. Sperling.'

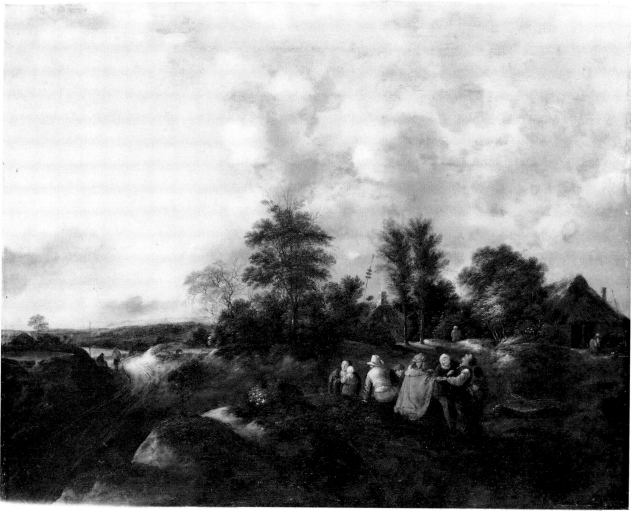

cat. no. 62

63 Attributed to Isack van Ostade

Haarlem 1621 – Haarlem 1649

Group listening to a Violin Player Outside an Inn c. 1640s

Illustrated alongside
Oil on panel 49 × 64.4 cm

Prov: ?Philip Meadows; Meadows Taylor; then by descent to Present owner.

Commander P.H.B. Taylor

This previously-unrecorded panel may well have entered the family collection in the early nineteenth century. It is in a frame provided by John Thirtle, the watercolourist, who also practised as a 'carver, gilder, picture frame and looking-glass manufacturer' from his premises in Magdalen Street, Norwich.[1] The frame is not original to the panel, but an eighteenth-century one: the rebate has been enlarged to fit the picture, presumably by Thirtle, but still a good part of the composition is hidden. This work indicates that the painting was quite probably acquired by Meadows Taylor in the early years of the nineteenth century.[2]

When acquired the panel was believed to be by Adriaen van Ostade (1610–1685).[3] The painting is here attributed to his younger brother and pupil, Isack, who began to specialise in outdoor scenes in c. 1643, when he

joined the Haarlem guild. He often depicted peasant scenes outside an inn, employing a sharp diagonal in his compositions. See also cat. no. 62.

1 Thirtle's label is on the reverse of the frame.

2 The reverse of the panel bears a carved monogram, presumably of a previous collector: (unrecorded by Lugt).

3 MS label on reverse of panel.

cat. no. 63

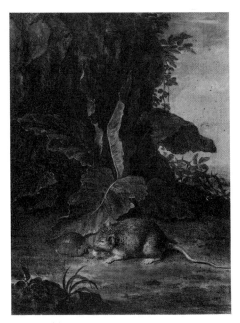

cat. no. 64

64 Attributed to Otto Marseus van Schrieck

Nijmegen 1619/20 – Amsterdam 1678

Herbage with Mouse

Illustrated above

Oil on panel 28 × 22.8 cm

Prov: ?Philip Meadows; Meadows Taylor; then by
descent to present owner.

Commander P.H.B. Taylor

Van Schrieck was the best of a group of Amsterdam
artists who specialised in depicting small animals, rep-
tiles and insects in their natural surroundings. Hou-
braken reports that 'he put these animals on a piece of
low land outside Amsterdam where they would thrive
best, and to this end he fenced them in and fed them
daily'.[1] He made careful drawings of his animals and
plants, which he would later use in imaginary settings.

This sense of naturalism and direct observation is also
to be found in the work of van Schrieck's contemporary
in Amsterdam, Willem van Aelst (cat. no. 53) and in the
work of Jan van Kessel (cat. no. 28). The taste for such
naturalism in the works of the Netherlandish masters
found an echo in the still lifes of John Crome and his
followers, notably John Crome's *Study of a Burdock*.[2]

1 Quoted in Haak 1984, p. 498.

2 Oil on panel, NCM 4.4.99.

65 Jacob van Ruisdael

Haarlem 1628 – ?Amsterdam 1682

Landscape

Illustrated colour plate xvii

Oil on panel 49.7 × 70.2 cm
Signed, lower left, with monogram: *JR*.

Prov: ?Philip Meadows; Meadows Taylor; then by
descent to present owner.

Commander P.H.B. Taylor

This panel gains a special interest insofar as it has been in
a Norfolk collection since at least the early years of the
nineteenth century. It is the type of landscape painting
most obviously connected with the Norwich School of
landscape painters, notably the work of John Crome and
James Stark. It is also of interest that the panel has been
regarded as by Hobbema, Jacob van Ruisdael's mono-
gram being barely visible. Hobbema was apprenticed to
Ruisdael in Amsterdam and imitated him quite closely,
often basing his compositions entirely upon Ruisdael's.

The records of landscapes by or attributed to Jacob van
Ruisdael in Norfolk collections all relate to the nineteenth
century, giving little indication that they might have a
longer local provenance. His work could be seen at
Langley Park, presumably purchased by Sir Thomas
Beauchamp Proctor.[1] John Patteson of Norwich sold two
landscapes in 1819 and John Crome owned one on his
death in 1821.[2] J.D. Palmer of Yarmouth owned a
landscape, recorded by Druery in 1826.[3] George Stacy lent
four landscapes attributed to Ruisdael to the Old Masters
exhibition in Norwich in 1828,[4] while Thomas Brightwell
lent one landscape[5] and William Freeman lent a *Watermill*
which was for sale.[6] The following year Matthew Gun-
thorpe lent a *Waterfall* to the Norwich Old Masters
exhibition,[7] while Freeman lent a landscape attributed to
Salomon Ruysdael.[8] In 1835 Francis H. Stone sold a 'fine
picture and a good specimen' by Jacob Ruisdael which
had belonged previously to his father, Francis Stone, the
county surveyor and a founder member of the Norwich
Society of Artists.[9] An important local collector of Ruis-
dael's work was Charles John West who owned four
apparently good examples, two of which he sold in 1835
and two in 1843.[10] Other local collectors who owned
works by or attributed to Ruisdael were William Wilde,[11]
John Harvey,[12] Thomas Osborn Springfield, a local raw
silk broker,[13] and the Rev. C.D. Brereton, rector of Little
Massingham and author of *An Enquiry into the Workhouse
System* (1825).[14] One other notable Ruisdael in Norfolk by
the 1830s was that at Intwood Hall, purchased from G.
Morant's collection in 1832.[15] (See also cat. nos. 87, 115,
116).

1 Chambers 1829, II, p. 845 (figures by A van de Velde);
exhibited Norwich 1885 (197).

2 Patteson Sale 1819, 1st day, lot 65; 2nd day, lot 41. Crome
Sale 1821, 2nd day, lot 63.

3 Druery 1826, p. 80.

4 Norwich 1828 (4, 41, 45, 48).

5 Norwich 1828 (42); ?Brightwell Sale 1869, lot 361.

6 Norwich 1828 (63).

7 Norwich 1829 (79).

8 Norwich 1829 (66).

9 Stone Sale 1835, 5th day, lot 89.

10 West Sale 1835, lots 58 & 60; West Sale 1843, 2nd day,
lots 34 & 37.

11 Norwich 1840 (3).

12 Harvey Sale 1842, 2nd day, lot 300.

13 Springfield Sale 1864, 1st day, lot 141.

14 Brereton Sale 1870, lot 157.

15 Unthank *et al.* Sale 1897, 2nd day, lot 164, bt Main-
waring; sold Mainwaring, Robinson's, 6 June 1898, lot
569, bt Sedelmayer (de Groot 1912, IV, no. 787).

IV John Patteson

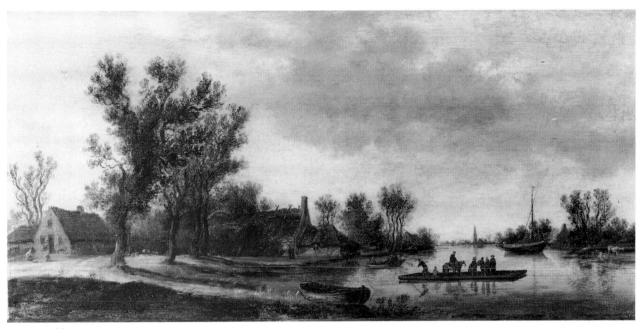

cat. no. 66

66 Pieter de Neyn

Leiden 1597 – Leiden 1639

River Landscape with Ferry Boat and Cottage
c. 1635

Illustrated above
Oil on panel 29.5 × 57.8 cm

Prov: John Patteson; by descent to Philippa and Charity
Patteson; on loan to Norwich Castle Museum
(30.L1984.1).

Exh: Norwich 1966 (31).

Norfolk Museums Service (Norwich Castle Museum)

This painting, traditionally attributed to van Goyen, was
first reattributed to the circle of Pieter de Neyn by
Hans-Ulrich Beck in 1964. Recent cleaning has revealed
the extent to which the paint layers in the sky are badly
worn due to previous attempts at restoration. The
thinness of the paint layers has allowed the wood grain to
become more prominent, due to the increasing trans-
parency of the oil paint with age. This has in fact revealed
the original carbon black underdrawing, particularly to
the left of the tree above the cottage chimney and the
outlines of ships' hulls to the left of the ferryboat.[1]

Although a Leiden painter, Pieter de Neyn was trained
in Haarlem. A pupil of van Goyen, his work also shows
the influence of Esias van de Velde. As a minor master,
his name was virtually unknown to early British collec-
tors, who would have readily attached better-known
attributions to those of his works to reach Britain.

1 I am grateful to Deirdre Mulley and Cathy Proudlove for
their comments on the condition of this panel.

67 Attributed to Jan van Goyen

Leiden 1596 – The Hague 1656

Estuary Scene with Shipping c. 1650s

Illustrated colour plate xv
Oil on panel 47.6 × 63.5 cm

Prov: John Patteson; by descent to Philippa and Charity
Patteson; on loan to Norwich Castle Museum
(29.L1984.1).

Norfolk Museums Service (Norwich Castle Museum)

This thinly-painted oak panel has been significantly
rubbed to the extent that its quality has become
obscured. It is unclear from the records of the Patteson

119

Collection just who was believed to be the painter of this panel, although in 1984 the frame carried a plaque inscribed 'Van de Capella'. For van de Cappelle to be considered the artist, it would have to be an early work by him, painted during the period he was most influenced by Simon de Vlieger.

The panel is here tentatively attributed to Jan van Goyen, as a late work c. 1650s. The thin monochrome paint, albeit rubbed, together with the delicate painting of the clouds are the most convincing aspects of the painting which suggest van Goyen rather than the more pedestrian Cappelle. The boats and figures darkly silhouetted against the foreground are comparable to those depicted in van Goyen's signed panel of 1656, *View of Haarlem Lake*, now at the Stadelsches Kunstinstitut, Frankfurt am Main.[1]

Van Goyen was a prolific painter, whose work was avidly collected in Britain. Early nineteenth century Norfolk collectors of his work were Sir Thomas Beauchamp-Proctor (see cat. no. 48), John Crome,[2] John Patteson and J.S. Muskett.[3] Other Norfolk collections which included works by or attributed to van Goyen were those of William Stevenson,[4] the Rev. William Trivett,[5] the Rev. William Gordon,[6] James Symonds,[7] William Freeman,[8] Matthew Gunthorpe,[9] J. Homfray,[10] Samuel Paget,[11] the Rev. G.R. Leathes,[12] C.J. West,[13] Cufaude Davie,[14] Thomas Brightwell,[15] Charles Weston[16] and the Rev. Brereton.[17]

1 Haak 1984, p. 337. I am grateful to Dr Christopher Brown for first suggesting this attribution to me and for his subsequent comments.

2 Crome Sale 1812, 1st day, lot 114, *View in Holland*; also Crome Sale 1821, 1st day, lot 95, *Landscape . . .*

3 Patteson Sale 1819, lot 32; Unthank *et al.* Sale 1897, 2nd day, lot 168 as formerly in John Patteson's Collection, 1819 (de Groot 1927, VIII, no. 691).

4 Stevenson Sale 1821, 3rd day, lot 3, *River Scene.*

5 Druery 1826, p. 152, *Landscape.*

6 Chambers 1829, II, p. 759, *Buildings and river scene;* Norwich 1840 (99) *View in Holland.*

7 Druery 1826, p. 120, *A Landscape.*

8 Exhibited Norwich 1829 (13) *Landscape;* Norwich 1840 (150), *River Scene.*

9 Exhibited Norwich 1829 (23) '*Landscape and Figures* Ostade and van Goyen'; Springfield Sale 1864, 1st day, lot 158, '*River Scene with Chateau . . .* deservedly esteemed by the late Captain Gunthorpe of Great Yarmouth, in whose collection it was for many years.'

10 Druery 1826, p. 81, *The Ferry.*

11 *Ibid.*, p. 86, *Village Scene.* This was purchased by Paget for £50 in 1814. Paget Sale 1848, 2nd day, lot 63:' . . . It was bought in Holland by a Norfolk Gentleman more than fifty years ago, and remained long in his possession . . .'

12 Norwich 1829 (113) *Flemish Landscape.*

13 West Sale 1843, 1st day, lot 61, *River Scene* and lot 64, *Portraits of the Painter and his Wife.*

14 Davie Sale 1851, 2nd day, lot 256, *A Village Inn.*

15 Exhibited Norwich 1828 (15) *Landscape;* Brightwell Sale 1869, lot 354, *Canal Scene.*

16 Weston Sale 1864, 1st day, lot 148, *Sea Piece*, lot 157, '*Fishing boats . . .* Purchased at Mr Harvey's Sale', and lot

182, *Small landscapes.*

17 Brereton Sale 1870, lot 156, *A River Scene.*

68 Attributed to Jan Both

Utrecht *c.* 1618 – Utrecht 1652

A Southern Landscape with Muleteers on a Roadway

Illustrated p. 42

Oil on canvas 52.2 × 65.6 cm

Prov: Dr Cox Macro; then by descent to John Patteson; ?Patteson Sale 1819, 1st day, lot 76, *A Landscape and Figures*, ?bt in; by descent to Philippa and Charity Patteson; on loan to Norwich Castle Museum 1984 (2.L1984.1).

Exh: ?Norwich 1878 (287), lent by Henry Staniforth Patteson.

Norfolk Museums Service (Norwich Castle Museum)

This painting is here tentatively attributed to Jan Both, but a contemporary imitator, perhaps Flemish, is also conceivable. Both's fame was such that an example of his work was in an English collection by 1684 – that of Thomas Howard, Earl of Arundel.[1] The dissemination of his influence may be seen in the number of eighteenth century engravings after his pictures. John Crome owned a drawing, *View in Rome*, by Both and also a Landscape in his style.[2] John Patteson's sale at Christie's in 1819 included two pictures attributed to Both.[3] The second Both was acquired by Patteson himself, while this example was almost certainly inherited from Cox Macro.

Jan Both was a painter of Italianate landscapes, evocative of the Roman Campagna bathed in atmospheric light, a style which could become formulaic. It is not surprising to find his work represented not only in Patteson's collection but also in the Gordon collection at Saxlingham. The creation of these collections was influenced by the Grand Tours of John Patteson and John Gordon in the 1770s. Both's work was also to be found in the Cabinet Room at Langley Hall. Both's reputation was to falter in England in the 1830s, and in 1836 John Constable wrote: 'I hope to murder Both and Berghem on Thursday next at a quarter to four o'clock. The rest that came after are not worth murdering'.[4] It was Constable's belief that a Dutch artist who painted Italianate landscapes was prostituting his native heritage.

1 Burke 1976, p. 4.

2 Crome Sale 1812, 1st day, lot 115 *View in Rome BOTH;* Crome Sale 1821, 1st day, lot 68 *Landscape in the style of BOTH*, 5 guineas.

3 Patteson Sale 1819, 1st day, lot 76; 2nd day, lot 16. The marked up catalogue shows that the first came from Little Haugh Hall, while the second was sold.

4 Beckett 1967, V, p. 45.

69 Salomon Rombouts

Active in Haarlem 1652–60

A Village Fair with a Mummer in the foreground

Illustrated p. 121

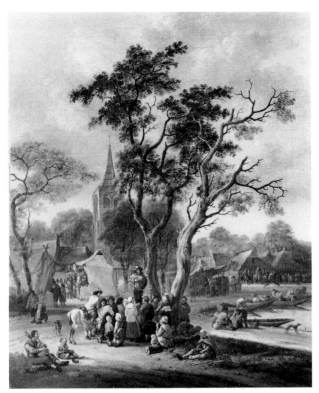

cat. no. 69

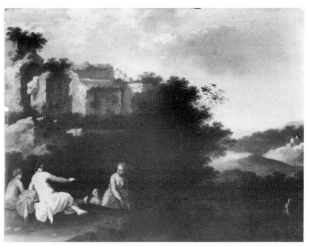

cat. no. 70

This panel is extremely well preserved, although some of the detail is almost lost through the increasing transparency of the paint through age. The painting is not recorded as having been in Cox Macro's collection. It may possibly be identified as one of a pair of paintings entitled *Nymphs bathing* and attributed to Schiffner in the Patteson Sale of 1819.[1] As such it is likely to have been one of those paintings purchased by John Patteson while on the Grand Tour 'at the commencement of the French Revolution, at Frankfort and elsewhere on the Continent'.[2]

Poelenburgh was one of the first generation of seventeenth century Dutch landscape painters to work in Rome and he had numerous followers, notably Daniel Vertangen. For other paintings attributed to Poelenburgh in Norfolk see cat. no. 40.

1 Patteson Sale 1819, 1st day, lots 59, 60.
2 Patteson Sale 1819, catalogue titlepage.

Oil on canvas 75.5 × 63 cm
Signed, lower left: *Rombouts*

Prov: John Patteson; by descent to Philippa and Charity Patteson; on loan to Norwich Castle Museum 1984 (15.L1984.1).

Norfolk Museums Service (Norwich Castle Museum)

This is a typical example of the work of Rombouts, both in terms of its format and its subject-matter.[1] Little is known of Rombouts' career. He may be related to Theodore Rombouts whose *Self-Portrait* was at Narford Hall.[2] Rombouts was one of a number of artists of middle ability who worked in Haarlem but were overshadowed by Ruisdael in the third quarter of the seventeenth century.

1 A comparable composition was Sotheby's, London, 19 April 1972, lot 44 *A Village Fair*, signed, panel, 52 × 46.5 cm.
2 Recorded at Narford in 1753, this may have been one of the '2 pictures of Painters' belonging to Sir Andrew Fountaine in 1738 (Narford MS Inventory). See also p 12.

70 Cornelis van Poelenburgh
Utrecht *c*. 1586/95 – Utrecht 1667

Nymphs bathing in a Southern Landscape

Illustrated above right
Oil on panel 18.2 × 24.6 cm

Prov: John Patteson; by descent by Philippa and Charity Patteson; on loan to Norwich Castle Museum 1984; (32.L1984.1).

Norfolk Museums Service (Norwich Castle Museum)

71 Philips Wouwermans
Haarlem 1619 – Haarlem 1668

A Cavalry Skirmish in a Mountainous Landscape

Illustrated below
Oil on canvas 46.4 × 61 cm
Signed, indistinctly, bottom right: . . . *mans*

cat. no. 71

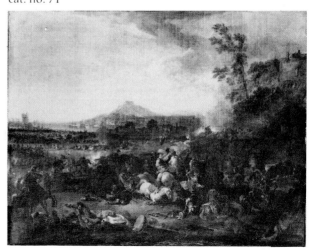

Prov: ?Dr Cox Macro; John Patteson; Patteson Sale 1819,
 1st day, lot 114 or 115, 'A small Battle Piece', bt
 in ?; by descent to Philippa and Charity Patteson;
 on loan to Norwich Castle Museum 1984
 (36.L1984.1).

Norfolk Museums Service (Norwich Castle Museum)

The quality of this small battlepiece has become obscured
as a result of the increasing transparency of the oil with
age. Allowances must be made for changes of tone, but
the quality of the painting of the horses and figures in
particular is high. Although the canvas is not directly
traceable back to Cox Macro's collection, it is certainly the
type of painting which Tillemans chose to emulate with
his own Battlepiece (cat. no. 81). Indeed, it has been
tempting to read the indistinct signature as that of
Tillemans, rather than Wouwermans. Nevertheless, this
has all the appearance of a seventeenth-century painting,
with the possibility of retouching in the trees.[1] See also
cat. nos. 50, 86.

1 A second oil attributed to Wouwermans in the Patteson
 Collection is *Figures on a Shore*, panel, 41.3 × 49.3 cm,
 signed, lower right, with monogram. See Appendix III.

72 Abraham Hondius

Rotterdam *c.* 1625/30 – London after 1695

The Stag Hunt *c.* 1675

Illustrated colour plate xxiv
Oil on canvas 109.2 × 155.3 cm
Signed lower left: *Abraham Hondius*

Prov: Dr Cox Macro; by descent to John Patteson; by
 descent to Philippa and Charity Patteson; on loan
 to Norwich Castle Museum (9.L1984.1).

Exh: Norwich 1828 (1), lent by J.S. Patteson.

Lit: Macro A, 'A hunting piece. Hondius'; Macro B,
 'Hongins 24 Hunting the Stage – 14'.

Norfolk Museums Service (Norwich Castle Museum)

This is a fine example of a type of composition and
subject typical of Hondius. The artist moved to Amster-
dam about 1660 and then on to England some six years
later and his work became popular with British collectors.
A comparable painting is that of *Pyramus and Thisbe*, now
at Rotterdam, which is dated 1675.
 Similar works in the region included a *Bear Hunt* at
Herringfleet Hall[1] and *Diana Hunting* at Long Melford
Hall – although the latter is almost certainly by Ludolf de
Jongh whose work is very similar to that of Hondius.[2]

1 Leathes *et al.* Sale 1971, lot 86.

2 Collection of Sir Richard Hyde Parker.

73 Cornelis Gerritsz. Decker

Haarlem before 1623 – Haarlem 1678

A Sluice – Wooded landscape with figures on a path

Illustrated colour plate xxiii
Oil on panel 40.1 × 52 cm

Prov: ?Dr Cox Macro; ?by descent to John Patteson; by
 descent to Philippa and Charity Patteson; on loan
 to Norwich Castle Museum 1984 (6.L1984.1).

Norfolk Museums Service (Norwich Castle Museum)

When in the Patteson family collection this panel was
thought to be by Jacob van Ruisdael. The frame still bears
a plaque inscribed 'Ruysdael'. As such it may be possible
to identify the painting in John Patteson's 1819 sale
catalogue as: 'Ruysdael – 41 A Landscape with a Bridge –
a beautiful specimen of this charming Painter.' This
picture was, according to the marked-up catalogue,
formerly in the Macro collection at Little Haugh Hall,
Norton.[1] Patteson also owned an oil, *An upright landscape
with figures*, squarely attributed to Decker, which he had
acquired himself.[2]
 Two oils attributed to Decker were lent by C. Turner to
the first Old Masters exhibition held in Norwich in 1828.[3]
These were both landscapes and may be assumed to be
reminiscent of Ruisdael during his Haarlem period.
Decker represents very much the taste for well-executed
grove scenes, characteristic of both Dutch and English
artists, prevalent during the first decades of the
nineteenth century. A significant feature of Decker's
work is his crispness in handling detail.

1 Macro A: 'A Bridge with Water. Ruisdale'.

2 Patteson Sale 1819, 1st day, lot 81.

3 Norwich 1828 (84; 85).

74 Follower of Jacob van Ruisdael

Haarlem School, *c.* 1675–80

Ferry boat on a river

Illustrated below
Oil on canvas 65 × 84.4 cm

Prov: John Patteson; by descent to Philippa and Charity
 Patteson; on loan to Norwich Castle Museum 1984
 (16.L1984.1).

Norwich Castle Museum (Norfolk Museums Service)

This painting is of interest as an example of a late
seventeenth-century Dutch landscape produced under
the shadow of Ruisdael, but showing an Italianate sense

cat. no. 74

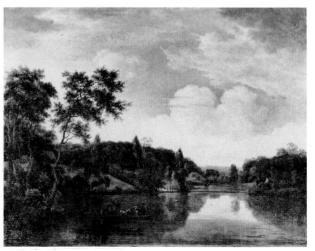

122

of composition. The ferryboat in the foreground is not original to the composition, but was probably added in the eighteenth century, possibly to cover a damaged area beneath. It is tempting to consider whether this may be an example of restoration by Peter Tillemans, but there is nothing to indicate whether this particular canvas was ever in Cox Macro's collection.

1 I am grateful to Carolyn Lamb for her conservation report on this painting.

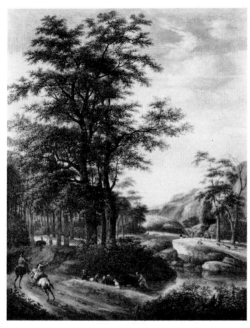

cat. no. 75

75 Antonie Waterloo

?Utrecht c. 1610 – ?Utrecht 1690

Landscape with Horsemen

Illustrated above
Oil on canvas 65.4 × 52.3 cm
Signed (or inscribed) lower left, with a monogram.

Prov: John Patteson; by descent to Philippa and Charity Patteson; on loan to Norwich Castle Museum 1984 (33.L1984.1).

Norfolk Museums Service (Norwich Castle Museum)

The previous history of this painting is obscure insofar as neither Cox Macro nor John Patteson is recorded as having owned a painting by Waterloo. It is, however, quite possible that the painting was in Patteson's collection with another attribution.[1] Oils by Waterloo are relatively rare, but seem to have been popular in the nineteenth century with British collectors who readily recognised a follower of Ruisdael.

The eighteenth-century Yarmouth collector and dealer Daniel Boulter owned a large landscape (5 feet 8 inches × 4 feet) attributed to Waterloo.[2] In 1829 Chambers recorded a *Wood Scene* by Waterloo at Intwood Hall, Norwich,[3] while Matthew Gunthorpe also owned 'a charming specimen of this master', another *Woody Scene*.[4]

1 e.g. Patteson Sale 1819, 1st day, lot 81, Decker: *An Upright Landscape with figures.*

2 Boulter [1794], p. 81, no. 1.

3 Chambers 1829, II, p. 803.

4 Gunthorpe Sale 1842, lot 17; subsequently sold Gunthorpe Sale 1853, lot 107, to White. Another landscape attributed to Waterloo in a nineteenth century collection was Steward Sale 1864, 1st day, lot 169.

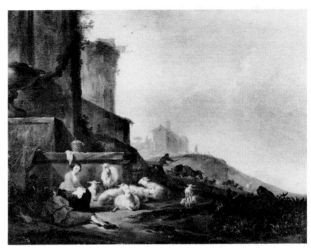

cat. no. 76

76 Attributed to Willem Romeyn

Haarlem c. 1624 – Haarlem c. 1694

A Shepherdess with Sheep

Illustrated above
Oil on panel 46 × 61.9 cm

Prov: John Patteson; by descent to Philippa and Charity Patteson; on loan to Norwich Castle Museum 1984 (34.L1984.1).

Norfolk Museums Service (Norwich Castle Museum)

Willem Romeyn was a pupil of Nicolaes Berchem and specialised in Italianate landscapes, often with cattle and sheep grazing in a mountainous landscape or in the vicinity of antique ruins or other buildings. His work was best known in England in the early nineteenth century from the examples at Dulwich Picture Gallery. This example has been thought to be by Jan Weenix, but is not recorded as such in John Patteson's collection sale of 1819. The attribution to Romeyn should only be regarded as tentative.

77 Frans van Mieris

Leiden 1689 – Leiden 1763

The Rev. Dr Cox Macro (1683–1767) c. 1703

Illustrated p. 124
Oil on copper 11.1 × 8.5 cm
Inscribed in ink on reverse, barely legible: *Dr Cox Macro/of/Little H[augh Hall] presented by ?him . . ./.../ Francis . . .'*

Prov: Dr Cox Macro; by descent to John Patteson; by descent to Philippa and Charity Patteson; on loan to Norwich Castle Museum (38.L1984.1).

Lit: Macro B, 'Van Mieris –79 A portt. of Dr Macro on copper 6'; Farrer 1908, p. 372, no. 9, illus.

Norfolk Museums Service (Norwich Castle Museum)

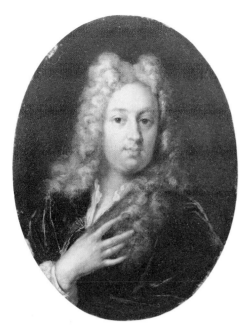

cat. no. 77

The Suffolk antiquary, Cox Macro was educated first at Bury Grammar School and then Jesus College, Cambridge and later, in 1701–2, went to Christ's Cambridge 'to enjoy better health . . . and to study medicine'.[1] The following year he entered Leiden University where he studied under Boerhaave. He gained his LLB at Cambridge in 1710 and his DD in 1717.

This portrait is almost certainly an example of a picture later worked on by Peter Tillemans. It is recorded in one catalogue (Macro B) that this portrait was by 'Van Mieris'. However, in an earlier manuscript catalogue, in Macro's own hand (Macro A) he records his portrait in 'The Chintz Chamber': 'Dr Macro. Young Mieris made the Drapery & Hand & P. Tillemans some part of the Face'. This presumably refers to this small portrait on copper as there is no other known portrait of Macro which could fit this description. The portrait has been dated *c.* 1716 because of its resemblance to Macro's portrait as seen in Tillemans' *The Artist's Studio*. However, it is likely that this similarity is entirely due to Tillemans reworking the portrait at that time. The portrait shows Macro as a young man wearing a full wig, and was presumably painted by the young van Mieris when Macro was at Leiden, *c.* 1703.

1 *Dictionary of National Biography.*

cat. no. 78

78 Peter Tillemans

Antwerp 1684 – Norton 1734

The Artist's Studio c. 1716

Illustrated p. 124
Oil on canvas 68.3 × 84 cm
Signed, lower left: *P. Tillemans. F.*

Prov: Dr Cox Macro; by descent to John Patteson; by descent to Philippa and Charity Patteson; on loan to Norwich Castle Museum 1984 (19.L1984.1).

Exh: London 1987–8 (29).

Lit: Macro A, 'P. Tillemans in his painting room, instructing a Disciple; Mr Macro standing by him'; Macro B, 'A Painters room, in which is the Portraits of Tillemans & Doctor Macro –5'; Macro D, f.261, 'A Painter's Shop by Tillemans 17–17–6'; Raines 1976, p. 1693, fig. 6; Raines 1978–80, p. 59, no. 80, illus pl. 9b.

Norfolk Museums Service (Norwich Castle Museum)

Dr Cox Macro was an important patron for Peter Tillemans. Macro owned twenty paintings by Tillemans, twelve being original compositions and the remainder copies or painted in the manner of other artists. The latter included 'A Moonlight. Copy of vander Neer' and 'A Harvest piece. Copy from Velvet Breughel' in the Great Parlour at Little Haugh Hall. In the 'Fore Parlour' hung 'Dutch Boors. Snick a Snee. Copy from Old Heemskirk', also by Tillemans.[1] Horace Walpole commented that Tillemans, when copying, 'succeeded admirably, particularly Teniers, of whom he preserved all the freedom and spirit'.[2]

Tillemans also restored paintings for Macro. One example at Little Haugh Hall was 'Moses with the Table of the Commandments perhaps Mart du Vos or Frans Floris. much damag'd & mended by P. Tillemans.' He also worked on paintings by other artists. Macro's catalogue of his collection included, for example, 'A Sea Storm, W. Van de Velde Junr. The Great Ship is by P. Tillemans', while a battlepiece by Rosa di Tivoli became 'A large Battle with the Drummer. Rose of Tivoli, heightened & new figures by P. Tillemans'.[3]

These factors make it difficult to determine whether the paintings depicted in Tillemans' studio are likely to be by identifiable artists, or by Tillemans himself. Reading from left to right, they appear to be in the manner of Salvator Rosa, possibly Courtois or Wouwermans, possibly de Heem and possibly Jan Wyck. The *Bacchanal* at Tillemans' feet is reminiscent of Poussin. The inference must be that they are by Tillemans and are intended to demonstrate his versatility in landscape, battlepieces, still life and figure painting. The painting is also interesting in its depiction of an artist teaching students to copy from the antique, notably a sculpture which seems to be a version of Giambologna's *Rape of the Sabines*.

The Artist's Studio can be dated from the costume and Macro's wig style, which is identical to that depicted in his miniature portrait by Zincke of 1716. In his inventory Macro refers to this image of himself as 'Mr Macro', which suggests that the painting dates to before 1717, when he received his Doctorate in Divinity. At this time Tillemans was living in London, possibly in the parish of St Margaret's, Westminster, where he was recorded as living by 1719.[4]

1 Raines 1978–80, Appendix B.
2 Walpole 1798, *Anecdotes*, II, p. 291.
3 Raines 1978–80, Appendix B.
4 *Ibid*. p. 23.

79 Peter Tillemans

Antwerp 1684 – Norton 1734

Hunting Piece mid 1720s

Illustrated p. 126
Oil on canvas 46.5 × 67.7 cm
Signed lower left: *P. Tillemans F.*

Prov: see cat. no. 78 (22.L1984.1).

Exh: Australia 1977–78 (46, as 'The Hounds at Little Haugh and Norton with William Staniforth and Mary Macro).

Lit: Macro A, 'Going a Hunting with Lord Biron's pack of Hounds'; Macro B, 'Tillemans . . . 32 Hunting Piece. L. Byrons pack'; Macro D, f. 260, 'The hunting piece by Tillemans 10–10–0'; Raines 1976, p. 1693; Raines 1978–80, p. 44, no. 4, illus. pl. 10b.

Norfolk Museums Service (Norwich Castle Museum)

The fourth Lord Byron of Newstead seems to have been one of Tillemans' 'most appreciative patrons'.[1] The traditional identification of two of the figures as William Staniforth and Mary Macro may explain how this painting came into the possession of Cox Macro. Tillemans was probably at Newstead in the autumn of 1734, shortly before his death at Little Haugh Hall.

1 Raines 1978–80, p. 24. It may be assumed from Macro A (see Lit. above) that Lord Byron and his pack of hounds are here depicted in the grounds at Newstead.

80 Peter Tillemans

Antwerp 1684 – Norton 1734

Little Haugh Hall, Suffolk

Illustrated colour plate xxv
Oil on canvas 85.8 × 152.2 cm
Signed, lower left: *P. Tillemans F.*

Prov: See cat. no. 78 (23.L1984.1).

Lit: Macro A, 'View of the house in Norton. A chimney Piece'; Macro D, f. 260, 'The Chimney Piece of my house £6.6.0d.'; Scarfe 1958, pp. 1238–9, illus.; Harris 1979, p. 235; Raines 1978–80, p. 49, no. 32.

Norfolk Museums Service (Norwich Castle Museum)

This view of the country seat of the antiquary Cox Macro (1683–1767) is an important record of the original appearance of Little Haugh Hall at Norton, Suffolk. The hall had been purchased by Cox Macro's father, a leading tradesman of Bury St Edmunds, who himself lived in the Cupola House at Bury.[1] Although now sadly rubbed in some areas, the painting portrays a characteristically

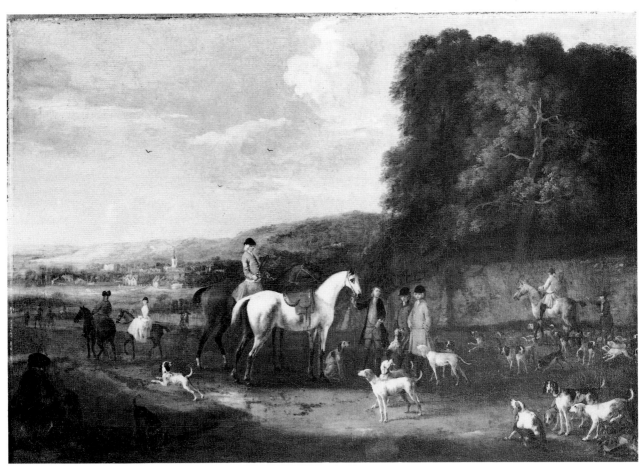

cat. no. 79

Flemish sense of detail, much in the tradition of Hendrik Danckerts.

Although the core of the house remains intact, the facade of the building was drastically altered in the 1830s. Tillemans' painting reveals Tudor or Jacobean brickwork at each end of the main facade, which was then three storeys high. The top storey, the farm-buildings, the pigeon-cote and the brick courtyard are all now gone. The stream, a tributary of the Little Ouse, has been diverted, although the small hump-back bridge remains.

It is likely that the figures in the foreground are portraits. It has been suggested that the portly figure on the near side of the stream is Cox Macro, the figure next to him conceivably the artist. Among the figures in the middle distance one might expect to find Macro's wife Mary, and possibly her sister and brother-in-law Alethea and Samuel Staniforth who are recorded as frequent visitors to the Macros.

In addition to twelve paintings by Tillemans which Cox Macro owned, he also commissioned a series of overdoors and an overmantel for the entrance hall at Little Haugh Hall, which still survive *in situ*.[2]

1 It is unclear whether Cox Macro's father ever lived in Little Haugh Hall.

2 Croft-Murray 1970, p. 287.

81 Peter Tillemans

Antwerp 1684 – Norton 1734

Battle Scene

Illustrated p. 44

Oil on canvas 85 × 109.8 cm

Signed lower left: *P. Tillemans F*

Prov: See cat. no. 78 (20.L1984.1).

Lit: Possibly Macro A, 'A little Battle, P. Tillemans. This he always call'd his Masterpiece'; Macro D, f. 259, 'A small battle by Tillemans 17–4–0'; Raines 1978–80, p. 56, no. 66.

Norfolk Museums Service (Norwich Castle Museum)

Tillemans painted a number of battle scenes, including examples acquired by Sir Paul Methuen (1672–1757) of Corsham Court and the tenth Earl of Derby.[1] Tillemans was imitating the example, primarily, of Philips Wouwermans and Courtois. George Vertue records that Tillemans 'copyd Bourgonione for Battles which he did many & of his own designs very well.'[2] The first purchase recorded in Macro's 'Diary of Purchases' was in 1715 when he paid Tillemans £17.4.0d. for 'a small Battle piece', which Tillemans always regarded as his 'masterpiece'.[3] Battle-pieces were extremely popular and Tillemans would have had every incentive to specialise in such scenes. A similar work can be seen hanging in the painting of his studio (cat. no. 78 and cover).

Three battlepieces by Tillemans all appeared in Norfolk sales in the year 1821. One of these had belonged to John Crome,[4] while two were from the collection of the editor of the *Norfolk Chronicle*, William Stevenson (1741–1821).[5]

1 Raines 1978–80, nos. 60–68 and pp. 28–9.

2 Vertue [1934], III, p. 14.

3 See Lit. above.

4 Crome Sale 1821, 2nd day, lot 29.

5 Stevenson Sale 1821, 3rd day, lots 13 and 14.

82 Peter Tillemans

Antwerp 1684 – Norton 1734

Master Edward and Miss Mary Macro c. 1733

Illustrated p. 47
Oil on canvas 117.2 × 88.1 cm
Signed lower centre left: *Peter Tillemans F.*

Prov: See cat. no. 78 (21.L1984.1).

Lit: Macro A, 'Mr Edw. Macro & his Sister'; Macro B,
'68 Master & Miss Macro with: 3 favourite Dogs
12'; Macro D, f. 260, 'The Children Picture by
Tillemans 10–10–0'; Farrer 1908, p. 373, no. 15;
Raines 1978–80, p. 58, no. 79, illus. pl. 19a.

Exh: Norwich 1948 (7); London 1987–8 (45).

Norfolk Museums Service (Norwich Castle Museum)

Tillemans painted few portraits and this must rank as
among his finest, demonstrating some feeling for perso-
nality and character as well as for colour and texture. It
has been stated that Arthur Devis was a pupil of
Tillemans, but Raines has argued that if this is so, his
training was in landscape and architecture, rather than in
figure-painting. A comparison between this portrait and
the works of Devis reveal Tillemans to have been equally
skilful and sensitive as a portraitist. The apparent ages of
Edward (died 1766) and Mary (1719–75) indicate a date for
this portrait of *c.* 1733.

83 Peter Tillemans

Antwerp 1684 – Norton 1734

Horse with Groom and Hounds 1734

Illustrated colour plate xxvi
Oil on canvas 134.5 × 167.3 cm
Inscribed, top right: *This Picture was left thus unfinsh'd, by
the /justly celebrated PETER TILLEMANS of/ANTWERP, it
being the last piece that he/painted, and he working upon it
the day/before his Death which hapned in this-/House in
NORTON the fifth of DECEMBER-/MDCCXXXIV.*

Prov: See cat. no. 78 (26.L1984.1).

Lit: Macro A, 'The Horse over the Chimney, P.
Tillemans unfinish'd, it being his last piece';
Macro D, f. 261, 'The Horse over ye Hall Chimney

and the three door pieces 8–8–0'; Raines 1976, p.
1692, illus.; Raines 1978–80, p. 43, no. 2.

Norfolk Museums Service (Norwich Castle Museum)

In April 1733 Peter Tillemans sold his own collection,
prior to 'retiring into the Country on Account of his ill
State of health'.[1] He had almost completed three over-
doors and was only part way through painting *Horse with
Groom and Hounds* as an overmantel, when he died
suddenly at Little Haugh Hall on 19 November 1734. He
was buried at Stowlangtoft on 5 December. Vertue
commented that 'after many years indisposition that to all
who knew him it was wonderful he lived so long having a
continual Asthma'. Vertue added that 'some friend of his
gave him this Monumental Encomium "Last thursday
Died . . . the Famous Painter Peter Tillemans of Antwerp
whose private Virtues secured to him the love of all who
knew him, as his publick works have raised him a
Monument that will last while Painting has any
reputation."'[2]

Tillemans' sale catalogue, besides revealing how ill he
was by 1733, tells something of his art collection. The sale
included paintings attributed to artists such as Rem-
brandt, Berchem, Brouwer and Teniers as well as Italian
masters. According to Vertue, Tillemans was a master of
'that secrett in oil painting of transparency known and
practized [sic] so much by the Flemish painters – Rubens
Vandyke Jordaens Snyders & Teniers &c . . .'[3] It is
interesting to consider this comment upon Tillemans'
technique when viewing *Horse with Groom and Hounds*, a
composition upon which the final glazes were never
applied. Raines points out: 'That Tillemans' method of
painting was regarded as unusual receives support from
Philips' reply in 1745 to Macro who had asked him to
enlarge some paintings by Tillemans – "I don't know any
body that paints in that way as Mr Tillemans excell'd
in".'[4] Certainly, on the evidence of this painting his
method was fresh and rapid, with a reliance upon
subsequent glazes.

1 Raines 1978–80, Appendix A (British Library, press
mark SC 213/4).

2 Raines 1978–80, p. 26.

3 Vertue [1934], III, p. 105.

4 Raines 1978–80, p. 27.

V Norwich and London

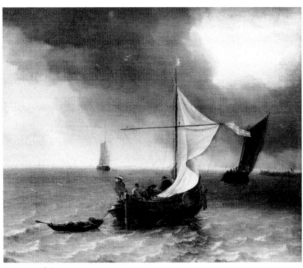

cat. no. 84

84 Jan van de Cappelle

Amsterdam *c.* 1623/5 – Amsterdam 1679

Shipping on a ruffled sea c. 1650

Illustrated above
Oil on canvas 57.8 × 69.8 cm

Prov: Lord Charles Townshend by 1824; Townshend
Sale 1835, lot 42?; sold by Smith to Lord
Lansdowne, 1835; then by descent to present
owner.

Exh: London 1824 (108) as *A Breeze on the Dutch Coast*;
?Norwich 1829 (72) as *Sea View*; London 1835 (142)
as *A Gale*; London 1929 (156); London 1938 (197).

Lit: W.B. Cooke, *Gems of Art*, 1825, engraved by J.
Bromley, pl. 22; Waagen 1854, III, p. 164; de Groot
1923, VII, no. 129.

Trustees of the Bowood Collection

Van de Cappelle's work owes a strong debt to that of de
Vlieger: the inventory of his extensive art collection on
his death lists nine paintings and thirteen hundred
drawings by de Vlieger, as well as a copy he had himself
painted after de Vlieger. His few dated works range from
the years 1644–63. His work also comes close to that of
Hendrik Dubbels, another painter much influenced by de
Vlieger. When this painting was hung at the Norwich
Old Masters exhibition in 1829, a comparable work by

John Crome was hung beside it. The *Norwich Mercury*
commented: 'As a companion to the last hangs a View of
Yarmouth Beach, by the founder of our Institution,
Crome, now in the possession of Mr B. Steel. Although
only a sketch, there is breadth of light and shade, a
liveliness in the water, and a vigour of expression, truth
of colour, and breadth of light and shadow, which loses
nothing by the honourable companionship in which it
has been placed.'[1]

Townshend owned two oils by van de Cappelle, both
of which he sold in 1835.[2] He lent this painting to the
British Institution in Pall Mall, in 1824.[3] That year it was
in the company of other Dutch seapieces, notably works
by van de Velde, Bakhuizen and de Vlieger, and John
Constable commented on 1 June that he had seen in Pall
Mall 'some excellent Dutch pictures – especially some sea
pieces.'[4] Norfolk collectors who shared the taste for de
Cappelle were William Stevenson FSA, editor of the
Norfolk Chronicle,[5] Sir Jacob Astley of Melton Constable[6]
and Matthew Gunthorpe of Great Yarmouth.[7]

1 *Norwich Mercury*, 31 October 1829.

2 Townshend Sale 1835, lots 42 and 45.

3 Another version of this composition is in The Detroit
Institute of Arts, Michigan: panel, 63.5 × 76.84 cm,
signed, no. 41.6. This was formerly in the collection of
Sir Upton Grenville Smythe.

4 Beckett 1962–69, II, p. 322.

5 Stevenson Sale 1821, 3rd day, lots 15, 16.

6 Chambers 1829, II, p. 786.

7 Gunthorpe Sale 1842, lot 8, bt in; Gunthorpe Sale 1853,
lot 101 (to Gunthorpe).

85 Rembrandt Harmensz. van Rijn

Leiden 1606 – Amsterdam 1669

*Portrait of Margaretha de Geer, Wife of Jacob
Trip* 1661

Illustrated colour plate xiii
Oil on canvas 75.3 × 63.8 cm
Signed, lower left, *Rembrandt. f/1661*

Prov: Lord Charles Townshend by 1818; [Townshend]
Sale 1819, lot 26, bt in at 235 guineas; Townshend
Sale 1835, lot 49, bt by John Smith for 231 pounds;
Baron J.G. Verstolk van Soelen, The Hague by

1836; S. Jones Loyd (later Baron Overstone), 1846; by descent to his daughter, Lady Wantage, 1883; given by Lady Wantage to the Earl of Crawford and Balcarres, 1920; purchased by the NACF in 1941 and presented to the National Gallery (5282).

Exh: London 1818 (63); Norwich 1829 (16) as *Portrait of a Lady*; London 1848 (49); Manchester 1857 (677); see MacLaren [revised] 1988, no. 5282 for full exhibition history.

Lit: Smith 1836, VII, no. 516; de Groot 1916, VI, no. 863; Bredius 1937, no. 395; MacLaren [revised] 1988, no. 5282.

Trustees of the National Gallery

Margaretha de Geer, the daughter of Louis de Geer, was born at Liège in 1583. She married Jacob Trip, a merchant of Dordrecht, in 1603 and died at Dordrecht in 1672. There is a second portrait of her by Rembrandt in the National Gallery, London, together with a companion portrait of Jacob Trip.[1] Her gown and ruff are in a style which came into fashion more than forty years earlier than 1661, the date of this portrait. The sitter was unidentified until recognised by Hofstede de Groot in 1928. Margaretha and her husband were probably painted by Rembrandt when they were on a visit to Amsterdam, where two of their sons were then living.

In the absence of any documentary evidence before 1818, it may be assumed that this portrait of Margaretha de Geer was acquired by Lord Charles Townshend *c.* 1814–18. He lent the painting to the British Institution in 1818 and it was one of those selected by the Directors of the British Institution to be retained until the end of November 'for the study of the Artists attending the British Gallery'.[2] During the period of 31 August to 5 December, seventy-one students were admitted to paint or draw copies from the selected old masters.[3] Among the regular attenders were the Norwich artists George Vincent and James Stark, the latter then studying at the Royal Academy Schools. There is a picture of a woman painting a copy of the portrait which has been attributed traditionally to Richard Parkes Bonington. This almost certainly shows one of the women students at the British Institution in 1818.[4]

Lord Townshend lent this portrait, as one of six paintings, to the 'Second Exhibition of the Works of Antient Masters contributed by the Nobility and Gentry of the County of Norfolk for the Promotion of the Fine Arts' held in Norwich in 1829. James Stark was then President of the Norwich Society of Artists, recently renamed the Norfolk and Suffolk Institution for the Promotion of the Fine Arts. The *Norwich Mercury* devoted a considerable part of its review of the exhibition to this portrait, quoting Opie's comments on Rembrandt from his *Lectures*. The proprietor and editor of the *Norwich Mercury*, Richard Mackenzie Bacon, also wrote the art reviews and, confronted by this portrait, commented 'Rembrandt appears to have had but a slight conception of elegance, and although his genius was of an exalted kind, and his style remarkable for strength, expression, and simplicity of arrangement, he contrived to make painting a vehicle for the display of immense power of light and shade, as well as for the exhibition of the passions of the mind . . .'[5]

Lord Townshend also owned, briefly, Rembrandt's *Portrait of Agatha Bas*, subsequently purchased on behalf

of George IV by Lord Yarmouth in 1819.[6] Apart from *Johannes Elison* and *Maria Bockenolle* (see pp. 3–6), the only Rembrandts in Norfolk which could claim to be authentic were at Houghton.[7] The most important of the various attributed works were those at Narford (cat. no. 23), Felbrigg,[8] Wolterton[9] and Melton Constable.[10] Two other paintings attributed to Rembrandt and exhibited at Norwich in 1829 were *Portrait of a Spanish Hidalgo*, lent by 'Mr Ladbrooke' and a *St Peter* lent by J. Curr.[11]

1 MacLaren [revised] 1988, nos. 1674, 1675.

2 British Institution Minutes, Victoria & Albert Museum, RCV12, vol. III, 11 July 1818.

3 *Ibid.*, 25 January 1819.

4 Reproduced in A. Shirley, *Bonington*, 1940, pl. 63 (there dated 1825).

5 31 October 1829.

6 White 1982, no. 162; see also pp. 55–56.

7 *Abraham's Sacrifice* and *Hannah teaching her son Samuel to read*, both now at the Hermitage Museum, Leningrad.

8 A good quality version of Bredius 1937, no. 333, first recorded at Felbrigg in 1764.

9 Chambers 1829, I, p. 219; Walpole Sale 1856, 3rd day, lot 268.

10 Chambers 1829, II, p. 786; Hastings *et al.* Sale 1929, lot 43.

11 Norwich 1829 (37; 126).

86 Philips Wouwermans
Haarlem 1619 – Haarlem 1668

A View on a Seashore, with Fishwives offering Fish to a Horseman

Illustrated colour plate xix
Oil on panel 35.3 × 41.2 cm
Signed, bottom right: *PHILS. W* (*PHILS* in monogram)

Prov: In the collection of Queen Isabella Farnese; perhaps among the pictures removed from the Spanish royal palaces by the French, 1809–13; ?bt in Spain by George A. Wallis, consigned for sale to W. Buchanan, London, 1813; in the collection of Lord Charles Townshend by 1818; [Townshend] Sale 1819, lot 29, bt by Rutley; Joseph Barchard; bt in 1823 by Thomas Emmerson; sold by John Smith to (Sir) Robert Peel by 1824; Purchased by the National Gallery with the Peel Collection, 1871 (880).

Exh: London 1818 (20); London 1976 (127).

Lit: Smith 1829, I, no. 295; de Groot 1909, II, no. 977; MacLaren [revised] 1988, no. 880.

Trustees of the National Gallery

This must have been one of Lord Townshend's earliest acquisitions of *c.* 1814–18. When he lent the painting to the British Institution in 1818 it was described as Wouwermans' last picture, a tradition repeated by both Buchanan in 1824 and by Smith. However, MacLaren has pointed out that 'there seems to be no stylistic reason for this tradition.' Townshend sold the painting within a year of lending it to the British Institution.

The popularity of Wouwermans was certainly reflected in Norfolk collections. The great eighteenth century collections at Holkham,[1] Houghton,[2] Narford[3] and Melton Constable, all included works by or attributed to Wouwermans, the latter having a group of three from the Pourtalés collection.[4] Thomas Harvey of Thorpe House, Catton owned a Battlepiece together with a copy after Wouwermans by Mrs Harvey.[5] John Patteson,[6] the Rev. William Gordon[7] and Matthew Gunthorpe[8] owned works attributed to Wouwermans, while two local collectors, J. Curr and George Stacy, lent landscapes to the Norwich Old Masters exhibition in 1828.[9] Stacy lent a second work by Wouwermans to the Old Masters exhibition the following year, while Mason lent two works.[10] Charles J. West owned three works attributed to Wouwermans[11] and also a *Hawking*, after Wouwermans by Alfred Stannard.[12] Yarmouth collectors owning works by Wouwermans in the first half of the nineteenth century included John Penrice[13] and Charles Palmer,[14] but also the Rev. William Trivett[15] and probably William Leathes.[16] The Yarmouth dealer Daniel Boulter's catalogue of 1794 included three works attributed to the artist.[17] See also cat. no. 71.

1 Dawson 1817, p. 126, *Battlepiece*.

2 *Norfolk Tour* 1772, p. 25, *A stud of horses*.

3 Chambers 1829, II, p. 640, *Travellers and Gypsies*.

4 Chambers 1829, II, p. 786. Four oils in the Portico Room: *Rendez vous de Chasse; La partie de Chasse; The Baggage Waggon; The Gypsies*.

5 Chambers 1829, I, p. 21.

6 See pp. 121–122.

7 Chambers 1829, II, p. 759.

8 Gunthorpe Sale 1842, lot 22, 'formerly in the Earl of Musgraves Collection', bt in; Gunthorpe Sale 1853, lot 111, to Nieuwenhuys.

9 Norwich 1828 (5) and (108).

10 Norwich 1829 (30, 114 and 115).

11 West Sales 1835, lot 59; 1843, 1st day, lot 34; 2nd day, lot 32.

12 West Sale 1843, 1st day, lot 60, '*Hawking, after Wouwermans*. A. Stannard'.

13 Druery 1826, p. 80; sold Penrice Sale 1844, lot 8. *A Hawking Party . . .* bt Farrer.

14 Palmer Sale 1867, 2nd day, lot 92. Possibly now in the Museum of the Rumanian Republic, Bucharest (White 1982, p. 150).

15 Druery 1826, p. 152.

16 Leathes *et al.* Sale 1971, lot 88 (not mentioned by Druery 1826).

17 Boulter [1794], nos. 39, 44 and 119.

87 Jacob van Ruisdael

Haarlem 1628/29 – Amsterdam 1682

A Waterfall at the Foot of a Hill, near a Village *c.* 1665–9

Illustrated p. 57
Oil on canvas 84.8 × 100 cm
Signed, bottom right: *J v Ruisdael* (J v R in monogram)

Prov: Josephus Augustinus Brentano Sale, Amsterdam, 13 ff. May 1822, lot 300, bt by Nieuwenhuys; in the collection of Lord Charles Townshend by 1824; Townshend Sale 1835, lot 46, bt by Nieuwenhuys for Sir Robert Peel, Bart. Purchased for the National Gallery, London, with the Peel Collection, 1871 (855).

Exh: London 1824 (59).

Lit: Smith 1835, VI, no. 178 and 1842, Supplement, no. 55; de Groot 1912, IV, no. 242; MacLaren [revised] 1988, no. 855.

Trustees of the National Gallery

This painting reached England in 1822 when the taste for Ruisdael's work was well established. It was in the collection of Lord Charles Townshend only briefly before he characteristically lent it to the British Institution in 1824. He had become a Governor of the British Institution in 1818 and made a practice of lending the best works from his collection. The fashion for Ruisdael's work was still strong when he auctioned the painting in 1835 and it was purchased on behalf of Sir Robert Peel.

The composition dates from Ruisdael's last years and represents a typical format of the late 1660s. Earlier in the decade Ruisdael had produced a significant group of towering waterfall scenes on a vertical format, inspired by the work of the Alkmaar artist Allart van Everdingen (1625–75) who popularized such scenes in the Netherlands. These scenes found equal favour among British collectors of the early nineteenth century, equally susceptible to the sublime in nature and art. See also cat. nos. 65, 115, 116.

88 Jan Wijnants

Haarlem *c.* 1627 – Amsterdam 1684

A Wood near the Hague, with a view of the Huis ten Bosch

Illustrated above right
Oil on canvas 118.7 × 154.9 cm

Prov: Sir Peter Francis Bourgeois Bequest, 1811, as 'Ruysdael'.

Exh: London 1952/3 (316, as by Wijnants); Washington and Los Angeles 1985–6 (35).

Lit: Dulwich Catalogue 1816 (as Ruisdael); Smith 1835, VI, no. 168 (as Wijnants); de Groot 1912, IV, no. 761 (as Ruisdael); H. Gerson, *Burlington Magazine*, 1953, XCV, pp. 34, 51, note 17.

By permission of the Governors of Dulwich Picture Gallery

Although comparatively little is known of Wijnants' life, his work was particularly influential upon British landscape painters, notably Thomas Gainsborough. His earliest dated paintings are from 1643 and show the strong influence of his contemporary Jacob van Ruisdael. His paintings tend to have an increasingly lighter palette and this particular example is unusually sombre in tone and large in scale.

The painting entered the Dulwich collection, open to the public for the first time in 1814, as by Jacob van Ruisdael. The painting had been reattributed to Wijnants by the dealer and connoisseur John Smith by 1835. The

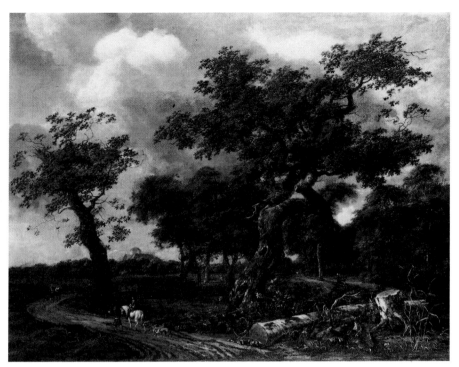

cat. no. 88

figures in the composition have been variously attributed to Adriaen van de Velde (Smith) and Jan Lingelbach (de Groot) but it has most recently been considered entirely the work of Wijnants (Brown). The painting can be dated to the second half of the 1650s, shortly after the completion of the Huis ten Bosch, or 'House in the Wood', in 1652. This small summer palace was built about a mile and a half east of The Hague for Amalia van Solms, the wife of the Stadholder, Prince Frederik Henry of Orange. On his death, the Huis ten Bosch was transformed by Amalia into a mausoleum for the Prince.

It is possible that Wijnants had some influence upon John Crome. The light, airy quality of his duneland scenes finds echoes in some of Crome's depictions of sandy banks and open heathland, such as may be found among Crome's etchings. Two small panels by Wijnants which were included in the Bourgeois bequest to Dulwich College are also important in this respect.[1] The motifs of a felled tree and a road winding into the distance, common to Wijnants, are also typical of the Norwich painters, notably James Stark. *A Wood near The Hague, with a view of the Huis ten Bosch* represents here a London collection with which the Norwich artists would almost certainly have been familiar. See also pp. 50–53.

Works by or attributed to Wijnants were relatively common in Norfolk by the first quarter of the nineteenth century. Norfolk collectors who owned such works were John Patteson,[2] John Crome,[3] the Rev. John Homfray,[4] Joseph Muskett,[5] Matthew Gunthorpe[6] and Charles John West.[7] J. Curr and William Freeman both lent examples to the Old Masters exhibition held in Norwich in 1829.[8] The collections at Melton Constable[9] and Langley Park[10] also included works attributed to Wijnants. In 1835 Lord Charles Townshend sold an example dated 1663,[11] and Charles Savill Onley owned 'an early work'.[12]

1 Dulwich Picture Gallery, nos. 114 and 117.

2 Patteson Sale 1819, 2nd day, lots 68 and 73.

3 Crome Sale 1821, 1st day, lot 97.

4 Druery 1826, p. 81.

5 Chambers 1829, II, p. 803; Unthank *et al.* Sale 1897, 2nd dày, lot 145 (purchased from John Patteson, 1819) and lot 182.

6 Gunthorpe Sale 1842, lot 9.

7 West Sale 1843, 2nd day, lot 13.

8 Norwich 1829 (29; 77).

9 Chambers 1829, II, p. 786 (Hastings *et al.* Sale April 1975, lot 53).

10 Chambers 1829, II, p. 845.

11 Townshend Sale 1835, lot 41.

12 Savill-Onley Sale 1894, lot 90.

89 Gerard ter Borch

Zwolle 1617 – Deventer 1681

Portrait of Cornelis Vos, Burgomaster of Deventer (1623–84) c. 1665

Illustrated p. 132

Oil on copper 22.7 × 19 cm

Prov: George Rossi, by 10 March 1832; ?Charles Norris, Bracon Ash, Norfolk; Rev. Charles Norris, Briston, Norfolk; Rev. Charles Lloyd Norris, Blo-Norton; Mr and Mrs Assheton Bennett; Bequeathed to Manchester City Art Galleries in 1979 (1979.446).

Exh: London 1952 (119); London 1965 (30).

Lit: Gudlaugsson 1959, I, p. 141 fig. 198; 1960, II, p. 191, no. 198; *Catalogue of Paintings and Drawings from the Assheton Bennett Collection*, 1965, p. 10.

Manchester City Art Galleries

Gerard ter Borch is perhaps the best-documented Dutch artist of the seventeenth century: the Print Room of the Rijksmuseum houses a rich family archive. The first of several trips abroad was to London and it was there that he first became familiar with the elegant court portraiture

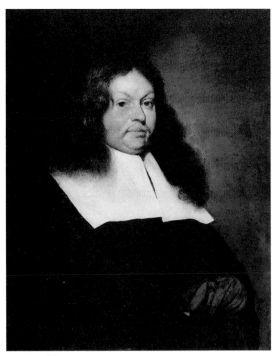

cat. no. 89

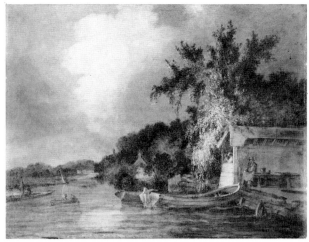

cat. no. 90

90 John Crome

Norwich 1768 – Norwich 1821

The Yare at Thorpe, Norwich c. 1806

Illustrated above

Oil on panel 42.2 × 57.6 cm

Prov: Charles Norris, *c.* 1860; bt from him by Joseph
Parrington, Bungay; his Sale, 18 December 1886,
lot 257; bt by C.J. Watson; bt by H.G. Barwell in
1888; by descent to his sister; from whom bt by
Russell James Colman in 1906; R.J. Colman
Bequest 1947 (707.235.951).

Lit: Dickes 1905, p. 130; Hawcroft 1959, p. 236; Moore
1985, p. 23.

Norfolk Museums Service (Norwich Castle Museum)

The Yare at Thorpe, Norwich is one of the earliest and most
subtle of Crome's oils. The fluid use of a monochromatic
palette lends a sense of atmospheric effect which recalls
the work of Jan van Goyen in the early 1630s. The
triangular composition is also reminiscent of van Goyen
at that period. Nevertheless, the survival of the pencil
sketch upon which this composition is based, acts as a
timely reminder that this composition is no idle pastiche
or homage. Signed, inscribed and dated *View from King's
Head Gardens at Thorpe July 3rd 1806 J. Crome*, the pencil
sketch[1] differs only in the exclusion of the river traffic to
the left. We see the artist creating a romantic interpreta-
tion of a sense of the place, drawing from a topographi-
cally accurate sketch in a way which is typical of the early
nineteenth century. Jan van Goyen would also sometimes
paint from sketches drawn on the spot and it is in this
sense that Crome may be compared with the Dutch
Master.

It is interesting to note just how Crome achieved his
monochromatic effects in this instance.[2] Technical analy-
sis of the panel reveals several paint layers underlying the
ground, including a dark green and brown. These
presumably relate to a previous use of the panel. The
ground itself is cream, with a brushmarked texture, over
which is a pinkish priming which gives an appearance
resembling the preparation of many Dutch landscapes.
However, in this case the texture of the wood is
completely lost, due to the paint layers beneath, while the
brushstrokes in the ground do impart some sense of
texture. The composition is painted very thinly, with
diluted paint, apart from the highlighted trees on the

of Anthony van Dyck. He returned to Holland in 1636 and
then set out on further travels, including Spain and Italy
in his itinerary. He had made a name for himself as a
portrait painter by the mid 1640s, specializing in small
bust-length portraits and also small full lengths. Accord-
ing to Gudlaugsson, this example may be dated to the
mid-1660s. The identification of the sitter, suggested by
Gudlaugsson, is based upon the portrait of Cornelis Vos
in a group of Deventer dignitaries by ter Borch, dated
1667.

The fact that this portrait was ever in a Norfolk
collection would have been lost but for a letter of
authentication attached to the back of the picture,
addressed by G. Stacy to a Mr Rossi and dated 10 March
1832. George Stacy was a Norwich collector who lent
sixteen Netherlandish works to the Norwich Old Masters
exhibition organised in 1828. His collection included
works by or attributed to Ruisdael, Wouwermans,
Ostade, Pynacker and Jan Steen. His opinion as a
collector was evidently respected. 'Mr Rossi' was presum-
ably George Rossi, the founder of the family gold and
silversmith's shop in Guildhall Hill, Norwich, which
finally closed in 1936. George Rossi was born in Italy and
fought under Marshall Soult in the Napoleonic Wars,
before finding his way to Norwich. In 1840 he lent nine
works to the Norwich Polytechnic exhibition, all marked
as for sale. These included paintings by Crome and
George Vincent, as well as Dutch and Italian masters.

Other Norfolk collectors who owned examples by or
attributed to ter Borch were William Freeman,[1] Jacob
Astley of Melton Constable,[2] Charles John West of St
Faith's Lane, Norwich,[3] the Rev. John H. Sperling of
Catton House[4] and Onley Savill-Onley (see pp. 30–31).

1 Exhibited Norwich 1829 (62), *Tasting*.

2 Chambers 1829, II, p. 786, *Woman Drinking*.

3 West Sale 1843, 1st day, lot 36, '*Lady at her Toilet . . .
 exquisitely finished*'.

4 Sperling Sale 1886, 2nd day, lot 733, *A Gentleman
 presenting a Flower to a lady in a white satin dress*.

right. This has led some critics to consider whether it might be unfinished, but the use of thinly painted monochromatic areas, together with more thickly applied areas can also be seen in Crome's *Carrow Abbey*, exhibited with the Norwich Society in 1805.[3] One technique to be found in *The Yare at Thorpe, Norwich* is the use of the brush handle in the trees, a method associated with some Dutch Masters, notably Rembrandt and Aert de Gelder. The quiet tranquillity of this composition belies its disparate range of influences which include actual topography, contemporary Romanticism, the Dutch Old Masters, and even Gainsborough.

1 British Museum 1898.5.20.21.

2 I am indebted to Cathy Proudlove for her technical analysis of this painting.

3 Norwich 1805 (145).

91 John Crome

Norwich 1768 – Norwich 1821

Grove Scene c. 1820

Illustrated below

Oil on canvas 47.6 × 65.1 cm

Prov: The artist's widow; bt from her in 1821 by Joseph Geldart; by descent to Robert Geldart; bt from him by Jeremiah James Colman, 1890; by descent to Russell James Colman; R.J. Colman Bequest 1947 (727.235.951).

Exh: Norwich 1820(53); Norwich 1821(76).

Lit: *Norfolk Chronicle*, 29 July 1820; Dickes 1905, p. 134; Hawcroft 1959, p. 236; Clifford 1968, pp. 251–2; Moore 1985, p. 29.

Norfolk Museums Service (Norwich Castle Museum)

The influence of Meindert Hobbema upon this composition has often been remarked upon. The debt is specifically to Hobbema's late work, its degree of careful finish combined with a sense of breadth which may be seen as Crome's hallmark. Crome returned to the Dutch example at different points in his career, and not simply at a specific stage in his development. It is interesting to speculate whether his interest at different times was in fact the result of having recently seen major works by Dutch Masters either locally or in London. The first London exhibition of Dutch and Flemish Masters at the British Institution in 1815 does not, however, provide an especially useful signpost to an increasing interest in the Dutch Masters within Crome's oeuvre. Nor, indeed, does his visit to the Louvre, Paris, in 1814.

The influence of Ruisdael and Hobbema to be seen in the composition is not particularly matched in terms of technique. Crome has selected a fairly fine canvas which, in common with other examples in his oeuvre,[1] has woven-in irregularities and uneven stretch marks, which strongly suggest that the artist has prepared the canvas himself. The canvas is covered with a thin cream ground which does not completely fill the canvas structure, leaving a slight canvas texture. There may also be a

cat. no. 91

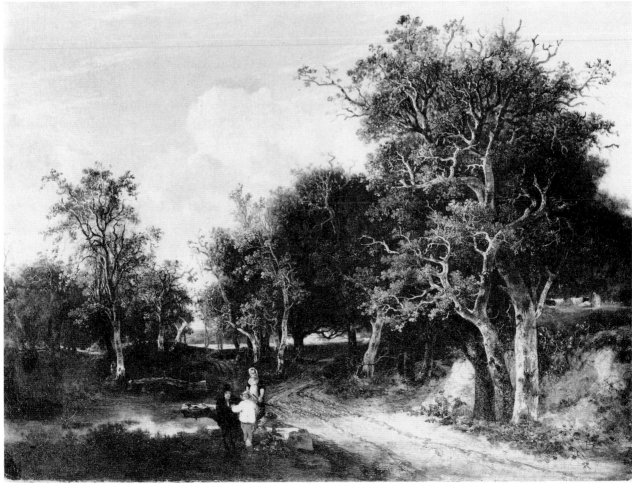

pinkish priming in the Dutch manner. The build-up of paint layers is difficult to detect, but one analysis has suggested 'about four layers, none of which is entirely glazes or entirely opaque or entirely monochrome. Possibly first sketch in burnt umber.'[2] In all, the techniques employed only emulate the Dutch example to a degree. The resulting image has a sense of atmospheric effect which belies any suggestion that the painting is a mere pastiche of a seventeenth-century formula.[3]

1 For example, *Boulevard des Italiens* (Norwich Castle Museum 1.935) and *Back of the New Mills* (NCM 2.4.99).

2 G. Helmkampf.

3 I am grateful to Cathy Proudlove for her comments. See also Appendix I.

92 James Stark

Norwich 1794 – London 1859

Landscape: a view through trees

Illustrated p. 59

Oil on panel 42.5 × 56.2 cm

Prov: Joseph Stannard; bt by W.H. Cozens-Hardy at Joseph Stannard's sale, St George's Plain, Norwich, 1856; R.J. Colman Bequest 1947 (1304.235.951).

Lit: Dickes 1905, p. 479.

Norfolk Museums Service (Norwich Castle Museum)

Stark's debt to the Dutch masters in this example is such that it is hardly possible to identify the scene as a local Norfolk view. This typifies Stark's work of the 1820s. On 24 March 1821 the *Norwich Mercury* reprinted a London review which commented that Stark had 'got by heart the express and almost infinite touchiness of HOBBIMA ... and avoids the damning character of a plagiarist' by retaining his eye for direct observation. By December 1825, however, the *London Magazine* reported '... we must object to his iteration of subject; a practise which shows he is more conversant with Hobbema and Ruysdael than with nature ... What he has done is good; but he has as yet painted but one picture.' By 1839 Stark had moved away from the formulae of Hobbema with which he had courted popularity until the taste for such work was sated.

It is interesting to consider just how much Stark was influenced technically by the work of the Dutch masters such as Ruisdael and Hobbema. This panel is covered with a red earth-coloured coat of paint on the reverse, which is almost certainly the same pigment with which the ground has been prepared, with a thick, opaque and very smooth application. This is visible in places, especially among the trees, and may well be an attempt to imitate a Dutch ground.[1] Ruisdael is the only Dutch artist known to have used a dark ground in this manner, the usual method being to coat the panel with a reddish or pink ground. The effect of using such a dark ground is to deaden the effect of the strongly coloured pigments.

The trees are painted with a thick, medium-rich paint in a manner which emulates that of both Ruisdael and Hobbema, although not necessarily found among other Dutch seventeenth-century masters. The Norwich artist did not emulate the work of Hobbema entirely, insofar as

his work suffered from drying problems (notably cracks and 'bobble'), whereas Hobbema's did not.[2]

1 There is a thin white layer underneath the ground, painted direct on the panel, but this plays no part in the picture. The panel may have been purchased with the white ground already present.

2 I am indebted to Cathy Proudlove for her analysis of Stark's technique in this instance.

cat. no. 93

93 James Stark

Norwich 1794 – London 1859

Whitlingham from Old Thorpe Grove *c.* 1837–43

Illustrated above

Oil on canvas 43.5 × 61 cm

Prov: Painted for the artist's sister, Mrs John Skipper; by descent to William Skipper; from whom purchased by Jeremiah James Colman; R.J. Colman Bequest 1947 (1299.235.951).

Lit: Moore 1985, p. 39.

Norfolk Museums Service (Norwich Castle Museum)

This canvas epitomises the questions that need to be asked in relation to the influence of Dutch painting upon the Norwich School and James Stark in particular. The summary handling of the fresh blonde range of tones gives the painting a light airiness far removed from the more consciously studied formulae of the grove scenes with which Stark made his reputation in Norwich. The composition bears all the hallmarks of a directly-observed scene, and is traditionally identified as the view from a spot near the home of the artist's sister, Mrs John Skipper of Thorpe, Norwich.

In his later works, Stark used lighter grounds and lighter less elaborate underpainting, helping to keep the finished pictures brighter. This is almost certainly in response to criticism he received in the 1820s for his increasingly formulaic approach in the Dutch manner. By 1839 the *Norwich Mercury* found that he had 'freed himself from his original and local manner' whereby his work had become 'brilliant with beauty and light. The exchange from Hobbima to nature is indeed a marvellous improvement.'[1]

Yet this painting may also owe a debt to the open, panoramic landscapes of Jacob van Ruisdael and his

pupil Philips Koninck. The taste for both artists during the early 1820s and 1830s was on the increase and Stark himself may have conceived this view in those terms. It is very different from the usual Norwich School landscape such as is typified by Stark's early work, almost invariably following more consciously picturesque criteria. The painting has a smooth white ground (visible in patches along the horizon) which emulated the example of the Dutch artists in its search for a smooth, glossy finish.[2]

1 17 August 1839.

2 The painting now has a coarse canvas texture which is not original. This is caused by a relining with a coarse canvas. I am grateful to Cathy Proudlove for her observations on this painting.

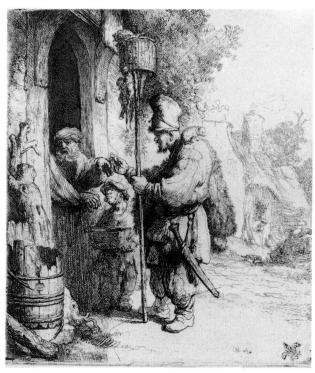

cat. no. 94

94 Rembrandt Harmensz. van Rijn

Leiden 1606 – Amsterdam 1669

The Rat-Killer 1632

Illustrated above
Etching, second state, 14 × 12.4 cm
Signed, lower right: *RH* (monogram) *1632*

Prov: Holford collection; Percy Moore Turner; by whom bequeathed to Norwich Castle Museum 1951 (7.47.951).

Lit: Bartsch 1797, 121; Hind 1912, 97, II.

Norfolk Museums Service (Norwich Castle Museum)

An impression of *The Rat-Killer* was included in John Crome's four day collection sale held after his death in 1821. Two other named Rembrandt etchings sold from his collection at that time were *The Good Samaritan*[1] and *The Death of the Virgin*.[2] His collection included three other (unnamed) etchings by Rembrandt and a host of prints by or after old masters.

During his lifetime John Crome held one collection sale, in September 1812, apparently to clear his debts with the Gurneys. This included four hundred and forty nine lots of prints, including a significant number of original works by, or reproductive prints after, Netherlandish artists. These included impressions of Rembrandt's *The Gold-Weigher*[3] and *The Wise Men's Offering*.[4] An etched copy of *The Rat-Killer* by Crome's son Frederick could equally have been copied from an impression in a different collection, possibly that of Dawson Turner.[5]

1 Hind 1912, 101.

2 *Ibid.*, 161.

3 *Ibid.*, 285.

4 *Ibid.*, 254.

5 A version of this etching by the Great Yarmouth etcher, Edmund Girling (1796–1871), signed and dated 1817, is in the British Museum (1902.5.14.810).

95 Rembrandt Harmensz. van Rijn

Leiden 1606 – Amsterdam 1669

The Three Trees 1643

Illustrated p. 136
Etching with drypoint, 21.1 × 28 cm, plate cut
Signed and dated *Rembrandt* (?) *f. 1643*

Prov: Percy Moore Turner Bequest to Norwich Castle Museum 1951 (44.47.951).

Exh: London, Turner Bicentenary, 1974–5 (B32).

Lit: Bartsch 1797, 43B; Hind 1912, 205.

Norfolk Museums Service (Norwich Castle Museum)

The emotive power of this image is as much due to its religious symbolism as to its definitive opposition of light and shade. Rembrandt has depicted the skyline of Amsterdam, the view probably being from the north-east of the city. At the same time the scene is invested with an intensity which has been described by Christopher Brown in the following terms: 'The three trees are an intentional recollection of the three crosses on Calvary. Such a direct reference to a Biblical event is a natural extension of the notion of the spiritual immanence of landscape. Because the landscape is God's creation, any depiction of it is an act of worship . . . This is the only one of Rembrandt's landscape etchings in which he shows a dark threatening sky with dramatic effects of light and shadow. The lowering clouds are intended to suggest the moment during the crucifixion when the sky went dark: "Now from the sixth hour there was darkness over all the land unto the ninth hour" (Matthew 27:45) . . .'[1] This hypnotic plate was one of Rembrandt's most influential images for British copyists and artists alike during the eighteenth and nineteenth centuries.[2]

1 Brown 1986, p. 226.

2 A version of this etching by the Great Yarmouth etcher, Edmund Girling (1796–1871), signed and dated 1817 (in reverse), is in the British Museum (1902.5.14.800).

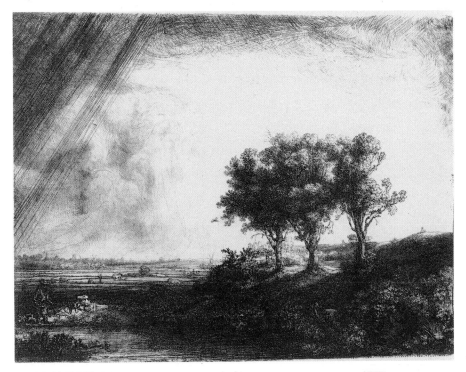

cat. no. 95

cat. no. 96

96 John Crome

Norwich 1768 – Norwich 1821

Mousehold Heath *c.* 1810–11

Illustrated above

Etching, second state, 22.9 × 30.5 cm

Prov: Henry Studdy Theobald Gift 1921 (9.25.21).

Lit: Moore 1985, p. 28.

Norfolk Museums Service (Norwich Castle Museum)

Mousehold Heath is one of John Crome's most celebrated etchings. Crome's total etched oeuvre is of nine soft-grounds and twenty five pure etchings, but few original impressions survive from Crome's lifetime, his practice being to take test impressions, quite lightly bitten.

Although there is no record of Crome having owned an impression of Rembrandt's *The Three Trees,* he surely must have known the image and arguably *Mousehold Heath,* with its lowering clouds and landscape bitten with light and shade, might not have been conceived without it. At the same time Crome achieves a silvery tonality to his plate which owes much to Rembrandt's other landscape etchings. Crome's delicacy of line places him at the forefront of the revival in etching in the subsequent tradition of British painter-etchers. Ironically, the early Victorian taste for Rembrandtesque effect encouraged Dawson Turner to have Crome's plates reworked to achieve greater density. The later states of *Mousehold Heath* show the reworking of the sky in particular, ruled with diamond point by W.C. Edwards, who attempted to make the plate 'more applicable to the public taste,' trusting that he had 'much improved' it.[1]

cat. no. 97

cat. no. 98

1 W.C. Edwards to Dawson Turner, 8 May 1837, Trinity College Library, Cambridge.

97 Jacob van Ruisdael

Haarlem 1628/29 – Amsterdam 1682

Grain Field at the edge of a Wood

Illustrated above (top)
Etching, second state, 10 × 14.7 cm
Inscribed, top right: *Ruysdael fe.*

Prov: Percy Moore Turner; by whom bequeathed to Norwich Castle Museum 1951 (126.47.951).

Lit: Bartsch 1803, I, p. 315, no. 5.

Norfolk Museums Service (Norwich Castle Museum)

The signature is spurious, and was probably added by the Antwerp printmaker and publisher Frans van der Wyngaerde (1614–79).[1] This etching is included here for comparison with Crome's very similar composition of 1812, *The Hall Moor Road near Hingham* (see cat. no. 98).

An impression of this etching was copied line for line by John Constable, including the signature and even the plate mark, in pen and ink in 1818.[2]

1 Slive and Hoetink 1982, pp. 246–9.
2 Victoria and Albert Museum (R169).

137

98 John Crome

Norwich 1768 – Norwich 1821

The Hall Moor Road near Hingham

Illustrated p. 137
Etching, third state, 17.8 × 22.8 cm
Signed (in plate), top left: *J. Crome, Fecit, 1812.*

Prov: Henry Studdy Theobald Gift, 1921 (48.25.21).

Exh: Aldeburgh 1968 (28).

Lit: Theobald 1906, no. 16.

Norfolk Museums Service (Norwich Castle Museum)

Dawson Turner, in his *Biographical Memoir* of John
Crome, recounts how Crome made numerous etchings
while at Yarmouth, staying in Turner's home. On one
occasion, Turner recounts how he 'will never forget the
smile of self-satisfaction, which beamed on his brow,
when bringing him an impression from a new plate
printed on soiled paper, he called out "What think you of
this, Ruysdale?"'[1] A number of Crome's etchings show
the influence of Ruisdael (see cat. no. 97), particularly in
their use of composition.

1 Turner 1838, Introduction.

99 John Sell Cotman

Norwich 1782 – London 1842

Sketch after 'The Castle of Bentheim' by Jacob van Ruisdael 1815

Illustrated above right
Pencil on paper, 9.6 × 14.8 cm

Prov: S.D. Kitson Bequest 1938 (9.51/49).

Lit: Kitson 1937, p. 168.

Leeds City Art Galleries

This small pencil sketch is a compositional study of Jacob
van Ruisdael's *The Castle of Bentheim*[1], drawn by John Sell
Cotman when the painting was owned by William Smith
(1756–1835) MP for Norwich. Ruisdael painted a number
of compositions based upon the Castle, and the version
once owned by Smith is commonly regarded as the most
imposing of them all. Ruisdael in fact heightened and
enhanced the unimposing site of Bentheim, enlarging
what is actually a low hill, into a wooded mountain of
imposing splendour. The painting is all the more spec-
tacular for the unity achieved between the castle, the
distant landscape and the wealth of detail in the vegeta-
tion of the foreground.[2]

John Sell Cotman is not an artist whose work is readily
associated with the influence of the Dutch Old Masters.
Yet this small sketch well illustrates just how one great
artist may respond to the work of another. Cotman's
colour notes to the left and bottom have the intimacy of a
personal conversation as he records those elements he
most wants to remember. Confronted by the enormous
canvas, Cotman quickly sketches the composition in
terms of its light and shade, its silhouette and the detail of
the vegetation in the foreground. He particularly notes
the 'Greenish Grey' of the distant hillside and the 'Broken
Cols. [colours] Trees & Roofs of Cottages thatched & tiled
minutely touched but very free.' He notes the little
touches of white that Ruisdael uses to enliven the

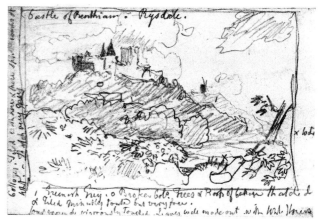

cat. no. 99

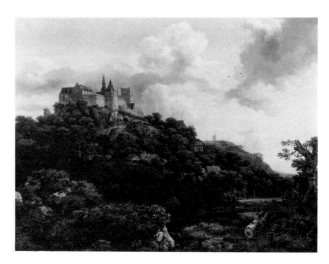

figure 52:
Jacob van Ruisdael (1628/9–1682)
The Castle of Bentheim 1653
oil on canvas 110.5 × 144 cm
National Gallery of Ireland

cottages on the hillside, while the foreground is 'vigor-
ously touched. Leaves well made out with wht. flowers.'

The Castle of Bentheim was one of five paintings lent by
William Smith to the exhibition of Netherlandish art held
by the British Institution in Pall Mall in 1815.[3] This is
almost certainly the occasion when John Sell Cotman
made his compositional sketch. He was responding to a
composition which mirrors many of his own, particularly
his views of the Welsh mountains, notably those depicted
in his softground etchings. Three years later, Cotman was
to sketch the north view of the Castle of Falaise, in
Normandy,[4] selecting a composition which eminently
recalls that of *The Castle of Bentheim*.

1 Sir Alfred Beit; on loan to the National Gallery of
 Ireland, Dublin: fig. 52.

2 Slive and Hoetink 1982, pp. 54–5.

3 British Institution, 1815 (37) *The Windmill* by Rem-
 brandt; (94) *The Castle of Bentheim* by 'Ruysdale'; (96) *A
 brisk gale, with men of war* by 'Vandervelde'; (99)
 Landscape, evening, with travellers by Cuyp; (108) *Land-
 scape, evening with peasants travelling,* by 'Berghem'.

4 Whitworth Art Gallery, Manchester. Etching: Popham
 1922, no. 287.

cat. no. 100

100 John Sell Cotman

Norwich 1782 – London 1842

Duncomb Park, Yorkshire, published 1811

Illustrated above
Etching, 22.6 × 14.3 cm
Inscribed, lower left: *JSC.*

Prov: Purchased by Norwich Castle Museum 1956
(254.956).

Lit: Popham 1922, no. 5.

Norfolk Museums Service (Norwich Castle Museum)

Correspondence between John Sell Cotman and the Cholmeley family, his patrons, reveals Cotman's admiration for Rembrandt. This composition is one of Cotman's earliest etchings and was particularly admired by his former pupils Katherine Charlton and her sister Anne Cholmeley. The latter commented that the trees in *Duncomb Park* 'strike me as most like Rembrandt's'. Viewing some of Cotman's early etchings she commented that she had 'never seen any etchings I thought nearly so soft and forcible, except some of Rembrandt's Sir Harry shewed me'.[1] Cotman found such references to Rembrandt 'a great compliment', but added that 'it would not do to follow that master in my subjects'.[2] He was clear in his own mind that Rembrandt was a source of inspiration rather than an example to follow slavishly. He was equally, if not more, impressed with the work of the Italian etcher Piranesi, in his search for a technique 'where the broad black line looks not coarse but full and mellow'.[3]

1 6 April 1811.
2 John Sell Cotman to Francis Cholmeley, 5 March 1811.
3 *Ibid.*

101 Rembrandt Harmensz. van Rijn

Leiden 1606 – Amsterdam 1669

View of Amsterdam c. 1640

Illustrated p. 140
Etching, second state, 11.2 × 15.3 cm

Prov: F. Kalle; A. Roemer; A. Voigtlender-Tetgner;
W.H. Upjohn KC; Percy Moore Turner; by whom
bequeathed to Norwich Castle Museum 1951
(31.47.951).

Lit: Bartsch 1797, 210; Hind 1912, 176, II.

Norfolk Museums Service (Norwich Castle Museum)

See cat. no. 103.

102 Rembrandt Harmensz. van Rijn

Leiden 1606 – Amsterdam 1669

Cottage with a white Paling

Illustrated p. 140
Etching, second state, 13 × 15.8 cm
Signed, lower left centre: *Rembrandt f.*
Inscribed: *1642.*

Prov. R. Gutekunst; Percy Moore Turner; by whom
bequeathed to Norwich Castle Museum, 1951
(67.47.951).

Lit: Bartsch 1797, 232, I; Hind 1912, 203, II.

Norfolk Museums Service (Norwich Castle Museum)

See cat. no. 103.

103 Rembrandt Harmensz. van Rijn

Leiden 1606 – Amsterdam 1669

Landscape with a Milkman c. 1650

Illustrated p. 140
Etching, second state, 6.5 × 17.4 cm

Prov: Collection of John Malcolm of Poltalloch; British
Museum (duplicate); Percy Moore Turner; by
whom bequeathed to Norwich Castle Museum,
1951 (56.47.951).

Lit: Bartsch 1797, 213, II; Hind 1912, 242, II.

Norfolk Museums Service (Norwich Castle Museum)

Cat. nos. 101–3 have been selected to represent the collection of ten Rembrandt etchings owned by the Norwich painter-etcher, the Rev. E.T. Daniell. They are not the impressions owned by Daniell himself, which were sold on his death and as yet remain untraced. The ten Rembrandt etchings sold on 17 March 1843 at Christie's, London, were as follows:

lot 24: *St Peter and St Paul at the Beautiful Gate*, pur-
chased Campbell, nine shillings.
[Hind 1912, 301].

lot 25: *The Long Landscape, with the Dutch barn*, purchased Campbell, five shillings. [Hind 1912, 177].

lot 26: *The Long Landscape, without the pointed tower*, purchased ?Graves, four guineas.
[Hind 1912, ?264].

lot 27: *The Arched Landscape, with an Obelisk*, purchased Tiffin, one pound, sixteen shillings.
[Hind 1912, 243].

lot 28: *The Cottage, with the white pails*, purchased Graves, two pounds. [Hind 1912, 203].

lot 29: *The landscape, with the milkwoman*, purchased Graves, two pounds, three shillings.
[Hind 1912, 242].

lot 30: *View of Amsterdam*, purchased Graves, one pound eight shillings. [Hind 1912, 176].

lot 31: *The Cottage, with a man sketching*, purchased Graves, two pounds. [Hind 1912, 213].

lot 32: *St Jerome reading by the side of a tree*, purchased Graves, two guineas. [Hind 1912, 267].

lot 33: *Beggars at a Cottage door*, purchased Colnaghi, two pounds twelve shillings six pence.
[Hind 1912, 233].

This choice collection, with its predominance of landscape etchings, reveals the connoisseurship behind Daniell's own output as an etcher. The *View of Amsterdam* was Rembrandt's earliest landscape etching, marking the start of his great series, of which Daniell owned seven impressions. Rembrandt's example has particular significance for the Norwich etchers. For although landscape was by no means Rembrandt's prime concern as an artist, his etchings reveal a direct response to landscape with an immediacy that inspired the Norwich painter-etchers. Rembrandt's ability to capture with the utmost economy of line the details of his native countryside was such that Fritz Lugt, in his book *Mit Rembrandt in Amsterdam* (1920), was able to trace the artist's walks from the city gate nearest to his home. Something of this immediacy can be traced in the work of Daniell, despite his amateur status as an artist. See cat. nos. 104, 105.

cat. no. 101

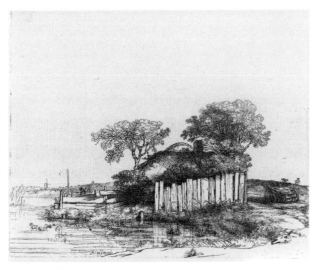

cat. no. 102

cat. no. 103

104 Edward Thomas Daniell

London 1804 – Lycia 1842

River Scene with Boathouse c. 1833

Illustrated p. 141
Etching and drypoint, second state, 7.6 × 7.6 cm

Prov: R.J. Colman Bequest, 1947 (86.61.925).

Lit: Thistlethwaite 1974, no. 47.

Norfolk Museums Service (Norwich Castle Museum)

This composition is strongly reminiscent of Rembrandt's *Cottage with white palings* (cat. no. 102) and also his *Long Landscape with Dutch barn*, impressions of both of which

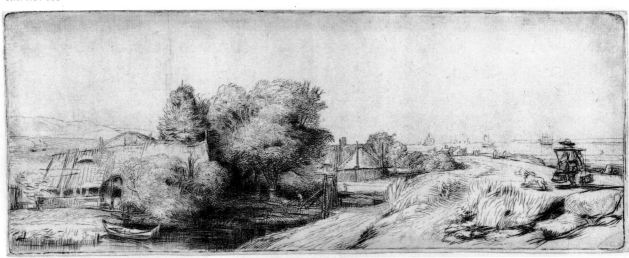

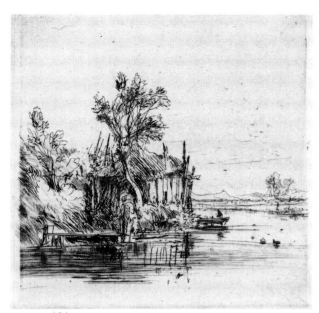

cat. no. 104

Daniell owned. Although the inspiration of Rembrandt is evident, Daniell is no copyist.

105 Edward Thomas Daniell

London 1804 – Lycia 1842

Tasburgh Bridge c. 1833

Illustrated below
Etching 14.5 × 23 cm

Prov: R.J. Colman Bequest, 1947 (63.61.925).

Lit: Thistlethwaite 1974, no. 48.

Norfolk Museums Service (Norwich Castle Museum)

cat. no. 105

Daniell excelled in the use of drypoint, the technique whereby the design is richly strengthened by drawing directly on the metal plate with a needle and thus causing a soft ride or 'burr' of metal to rise at the edge of the line – which in turn gathers the ink to print a richer, darker tone. This was a technique which he almost certainly learnt from the study of Rembrandt. The Norwich artists Thomas Lound and Henry Ninham also adopted this technique to some extent, suggesting Daniell's influence upon their work. It is likely that Ninham was the channel for this influence, as it was he who printed Daniell's plates.

Tasburgh, eight miles south of Norwich, is a village at the junction of three streams which form the river Tas.

106 Rembrandt Harmensz. van Rijn

Leiden 1606 – Amsterdam 1669

The Windmill 1641

Illustrated p. 142
Etching 14.4 × 20.7 cm
Signed and dated: *Rembrandt f. 1641*

Prov: Bequeathed to Norwich Castle Museum by Percy Moore Turner 1951 (33.47.951).

Lit: Bartsch 1797, 233; Hind 1912, 179.

Norfolk Museums Service (Norwich Castle Museum)

The network of fine cracks in the centre of this magnificently asymmetrical composition is due to the accidental cracking of the etching ground while Rembrandt was working on the plate. As Hind observed: 'the accidental effect perhaps even enhances the wonderful expression of atmosphere'.

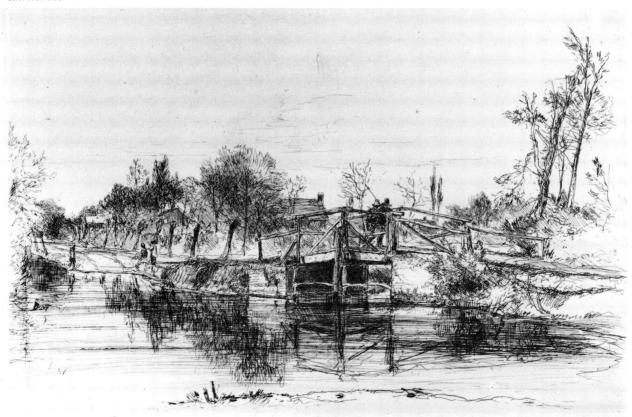

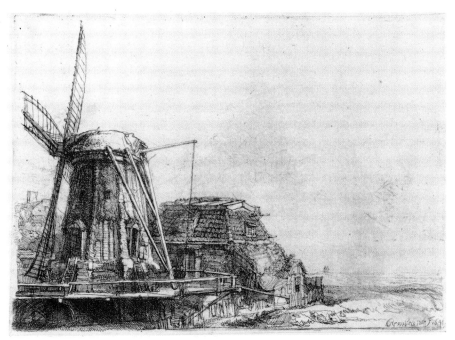

cat. no. 106

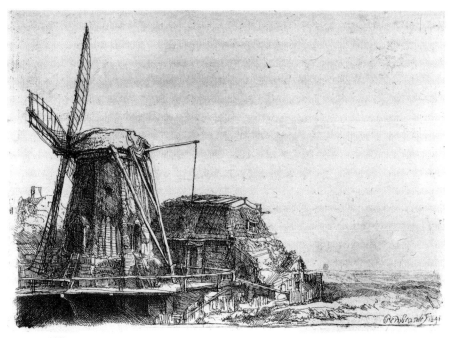

cat. no. 107

107 Cecilia Lucy Brightwell

Thorpe, Norwich 1811 – Norwich 1875

The Windmill, after Rembrandt c. 1834

Illustrated above

Etching 15.7 × 21.6 cm

Prov: Miss C.L. Brightwell gift to Norwich Castle Museum 1861 (2.43.61).

Lit: Kitson 1937, p. 301.

Norfolk Museums Service (Norwich Castle Museum)

Lucy Brightwell is remarkable as a skilled copyist after the work of other artists. Her own compositions are competent, but her direct replicas take on the quality of the original in a quite remarkable way. John Sell Cotman informed Dawson Turner on 27 January 1834: 'Miss

Brightwell's copy of Rembrandt's *Mill* is most astonishingly etched, and more like Rembrandt than anything I have ever seen.'[1] Sydney Kitson records that 'One of Miss Brightwell's etchings was accepted as an original Rembrandt by the British Museum, until E.T. Daniell corrected the error'. Hind also recorded this 'excellent copy' and commented that the absence of the network of fine cracks on Rembrandt's original 'serve to distinguish it from the original'.[2] Hind also warned the unwary collector of the deceptive quality of Lucy Brightwell's replicas of Rembrandt's *View of Amsterdam* and the *Landscape with a Cottage and Hay Barn*.[3]

1 Christopher Barker Collection; quoted Kitson 1937, p. 301.

2 Hind 1912, under no. 179.

3 Hind 1912, p. 18.

108 Jan Weenix

Amsterdam ?1642 – Amsterdam 1719

Dead Hare and Partridges 1704

Illustrated below
Oil on canvas 118.7 × 91.4 cm
Signed and dated, lower right: *J. Weenix f. 1704*

Prov: Acquired by George IV with the Baring collection
 in 1814; recorded in store at Carlton House in 1816
 (206); later in the Picture Gallery at Buckingham
 Palace: 1841 (60), 1852 (96); removed to Hampton
 Court in 1976.

Exh: London 1826 (84) and 1827 (14), on both occasions
 as by J.B. Weenix.

Lit: Jameson 1844, no. 174; Waagen 1854, II, p. 23;
 White 1982, no. 299.

By Gracious Permission of H.M. The Queen

cat. no. 108

Jan Weenix was the son and pupil of Jan Baptist Weenix.
For a time he was a member of the Utrecht painters'
college (*c.* 1664–8). *Dead Hare and Partridges* was painted
during the period when Weenix was court painter to the
Elector Palatine Johann Wilhelm, working on a series of
paintings of live and dead game for Schloss Bensberg
(1702–14). Weenix's work tends to be more decorative
than that of his father and he would often arrange his
dead game and birds against a park-like background
following the example of Melchior d' Hondecoeter. The
hare recurs as a central motif in a number of similar
compositions by Weenix, two notable examples in Britain
being in the Wallace Collection, London.[1]

This painting was acquired by the Prince Regent as
part of the Baring Collection in 1814.[2] To avoid duplica-
tion the Prince Regent selected a number to be sold
within three weeks of their arrival at Carlton House.[3] A
good number of those rejected were still-life pictures, but
the retention of *Dead Hare and Partridges* is a good

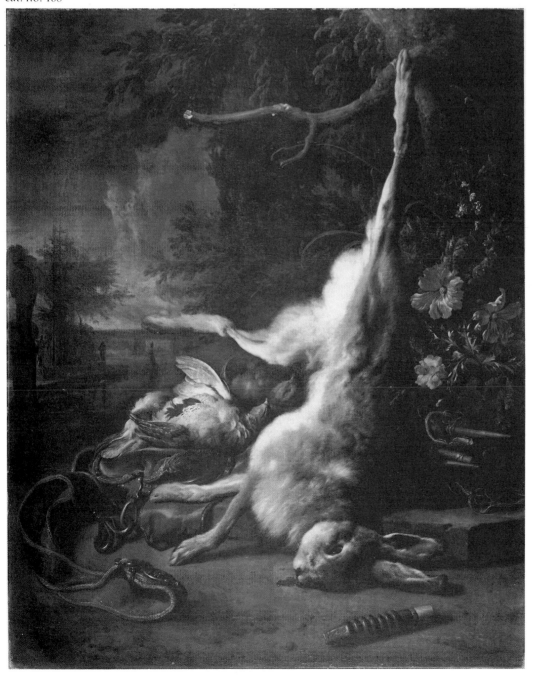

indication of the Prince Regent's taste for outdoor pursuits. In 1821 John Nash reported that 'the King had felt a dislike to Carlton House and wished to remove to Buckingham Palace'.[4] Rather than see the collection disappear totally from public view until the new Picture Gallery at Buckingham Palace was complete, the King lent one hundred and sixty four pictures to the British Institution for two consecutive years, 1826–27. *Dead Hare and Partridges* was one of those exhibited.

The taste for Weenix can also be traced in Norfolk collections. John Crome owned two pictures attributed to 'Weeninx' at his death, *Study of a Hare* and *The Steel Bow*.[5] Chambers records a *Garden-Scene* at Thurning Hall,[6] a *Dead Game and Dog* at Saxlingham[7] and an untitled painting 'of great excellence' on the great staircase at Wolterton Hall.[8] This was subsequently described in the Walpole Sale of 1856 as 'A dead hare, suspended from a carved stone pedestal, on which is a monkey with fruit; dead birds on the ground; a lake and palace in the background – upright. Very delicately finished.'[9] Chambers also records a Weenix at Raynham Hall.[10] This was a *Garden Scene, with dead game and shooting Implements*.[11] See also cat. no. 109.

1 Wallace Collection catalogue, 1968, nos. P87 and P103.

2 The Baring Collection was formed mainly by the banker Sir Francis Baring (1740–1810).

3 White 1982, Appendix; Christie's, 29 June 1814.

4 The Farington Diary, VIII, 1928, p. 219; White 1982, p. 1xiv.

5 Crome Sale 1821, 1st day, lots 78, 89.

6 Chambers 1829, I, p. 231.

7 *Ibid.*, II, p. 759.

8 *Ibid.*, I, p. 217.

9 Walpole Sale 1856, 3rd day, lot 266, sold to Barchard; subsequently ?Petit Palais, Paris (Dutuit Collection).

10 Chambers 1829, III, p. 1341.

11 Townshend *et al.* Sale 1836, lot 55, bt in; Townshend *et al.* Sale 1849, lot 110, from the Brentano Collection, sold to Nieuwenhuys.

109 Emily Stannard

Norwich 1803 – Norwich 1885

Still Life – Dead Ducks and a Hare with Basket and a Sprig of Holly 1853

Illustrated above

Oil on canvas 91.8 × 70.8 cm

Prov: R.J. Colman Bequest 1947 (1261.235.951).

Lit: Moore 1985, p. 105, illus. in colour.

Norfolk Museums Service (Norwich Castle Museum)

Emily Stannard, née Coppin, was the daughter of Daniel Coppin (*c.* 1770–1822) a local Norwich collector, house-painter and amateur artist. In 1820 she received the large gold medal from the Society of Arts for an original painting of flowers and in August that year accompanied her father to Holland. Her obituarist records in the *Norfolk Chronicle* for 7 January 1885 that while in The Hague and Amsterdam she obtained permission to copy paintings after van Huysum and in 1821 'she was

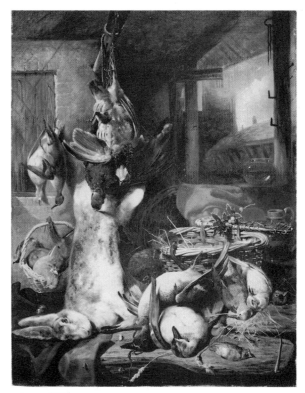

cat. no. 109

presented with the large gold medal of the Society of Arts, London for an original painting of fruit.'

Emily Stannard first exhibited a picture of dead game with the Norwich Society in 1829. This was the picture for which she received the Isis Gold Medal for an original painting of game the previous year, and she persisted with this new genre throughout her subsequent career. When she exhibited three paintings, all of dead game, in Norwich in 1831, the *Norwich Mercury* praised her 'really exquisite' work. Dated examples reveal that both her technique and command of composition strengthened. *Still Life – Dead Ducks and a Hare with a Basket and a Sprig of Holly* reveals her debt to her studies of the Dutch Masters, and of Jan Weenix in particular. It is interesting to speculate that she embarked upon her dead game pieces the year after presumably seeing Jan Weenix's *Dead Hare and Partridges* at the British Institution. She could equally have known comparable examples at Thurning Hall, Saxlingham, Wolterton and Raynham. Emily Stannard's compositions are not, however, mere pastiches of seventeenth-century examples. In this example, the artist has chosen to include a view of the church of St Peter Mancroft in the distance, placing the game shop squarely at the edge of the Norwich marketplace.

Emily Stannard's study of the Dutch Masters markedly influenced her technique. She consistently used a thin, diluted paint with virtually no use of impasto. She did not, however, aim for a high gloss finish and would often leave her paintings unvarnished. This painting is built up from an underpainting based on dark brown, comparable with Dutch examples, but is by no means especially Dutch in appearance. This is essentially because the artist has used contemporary materials such as machine-woven canvas and new pigments, such as artificial ultramarine and possibly oxide of chromium, a more reliable green than was hitherto available.[1]

1 This may be the pigment used for the fabric, lower left. I am indebted to Cathy Proudlove for her comments.

VI Later Collectors

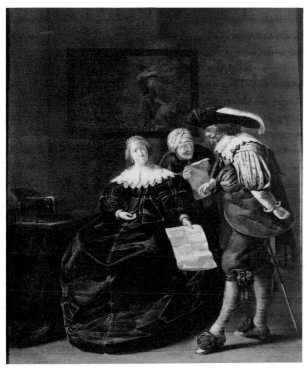

cat. no. 110

110 Jacob Duck

Utrecht *c.* 1600 – Utrecht 1667

Interior with Lady and Cavalier 1635

Illustrated above
Oil on panel 48.9 × 40.6 cm
Signed (on the document): *1635/J. Duck*

Prov: Sir Jacob Astley (1797–1859), probably after 1829;
by descent to present owner.

Exh: Norwich 1966 (14).

Private Collection

Jacob Duck is first listed in the records of the Utrecht Guild of St Luke in 1621 when he was described as an apprentice portraitist (a *counterfeyt jongen*). He was enrolled as a master by 1630–32 and seems to have resided at Haarlem for a period by 1636. He is recorded as being back in Utrecht in the 1640s and in The Hague in 1656–60. He followed the tradition of portraying guard-room scenes, but also painted tavern and domestic scenes.

Interior with Lady and Cavalier is a relatively early work by Duck which shows his ability in depicting elaborate details of costume and in the definition of character, within an uncluttered context. The monochromatic tones of the background enhance the finery of the figures. The painting on the wall in the background shows the scene of Abraham's sacrifice of Isaac, which provides a moral context for the secular scene depicted. Such scenes are typical of Duck who depicted a well-to-do lady with her old maid in attendance more than once.[1] His paintings would often incorporate a Calvinistic moral which might well not flatter the protagonists. Here, it seems that a contract is at issue.

1 *c.f.*, for example, a panel by Duck, 40 × 32 cm, in the R.H. Ward Collection, London, 1930 (Witt Library). These figures are invariably courtesans accompanied by a procuress.

111 Abraham Begeijn

Leiden *c.* 1637 – Berlin 1697

Landscape with Waterfall 1664

Illustrated p. 62
Oil on canvas 63.5 × 78.2 cm
Signed, bottom left: *A Begeijn f/1664* (the AB conjoined).

Prov: Sir Jacob Astley (1797–1859), probably after 1829;
by descent to present owner.

Exh: Norwich 1966 (4).

Private Collection

Abraham Begeijn was one of the few landscape painters in Leiden during the second half of the seventeenth century. He was a member of the Leiden guild from 1665–67 and specialised in Italianate landscapes with cattle and sometimes with reptiles, insects and birds in the manner of Otto Marseus van Schrieck (see cat. no. 64). He visited London for a period in the 1670s and is also thought to have possibly visited Italy and France.

This painting is not listed among the paintings at Melton Constable Hall in 1829 and it is a fair supposition that it was purchased by Sir Jacob Astley after that date. There is one other painting attributed to Begeijn in a Norfolk collection, that of Joseph Salusbury Muskett of Intwood Hall, who probably purchased his painting, *A woman milking a Goat*, at about the same period.[1]

1 Unthank *et al.* Sale 1897, 2nd day, lot 124.

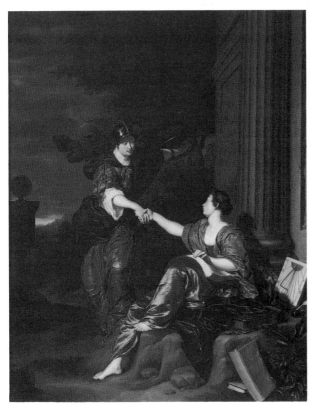

cat. no 112

112 Jan van Mieris

Leiden 1660 – Rome 1690

Minerva Protecting the Arts 1685

Illustrated above
Oil on canvas 81 × 64 cm
Signed, on the half column, extreme left: *J. van Mieris 1685*.

Prov: Sir Jacob Astley (1797–1859) by 1829 (see Lit. below); then by descent; Hastings *et al.* Sale 1929, lot 42, purchased by Tooth & Sons; Brian Koetser Gallery, London, by 1973; Sotheby's, London, 18 February 1976, lot 20, when purchased by present owner.

Exh: Brian Koetser Gallery 1973 (27), as William van Mieris.

Lit: Chambers 1829, II, p. 790, as by F. Mieris.

Private Collection

Jan van Mieris, like his brother Willem, meticulously followed the example of his father, Frans van Mieris (1635–81). Frans van Mieris was one of a group of Leiden followers of Gerrit Dou who became known for their high finish. Their brushwork is almost invisible and Frans van Mieris was particularly versatile, painting allegorical and Arcadian subjects as well as scenes of daily life. His sons followed him so specifically that their work was invariably attributed to him in Dutch collections as much as in England.

Minerva Protecting the Arts was believed to be by Frans van Mieris in 1829, when it hung in the Portico Room at Melton Constable Hall.[1] Other Norfolk collectors who owned works attributed simply to 'van Mieris' in the early nineteenth century were John Patteson, who owned *A Cook Maid*[2] and *An old woman and her favourite hen*[3] and

the Rev. Trivett whose *A Man in a Window, with Game* was described by Druery as 'a most beautifully finished and highly valuable painting'.[4] John Harvey owned an *Alchymist* and a *Boy saying Grace* (?Willem van Mieris)[5] and William Freeman lent a *Head* to the Norwich Old Masters exhibition in 1828.[6] Sperling owned *A Girl at a balcony* attributed to Frans Mieris.[7]

1 See Lit. above.

2 Patteson Sale 1819, 2nd day, lot 25, described as 'exquisitely finished'.

3 *Ibid.*, lot 26. See also cat. no. 76.

4 Druery 1826, p. 151; Trivett Sale 1864, 1st day, lot 165.

5 Chambers 1829, I, p. 21; Savill-Onley Sale 1894, lot 81; de Groot 1928, X, no. 158.

6 Norwich 1828 (118). Another oil attributed to van Mieris was exhibited Norwich 1840 (14), lent by Horton.

7 Sperling Sale 1886, 2nd day, lot 1771.

113 Jan Davidsz. de Heem and Daniel Seghers

Utrecht 1606 – Antwerp 1683–4 and
Antwerp 1590 – Antwerp 1661

Head of Christ 1641

Illustrated colour plate iv
Oil on canvas 100.4 × 79 cm
Signed, lower left: *Ja. de Heem F 1641*

Prov: Horatio, Lord Walpole, Earl of Orford, by 1829; Walpole Sale 1856, lot 251, as by Seghers; bt Rutley for £79:16s. on behalf of Staniforth Beckett; then by descent to present owner.

Lit: Chambers 1829, I, p. 217.

Private Collection

When Chambers noted this picture in the collection of Lord Orford at Wolterton Hall in 1829 he described it as 'an exquisitely finished Picture of Flowers, with the Head of our Saviour in the centre, in Chiaro Oscuro – J. David de Heem'. When the picture was sold, along with a considerable part of that collection, in 1856, the painting was reattributed to Daniel Seghers. This is, at first sight a more reasonable attribution as the composition is not at all typical of de Heem. However, if the signature is correct, it seems likely that this finely-wrought painting is a collaboration between Seghers and Jan Davidsz. de Heem. Seghers specialised in devotional paintings in grisaille, often painted in collaboration with other artists.

It is by no means certain when this painting entered the collection at Wolterton but it seems likely to have been purchased by the third Earl of Orford of the second creation who succeeded to the title in 1822. It was he who purchased the celebrated *Landscape with Rainbow* by Rubens in 1823 and also the deeply religious subject, *A Christ bearing his Cross, the Virgin kneeling by him* by Murillo (see also pp. 63–64).

Three other Norfolk collections are recorded in the nineteenth century as having works painted by, or jointly with, Seghers. The Townshend Collection at Raynham owned a pair of oils depicting 'sculptured medallions, with wreaths and bunches of flowers and fruit' by Seghers.[1] Edmund Sparshall, the Norwich wine merchant, owned a *Holy Family encircled by Flowers*, attri-

buted to Seghers and Rottenhammer.[2] Charles John West of Norwich owned a *Vase and Flowers* attributed to Seghers and Schutz.[3]

A number of Norfolk collections included works attributed to de Heem. The single largest group, including flowerpieces and dead game pictures, belonged to the Walpole family.[4] In Norwich John Patteson sold an *Emblems of Mortality* attributed to de Heem, in 1819, a picture which could conceivably be the *Still Life* in John Crome's collection sale of 1821.[5] Both Thomas Brightwell and Rev E. Burroughes of Norwich owned a fruit piece attributed to de Heem, in the 1820s.[6] Samuel Paget of Yarmouth bought a fruit piece attributed to de Heem for £40 in 1815,[7] while Dawson Turner owned a fruit piece attributed to Cornelis de Heem.[8] Joseph Muskett of Intwood Hall owned a flowerpiece by Jan Davidsz. de Heem.[9] In 1940 the Norwich Polytechnic exhibition included oils attributed to de Heem, lent by William Freeman of Norwich, George Grout and R.W. King of Yarmouth.[10]

1 Townshend Sale 1904, 2nd day, lot 126.

2 Sparshall Sale 1848, 2nd day, lot 39.

3 West Sale 1843, 1st day, lot 26.

4 Walpole Sale 1856, 3rd day, lot 265; also Walpole Sale 1859, 4th day, lots 1007, 1012.

5 Patteson Sale 1819, 2nd day, lot 24; *c.f.* Crome Sale 1821, 1st day, lot 50.

6 Exhibited Norwich 1829 (3); Brightwell Sale 1869, lot 364, bt Brightwell; Norwich 1829 (127) lent by Rev. E. Burroughes.

7 Paget MS, 'cost Price of my Paintings . . . 1815. Fruit Piece. De Heem £40.00'; also Druery 1826, p. 85; Paget Sale 1848, 2nd day, lot 50.

8 Druery 1826, p. 74; Turner 1840, illus.; Turner Sale 1852, lot 34.

9 Chambers 1829, II, p. 803; ?Unthank *et al.* Sale 1897, 2nd day, lot 162.

10 Norwich 1840(86) *Fruit Piece . . . De Heem*, lent by Mr William Freeman (for sale); (91) *Lobster, with Fruits & Flowers . . . De Heem*, lent by George Grout Esq.; (93) *Fruit Piece . . . De Heem* lent by R.W. King, Esq. Yarmouth. The latter was lent by Captain King to Norwich 1878 (218) and Yarmouth 1889 (242).

114 Abraham Storck

Amsterdam 1644 – Amsterdam after 1708

View of Amsterdam

Illustrated above
Oil on panel 29.8 × 37.8 cm
Signed (bottom right): *A. Storck*

Prov: ?Purchased by Vice-Admiral William Lukin by 1835 (possibly when living in Brussels in the early 1820s); by descent to Wyndham Ketton-Cremer; by whom bequeathed to the National Trust 1969.

The National Trust (Felbrigg Hall)

Abraham Storck was the best known of three brothers. He specialised in naval battles and imaginary harbour views and also boating scenes on the rivers Amstel and Vecht. Both he and his brother Jacobus painted views of

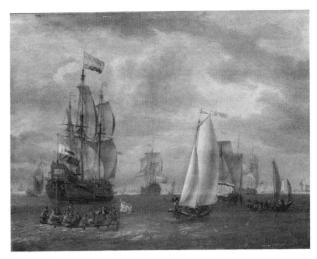

cat. no. 114

the Amsterdam canals and inner harbour, of which this is a late example. Storck would often repeat his compositions and a version of another of his views of Amsterdam is also at Felbrigg.[1]

Vice-Admiral Lukin purchased two other paintings by Abraham Storck to add to the many marine paintings already at Felbrigg Hall (see cat. no. 42 and pp. 65–66). Two Yarmouth collectors of Storck's work were J.D. Palmer who owned *An Italian Port* and *A Palace in Genoa*,[2] and James Symonds who owned a shipping scene entitled *A Breeze*.[3] The Rev. Brereton owned *Rotterdam Harbour*,[4] while Robert Scott lent *A Calm* to the Norwich Polytechnic exhibition in 1840.[5]

1 Possibly purchased by Lukin, this is an almost identical composition (with additional figures in the foreground) to Van Gelder Sale, Moos, Amsterdam, 7 April 1933, lot 53, *Vue sur Amsterdam*, 53 × 63 cm, signed. The Felbrigg version (canvas, unsigned, 69.8 × 87.6 cm) has been considered a copy by Ranelagh Barret.

2 Druery 1826, p. 80.

3 *Ibid.*, p. 119.

4 Brereton Sale 1870, lot 142.

5 Norwich 1840 (21).

115 Jacob van Ruisdael

Haarlem 1628/29 – Amsterdam 1682

Landscape with a Cloudy Sky

Illustrated colour plate xviii
Oil on canvas 47.5 × 65.5 cm
Signed, bottom left: *JR* (monogram)

Prov: ?Duke de Paramont, Vienna (according to Fountaine 'Family Book', pp. 93–4); Andrew Fountaine by 1840 (see Exh. below); by descent to present owner.

Exh: London 1840 (123, as *Landscape, ruined bridge*), lent by Andrew Fountaine.

Lit: Smith 1842, Supplement, no. 88; Waagen 1854, III, p. 430, no. 2.

Andrew Fountaine

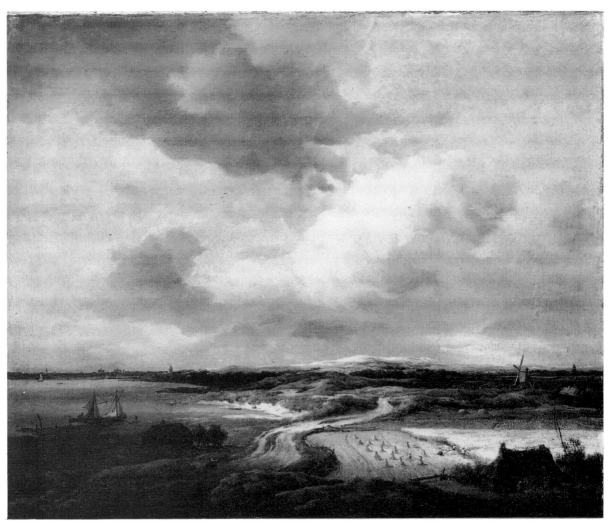

cat. no. 116

The taste for the work of Jacob van Ruisdael began in England in the 1740s and before 1750 Thomas Gainsborough had made a drawing in black and white chalks after Ruisdael's *Wooded Landscape with a Flooded Road* now in the Louvre collection.[1] Ruisdael's romantic feeling for landscape took its strongest hold upon the imagination of the British collector in the early nineteenth century. In 1812, the painter of historical narrative pictures, Benjamin Robert Haydon could not hide his contempt for 'idling and capricious connoisseurs with Raphael in their mouths and Ruysdael in their hearts'.[2] In the 1820s Constable often refers, in his correspondence, to the desirability of emulating Ruisdael. In his third lecture before the Royal Academy Constable observed: 'Ruisdael . . . delighted in, and has made delightful to our eyes, those solemn days, peculiar to his country and to ours, when without storm, large rolling clouds scarcely permit a ray of sunlight to break the shades of the forest. By these effects he enveloped the most ordinary scenes of grandeur . . .'[3] However, Constable could be frustrated by the expense of such works: in May 1824 he added a postscript to a letter to John Fisher: 'The Town is full of pictures, and foolish people to buy them. One Ruysdael 1700£.'[4]

1 Slive and Hoetink 1982, p. 13.

2 *Ibid.*

3 Leslie 1951, p. 318.

4 Beckett 1968, VI, p. 161.

116 Jacob van Ruisdael

Haarlem 1628/29 – Amsterdam 1682

View of the Lake of Haarlem

Illustrated above and back cover

Oil on canvas 57.5 × 69 cm

Prov: Duval Collection, Geneva (according to the Fountaine 'Family Book', pp. 92–3); Andrew Fountaine by 1840 (see Exh. below); by descent to present owner.

Exh: ?London 1840 (64, as *River Scene in Holland*).

Lit: Waagen 1854, III, p. 430, no. 3; de Groot 1912, IV, no. 138.

Andrew Fountaine

This is one of four oils by Jacob van Ruisdael purchased by Andrew Fountaine IV (1808–73). His earliest recorded purchase was a large seapiece purchased from the dealer John Smith in 1839.[1] Smith considered that canvas 'evince[d] the true poetical feeling of the artist, when delineating scenes affecting the soul'. All Andrew Fountaine's paintings by Ruisdael were of high quality, including a small oil entitled *View from the Dunes to the Sea*, which Andrew Fountaine described as 'treated with great breadth'.[2]

Andrew Fountaine wrote of this painting: 'The sky is silvery & lovely in the extreme, & the whole produces a

harmonious & most enchanting effect. I know of but one other Ruysdael that can approach it in these particular qualities, viz. the "Coup de Soleil" in the Louvre which unfortunately is not in the pure state that this is in. It came from the Duval collection at Geneva & was considered its choicest gem.'[3] See also cat. no. 115.

1 Smith 1842, Supplement, p. 695, no. 44.

2 Fountaine 'Family Book', p. 95; Fountaine Sale 1894, lot 33; now Zurich, Kunsthaus, Stiftung Prof. Dr L. Ruzicka (no. R31); Slive and Hoetink 1982, no. 26.

3 Fountaine 'Family Book', p. 93.

117 Jan van Huysum

Amsterdam 1682 – Amsterdam 1749

A Group of Fruits and Flowers

Illustrated colour plate v

Oil on panel 80 × 60.3 cm
Signed, bottom left: *Jan Van Huysum fecit*

Prov: ?Marie Antoinette; given by her to Madame de Lamballe (according to MS label on the back of the panel by H. Farrer[1]); Sir John Dean Thompson, sold 1838, 340 gns.; bt by Farrer; by whom sold to Andrew Fountaine by 1839 (see Exh. below); by descent to present owner.

Exh: London 1815 (138), lent by Sir John Dean Thompson; London 1839 (11), lent by Andrew Fountaine Esq.

Lit: Smith 1842, Supplement, no. 2.

Andrew Fountaine

This panel is a virtuoso example of Jan van Huysum's decorative style of flower and fruit painting, very much in accord with the taste of the first half of the eighteenth century and with subsequent collectors. It is a style influenced by French trends and the tradition that the picture once belonged to Marie Antoinette is quite possible (see Prov.). The fruits and flowers depicted include melon, plum, pomegranate, pears, peaches, grapes, red currants, hollyhock, bindweed, vine leaves and hazelnuts, with a nest, moths, butterflies, snails and flies in carefully composed profusion.

The fruit and flowers belong to different seasons and the picture is a prime example of van Huysum's painstaking method hinted at in a surviving letter by the artist to A.N. van Haften, agent of the Duke of Mecklenburg, dated 17 July 1742: '. . . the flower-piece is very far advanced; last year I couldn't get hold of a yellow rose, otherwise it would have been completed.'[2] We may infer that van Huysum preferred to work from nature, planning his composition in advance. The closest parallel with this painting in van Huysum's oeuvre is perhaps the canvas now in a private collection, New Zealand.[3]

Earlier Norfolk collections to include works by or attributed to Jan van Huysum included Houghton Hall (see p. 15) and Thomas Hunt of Harleston, whose 'piece of flowers, finely painted, 30 by 24' was included in his collection sale of 1781.[4]

1 The back of the panel bears a red wax seal, showing a double headed eagle with coronet above.

2 Auckland City Art Gallery, *Still-Life in the age of*

Rembrandt, 1982, p. 171, quoting from F. Schlie, 'Sieben Briefe und eine Quittung', *Oud Holland* 18 (1900), p. 141.

3 *Ibid.*, no. 34.

4 Hunt Sale 1781, lot 174, unsold.

118 Rogier van der Weyden

Tournai *c.* 1399 – Brussels 1464

Portrait of a Man *c.* 1460

Illustrated p. 69
Oil on panel 20 × 15.2 cm
Inscribed on the reverse of the panel: *R. Hen. VI.*

Prov: ? The Rev. James Bulwer of Aylsham by 1850; by descent to James Redfoord Bulwer; by descent to Walter John Redfoord Bulwer from whom purchased by Knoedler and Parrish Watson of New York, 1920; from whom purchased by Lord Bearsted of Upton House; by whom given to the National Trust.

Exh: For full exhibition history see *Upton House, the Bearsted Collection: Pictures*, National Trust, 1964, p. 56.

Lit: *Ibid.*, p. 56; Friedlander 1972, II, p. 69, no. 45.

The National Trust (Upton House, Bearsted Collection)

The panel is almost certainly the right wing of a diptych, for which the corresponding panel is likely to have been the *Madonna and Child*. The painted surface reaches to the edge of the unbevelled panel at the bottom (at the top and sides it stops just short of the edge) which suggests that it could be cut down at the bottom. The copy by Frederick Sandys (cat. no. 119) confirms that the panel has not been altered since the mid nineteenth century. The panel has been dated by Friedlander and others to late in van der Weyden's oeuvre. The long hair style of the sitter appears to have been fashionable in the 1460s.

The provenance of this panel before the mid nineteenth century remains unknown. Its appearance in the collection of the antiquarian artist, the Rev. James Bulwer is entirely consistent with the increasing fashion for early Netherlandish painting during the mid nineteenth century.

119 Frederick Sandys

Norwich 1829 – London 1904

Portrait of a Young Man, after Rogier van der Weyden ? before 1850

Illustrated p. 69
Oil on panel (unfinished) 20.9 × 16.5 cm
Inscribed in ink on back of panel (? in Sandys' hand) *F.A. Sandys* and on an old label *after Memling?*

Prov: Charles Fairfax Murray; given by him to the Fitzwilliam Museum, Cambridge 1917 (no. 886).

Exh: Brighton Museum and Art Gallery 1974, *Frederick Sandys* (10).

Lit: J.W. Goodison, Fitzwilliam Museum, *Catalogue of Paintings*, III, *British School*, 1977, no. 886.

The Syndics of the Fitzwilliam Museum, Cambridge

Frederick Sandys was educated at Norwich Grammar School and the Government School of Design at Norwich. He met James Redfoord Bulwer (1820–99), the son of the Rev. James Bulwer, in 1846. Although he won two silver Isis medals awarded by the Royal Society of Arts, for works drawn 'from life' (1846) and painted 'from nature' (1847), in accordance with the teaching of the Government School, he also copied from old masters.[1]

Numerous studies, sketches and tracings survive which attest to Frederick Sandys' continuing study of old masters.[2] A number of these are after landscape engravings by artists such as Pieter Molin, Thomas Wyck, Jacob van Ruisdael and J.B. Weenix while many have yet to be identified. There is evidence that Sandys worked at the British Museum in the 1850s and it is likely that he made studies after engravings there. In April 1862 Sandys travelled to the Low Countries, accompanied by James Anderson Rose, and surviving sketches from that trip include a sketch of Rubens' *Helena Fourment*, then in the van der Hoop Museum, Amsterdam.[3]

The Rev. James Bulwer (1793–1879) was curate of Blickling with Stody and is presumed to have lived at Aylsham Old Manor House from 1840. In 1849 he moved into the newly-built rectory at Hunworth.[4] A former pupil of John Sell Cotman, Bulwer employed Sandys to make architectural and antiquarian drawings on his behalf. Sandys must have copied Bulwer's small panel. *Portrait of a Man* by 1850, before he moved to London. The young artist left the hands and costume unfinished and selected a rich green background which did not exactly replicate the turquoise of the original. The flesh tones are modelled closely upon the original. Sandys shows a disciplined enthusiasm for the Flemish master's controlled, exquisite finish, a taste which foreshadows his later status as a Pre-Raphaelite painter of high definition and finish.

1 For example, *Drawing from a bearded man with a conical hat* (1849) presented by Fairfax Murray to the Fitzwilliam Museum, Cambridge, 1917 (PD 865, p. 39), is presumably copied from a seventeenth-century Dutch or Flemish work; Brighton 1974 (5). This resulted in an etching, inscribed *Fred Sands 1849* (Victoria & Albert Museum, 27404.1).

2 Birmingham City Museum and Art Gallery; I am indebted to Betty Elzea for her advice and information concerning this aspect of Sandys' career.

3 Brighton 1974 (296–298).

4 Sarah Knights, 'Revd. James Bulwer (1794–1879) Patron, Artist and Antiquary', 1982, unpublished dissertation for the School of Fine Art and Music, University of East Anglia.

Appendix I

The Early Norwich Artists; their techniques and the Dutch Example

A Dutch artist of the seventeenth century was normally thoroughly trained as apprentice to a mature artist. Some materials were available commercially, so not all preparatory work was done in the studio. For instance, the oak panels were prepared by members of the woodworkers' guild, under strict regulations. They were radially cut and carefully bevelled so as to minimise warping. Larger paintings were more often on canvas, of medium or fine weight: usually the larger the work the coarser the canvas. Canvas could be bought ready-prepared with a ground to paint on, or this could be done by the apprentices in the studio. Some very small paintings were done on sheets of copper, often re-using old etching plates.

The layers between the panel or canvas and the final paint layers are very influential on the final appearance of the picture and the Dutch artists of the seventeenth century exploited this in new ways. Earlier Dutch paintings had used a simple preparation of chalk in animal glue which was pure white and reflected light back through the paint, adding to the intensity of the colours. While continuing to use light-coloured grounds, the seventeenth-century artists varied them, and oil was now usually included. A number of paintings by Wijnants, Cuyp and other artists familiar to the Norwich School painters appear to have pinkish or tan coloured grounds, but it is not clear how these colours were arrived at. The whole ground layer could have been tinted, or a final coloured layer applied over a white ground. Some paintings, notably a group by van Goyen and Salomon van Ruysdael can give the impression of having no ground at all. A study by E.M. Gifford[1] has shown that some form of ground is always present, but it is often made semi-transparent by using oil as the medium and pigments such as chalk, which are transparent in oil, with or without the opaque white lead more usually found in oil grounds. A transparent material resembling glass was found in the grounds of some van Goyens.

Some artists are known to have sketched in their composition using black chalk or charcoal as can be seen in the painting by Peter de Neyn (cat. no. 66) but this does not seem to have been universal. More typical was the working out of the picture in a fair amount of detail using fluid paint of medium to dark brown, before starting to use local colour. Most of the Dutch artists did this, and parts of this 'monochrome' are often retained in the final painting, in the shadows or in the middle tones.

The Dutch painters had a limited range of pigments available to them. White lead, bone black, the relatively dull red and yellow earth colours were all freely available. Vermilion, the brightest red was expensive, but the main problem for the landscape painters was with the greens and blues. The best blues, ultramarine and azurite, were scarce and expensive so smalt, a ground blue glass, was often substituted. No satisfactory green was available, so greens were often mixed from smalt or azurite with yellow ochre or dye-based yellow pigments which were prone to fade.

An important aspect about which little is known is the medium or binder used in these paintings. Linseed and walnut oils would be expected at this date, but it is possible that hard resins were added. As it has only recently become possible to analyse paint media, few paintings have been studied in this way. It appears that the seventeenth-century painters varnished their work with a solution of mastic (a natural resin) in turpentine, but they are not thought to have added such mixtures to their paint.[2]

Had they wished to imitate the techniques of the seventeenth-century Dutch artists, the Norwich School painters had first of all the example of original paintings available to them in

East Anglia or seen on visits to London. They would have been able to examine some of these paintings closely and perhaps handle them. But it is surprisingly difficult to discover the means by which the final effect of a painting is produced. It has only become possible this century to identify pigments with certainty and to verify the layer structure of a painting by means of cross-sections, whilst the identification of aged binding media is an even more recent development yet to be perfected. Enough theories have been disproved by these methods to show that the appearance of a painting does not tell all about its construction.

By the time Crome started painting, the works of Hobbema and van Goyen were already 150 years old and would have changed considerably since they were made. Oil paint yellows with age and becomes more transparent. Some pigments tend to fade or darken, while others retain their colour. Cleaning of paintings in the sense of removing the varnish, was certainly possible, but it is likely that the distorting effect of discoloured varnish would not have been fully recognised. Crome worked as a restorer from time to time but we cannot assume this would have included removal of varnish as practised today.

Artists might also have looked for information from technical manuals, but we do not know just how much written material would have been available to them. The researches of Eastlake[3] and Merrifield[4] which collected and interpreted many early treatises on painting were not published until 1847 and 1849 respectively. The two treatises of Dutch seventeenth-century art[5,6] were not available in English although some of the information they contained turned up in English seventeenth-century treatises such as Norgate's *Miniatura*.[7] It seems that the Norwich artists knew some of these works; Crome's library, for example, contained a copy of Salmon's *Polygraphice*[8] among other technical works.[9] The information in such works is not exhaustive however and can be misleading, especially where translation is involved. This was not the principal means by which earlier artists learnt their craft: the subtleties of craftsmanship are remarkably difficult to put down on paper.

Interest in the methods of earlier schools was very strong among English artists of the late eighteenth and early nineteenth centuries, but their attempts to imitate them were not always successful. Reynolds' disastrous experiments are well known.[10] In 1797 a group of eminent Royal Academicians including Opie were persuaded to invest in a spurious 'Venetian Secret' painting technique based on an 'apparently authentic' sixteenth-century manual.[11] The only thing William Blake's personal 'fresco' technique had in common with the Italian original was that it did not involve oil.[12] Although Reynolds and Beechey as pupils of Thomas Hudson benefited from a continuous studio tradition going back to Jonathan Richardson and John Riley, by the early nineteenth century this system of training had virtually broken down. Many artists were largely self-taught in painting technique. The Royal Academy Schools concentrated on drawing, giving no formal instruction in painting methods and materials. The long struggle to raise the social status of painters in England away from that associated with manual work towards that of an intellectual or 'artist' in the modern sense of the word combined with the new concerns for self-expression and experiment to encourage a neglect of craftsmanship. George Field, the colourmaker, had already begun the systematic testing of pigments which was to lead to an improvement later in the century, but at the time of the early Norwich painters, sound information on the techniques of earlier artists and on the properties of materials currently available would have been hard to come by.

The use of commercially prepared materials of doubtful composition has also been blamed for the poor technical quality of English paintings of the early nineteenth century. Such materials became increasingly available during the period of the Norwich Society of Artists, though a provincial city like Norwich would have lagged behind London in terms of supply. All the suppliers whose marks have been found on Norwich School works were London-based; their products may have been available through Norwich firms of carvers and gilders. The first specialised Norwich artists' colourman appeared only after 1850. Robert Ladbrooke and Crome, in his earlier works, appear to have prepared their own materials at least to some extent, but there is certainly an increasing use of prepared supports by all the artists from about 1820.[13]

The Norwich School artists would surely have known Bardwell's treatise[14] but this thorough and systematic description of eighteenth-century portrait painting technique was not particularly helpful to landscape painters. A number of artists – Crome, Ninham, Sillett, – had a background in decorative and sign painting and here it seems safe to assume that a sound craft tradition would have persisted, if only because of the demands of producing weatherproof work for outdoor display. Taking all this into account it is not surprising that we find among the Norwich School artists no slavish imitation of seventeenth-century Dutch painting techniques; but their work does show a sincere attempt to understand and learn from them.

The early Norwich School painters were among the first English artists to revive the use of panels as painting supports. In the eighteenth century a few seascapes and decorative and naive paintings were done on panel, but all the 'fine' painters used canvas exclusively. About 1800, panels start to appear again in the work of Turner, Wilkie and Stothard, and very soon afterwards among the Norwich School painters. But their panels were very different from the standardised oak supports universally used by the Dutch seventeenth-century artists. Mahogany had been available in Europe for some time and they used this wood most frequently. In the early nineteenth century, colourmen started to supply prepared mahogany panels for artists' use and a principal attraction of these seems to have been the extremely smooth painting surface that could be produced. J.S. Cotman bought prepared mahogany panels from Cowen and Waring and Robert Davy, who was also patronised by Joseph Clover. But Cotman and the other early Norwich painters used many different solid supports, including pine (with no attempt to subdue the grain in the case of Ladbrooke), oak and millboard as well as mahogany. In some cases the panels had a previous use, as with Cotman's *Baggage Wagon*.[15] Earlier coats of paint were not always removed but could be retained as priming layers, as in Stark's *River Scene*[16] and Vincent's *Pastoral Scene*.[17] It is perhaps surprising to find that this is the case with Crome's *Yare at Thorpe* (cat. no. 90). Many Norwich School panels have a coat of paint on the back which helps to stabilise them. Dutch panels lack this, though many were coated with unpigmented oil at an early date. All the Norwich School panels examined have an opaque ground: none have yet been discovered with a minimal transparent ground like that used by van Goyen and his associates. But a ground answering this description is certainly present in a number of Crome's early works on canvas (e.g. *Road with Pollards*,[18] *High Tor Matlock*[19] and *Slate Quarries*[20]) and a small group attributed to Robert Ladbrooke now in the Castle Museum, Norwich. These canvases are notably coarse, unevenly stretched and unlike anything used by the Dutch seventeenth- or English eighteenth-century painters. It seems that Crome set out to retain the texture of the coarse, uneven canvas in these works, as J.S. Cotman and J.M.W. Turner were also doing in the years 1800–1820 and mutual influence seems likely.

Twill canvas, with its conspicuous diagonal grain, had been very popular with the artists of the late eighteenth century, but was rarely used by the Norwich School artists. The later artists mainly used the fine plain-woven canvas which became a standard product during the nineteenth century, and which by this time would have been produced by machine.[21] Stark seems always to have preferred a very smooth painting surface whether on canvas or panel, while Vincent's canvases tend to be slightly coarser and more robust with a slight retention of texture. Although commercially primed canvases have been identified in the works of Vincent and Stark it is in the works of the mid-nineteenth century that the marks of artists' colourmen are regularly found.[22]

Microscopic examination of many more paintings is needed before we can generalise about the grounds used by the Norwich School artists. Where commercially primed supports were used the priming is usually white or cream. Crome's grounds are variable, including cream, grey and the transparent grounds described above, while strongly coloured red-brown grounds have been observed in some paintings by Stark. What does seem sure is that the Norwich School artists frequently used a well-developed monochrome underpainting similar to those found in the Dutch paintings. The darkness of these underpaintings has a strong influence on the tone of the final painting. If very dark they tend to exacerbate the darkening of the picture through age. Among the Dutch painters the works of Berchem and Wouwermans show evidence of this. Examples of this early stage of painting can be seen in Cotman's unfinished *From my father's house at Thorpe*[23] and *Alder Carr*[24] and in thinly painted works like Crome's *Yare at Thorpe* (cat. no. 90). Cotman frequently used an orange priming probably unique to himself. The pigment is thought to be chrome orange, which became available about 1815.

More pigments were now available than in the seventeenth century and more continued to appear throughout the nineteenth century. Reliable artificial blues were becoming available: prussian blue was widely used from the early eighteenth century onwards. Cobalt blue, discovered in 1802, came into common use about 1815. Artificial ultramarine became available after 1830.[25] Greens were still a problem and mixed greens are to be expected in Norwich School paintings. A bright transparent green observed in the works of Stark and Crome has yet to be identified. Emerald green (available from *c.* 1814), Scheele's green (from 1775) and cobalt green are possible candidates. Chrome yellow came on the market about 1809. Interest in historical methods also led to a revival in the use of traditional colours such as natural ultramarine in the early nineteenth century.[26] As yet we know very little for certain about the

pigments used by the Norwich School artists.[27] They could hardly have failed to make use of the artificial blues and greens, but it is only in Cotman's oils of the 1820s and 1830s and those of his sons that full advantage is taken of strong bright pigments. The fact that most of the artists stuck to a relatively sober palette shows a choice as deliberate as that made by van Goyen and his associates in their days and from which questions of economy can be safely excluded. Identification of new pigments in Norwich School paintings would be helpful in questions of dating and attribution but so far no such study has been made.

Many English painters tried to imitate the rich transparent shadows in Dutch landscape paintings. This pursuit led a number into the lavish use of bituminous paint, known in those days by romantic names such as mummy, vandyke brown and asphaltum. The cracking and distortion resulting from the drying of these paints disfigures the work of Opie among many others. The Norwich School artists did not fall too heavily into this trap, though some paintings such as Stark's *Marlborough Forest*[28] do show areas of cracking probably caused by bitumen. But the works of the Norwich School as a whole exhibit a range of drying problems causing the disruption of the intended smooth surface of the paint: cracking, wrinkling, 'alligatoring' and other distortions. The possible reasons for this abnormal drying behaviour are many and complex.[29] Varying proportions of medium in the different paint layers are often a factor. Addition of mixtures containing soft resins in volatile solvents (known as 'megilp') to the oil paint are another, and this seems a likely candidate in the case of the Norwich School artists.

Not every work of an artist is affected in a similar way or to the same extent. Crome's *Carrow Abbey*[30] for example, in which the uneven drying of the paint combined with later damage by inconsiderate cleaning, has caused a serious loss of clarity in the details, can be compared with his *New Mills, men wading*[31] which, in spite of a distinctive pattern of cracks, is strikingly well-preserved. The trees in many Stark paintings (e.g. *Forest Oak*)[32] share a characteristic disruption whereas others (e.g. *Lane Scene*)[33] do not. Many of Cotman's oils have their own distinctive drying behaviour. Among the later artists the works of David Hodgson, John Berney Crome and William Henry Crome are badly affected. Such problems are lacking in the works of the Dutch seventeenth-century painters, even Hobbema, whose dark greens are often thickly painted. The cracks can be very disfiguring and, when associated with the use of soft resin as a medium, make paintings very vulnerable to damage by inappropriate cleaning and restoration. This in turn may lead to confusion as to the artist's true intentions and abilities.

Gifford's study suggests that the transparent dark browns achieved by the Dutch masters and so admired in nineteenth-century England, contained bone black (a transparent pigment), possibly an organic earth pigment,[34] and a glassy material, either ground glass or pale smalt. The purpose of this material could have been to add transparency or to aid the drying of the paint. Although they could not have observed it directly in the Dutch landscapes, there is evidence that this material was known to the nineteenth-century artists. It was a feature of the 'Venetian secret' of 1797 and was presumably a constituent of Miller's 'Flemish Glass Medium' advertised in 1841. Substantial quantities of transparent glassy particles have been observed in several of Crome's paintings. It would be difficult to establish whether he used such a material consciously or as an ingredient of a purchased paint or medium.

The seventeenth-century Dutch painters varied considerably in their techniques and further study is needed before we can say how far individual Norwich School painters tried to imitate the techniques of specific Dutch artists. We can only draw some general conclusions. The revival of the use of wooden panels as painting supports may well have owed something to Dutch influence, but this was shared with other English artists of the period. The choice of wood species and the manner of preparation was usually quite different from that of the Dutch artists. Where canvas was chosen it was often finer but occasionally much coarser than theirs. The quality of the texture of the support was not exploited in the same way, although Crome and Ladbrooke did exploit it in their own individual fashion.

Many Norwich School paintings seem to show an attempt to imitate the sequence of construction of paintlayers which the artists saw or thought they saw in certain Dutch paintings. The use of coloured grounds and elaborate monochrome underpaintings are evidence of this. Often they seem to have aimed at similar colour effects, although not all the pigments would have been the same. The use of bituminous paint and of additives like megilp may well have resulted from attempts to imitate the translucent dark greens and browns they saw in the work of many Dutch landscape painters.

The Norwich School artists left no written information about their oil painting methods. A similar interval now separates us from them as divided them from the Dutch painters whom they admired and whose work was often better constructed to survive the test of time. Much

remains to be explained about painting techniques in the nineteenth century which will begin to emerge as more works are subjected to modern analytical methods. It is hoped that the opportunity presented by the exhibition *Dutch and Flemish Painting in Norfolk* will help to suggest directions for further research.

Cathy Proudlove

1 E.M. Gifford, 'A technical investigation of some Dutch 17th century tonal landscapes', American Institute for Conservation, *Conference Preprints*, Baltimore, 1983, pp. 39–49.

2 For a fuller account of the methods and materials used by the Dutch painters, see D. Bomford, 'Techniques of the Early Dutch Landscape Painters' in Brown 1986.

3 C.L. Eastlake, *Materials for a history of oil painting*, London, 1847 (Reprint, New York 1960).

4 M. Merrifield, *Original treatises on the arts of painting*, 1849 (Reprint, New York 1967).

5 S. Van Hoogstraten, *Inleyding tot de Hooge Schoole der Schilderkonst*, Rotterdam, 1678.

6 C. Van Mander, *Het Schilderboek*, Haarlem, 1604.

7 E. Norgate, *Miniatura, or the art of limning*, M. Hardie ed., Oxford, 1919.

8 W. Salmon, *Polygraphice or the art of drawing, engraving, etching, limning, washing, varnishing, colouring and dyeing*, London, 1672.

9 Crome Sale 1821, 5th day.

10 M.K. Talley, Jr. 'All good pictures crack' in N. Penny, *Reynolds*, London, Royal Academy, 1986.

11 J. Gage, 'Magilphs and Mysteries', *Apollo*, July 1964, pp. 38–41.

12 R. Lister, *Infernal Methods: a study of William Blake's Art techniques*, London, 1975, pp. 35–37.

13 Information on Norwich School paintings comes from examination of paintings in the collections of the Castle Museum, Norwich.

14 T. Bardwell, *The practice of painting and perspective made easy*, 1756.

15 Norwich Castle Museum (5.4.99).

16 Norwich Castle Museum (241.977).

17 Norwich Castle Museum (1361.235.951).

18 Norwich Castle Museum (722.235.951).

19 Fitzwilliam Museum, Cambridge.

20 Tate Gallery, London.

21 C. Villers, 'Artists' Canvases: a history', ICOM Committee for Conservation, Conference Papers, Ottawa, 1981, (81/2, pp. 7–8).

22 Ninham frequently used prepared mahogany panels from Winsor & Newton, whilst the Stannards used Reeves and Rowney. Henry Bright used canvases from Winsor & Newton and also from Dimes & Elam and Sherborn & Tillyer. Many canvases have already been lined, obscuring the colourmen's marks, but more information may come to light as not all the Norwich School paintings at Norwich Castle Museum have yet been examined.

23 Norwich Castle Museum (1.75.94).

24 Norwich Castle Museum (113.235.951).

25 R.D. Harley, *Artists' pigments, ca. 1600–1835*, 2nd edition, London, 1982.

26 Harley 1982, p. 45. Thirtle's treatise on watercolour gives a list of colours which may not be comprehensive, but is very conservative. No recently-introduced colours are mentioned. He refers to natural ultramarine more than once, indigo being the only other blue pigment mentioned. (Published in M. Allthorpe-Guyton, *John Thirtle 1777–1839*, Norfolk Museums Service, 1977, pp. 29–34.)

27 Crome owned a copy of *A treatise on the art of painting and the composition of colours* (London 1797), the work of Constant de Massoul, a French colourmaker. See Harley 1982, pp. 24–25.

28 Norwich Castle Museum (1308.235.951).

29 S. Keck, 'Mechanical Alteration of the paint film', *Studies in Conservation*, Vol. 14, No. 1, Feb. 1969, pp. 9–29.

30 Norwich Castle Museum (705.235.951).

31 Norwich Castle Museum (531.970).

32 Norwich Castle Museum (9.4.99).

33 Norwich Castle Museum (1306.235.951).

34 Gifford, 1983, p. 44. The organic colouring matter in these naturally occurring earths is chemically similar to that found in the bituminous paints which caused such problems in the nineteenth century. Small differences in composition may account for the difference in drying behaviour, but it seems likely that the manner of application as regards thickness, drying time before overpainting, and addition of media and driers may have helped cause the problems.

Appendix II
Collectors and Sales

The following compilation is selective, relating only to collectors mentioned in this book. The sales are those which included Dutch and Flemish pictures and which have been considered in the preparation of *Dutch and Flemish Painting in Norfolk*. The biographical information has been kept brief, and is taken mainly from sale catalogues, local directories and standard works of reference. Abbreviations relate to sales mentioned more than once in the text.

Collectors	Sales	Abbreviations
Sir Edward Astley, 4th baronet, 1729–1802 Melton Constable Hall. Politician, landowner, and antiquarian. MP for Norfolk 1771–1802. Succeeded baronetcy 1760.		
Sir Jacob Astley, 1797–1859	*see* Hastings *et al.* Sale	
Sir Thomas Beauchamp-Proctor, 1756–1827	*see* Proctor-Beauchamp Sale	
Henry Bell BA, 1647–1711 High Street, King's Lynn, and North Runcton Hall 1700. Architect, merchant, and author. Mayor of King's Lynn 1692 and 1703.		
Henry Bennet KG, 1st Earl of Arlington, 1618–1685 Goring House, London, and Euston Hall, Suffolk (completed 1670). Statesman and landowner. Secretary of State for Foreign Affairs 1662–74, Lord Chamberlain 1674–85. Married Isabella von Beverwaert, daughter of Prince Louis of Nassau, 1667. Created Earl of Arlington, and Knight of the Garter 1672.		
Thomas Bignold 1762–1835 Bridge Street, Blackfriars, Norwich. Brandy, wine and hop merchant 1802; banker 1811, and shoe dealer 1823.		
Daniel Boulter 1740–1802 19 Market Place, Great Yarmouth. Ironmonger, stationer, bookseller and ·museum curator.		

Rev. Charles David Brereton AM, 1790–1868
Little Massingham Rectory. Rector of Little Massingham, and author.

Rev. C.D. Brereton Decd, Spelman's Norwich, 21 June 1870.

Brereton Sale 1870.

Thomas Brightwell FLS, 1787–1868
Letheringsett; Thorpe; and Surrey Street, Norwich. Solicitor, scientific author, and Nonconformist. Mayor of Norwich 1837. Father of Cecilia Lucy Brightwell.

Thomas Brightwell, Esq., FLS, Spelman's, Norwich, 12 March 1869.

Brightwell Sale 1869.

Rev. James Bulwer MA, 1794–1879
Manor House, Aylsham 1840; Hunworth 1848. Clergyman, artist, and antiquarian. Curate of Blickling 1841, Rector of Hunworth 1848.

Rev. Ellis Randall Burroughes, d. 1831
Stratton House, Long Stratton, Clergyman.

Thomas Proctor Burroughs FSA, *c.* 1837–*c.* 1887
2 Swan Row, Great Yarmouth; and Hampden Lodge, Filby 1879. Wine merchant, and solicitor.

Cornelius Harley Christmas *c.* 1805–*c.* 1883
Great Yarmouth: Market gate 1836; King Street 1845; and 57 Southmarket Road 1879. Accountant 1826, and wine merchant (Frere, Williams and Bell).

Cornelius Harley Christmas Esq., Deceased, Spelman's, Norwich, 16, 17, 18, 19, 20 July 1883

Christmas Sale 1883.

Thomas Churchyard 1798–1865[1]
Woodbridge, Suffolk. Painter.

Thomas Coke, 1st Earl of Leicester (of the 1st creation) 1697–1759. Holkham Hall. Landowner.

Robert Cory, junior, FSA, 1776–1840
Middlegate Street, Great Yarmouth; and Burgh Castle. Registrar, Yarmouth Admiralty Court, and author. Captain in the Local Militia 1803–15. Mayor of Great Yarmouth 1815.

John Sell Cotman 1782–1842
Wymer Street, Norwich 1809; Southtown, Great Yarmouth 1810–25; St. Martin's at Palace, Norwich 1825–34; 42 Hunter Street, Brunswick Square, London 1834–42. Painter and etcher. President of the Norwich Society of Artists 1811 and 1833. Drawing-master to King's College School, London 1834. Hon. member of Institute of British Architects 1836.

John Crome 1768–1821
Gildengate Street, St George's, Colegate, Norwich 1801–21. Painter and etcher. President of the Norwich Society of Artists 1808.

Mr Crome, Noverre, Yarmouth, 23, 24, 25 September 1812. Crome Sale 1812

Mr J. Crome, Dec., J. Athow, Norwich, 25 September 1821. Crome Sale 1821

John Curr *fl.* 1840
Norwich. Painter.

Rev. Edward Thomas Daniell BA, 1804–1842
Banham, Norfolk 1832–5; 13 Green Street, Grosvenor Square, London 1836–40; Near East 1840–2. Painter, etcher and clergyman.

Cufaude Davie JP, 1798–1851
9 Row 52, Great Yarmouth. Chemist and churchwarden.

William Delf d. ?1846
St Mary's Hill, Beccles, Suffolk. (?) Linen and woollen draper.

William Delf Esquire, B. Rix at St Mary's Hill, Beccles, 30 September; 1 October 1846. Delf Sale 1846.

Sir Andrew Fountaine KB, 1676–1753
Narford Hall. Landowner and antiquarian. Vice-Chamberlain to Princess (later Queen) Caroline 1725. Created Knight of the Bath 1725. Warden of the Mint 1727–53.

Andrew Fountaine DL, JP, 1808–1873
Narford Hall. Landowner. High Sheriff of Norfolk 1857.

A. Fountaine, J. Trundle at Narford Hall, 10, 11, 12, 13 October 1838. Fountaine Sale 1838.

Andrew Fountaine, Christie's, London, 7 July 1894. Fountaine Sale 1894.

William Freeman 1784–1877
St Giles Road, Norwich. Framer, gilder, printseller and colourman. President of the Norwich Society of Artists 1820.

Rev. William Gordon *c.* 1754–1830
Saxlingham Nethergate. Clergyman and amateur painter. Rector of Saxlingham Nethergate. Member 1806–11, exhibitor 1816–17 of the Norwich Society of Artists.

George Grout ?d. *c.* 1891
Magdalen Street, Norwich 1843. Silk and crape manufacturer. His daughter married T.O. Springfield's (q.v.) son, Osborne.

Rev. John Gunn MA, FGS, 1801–1890[2]
Irstead Rectory; and 82 Prince of Wales Road, Norwich. Clergyman, amateur geologist, and author. Rector of Irstead.

Eliza Gunn, Christie's, London, 26 April 1912

Captain Matthew Gunthorpe d. *c.* 1853 Church Plain, Great Yarmouth; Crown Road, Great Yarmouth; Ovington Square, London 1850. Naval Officer.	Matthew Gunthorpe Esq., Christie's, London, 23 April 1842.	Gunthorpe Sale 1842.
	Captain Gunthorpe, Deceased, Christie's, London, 5 March 1853.	Gunthorpe Sale 1853.
Charles Harvey (Savill-Onley) 1756– 1843 Surrey Street, Norwich; 21 Norfolk Street, Strand, London; Stisted Hall, Essex 1822. Politician and lawyer. MP for Norwich 1812–18, and later for Carlow, Ireland. Recorder for Norwich 1801–43. Took name Savill-Onley 1822.		
Lieut-Col John Harvey JP, 1755–1842 Thorpe Lodge 1787. Merchant and banker. Lieutenant-Colonel East Norfolk Yeomanry Cavalry 1823. Sheriff 1784 and Mayor 1792 of Norwich. High Sheriff of Norfolk 1825. 'Father of the City' at his death.	Lieut-Colonel Harvey, Gadsden at Thorpe Lodge, 29, 30, 31 August; 1, 2, 5, 6 September 1842.	Harvey Sale 1842.
Thomas Harvey 1748–1819 3 Snail Gate, Norwich 1783; Catton House, Norwich 1788; The Close, Norwich 1818. Master weaver and merchant.	Thos. Harvey Esq., Deceased, Christie's, London, 12, 13 January 1821.	Harvey Sale 1821.
Sir Jacob Astley BA, DCL, FSA, 6th baronet, 16th baron Hastings, 1797–1859 Melton Constable Hall. Politician and landowner. Awarded barony of Hastings by Act of Parliament 1841. High Sheriff of Norfolk 1821-2. MP (Liberal) for West Norfolk 1832–7.	Christie's, London, 3 May 1929.	Hastings *et al.* Sale 1929.
	Christie's, London, 10 July 1931.	Hastings *et al.* Sale July 1931.
	Christie's, London, 27 July 1945.	Hastings *et al.* Sale 1945.
	Christie's, London, 1 February 1950.	Hastings *et al.* Sale 1950.
	Christie's, London, 11 April 1975.	Hastings *et al.* Sale April 1975.
	Christie's, London, 31 October 1975	Hastings *et al.* Sale October 1975.
	Christie's, London, 12 March 1976.	Hastings *et al.* Sale 1976.
	Sotheby's, London, 6 April 1977.	Hastings *et al.* Sale 1977.
Rev. John Homfray MA, FAS, 1768– 1842 Row 62, Great Yarmouth, to 1839; and Sutton Rectory 1839–42. Minister, St George's Chapel, Great Yarmouth 1821–39; and Rector, Sutton 1839–42; antiquarian and genealogist. Married James Symonds' (q.v.) only daughter.		

Samuel Valentine Hunt 1803–1892[3]
Norwich; moved to USA 1834. Painter
and engraver. Pupil of James Stark.
Exhibited with the Norwich Society of
Artists 1817–30.

Thomas Hunt d. *c.* 1781
Harleston. Bookseller.

Reuben Webster King *fl.* 1840–5
Yarmouth 1840; Palace Street,
Norwich 1845. Portrait painter.

Robert Ladbrooke 1770–1842
Scoles Green, Norwich. Painter.
President of the Norwich Society of
Artists 1809.

William Leathes 1674–1727
County Antrim, Ireland. Diplomat.
H.M. Secretary 1715–17, Resident
1717–24 at Brussels.

Christie's, London, 7, 8 October 1971.

Leathes *et al.* Sale 1971.

**Vice Admiral William Lukin
(Windham)** 1768–1833
Felbrigg Hall (inherited 1824). Naval
Officer and landowner. Changed
name on inheriting estate, 1824.

Lieut-Col William Mason d. 1864
Necton Hall. Landowner and soldier.
Lieutenant-Colonel, East Norfolk
Regiment 1824–59.

Joseph Salusbury Muskett 1784–1860

See Unthank *et al.* Sale

Charles Norris 1800–1874
Bracon Ash. Solicitor. Also son,

Rev. Charles Norris BA, 1830–1894
Briston 1855; The Close, Norwich
1893. Clergyman. Vicar of Briston and
Melton Constable 1855–93.

Hon. Roger North 1653–1734
Rougham Hall 1690. Lawyer,
politician, historian, amateur
musician, and landowner. Attorney-
General to Queen Mary of Modena
1686. MP for Dunwich 1685.

Samuel Paget *c.* 1770–*c.* 1848
59 Row 139, South Quay, Great
Yarmouth. Victualler 1790;
bookkeeper 1795; ship owner and
brewer *c.* 1800. Lieutenant-Colonel of
Yarmouth Volunteers 1803. Mayor of
Great Yarmouth 1817.

Samuel Paget, Pettingill at South Quay, Great Yarmouth, 24, 25, 26 October 1848

Paget Sale 1848

John Danby Palmer 1769–1841
4 Row 83, South Quay, Great
Yarmouth 1809. Merchant. Mayor of
Great Yarmouth 1821 and 1833.

Charles John Danby Palmer Esq., FSA, Spelman's Norwich, 27, 28 February; 1 March 1867.

Palmer Sale 1867.

Sir Robert Paston FRS, PC, 1st Earl of Yarmouth, 1631–1683 Oxnead Hall. Politician and landowner. MP for Castle Rising 1661–73. Deputy-Lieutenant for Norfolk 1661–75, and Lord-Lieutenant 1675–83. High Steward of Great Yarmouth 1674–83. Vice-Admiral of Norfolk 1675. Colonel of 3rd Norfolk Militia 1679. Knighted 1660; created Viscount Yarmouth 1673 and Earl of Yarmouth 1679.

John Patteson 1755–1833 Surrey Street, Norwich, to 1819; Mangreen Hall 1819–31; St Helens, Norwich. Textile merchant and manufacturer; politician. Sheriff 1785 and Mayor 1788 of Norwich. MP for Minehead 1802–6 and Norwich 1806–12. Lieutenant-Colonel of Norwich Volunteers 1803.	John Patteson, Esq., Christie's at Surrey Street, Norwich, 28, 29 May 1819.	Patteson Sale 1819.
Thomas Penrice 1757–1816 Row 98, South Quay, Great Yarmouth. Apothecary, surgeon and legatee.	John Penrice, Esq., Christie's, London, 6 July 1844.	Penrice sale 1844.
	John Penrice, Esq., Deceased, B. Rix at Great Yarmouth, 3–7, 10–12 March 1845.	Penrice Sale 1845.
Sir Roger Pratt 1620–1684 Ryston Hall. Architect and landowner. Knighted 1668.		
Sir Thomas Beauchamp-Proctor 1756–1827 Langley Park. Landowner. High Sheriff of Norfolk 1780–1.	Christie's, London, 31 May 1946.	Proctor-Beauchamp *et al.* Sale 1946
	Sotheby's, London, 11 June 1947.	Proctor-Beauchamp *et al.* Sale June 1947.
	Christie's, London, 29 November 1947.	Proctor-Beauchamp *et al.* Sale November 1947.
	Sotheby's, London, 11 June 1969.	Proctor-Beauchamp *et al.* Sale 11 June 1969.
	Sotheby's, London, 25 June 1969.	Proctor-Beauchamp *et al.* Sale 25 June 1969.
	Christie's, London, 29 November 1974.	Proctor-Beauchamp *et al.* Sale November 1974.
	Christie's, London, 13 December 1974.	Proctor-Beauchamp *et al.* Sale December 1974.
	Christie's, London, 11 July 1975.	Proctor-Beauchamp *et al.* Sale 1975.
	Christie's, London, 30 May 1980.	Proctor-Beauchamp *et al.* Sale May 1980.
	Christie's, London, 11 July 1980.	Proctor-Beauchamp *et al.* Sale July 1980.

George Rossi d. *c.* 1865
Unthank's Road, Eaton, Norwich
1852. Silversmith, jeweller and picture
dealer.

Robert Bagge Scott d. *c.* 1865
St. Andrew's Broad Street, Norwich.
Upholsterer; and looking glass maker
1845.

William Smith MP, 1756–1835
Aldermenbury; Clapham Common;
and Park Street, Westminster,
London. Politician. MP for Sudbury
1784–90, Camelford 1791–96, Sudbury
1796–1802, and Norwich 1802–6, 1807–
30.

Edmund Sparshall 1758–*c.* 1848
23 Magdalen Street, Norwich; and
Pottergate Street, Norwich 1841. Wine
merchant, and Quaker.

Rev. John Hauson Sperling MA,
1825–1894
Catton House, Norwich 1871.
Clergyman, and author.

J.H. Sperling, Spelman's
Norwich, 28, 29, 30 September; 1
October 1886.

Sperling Sale 1886.

Thomas Osborn Springfield JP, 1782–
1858
St Mary's, Catton, Norwich.
Watchmaker 1834; and raw silk
broker. Sheriff of Norwich 1827.
Mayor of Norwich 1829 and 1836.

The late T.O. Springfield, Esq.,
Spelman's at St Mary's,
Norwich, 27, 28 October 1864.

Springfield Sale
1864.

George Stacy d. *c.* 1856
Back Street, Norwich 1836; New
Lakenham 1843; Brazen Doors Road,
Norwich 1854. Gentleman.

William Stevenson FSA, 1741–1821
Surrey Street, Norwich. Publisher,
author, and miniature painter. Editor
of *Norfolk Chronicle* 1786–1821. Sheriff
of Norwich 1799.

William Stevenson, Esq., FSA,
Dec., Christie's at Surrey Street,
Norwich, 16, 17, 18, 19, 20
October 1821.

Stevenson Sale
1821.

Christopher Steward 1814–after 1864
163 King Street, Great Yarmouth.
Pawnbroker.

Mr. Christopher Steward,
Spelman's at 163 King Street,
Great Yarmouth, 15, 16 August
1864.

Steward Sale 1864.

Francis Stone 1775–1834
King Street, Norwich; and The
Shrubbery, St Stephen's Gate,
Norwich. Architect. County Surveyor
for Norfolk 1806–34. Founder member
of Norwich Society of Artists 1805,
and President 1812 and 1822.

James Symonds MA, JP, 1756–1821.
Ormesby Old Hall. Gentleman.
Father-in-law of Rev. John Homfray
(q.v.).

Rev. Thomas Talbot MD, DL, 1778–
1832[4]
Sprowston Hall. Clergyman. Rector of
Tivetshall.

Meadows Taylor 1755–1838
Manor House, Mount Street, Diss; and
Starston. Solicitor.

| **Rev. Samuel Titlow** MA, 1793–1871
16 The Crescent, Norwich. Vicar of St.
John Timberhill 1831–71; and Rector
of St Peter Hungate 1839–71; author. | Rev. Samuel Titlow, deceased,
Spelman's, Norwich, 13, 14, 15,
16 June 1871. | Titlow Sale 1871. |

?Samuel Tolver 1780–1865[5]
Row 76, South Quay, Great Yarmouth.
Merchant. Town Clerk of Great
Yarmouth 1822–48.

Lord Charles Vere Ferrers Townshend 1785–1853 Raynham Hall, and (?) Richmond, London. Landowner. Inherited the entire Raynham estate on the death of his father, George, 2nd Marquis (d. 1811).	A Nobleman [Lord Charles Townshend], Robins, London, 4 June 1819	Townshend Sale 1819.
	London, 1824	Townshend *et al.* Sale 1824.
	Right Hon. Lord Charles Townshend, Christie's, London, 11 April 1835.	Townshend Sale 1835.
	Right Hon. Lord Charles Townshend, Christie's, London, 6 May 1836.	Townshend *et al.* Sale 1836.
	Christie's, London, 30 June 1849.	Townshend *et al.* Sale 1849.
	Christie's, London, 24 May 1851.	Townshend *et al.* Sale 1851.
	Right Hon. Lord Charles Vere Townshend, Deceased, Christie's, London, 13 May 1854.	Townshend Sale 1854.
	Christie's, London, 16 June 1860.	Townshend *et al.* Sale 1860.
	The Townshend Heirlooms, Christie's, London, 5, 7 March 1904.	Townshend Sale 1904.
	Christie's, London, 4 July 1947.	Townshend *et al.* Sale 1947.

Rev. William Trivett MA, 1776–1863
Rectory, Bradwell, Great Yarmouth.
Rector of Bradwell 1810–63.

Charles Joseph John Turner d. *c.* 1873 Norwich: Chapelfield Road 1843; Pottergate Street 1845; 10 Crescent 1852; Lower King Street 1859; Julian Street 1872. Wine merchant.		
Dawson Turner FLS, FRS, FSA, FRSL, etc., 1775–1858 Row 53, South Quay, Great Yarmouth, and Brompton. Banker, botanist, antiquarian, and author.	Dawson Turner, Esq., FRS, Christie's, London, 13 May 1852.	Turner Sale 1852.
Thomas Turner d. *c.* 1897 42 Mill Hill Road, Norwich. Gentleman.	Thomas Turner, Esq., Maddison's, Norwich, 5 April 1897.	Turner Sale 1897.
Joseph Salusbury Muskett 1784–1860 Intwood Hall. Landowner. His aunt married William Yetts (q.v.). Collection passed by descent to Clement Unthank (1847–1936).	Robinson's, 27, 28 May 1897.	Unthank *et al.* Sale 1897.
(?) John Utting d. *c.* 1886[6] Gildengate Street, Norwich 1852; St George's Bridge, Norwich 1872. Boot and shoemaker.		
Horatio, Lord Walpole, 3rd Earl of Orford (of the 2nd creation) 1783–1856 Wolterton Hall. Landowner. Succeeded his father, Horatio, 2nd Earl, 1822.	'From a Noble Mansion in the Country', Christie's, London, 26, 27, 28 June 1856.	Walpole Sale 1856.
	Rt. Hon. Horatio Earl of Orford (Deceased), Butcher's at Wolterton Hall, 7, 8, 9, 10, 11 March 1859.	Walpole Sale 1859.
Sir Robert Walpole KG, 1st Earl of Orford, 1676–1745 Houghton Hall. Statesman and landowner. MP for Castle Rising 1700– 2; King's Lynn 1702–42. First Lord of the Treasury and Chancellor of the Exchequer 1715–17; 1721–42. Effectively 'Prime Minister' 1721–42. Created Knight of the Garter 1726, 1st Earl of Orford 1742.		
Charles John West d. *c.* 1843 St Faith's Lane, Norwich. Attorney and Proctor.	Christie's, London, 21 March 1835.	West *et al.* Sale 1835.
	Mr. Chas. John West, Spelman's at St Faith's, Lane, Norwich, 12, 13 September 1843.	West Sale 1843.
Charles Weston d. *c.* 1864 Thorpe House, Thorpe. Brewer (Miles and Weston).	Charles Weston, Esq., deceased, Spelman's at Thorpe, 14, 15, 16 September 1864.	Weston Sale 1864.
William Wilde d. *c.* 1865 Palace Plain, Norwich; Bramerton 1864. Auctioneer, City Coroner 1845.		
William Windham II 1717–1761 Felbrigg Hall. Landowner.		

William Yetts JP, 1796–1863
118/9 Row 127 (Thompson's, later
Foundry, Row), Chapel Street, South
Quay, Great Yarmouth. Merchant,
ship owner, amateur artist, and
inventor; established an iron foundry.
Councillor and murager of Great
Yarmouth 1819. Married Joseph
Muskett's only daughter.

Notes to Appendix II

1 T. Churchyard Esq. lent on oil entitled *Fish*, attributed to 'A. Adriansen', to the Old Masters exhibition held in Norwich in 1829 (56).

2 John Gunn's collection included only two Flemish works, attributed to Lucas van Uden and the School of van Dyck. Gunn is of interest in the context of this study for his owning an oil copy of Rubens' *Peace Embracing Plenty* (fig. 29) by John Joseph Cotman: Gunn *et al.* 26 April 1912, lot 21, 'P.P. Rubens (after), *Righteousness and Peace*, by J.J. Cotman, 23½ in. by 17½ in.'

3 Samuel Valentine Hunt lent a *Landscape – Morning*, attributed to Moucheron, to the Old Masters exhibition held in Norwich in 1829 (64).

4 This was presumably the Rev. T. Talbot who lent 'Flight into Egypt – a finished sketch from his great picture, well known by the Engraving in the Imperial Collection at Vienna, Vandyke' to the Old Masters exhibition held in Norwich in 1829 (54).

5 This was possibly the S. Tolver Esq. who lent *The Cobler*, attributed to 'A. Brauwer', to the Old Masters exhibition held in Norwich in 1828 (69). The picture was marked as for sale.

6 Mr. J. Utting lent three Netherlandish works to the Old Masters exhibition held in Norwich in 1828: (8) *Historical Subject*, 'Vanderwerf'; (43) *Landscape*, 'Breughel'; (78) *Landscape and Figures*, 'Eglin Vanderneer'.

Appendix III
Dutch and Flemish Paintings and Drawings in Norwich Castle Museum: A concise catalogue

Ludolf Bakhuizen
Emden 1631 – 1708 Amsterdam
The Coming Squall
oil on canvas 54.7 × 58.6 cm
Presented by J.H.F. Walter 1894 (7.94)

Abraham Begeijn
Leiden *c.* 1637–1697 Berlin
Plant Study with Goat
oil on canvas 35.5 × 31.1 cm
Signed lower right *A Bega*
Presented by the Friends of
the Norwich Museums 1957 (390.957)

Nicholaes Berchem, follower of
1620–1683
*Cowherd with Cattle on a path
beneath a cliff*
oil on panel 29.4 × 26.9 cm
On loan from Miss P.C. and
Miss C.E. Patteson 1984 (1.L1984.1)

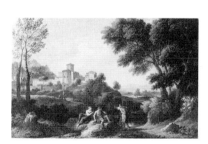

Jan Frans van Bloemen, called
Orizonte
Antwerp 1662 – 1749 Rome
Southern Landscape with Figures
oil on canvas 48.3 × 76.3 cm
On loan from Miss P.C. and
Miss C.E. Patteson 1984 (12.L1984.1)

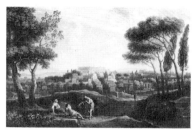

Jan Frans van Bloemen, called
Orizonte
Antwerp 1662 – 1749 Rome
Southern Landscape with Figures
oil on canvas 48.3 × 76.3 cm
On loan from Miss P.C. and
Miss C.E. Patteson 1984 (13.L1984.1)

Jan Both, attributed to
Utrecht *c.* 1615–1652 Utrecht
*A Southern Landscape with
Muleteers on a Roadway*
oil on canvas 52.2 × 65.6 cm
On loan from Miss P.C. and
Miss C.E. Patteson 1984 (2.L1984.1)
See cat. no. 68, illustrated p.42

Pieter Bruegel II
Brussels 1564 – 1638 Antwerp
The Rent Collectors 1618
oil on panel 54 × 84.9 cm
Signed and dated lower centre left
P. BREVGHEL.1618.
Bequeathed by Mrs. W.N. Arnold
1975 (272.975)

**Cornelis Jonson van Ceulen I
(Cornelius Johnson)**
London 1593 – 1661/2 Utrecht
or Amsterdam

*Portrait of Sir Henry Spelman
(c. 1564–1641)*

oil on canvas 76 × 63 cm
Purchased 1976 (28.369.976)

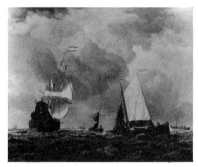

Pieter Coopse
fl. 1672–77

*A Dutch Man of War and Vessels in
a Breeze*

oil on canvas 50.2 × 65.1 cm
Signed lower right on driftwood
P.I. Coopse
Presented by the National
Art-Collections Fund 1973
(1.161.973)

Aelbert Cuyp, attributed to
Dordrecht 1620 – 1691 Dordrecht

Cattle in a field, a village beyond a wood

oil on panel 23.2 × 28.9 cm
On loan from Miss P.C. and
Miss C.E. Patteson 1984 (5.L1984.1)

Andries Daniels, attributed to
active 1599–1602 in Antwerp

*Floral Study with Insects in the
Foreground*

oil on copper 25.9 × 20.7 cm
Accepted by the Government in
lieu of Capital Transfer Tax 1987
(309.987)

Cornelis Gerritsz Decker
Haarlem before 1625–1678 Haarlem

*A Sluice – Wooded Landscape with
figures on a Path*

oil on panel 40.1 × 52 cm
On loan from Miss P.C. and
Miss C.E. Patteson 1984 (6.L1984.1)
See cat. no. 73, and colour plate xxiii.

Joost Cornelisz Droochsloot
?Utrecht 1586 – 1666 Utrecht

Village Scene 1644

oil on panel 63 × 106.7 cm
Signed and dated lower centre
J.C. Droochsloot 1644
Presented by the National
Art-Collections Fund 1967 (342.967)

Dutch School
c. 1665

The Yarmouth Collection c. 1665

oil on canvas 165 × 246.5 cm
Presented by Mrs. M. Buxton 1947
(170.947)
See cat. no. 15, and colour plate vi.

Dutch School
c. 1707

View of Norwich

oil on panel 133.7 × 125.1 cm
Purchased with Government
grant-in-aid 1967 (341.967)
See cat. no. 20, and colour plate viii.

Dutch School
17th century

*Group of Men and a Horse near a
Frozen River*

oil on board 31.2 × 29.2 cm
Presented by the National
Art-Collections Fund 1973
(2.161.973)

Dutch School
c. 1800

Shipping Scene

oil on panel 23.8 × 28.5 cm
E.E. Cook Bequest through the
National Art-Collections Fund 1955
(172.955)

Flemish School
Antwerp 1505–20

Triptych: The Adoration, with St Peter and St Barbara and donors

oil on panels centre 54.3 × 36.5 cm;
wings 54.3 × 16.8 cm
Presented by Miss E.M. and
Miss Helen Colman 1948 (117.948)

Flemish School
Early 16th century

Head of Christ (panel from an East
Anglian rood screen)

oil on panel 61 × 17.1 cm
Presented by Percy Moore Turner
1945 (95.945)

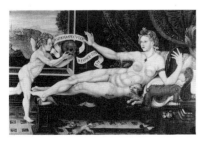

Flemish School
Early 17th century

Vanity

oil on seven panels 117 × 179 cm
Presented by Mrs Buxton 1925
(130.925)

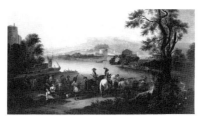

Flemish School
Late 17th – early 18th century

Landscape with Figures

oil on canvas 81.2 × 145.5 cm
Bequeathed by Harry W. Oddin-
Taylor 1969 (182.969)

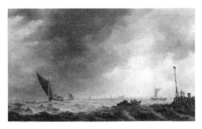

Jan van Goyen
Leiden 1596 – 1656 The Hague

A River Estuary 1639

oil on panel 38.5 × 62.4 cm
Signed with monogram and dated
on rowing boat lower left *VG 1639*
Purchased with the aid of grants
from the National Art-Collections
Fund and the Friends of the Norwich
Museums 1958 (223.958)

Jan van Goyen, attributed to
Leiden 1596 – 1656 The Hague

Estuary scene with Shipping c. 1650s

oil on panel 47.6 × 63.5 cm
On loan from Miss P.C. and
Miss C.E. Patteson 1984 (29.L1984.1)
See cat. no. 67, and colour plate xv.

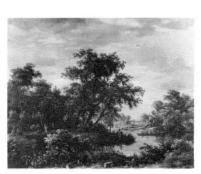

Meindert Hobbema
Amsterdam 1638 – 1709 Amsterdam

The Anglers

oil on panel 52.7 × 68.6 cm
Signed lower left *M. Hobbema*
E.E. Cook Bequest through the
National Art-Collections Fund
(171.955)

Abraham Hondius
Rotterdam *c.* 1625/30 – after 1695
London

The Stag Hunt c. 1675

oil on canvas 109.2 × 155.3 cm
Signed lower left *Abraham Hondius*
On loan from Miss P.C. and
Miss C.E. Patteson 1984 (9.L1984.1)
See cat. no. 72, and colour plate xxiv.

Cornelius Johnson *see* **van Ceulen**

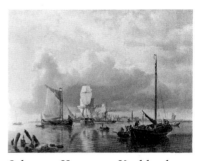

Johannes Hermanus Koekkoek
Vere 1778 – 1851 Amsterdam

View on the Scheldt

oil on canvas 41.5 × 54 cm
Signed lower left *J H Koekkoek*
Presented by J.H. Walter 1894 (7.94)

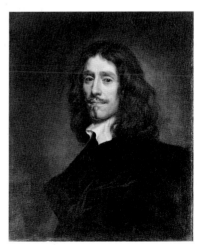

Peter Lely
Soest 1618 – 1680 London

*Portrait of Sir John Holland of
Quidenham (1602/3–1701) c.* 1650

oil on canvas 76.3 × 64 cm
Bequeathed by Mrs Maud Buxton
1949 (4.107.949)

169

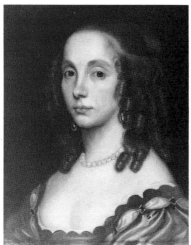

Peter Lely, attributed to
Soest 1618 – 1680 London

Portrait of Mrs Soame

oil on panel 39.5 × 31.6 cm
On loan from Miss P.C. and
Miss C.E. Patteson 1984 (39.L1984.1)

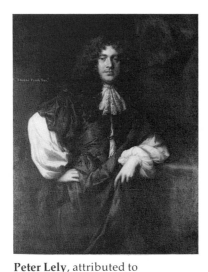

Peter Lely, attributed to
Soest 1618 – 1680 London

*Portrait of Sir Thomas Fitch, Bart
(1637–1688)*

oil on canvas 126.2 × 102.4 cm
Inscribed upper left *S*ʳ. *Thomas Fytch
Bart*!
Bequeathed by John R. Fitch 1904
(40.04)

**Master of the Legend of the
Magdalen**
fl. 1490–1525

*The Seven Sorrows of Mary
(The Ashwellthorpe Triptych) c.* 1520

oil on panels centre 83.8 × 64.2 cm;
wings 83.8 × 26.7 cm

Purchased by the Friends of the
Norwich Museums with Government
grant-in-aid and grants from the
National Art-Collections Fund and
a group of local benefactors 1983
(46.983)
See cat. no. 4, and colour plate i.

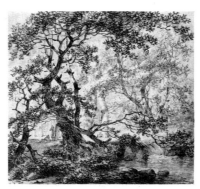

Hendrick de Meyer II
Amsterdam 1737 – 1793 London

Woodland Scene with Pool and Figures
1783

pencil and grey wash 23 × 25.5 cm
Signed and dated lower right
Hᵏ. Meyer inv / 1783
Purchased 1974 (1.328.974)

Frans van Mieris II
Leiden 1689 – 1763 Leiden

*Portrait of the Rev. Dr Cox Macro
(1683–1767) c.* 1703

oil on copper oval, 11.1 × 8.5 cm
On loan from Miss P.C. and
Miss C.E. Patteson 1984 (38.L1984.1)
See cat. no. 77, illustrated p.124

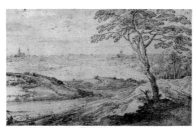

Josse de Momper II
Antwerp 1564 – 1635 Antwerp

Extensive Landscape

brown ink with brown and blue
wash 25.4 × 40.8 cm
Purchased with Government
grant-in-aid 1976 (11.369.976)

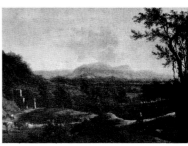

Frederik de Moucheron, attributed
to Emden 1633 – 1686 Amsterdam

Extensive Southern Landscape

oil on canvas 34.5 × 46.9 cm
On loan from Miss P.C. and
Miss C.E. Patteson 1984 (11.L1984.1)

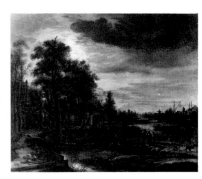

Aert van der Neer
Amsterdam 1603/4 – 1677
Amsterdam

Moonlit River Landscape

oil on canvas 82.7 × 98.2 cm
Signed lower left with monogram
AVDN
Purchased by the Friends of the
Norwich Museums with Government
grant-in-aid 1967 (23.967)

Pieter de Neyn
Leiden 1597 – 1639 Leiden

*River landscape with ferry boat and
cottage c.* 1635

oil on panel 29.5 × 57.8 cm
On loan from Miss P.C. and
Miss C.E. Patteson 1984 (30.L1984.1)
See cat. no. 66

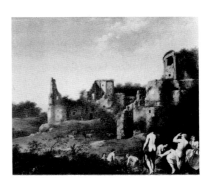

Cornelis van Poelenburgh
Utrecht 1586? – 1667 Utrecht

Landscape with Roman Ruins

oil on panel 39.4 × 48 cm
Purchased out of the Doyle Bequest
Fund 1957 (295.957)

Cornelis van Poelenburgh
Utrecht 1586? – 1667 Utrecht

*Nymphs bathing in a Southern
Landscape*

oil on panel 18.2 × 24.6 cm
On loan from Miss P.C. and
Miss C.E. Patteson 1984 (32.L1984.1)
See cat. no. 70

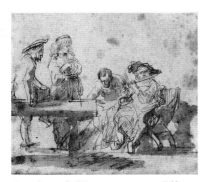

Rembrandt Harmensz. van Rijn
Leiden 1606 – 1669 Amsterdam

*Group of Musicians Listening to a
Flute Player* 1635

brown ink and wash on buff paper
13.5 × 15.3 cm
Accepted by the Government in lieu
of Capital Transfer Tax 1978 (184.978)

Salomon Rombouts
active 1652–60 in Haarlem and
Florence

*A Village Fair with a Mummer in the
foreground*

oil on canvas 75.5 × 63 cm
Signed lower left *SROMBOUtS*
On loan from Miss P.C. and
Miss C.E. Patteson 1984 (15.L1984.1)
See cat. no. 69

Willem Romeyn, attributed to
Haarlem *c.* 1624 – *c.* 1694 Haarlem

A Shepherdess with Sheep

oil on panel 46 × 61.9 cm
On loan from Miss P.C. and
Miss C.E. Patteson 1984 (34.L1984.1)
See cat. no. 76

Jacob Isaacksz. van Ruisdael,
follower of Haarlem School,
c. 1675–80

Ferry boat on a River

oil on canvas 65 × 84.4 cm
On loan from Miss P.C. and
Miss C.E. Patteson 1984 (16.L1984.1)
See cat. no. 74

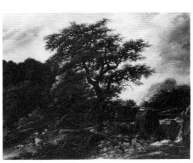

Jacob Salomonsz. van Ruysdael
Haarlem *c.* 1630 – 1681 Haarlem

Landscape

oil on canvas 83.2 × 109.8 cm
Bequeathed by E.D. Levine 1984
(55.986)

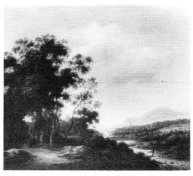

Herman Saftleven, circle of
1609–1685

*An Extensive River Landscape with
Figures on a Road, a wood to the left*

oil on canvas 50 × 58.2 cm
On loan from Miss P.C. and
Miss C.E. Patteson 1984 (17.L1984.1)

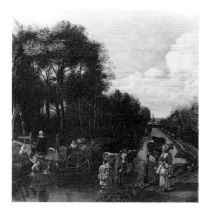

Jan Siberechts
Antwerp 1627 – *c.* 1700 London

Landscape

oil on canvas 104 × 104 cm
Purchased out of the Doyle Bequest
Fund 1949 (137.949)

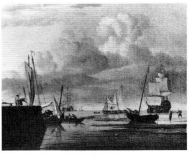

Abraham Storck
Amsterdam 1644 – after 1708
?Amsterdam

*Shipping in an estuary with a jetty
to the left*

oil on canvas 40.9 × 52.7 cm
On loan from Miss P.C. and
Miss C.E. Patteson 1984 (18.L1984.1)

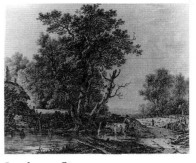

Jacob van Stry
Dordrecht 1756 – 1815 Dordrecht

*Landscape with figures, cattle and
sheep*

brown ink with brown and grey
wash 32.5 × 41.8 cm
Signed lower centre left *J: van Stry.*
Purchased with Government
grant-in-aid 1976 (16.369.976)

Peter Tillemans
Antwerp 1684 – 1734 Norton, Suffolk

The Artist's Studio c. 1716

oil on canvas 68.3 × 84 cm
Signed lower left *P. Tillemans. F*
On loan from Miss P.C. and
Miss C.E. Patteson 1984 (19.L1984.1)
*See cat. no. 78, illustrated front cover
and p. 124*

Peter Tillemans

Antwerp 1684 – 1734 Norton, Suffolk

Horse with Groom and Hounds 1734

oil on canvas 134.5 × 167.3 cm
Inscribed upper right *This Picture was left thus unfinsh'd by the / justly celebrated PETER TILLEMANS of / ANTWERP, it being the last piece that he / painted, and he working upon it the day / before his Death which hapned in this – / House in NORTON the fifth of DECEMBER – / MDCCXXXIV.*
On loan from Miss P.C. and
Miss C.E. Patteson 1984 (26.L1984.1)
See cat. no. 83, and colour plate xxvi.

Peter Tillemans

Antwerp 1684 – 1734 Norton, Suffolk

The Newmarket Watering Course

pencil, watercolour and ink on two sheets of paper, joined 29.8 × 93.9 cm
Engraved by Joseph Simpson, sen.
On loan from Miss P.C. and
Miss C.E. Patteson 1984 (27.L1984.1)
Illustrated p.45

Peter Tillemans

Antwerp 1684 – 1734 Norton, Suffolk

Battle Scene

oil on canvas 85 × 109.8 cm
Signed lower left *P Tillemans F*
On loan from Miss P.C. and
C.E. Patteson 1984 (20.L1984.1)
See cat. no. 81, illustrated p.44

Peter Tillemans

Antwerp 1684 – 1734 Norton, Suffolk

Portrait of Master Edward and Miss Mary Macro, the children of Revd. Dr. Cox Macro c. 1733

oil on canvas 117.2 × 88.1 cm
Signed lower centre left *Peter Tillemans F*
On loan from Miss P.C. and
Miss C.E. Patteson 1984 (21.L1984.1)
See cat. no. 82, illustrated p.47

Peter Tillemans

Antwerp 1684 – 1734 Norton, Suffolk

A Hunting Piece: Going a Hunting with Lord Biron's pack of Hounds

oil on canvas 46.5 × 67.7 cm
Signed lower centre left *P Tillemans F*
On loan from Miss P.C. and
Miss C.E. Patteson 1984 (22.L1984.1)
See cat. no. 79, illustrated p.126

Peter Tillemans

Antwerp 1684 – 1734 Norton, Suffolk

Little Haugh Hall, Suffolk

oil on canvas 85.8 × 152.2 cm
Signed lower centre left *P Tillemans F*
On loan from Miss P.C. and
Miss C.E. Patteson 1984 (23.L1984.1)
See cat. no. 80, and colour plate xxv.

Peter Tillemans

Antwerp 1684 – 1734 Norton, Suffolk

Four hounds with Gentlemen Shooting

oil on canvas 45.5 × 111.1 cm
Signed lower centre left *P. Tillemans F*
On loan from Miss P.C. and
Miss C.E. Patteson 1984 (24.L1984.1)

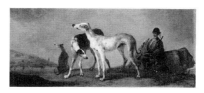

Peter Tillemans

Antwerp 1684 – 1734 Norton, Suffolk

Three hounds with Sportsman, a hunt to the left

oil on canvas 47.7 × 110.5 cm
On loan from Miss P.C. and
Miss C.E. Patteson 1984 (25.L1984.1)

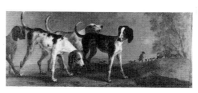

Peter Tillemans

Antwerp 1684 – 1734 Norton, Suffolk

Four hounds with Huntsmen to the right

oil on canvas 46.1 × 110 cm
Signed lower right *P. Tillemans f*
On loan from Miss P.C. and
Miss C.E. Patteson 1984 (41.L1984.1)

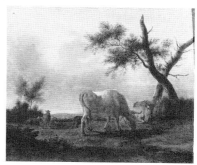

Adriaen van de Velde, attributed to
Amsterdam 1636 – 1672 Amsterdam

Landscape with Cattle

oil on panel 22.6 × 28.7 cm
Bears signature and date lower right *A V Velde / 166[?]*
On loan from Miss P.C. and
Miss C.E. Patteson 1984 (31.L1984.1)

Tobias Verhaecht
Antwerp 1561 – 1631 Antwerp

The Tower of Babel

oil on canvas 198.2 × 232.2 cm
Presented by Brigadier Hay Gurney 1949 (28.949)

Antonie Waterloo
?Utrecht c. 1610 – 1690 ?Utrecht

Landscape with Horsemen

oil on canvas 65.4 × 52.3 cm
Signed lower centre left with monogram *AW*
On loan from Miss P.C. and
Miss C.E. Patteson 1984 (33.L1984.1)
See cat. no. 75

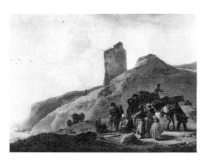

Philips Wouwermans
Haarlem 1619 – 1668 Haarlem

The Seashore at Scheveningen

oil on canvas 52.7 × 71.1 cm
Signed lower left with monogram
PHLS W
Purchased out of the Doyle Bequest
Fund 1956 (10.956)

Philips Wouwermans
Haarlem 1619 – 1668 Haarlem

*A Cavalry Skirmish in a Mountainous
Landscape*

oil on canvas 46.4 × 61 cm
Indistinct signature lower right
On loan from Miss P.C. and
Miss C.E. Patteson 1984 (36.L1984.1)
See cat. no. 71

Philips Wouwermans, follower of
1619–1668

*Figures on a Shore, a mother with a
child, a grey horse, a cart beyond*

oil on panel 41.3 × 49.3 cm
Bears monogram lower right *PsW*
On loan from Miss P.C. and
Miss C.E. Patteson 1984 (37.L1984.1)

Exhibitions

Australia 1977–78	*British Painting 1600–1800*, British Council
Cardiff 1960	*Ideal and Classical Landscape*, National Museum of Wales, Cardiff
Copenhagen 1983–4	*Konkylien og Mennesket*, Udstilling i Kunstindustrimuseet, Copenhagen
Haarlem 1979	*Johannes Cornelisz Verspronck*, Frans Halsmuseum, Haarlem
The Hague and London 1970–71	*'Shock of Recognition': The Landscape of English Romanticism and the Dutch Seventeenth-Century School*, Mauritshuis, The Hague, and Tate Gallery, London
Leeds 1868	*National Exhibition of Works of Art*
London 1815	*Pictures by . . . artists of the Flemish and Dutch Schools*, British Institution, London
London 1818	*Pictures of the Italian, Spanish, Flemish, Dutch and French Schools*, British Institution, London
London 1824	*Pictures by Sir J. Reynolds; with Selections from the Italian, Spanish, Flemish and Dutch Schools*, British Institution, London
London 1826	*His Majesty's collection of pictures from Carlton House Palace*, British Institution, London
London 1827	*His Majesty's collection of pictures from Carlton House Palace*, British Institution, London
London 1835	*Pictures by Italian, Spanish, Flemish, Dutch and French Masters*, British Institution, London
London 1842	*Works by Sir D. Wilkie RA, together with pictures by ancient masters*, British Institution, London
London 1848	*Pictures by Italian, Spanish, Flemish, Dutch, French and English Masters*, British Institution, London
London 1884	Royal Academy, London
London 1929	*Dutch Art*, Royal Academy, London
London 1938	*17th Century Art in Europe*, Royal Academy, London
London 1948	*Old Master Drawings from the Collection of the Earl of Leicester, Holkham Hall*, Arts Council of Great Britain
London 1952–3	*Dutch Pictures, 1450–1700*, Royal Academy, London
London 1953–4	*Flemish Art*, Royal Academy, London
London 1956–57	*British Portraits*, Royal Academy, London

London 1960–61	*The Age of Charles II*, Royal Academy, London
London 1964	*The Orange and The Rose*, Victoria & Albert Museum, London
London 1965	*The Assheton-Bennett Collection*, Royal Academy, London
London 1966	Rutland Gallery, London
London 1974	*Painting by Old Masters*, Thomas Agnew & Sons Ltd., London
London 1976	*Art in Seventeenth Century Holland*, National Gallery, London
London 1977	*Old Master Drawings from Holkham Collected by the First Earl of Leicester (1697–1759)*, Thomas Agnew & Sons Ltd., London
London 1978	*Sir Peter Lely*, National Portrait Gallery, London
London 1982	*Master Paintings 1470–1820*, Thomas Agnew & Sons Ltd., London
Manchester 1857	*Art Treasures of the United Kingdom*
Manchester 1965	*Renaissance to Baroque*, Manchester City Art Gallery
Münster and Baden-Baden 1980	*Still Life in Europe*, Westfälisches Landesmuseum für Kunst und Kulturgeschichte, Münster, and Staatliche Kunsthalle, Baden-Baden
Norwich 1805–27	The Norwich Society of Artists
Norwich 1828	*The Works of Ancient and Modern Masters*, The Norfolk and Suffolk Institution for the Promotion of the Fine Arts, Norwich
Norwich 1829	*Second Exhibition of The Works of Antient and Modern Masters*, The Norfolk and Suffolk Institution for the Promotion of the Fine Arts, Norwich
Norwich 1840	*The Norwich Polytechnic Exhibition*, Bazaar, St Andrews, Norwich
Norwich 1878	*Art Loan Exhibition in aid of St Peter Mancroft, Norwich*, St Andrew's Hall, Norwich
Norwich 1948	*Portraits in the Landscape Park*, Norwich Castle Museum
Norwich 1949	*Exhibition of Old Master Drawings Lent by the Earl of Leicester from the Holkham Hall Collection*, Norwich Castle Museum
Norwich 1953	*The Pastons*, Norwich Castle Museum
Norwich 1955	*Still Life, Bird and Flower Paintings*, Norwich Castle Museum
Norwich 1958	*Eighteenth-Century Italy and the Grand Tour*, Norwich Castle Museum
Norwich 1960	*The Restoration of King Charles II*, Strangers' Hall, Norwich
Norwich 1964	*Fine Paintings from East Anglia*, Norwich Castle Museum
Norwich 1966	*Dutch Paintings from East Anglia*, Norwich Castle Museum
Norwich 1985	*Norfolk and the Grand Tour: Eighteenth Century Travellers abroad and their Souvenirs*, Norwich Castle Museum
Washington and Los Angeles 1985–86	*Collection for a King: Old Master Paintings from the Dulwich Picture Gallery*, National Gallery of Art, Washington, DC, and Los Angeles County Museum of Art

175

Select Bibliography
Works referred to in abbreviated form

Amsterdam 1978	*Lucas van Leyden – Grafiek 1489 of 1494–1533*, Catalogue of exhibition, Rijksprentenkabinet/Rijksmuseum, Amsterdam
Astley, E.A.D. (Baron Hastings) 1936	*Astley of Melton Constable, 1236–1936*, privately published
Atkin, M., *et al.* 1985	'Excavations in Norwich 1971–78', part II, *East Anglian Archaeology* 26
Baart, J., *et al.* 1977	*Opgravingen in Amsterdam*, Amsterdam
Balis, Arnout, 1986	*Corpus Rubenianum Ludwig Burchard Part XVIII vol II, Rubens Hunting Scenes*
Barrell, John, 1986	*The Political Theory of Painting from Reynolds to Hazlitt, 'The Body of the Public'*, Yale
Barrett, G.N., 1981	*Norwich Silver and its marks*, Norwich
Bartsch, A., 1797	*Catalogue raisonné de toutes les estampes qui forment l'oeuvre de Rembrandt et ceux de ces principaux imitateurs*, Vienna
Bartsch, A., 1803–21	*Le Peintre Graveur*, 21 vols., Vienna
Bartsch, A., 1886	*Le Peintre Graveur*, vol. 6, new edition, Leipzig
Beck, Hans-Ulrich, 1972–3	*Jan van Goyen 1596–1656*, 2 vols., Amsterdam
Beckett, R.B., 1951	*Lely*, London
Beckett, R.B., 1962–68	*John Constable's Correspondence*, 6 vols., Ipswich
Berger, John, 1972	*Ways of Seeing*, BBC Publications, London
Borenius, T., 1923	*A Catalogue of the Pictures of 18 Kensington Palace Gardens, London, Collected by Viscount and Viscountess Lee of Fareham*
Boulter, Daniel, 1794	*Museum Boulterianum. A catalogue of the curious and valuable collection of natural and artificial curiosities in the Extensive Museum of Daniel Boulter, Yarmouth*, Yarmouth
Bredius, A., 1937	*The Paintings of Rembrandt*
Brettingham, M., 1773	*The Plans, Elevations, and Sections of Holkham in Norfolk*, 2nd ed., London
Brown, Christopher, 1986	*Dutch Landscape. The Early Years. Haarlem and Amsterdam 1590–1650* (Exhibition catalogue), London
Buchanan, W., 1824	*Memoirs of Painting, with a Chronological History of the Importation of Pictures by the Great Masters into England Since the French Revolution*, 2 vols., London
Burke, James D., 1976	*Jan Both: Paintings, Drawings and Prints*, New York and London

Chambers, John, 1829 — *A General History of the County of Norfolk intended to convey all the information of a Norfolk Tour . . .*, 2 vols., Norwich and London

Clifford, Derek and Timothy, 1968 — *John Crome*, London

Collins Baker, C.H., 1912 — *Lely and the Stuart Portrait Painters*

Colvin, H.M. and Wode-house, L.M., 1961 — 'Henry Bell of King's Lynn', *Architectural History*

Cotton, S., 1987 — 'Mediaeval Roodscreens in Norfolk – their Construction and Painting Dates', *Norfolk Archaeology*, XL, pt. 1

Cozens-Hardy, B., 1950 — *The Diary of Sylas Neville*, Oxford

Croft-Murray, Edward, 1970 — *Decorative Painting in England: 1537–1837*, vol. 2, *The eighteenth and nineteenth centuries*, Glasgow

Dawson, J., 1817 — *The Strangers Guide to Holkham, containing a description of the Paintings Statues &c. of Holkham House . . .*, Burnham

Dickes, W.F., 1905 — *The Norwich School of Painting*, London and Norwich

Druery, John Henry, 1826 — *Historical and Topographical Notices of Great Yarmouth, etc.*, London

Duleep Singh, Prince Frederick, 1927 — *Portraits in Norfolk Houses*, 2 vols., Norwich

Durham, J., 1926 — *The Raynham Pictures*, privately published

Farrer, Rev. Edmund, 1908 — *Portraits in Suffolk Houses (West)*, London

Fawcett, Trevor, 1974 — *The Rise of English Provincial Art*, Oxford

Fawcett, Trevor, 1976–78 — 'Eighteenth century Art in Norwich', *The Walpole Society*, XLVI

Friedländer, M.J., 1924 — *Lucas van Leyden*, Leipzig

Friedländer, M.J., 1975 — *Early Netherlandish Painting*, XII

Godfrey, Richard, 1987 — 'Rembrandt Etchings at the Norwich Castle Museum', *Print Quarterly*, IV

Graves, Algernon, 1970 — *Art Sales: from early in the eighteenth century to early in the twentieth century*, 3 vols., New York (originally published 1921)

Green, Barbara, and Young, Rachel, 1981 — *Norwich, the growth of a city*, Norfolk Museums Service

de Groot, C. Hofstede, 1907–28 — *A Catalogue raisonné of the works of the most eminent Dutch painters of the Seventeenth century*, 10 vols., Esslingen am Neekar

Gudlaugsson, S.J., 1959–60 — *Gerard Ter Borch*, 2 vols., The Hague

Gunther, R.T., ed., 1928 — *The Architecture of Sir Roger Pratt*

Gwynne-Jones, Allan, 1954 — *Introduction to Still-Life*, London and New York

Haak, B., 1984 — *The Golden Age, Dutch Painters of the Seventeenth Century*, London

Haak, B., et al., 1986 — *Stichting Foundation Rembrandt Research Project, A Corpus of Rembrandt Paintings, 1631–1634*, II

Harris, John, 1979 — *The Artist and the Country House*, London

Harris, John, 1986 — 'Oh Happy Oxnead', *Country Life*, 5 June 1986

Harvey, Lt. Col. J.R., 1912 — *Notes on the Harvey Family*, unpublished MS in Norwich Castle Museum

Hawcroft, F.W., 1957 — 'Dutch Landscapes and the English Collector', *Antique Collector*, June 1957

Hawcroft, F.W., 1959 — 'Crome and his patron: Thomas Harvey of Catton', *The Connoisseur*, December 1959

Hayward, J.F., 1967 — 'The Mannerist Goldsmiths: 4', *The Connoisseur*, January 1967

Hayward, John, 1976 — *Virtuoso Goldsmiths and the Triumph of Mannerism*, London

Hayward, John, 1983 — *The Art of the European Goldsmiths, From the Schroder Collection*, American Federation of the Arts

Held, J.S., 1980 — *The Oil Sketches of Peter Paul Rubens. A Critical Catalogue*

Hill, Oliver, and Cornforth, John, 1966 — *Country Houses, 'Caroline'*, London

Hind, Arthur M., 1912 — *Rembrandt's Etchings*, 2 vols., London

Hollstein, F.W.H., n.d. — *Dutch and Flemish Etchings, Engravings and Woodcuts ca. 1450–1700*, vol. XII, *Masters and Monogrammists of the 15th Century*, Amsterdam

Hulton, P.H., 1954–56 — 'Drawings of England in the Seventeenth Century by Willem Schellincks, Jacob Esselens and Lambert Doomer', *The Walpole Society*, XXXV, 2 vols.

Hutchison, J.C., ed., 1980 — *The Illustrated Bartsch*, vol. 8, *Early German Artists*, New York

Jacobowitz, E.S., and Stepanek, S.L., 1983 — *The Prints of Lucas van Leyden and his Contemporaries*, Washington

Jaffé, Michael, 1971 — 'Rubens and Snijders: A Fruitful Partnership', *Apollo*, March 1971, XCIII, no. 109 (New Series)

James, H., 1872 — The Metropolitan Museum's '1871 Purchase' in *The Painter's Eye*, London, 1956

Jameson, Mrs, 1844 — *Companion to the most celebrated Private Galleries of Art in London*

Jennings, S., 1981 — 'Eighteen Centuries of Pottery from Norwich', *East Anglian Archaeology*, 26

Jessop, Rev. Augustus, ed., 1887 — *The Autobiography of the Hon. Roger North*, London and Norwich

Jewson, Charles Boardman, 1954 — 'Transcript of Three Registers of Passengers from Great Yarmouth to Holland and New England 1637–1639', *Norfolk Record Society*, XXV

Jones, E.A., 1908 — *Old Silver Sacramental Vessels of Foreign Protestant Churches in England*, London

Kent, E.A., 1926 — 'Blackfriars Hall or Dutch Church, Norwich', *Norfolk Archaeology*, XXII

Ketton-Cremer, R.W., 1957 — *Norfolk Assembly*, London

Ketton-Cremer, R.W., 1962 — *Felbrigg, The Story of a House*, London

Keyes, George S., 1984 — *Esias van der Velde*, Doornspijk

Kirkpatrick, John, 1845 — *History of the Religious Orders and Communities, and of the Hospitals and Castle, of Norwich . . .*, ed. Dawson Turner, Norwich

Kitson, S.D., 1937 *The Life of John Sell Cotman*, London

Koeman, C., 1969 *Atalantes Neerlandici*, IV, 'Maritime Atlases', Amsterdam

Koreny, F., ed., 1981 *The Illustrated Bartsch*, vol. 9, *Early German Artists. Israhel van Meckenem*, New York

Lavalleye, J., 1967 *Pieter Breughel the Elder and Lucas van Leyden. The Complete Engravings, Etchings, and Woodcuts*, London

Lehrs, M., 1930 *Geschichte und kritischer Katalog des deutschen niederländischen und französischen Kupferstichs in 15. Jahrhundert*, VII

Leslie, C.R., 1951 *Memoirs of the Life of John Constable, composed chiefly of his letters*, Oxford

Liedtke, Walter A., 1984 *Flemish Painting in the Metropolitan Museum of Art*, I

Louw, H.J., 1981 'Anglo–Netherlandish architectural interchange *c.* 1600–*c.* 1660', *Architectural History*, 24

Lugt, F., 1921 *Les Marques De Collections De Dessins et D'Estampes*, Amsterdam

MacLaren, Neil, [revised] 1988 National Gallery Catalogues: *The Dutch School*, London, 1960. Revised Christopher Brown, 1988

Marrow, J., *et al.*, eds., 1981 *The Illustrated Bartsch*, vol. 12, *Hans Baldung Grien, Hans Springinklee, Lucas van Leyden*, New York

Martin, J. Rupert, 1972 *Rubenianum XVI The Decoration for the Pompa Introitus Ferdinandi*

Martindale, A., 1988 'The Ashwellthorpe Triptych', *The Harlaxton Papers*

Moens, William J.C., 1887–88 *The Walloons and Their Church at Norwich: Their History and Registers 1565–1832*, Huguenot Society of London

Moore, Andrew W., 1985 *Norfolk and the Grand Tour: Eighteenth Century Travellers and their Souvenirs*, Norfolk Museums Service
The Norwich School of Artists, Norfolk Museums Service

Murray, Peter, 1980 *Dulwich Picture Gallery: A Catalogue*, London

Neale, J.P., 1819–23 *Views of the Seats of Noblemen and Gentlemen in England, Wales, Scotland, and Ireland*, 6 vols., London

Norfolk Tour 1772 *The Norfolk Tour: or, Traveller's Pocket Companion*, printed by R. Beatniffe, Norwich

Oman, C., 1957 *English Church Plate*, London

Palmer, Charles John, 1872–5 *The Perlustration of Great Yarmouth*, 3 vols., Great Yarmouth

Plumb, J.H., 1960 *Sir Robert Walpole*, vol. II, *The King's Minister*

Popham, A.E., 1922 'The Etchings of J.S. Cotman', *The Print Collectors' Quarterly*, London, October 1922

Popham, A.E., and Lloyd, C., 1986 *Old Master Drawings at Holkham Hall*, Chicago

Raines, R., 1976 'An Art Collector of many parts', *Country Life*, 24 June 1976

Raines, R., 1978–80 'Peter Tillemans, Life and Work, with a list of representative paintings', *The Walpole Society*, XLVII

Rye, W., 1913 *Norfolk Families*, Norwich

Scarfe, Norman, 1958 'Little Haugh Hall, Suffolk', *Country Life*, 5 June 1958

Shestack, A., ed., 1969 *The Complete Engravings of Martin Schongauer*, New York

Silcox-Crowe, Nigel, 1985 · 'Sir Roger Pratt 1620–1685, The Ingenious Gentleman Architect', *The Architectural Outsiders*, ed. R. Brown, London

Slive, Seymour, 1970 · *Frans Hals*, London

Slive, S., and Hoetink, H.R., 1982 · *Jacob van Ruisdael*, New York and Amsterdam

Smith, J.A. 1829–42 · *A Catalogue raisonné of the works of the most eminent Dutch, Flemish and French Painters . . .*, 9 volumes and Supplement

Somof, A., 1901 · *Ermitage Impérial, Catalogue de la Galerie des Tableaux, II, Ecoles Neerlandaises et Ecole Allemande*, St Petersbourg

Stiennon, J., 1954 · *Les sites mosans de Lucas I et Martin I van Valckenborch. Essai d'identification*, Liège

Theobald, Henry Studdy, 1906 · *Crome's Etchings. A Catalogue and an Appreciation with some account of his Paintings*, London

Thieme, U., and Becker, F., 1949 · *Allgemeines Lexikon der bildenden Künstler*, H. Vollmer ed., XXXVII, Leipzig

Thistlethwaite, Jane, 1974 · 'The etchings of E.T. Daniell', *Norfolk Archaeology*, XXXVI, part I

Tingay, J.C., 1932 · 'Portraits of John Elison and his wife by Rembrandt', *Norfolk Archaeology*, XXIV

Turner, Dawson, 1838 · *Etchings and Views in Norfolk by the late John Crome together with a Biographical Memoir*

Turner, Dawson, 1840 · *Outlines in Lithography*, Great Yarmouth

Vertue 1934 · Vertue Note Books, vol. III, *The Walpole Society*, XXII

Vos, R., 1978 · *Lucas van Leyden*, Bentveld and Maarsen

Waagen, G., 1854–7 · *Treasures of Art in Great Britain, etc.*, vols. I–III and Supplement, London

Waterson, Merlin, 1986 · 'The Shipwright Squire, Marine pictures at Felbrigg, Norfolk', *Country Life*, 7 August 1986; 'Brigantines and Battle-Pieces, Marine Pictures at Felbrigg', II, *Country Life*, 18 September 1986

Westmacott, C.M., 1824 · *British Galleries of Painting and Sculpture*, London

White, G.M. 1926 · *Complete Peerage*, London

White, Christopher, 1982 · *The Dutch Pictures in the Collection of Her Majesty the Queen*, Cambridge

White, Christopher, et al. (David Alexander and Ellen D'Oench) 1983 · *Rembrandt in Eighteenth Century England*, Yale Center for British Art

Whitley, W.T., 1928 · *Artists and their friends in England 1700–1799*, London

Wilson, Timothy, 1987 · *Ceramic Art of the Italian Renaissance*, British Museum Publications

Woods, W., 1979 · 'Poetry of Dutch Refugees in Norwich', *Dutch Crossing. A Journal for Students of Dutch in Britain*, 8

Wornum, ed., 1862 · Horace Walpole, *Anecdotes of Painting in England . . .*, II

Lenders to the Exhibition

Numbers referred to are catalogue numbers

H.M. The Queen: 108

Sir Christopher Beauchamp Bt: 46–51; 53

Trustees of the Bowood Collection: 84

Foundation E.G. Bührle Collection, Zurich: 59

Cambridge, The Syndics of the Fitzwilliam Museum: 119

Viscount Coke and the Trustees of the Holkham Estate: 25–37

Andrew Fountaine: 23; 24; 115–117

His Grace the Duke of Grafton: 16; 17

Ipswich Museums and Galleries: 55–58

King's Lynn Museum (Norfolk Museums Service): 22

Leeds City Art Galleries: 99

London, Trustees of the British Museum: 2; 3; 44

London, Governors of Dulwich Picture Gallery: 88

London, Trustees of the National Gallery: 85–87

London, National Maritime Museum: 54

Manchester City Art Galleries: 89

The National Trust (Blickling Hall): 21

The National Trust (Felbrigg Hall): 38–43; 114

The National Trust (Upton House, Bearsted Collection): 118

New York, Metropolitan Museum of Art, The Jules Bache Collection: 13

New York, Metropolitan Museum of Art: 60

Norfolk County Library: 5

Norfolk Record Office: 7; 8

Norwich Castle Museum (Norfolk Museums Service): 1; 4; 6; 9–11; 15;
 20; 45; 66–83; 90–98; 100–107; 109

Private Collection: 12; 14; 18; 19; 61; 62; 110–113

Commander P.H.B. Taylor: 63–65

R. Hanbury Tenison, JP: 52

Index

Printed in the United Kingdom for Her Majesty's Stationery Office
Dd. 240064 8/88 C20